THE COMMUNITY
ARTS COUNCIL
MOVEMENT

THE COMMUNITY ARTS COUNCIL MOVEMENT

History, Opinions, Issues

Nina Freedlander Gibans

PRAEGER SPECIAL STUDIES • PRAEGER SCIENTIFIC

Library of Congress Cataloging in Publication Data

Gibans, Nina Freedlander.
 The community arts council movement.

 Bibliography: p.
 Includes index.
 1. Art commissions — United States. 2. Arts — United
States. I. Title.
NX22.G5 1982 352.94'54'0973 82-15146
ISBN 0-03-062052-X

Published in 1982 by Praeger Publishers
CBS Educational and Professional Publishing
a Division of CBS Inc.
521 Fifth Avenue, New York, New York 10175 U.S.A.

23456789 052 987654321

Printed in the United States of America

To my father, Samuel O. Freedlander, for his belief in life and challenge.

To Lester Glick, for his humanistic leadership and his belief in the potential of the arts council challenge.

To Sarah Lawrence College for instilling in each individual a sense of one's own responsibility for learning and self-fulfillment.

No other group [than the local arts agency] has had more experience in supporting and serving the arts in America and no other group has been more involved in developing the public and private support necessary to sustain our cultural resources. Unlike many of the other organizations, . . . most of the agencies have never received a grant from the National Endowment for the Arts . . . but our opposition stems from . . . our certain knowledge of the precarious financial state of the arts in America and the impact that these cuts will have upon the overall public commitment to the arts for present and future generations.

For too long, we have expected the arts in this country to be sustained by wooing rich old ladies and gentlemen, by holding charity balls and auctions, by submitting innovative proposals to foundations and corporations, by increasing admission fees, and by paying, if at all, ridiculously low wages and spending too little time on art and too much time on fundraising. While some of these activities may be necessary, both for the arts and members of Congress, they tend to obscure the reality — which is an inadequate public support base for the arts in America. No other civilized nation in the world expects its arts institutions to operate in such a manner. It is a testament to the resourcefulness of the arts to do so much, for so many, with so little, for so long.

The paltry sums which have been provided for federal arts support since 1965 have never, in any year, even approached the level of the public relations budget for the Pentagon. . . .

Those of us who were working in the arts prior to the creation of the National Endowment for the Arts in 1965 remember, only too well, a time of no federal support. A time of little state support and one in which municipal support was limited to a few public museums, zoos and recreation programs. We well remember this period when most of the nation's performing artists were seasonal employees or migrant workers. When teaching offered the only stable employment for most of our creative artists. When most arts programs were avocational, run by volunteers on nights or weekends. When parents viewed a career in the arts for their children as something akin to prostitution. We have no desire to return to those golden days.

The agencies I represent know that a decreasing federal commitment to the arts has a ripple effect upon state and local government support and that the cuts in many other federal programs have made it more difficult for the arts to compete for funds from the private sector at the local level. We know that this nation can ill afford to deny a significant portion of our population access to our cultural institutions or to restrict the arts to a handful of major cities who enjoy substantial private resources and growth.

> Robert Canon, President, National Assembly
> of Community Arts Agencies, in testimony
> before Senate Subcommittee hearing on the
> Fiscal 1983 National Endowment for the
> Arts appropriations, March 3, 1982.

Foreword

Nina Gibans' fine work is the most extensive documentation and insightful examination of a remarkable phenomenon in American life over the past few decades: the emergence of a national arts movement. The mark of this movement is that it has been founded, run, and guided from its inception by a growing professional group of dedicated people.

Above all else, this movement has been convinced that the output of the artist, whether as an individual or as part of a larger organization, is an indispensable part of the life of the people of this country and the world. Yet there is also a sense of pluralism — the right to be different, the right to experiment, to try, albeit always to be aware that the appetite for both artistic expression and appreciation is as wide and deep as the country itself. The amazing part of the arts today in America is that it now seems in retrospect that the people who wanted to be active in the arts seem to have been there all the time, awaiting the chance to participate. To those who did all the hard labor, survived the long hours of organization, and largely endured the bitter financial sacrifices in silence, but who have kept the faith, the United States owes a huge debt. For, in the end, the arts have provided solace and creative character in difficult and distressing times. Indeed, they have fulfilled a creative and even spiritual need in what often seem to have been endless gray times.

Our debt to Nina Gibans is that she has caught all of this and much more.

Louis Harris, Chairman
American Council for the Arts
May 1982

Preface

The city of Cleveland, Ohio, has made a turnaround in the past two years, caused by the emergence of a new spirit symbolized in the person of the new mayor, but representing the efforts of the private and public sector resolving to work through the city's problems together. In addressing basic issues such as economic development, racism, housing, and education, I would hope that the city would also recognize the importance of including cultural planning. For when the preoccupation with the reopening of the renovated fine old theaters in downtown Cleveland is past history, the ongoing need for planning for the future of the variety of the city's artistic opportunities, which are also of private *and* public concern, will become more evident.

Directing an arts council in a city like Cleveland during the 1970s was a special experience. Finding a place for an arts council in the context of one of the strongest traditions of private support for cultural institutions; an aggressive and innovative community foundation; at the time, a city in default with a problematic mayor; neighborhoods hopeful but tense about power and opportunity; and a desperate need to coalesce a new leadership to address the basic urban problems of an economic and political nature — this meant seeking the areas of need among the giant forces described. They emerged in the areas of concern for individual artists; training for professionals and volunteers; arts and education; neighborhood arts; advocacy; and local public funding. Even though the balance of factors weighs differ-

ently in every community, the struggles of this council were no different
from any others in an urban setting, albeit most difficult given its timing.
This is my experiential point of departure; and as I participated in and ob-
served the state and national scene, I learned that our problems and the is-
sues were by no means unique.

The idea for this book came from the fact that, on many occasions, I
have been approached by people interested in some of the new issues that
face citizens and policy makers in the arts, community and public advo-
cates, and, of course, professionals in the field. They are seeking informa-
tion and some synthesis of what has happened in the area of the multiple
arts, as opposed to single-discipline organizations, such as museums and or-
chestras. The material of experience in this community arts field is becom-
ing better documented, but remains fragmented and has not been analyzed
or synthesized.

By discussing the development of the community arts agencies, usual-
ly known as arts councils or commissions, this book examines the develop-
mental patterns, functions, and issues surrounding these agencies, which
have grown in number to over 1,000 over the last 30 years. What are some
of the things that they have been doing and ways that they have been func-
tioning in their individual communities? What has been their specific im-
pact? What have been their strengths, weaknesses, and common problems?

This book is based on material gathered in several ways — primarily
through interviews in the field with the people who are actively involved in
the day-to-day life of over 60 current arts councils, commissions, and relat-
ed associations. Other interviews have been held with those who are train-
ing today's arts managers, with former and current leaders who have de-
voted a major part of their professional life to this growing field, and with
others whose actions have had a bearing on the direction communities have
taken in recent years in regard to the arts — which often, though not al-
ways, includes the activities of an arts council. Another group of interviews
has been conducted with those who have been influential in the arts and edu-
cation — policy makers from the government and foundations, as well as
some persons inside the school systems of some communities. The longer in-
terviews have been synthesized and checked for accuracy; there was an or-
ganized framework of questions so that the interviews began from the same
point of inquiry. Each, however, took its natural course, and emphasis was
determined by the interviewee.

Statistics, even for specific agencies or numbers of arts councils, have
been problematic. What is one person's view by guess or wish is another
person's fact. All surveys have been challenged, but everyone knows that
survey results often depend on the way questions are asked, the numbers of
respondees, the scope of definition, and the expectations. Some are satisfac-
tory, but none are fully satisfying, for the reasons cited. However, they are

helpful in bringing attention to issues and patterns of behavior, and looking at ourselves and our communities.

I am indebted to those who placed their "archives" in my care and who so willingly helped sew the threads of history together through their recollection and participation. They range from persons who have headed the National Endowment for the Arts, to staff members of state and local arts councils, to many other individuals.

This research process allowed me to gather enough raw material to weigh issues and assess the lay of the land. The interviewees were chosen from recommendations and suggestions gathered from the staff and board of directors of the National Assembly of Community Arts Agencies (NACAA), and from my own knowledge of the field gathered from seven years as director of a community council and as a board member of two national organizations serving arts councils. Two newsletters — *The Arts Reporting Service*, edited by Charles C. Mark, and *Arts Management*, edited by Alvin H. Reiss — have been part of my professional reading for a decade and have influenced such decisions. Materials published by the American Council for the Arts (ACA) and by Partners for Livable Places were also important. The philosophy followed was that if a council somewhere had functioned in a certain area of community concern with some priority and expertise, it was a model for all communities to consider. A model equaled potential.

Following a field that has been fluid and about which little has been put into words is a challenge. Moreover, programs, activities, and organizations operative at one time may be radically altered. One is not always able to trace the history from the first moment, and yet in this field most of the "original" participants are still around. Yet it is clear that history is created by points of view. As someone said in the middle of a discussion, "Where you stand may depend on where you sit." Therefore I would not expect total agreement on any of the points made and issues raised. There is a common understanding on some issues that never before have been discussed in the open. And the many threads of the fabric come together only when one is able to focus on it from a wide angle. I hope that my years of observation have allowed me to do this in a way that is helpful to communities and individuals enmeshed in the details of the activity.

Acknowledgments

I am grateful to everyone with whom I have spoken or from whom I have requested assistance; not one person with whom I spoke was unwilling to share materials, information, and opinions. My informants are part and parcel of each point made, whether fact or opinion. Some brought up points that others raised, and the collective concern became my concern, no longer individually discernible. There are a few lone voices. Each arts council is unique in the community of its being, not in its network of like agencies.

The readers and advisors need special mention for wading through the uncut chapters and manuscript and contributing valuable comments. They include the following:

- Ralph Burgard, consultant.
- John Everitt, Director of Arts and Humanities Council of Tulsa; former chairman of NACAA.
- Maryo Ewell, Director, Community Program, Colorado Council on the Arts and Humanities; former Director of Community Arts Development, Illinois Arts Council.
- Clark Mitze, retired; former director of Missouri, Illinois, and California state arts councils, and of the Federal-State Partnership program, National Endowment for the Arts.
- Fred E. Schultz, former Community Development Coordinator for Western North Carolina.

- Gene C. Wenner, President, Arts and Education Consultants, Inc.; former President, American Music Conference; former Associate Director, JDR 3rd Fund, Arts-in-Education program; former Arts Education Coordinator, Office of the Commission, U.S. Office of Education.
- Gretchen Wiest, Executive Director, NALAA (until mid-1982, NACAA).
- Susan Neumann, Deputy Director, Ohio Arts Council.

There are the personal acknowledgments. The foundations and institutions who supported my efforts and research needs include the AHS Foundation and the Harry K. Fox and Emma R. Fox Charitable Foundation of Cleveland, Ohio; the Cleveland Public Library System and its director, Dr. Ervin J. Gaines, as well as the Shaker Heights (Ohio) Public Library System, and the computerized interloan capabilities that could bring documents from everywhere to Cleveland. Thanks to my family — supporters, advisors, and cheerleaders all; also to our golden retriever, Bailey, whose love of balled-up paper spared the good manuscript copies. I am grateful to Martha Gibbons, Deborah Eaton Bitterman, and Sharon Kumnick, whose availability and technical assistance were invaluable during the final phase of the work.

And to one who stands out as dearest friend and severest editor — my husband, Jim, my special pride.

Contents

List of Tables
and Figures

Tables

Figures

Glossary of Terms, Titles, and Jargon

AAA American Arts Alliance; an affiliation of major arts institutions such as large opera companies, museums, orchestras, and so on. The primary focus has been on lobbying in behalf of the arts.

AAE Alliance for Arts Education; a network of 55 committees, one in each state as well as in the Bureau of Indian Affairs, the District of Columbia, Puerto Rico, and Samoa and the Virgin Islands. Each committee has its own goals, objectives, and activities in pursuit of the idea of making the arts an integral part of the elementary and secondary school programs. National offices are located at Kennedy Center.

ACA American Council for the Arts; a national arts service organization that performs an advocacy role, publishes books and newsletters on the arts, and sponsors conferences and workshops. State and community assemblies (the National Assembly of State Arts Agencies, or NASAA, and NACAA) were under the ACA umbrella until 1973, when NASAA became independent. NACAA was a part of ACA from 1972 to 1978. ACA was formerly known as the Arts Councils of America (1965-66) and the Associated Councils of the Arts (1966-79).

ACUCAA Association of College, University, and Community Arts Administrators; a national service organization oriented toward educa-

tion and community organizations that sponsor touring productions. ACUCAA publishes a newsletter and sponsors workshops and research publications.

ASOL American Symphony Orchestra League; a nonprofit service and education organization dedicated to the development of American symphony orchestras and to the cultural vitality of the community they serve. ASOL organized the first arts council convention, housing subsequent ones until the movement became independent.

Arts Lottery In Massachusetts, a system of ticket purchase used to help the arts.

Association of Junior Leagues, Inc. An international voluntary organization whose focus is to educate and train individual women who exhibit the potential for leadership so that they can be effective volunteers in the community. Its purpose is to foster interest among local member chapters in the social, economic, educational, cultural, and civic conditions of the community and to make efficient their local volunteer services.

Beer and Culture Society An informal name of a group that used to meet to talk about the city of Seattle in the early 1950s; used to talk about "they" and realized "they" were "we." Became Allied Arts of Seattle, Inc. Name suggested by John Ashby Conway, a founder of Allied Arts, Inc., a member of Seattle's Advisory Arts Commission and the State Arts Council, now retired from the University of Washington School of Drama. He now runs the Farmhouse Restaurant and lives in Port Townsend, Washington.

CACI Community Arts Councils, Inc.; the first association of arts councils to give a united voice to the movement and direct service to communities with arts councils; preceded the development of the ACA.

CART Community Artists Residency Training program; has been sponsored by Affiliate Artists, Inc. A program designed to bring a greater awareness of the arts to culturally deprived areas of the country, often rural areas.

CEMREL Central Midwestern Regional Education Laboratory; sponsors of the Aesthetic Education program to make aesthetics and the arts an essential part of the total educational programs of school systems and state education departments.

CETA Comprehensive Employment and Training Act (1974–82); CETA support for the arts, in addition to attacking unemployment among artists and other cultural workers, generated jobs and economic development opportunities in the private sector.

Challenge Grant This National Endowment for the Arts program has encouraged cultural organizations to achieve financial stability, particularly by finding new sources of continuing support. Grants are available to institutions or groups of institutions with a proven commitment to artistic excellence. Most recipients are already grantees in other Endowment programs.

CityArts A National Endowment for the Arts Expansion Arts program to encourage municipal arts agencies or private arts councils designated by the city, to generate new local public monies, and to give their neighborhood arts programs financial and technical help. The Endowment has provided matching grants to the agencies, which in turn awarded subgrants to local community-based arts programs. Requirements included offering the programs technical assistance.

City Spirit A program of the National Endowment for the Arts (1974–78) interested in the process of involving many community interests in order to raise the priority of the arts in the lives of communities.

Community arts councils or agencies Since this book is a discussion of the genre, the definitions are part of the discussion. However, "councils," "agencies," "commissions," "associations," "federations," "departments," and "alliances" are all terms used for the genre. The various species are discussed in their context. However, terms have not been consistent in the field and functions are not delineated by title except that a united arts fund group raises monies as part of its function. The terms "community arts council" and "community arts agency" are used interchangeably throughout the text as they have become used in the field. (See also **Local arts agency**.)

Concerned Citizens for the Arts of New York State Forerunner of most advocacy groups in the nation.

Council of social agencies Historically, umbrella groups for social service agencies, established in such cities as Chicago (now the Welfare Council), Indianapolis, Hartford, and others.

Expansion Arts This program reflects the National Endowment for the Arts' desire to expand the involvement of all Americans in the arts and to encourage the artistic expression of the nation's diverse cultural groups. It carries out these goals by supporting professionally directed organizations that bring the arts to low-income groups, minority groups, and others who have little access to the arts.

Federal-state-local partnerships Partnership programs fostering collaboration among the members of the public support network for the arts.

Local As an adjective, "local" can be interpreted to mean city, county, multicounty, town, township, multitown, metro area, multicity, city and university, city and multicity, city and county, city and multicounty, and neighborhood among others. These are service areas for local arts agencies included in the NACAA membership survey of 1981–82.

Local arts agency A public or private not-for-profit organization or agency, whose primary purpose is to provide a support system and network to develop, deliver, and sustain arts activities in the community. Provides such services as support of individual artists, promotion of arts activities, grant making, space provision, and central administration services for art organizations. (See also **Community arts councils or agencies.**)

Municipal Arts Federation Formerly Urban Arts Symposium; incorporated January 1981 for local arts agencies of largest cities. Works within NACAA (NALAA).

NACAA National Assembly of Community Arts Agencies; formed to give community councils, commissions, arts centers, and united arts funds organizations a national voice. Name changed in mid-1982 to National Assembly of Local Arts Agencies (NALAA) to reflect the distinction between those multidisciplinary agencies that have as their purpose the provision of services and support to artists and arts organizations within the community (local arts agencies) and the recipients of such services and support (referred to generically as community arts organizations).

NAPNOC Neighborhood Arts Programs National Organizing Committee; a national nonprofit organization, open to neighborhood arts organizations and other groups and individuals who support the neighborhood arts movement.

NASAA National Assembly of State Arts Agencies; the counterpart to NACAA for the state arts agencies.

National Council on the Arts Advises the Endowment on programs, policies, and procedures. By law, the Council also reviews and makes recommendations on applications for grants. The Council is composed of the Chairman of the Endowment and 26 citizens appointed by the President who are widely recognized for their knowledge, expertise, or profound interest in the arts. They serve six-year terms, staggered so that roughly one-third of the Council rotates every two years. Sometimes known as the National Council (not to be confused with the Federal Council on the Arts and Humanities, basically a coordinating committee of federal officials).

National Endowment for the Arts An agency of the federal government that provides funding and information for arts programs and organizations. Known as The Arts Endowment or, in this book, as the Endowment.

National League of Cities A federation of state leagues of municipalities representing 900 municipalities plus individual cities. Develops and puts into effect national municipal policy — a statement of major municipal goals in the United States. It was created to help cities solve critical problems they have in common. It maintains an information and consultation service as well as a library of 20,000 books and 800 periodicals. Formerly the American Municipal Association; founded in 1924, located in Washington, D.C.

NEH National Endowment for the Humanities; an agency of the federal government that provides funding and support for research and programs in the humanities.

Office of Partnership This is the division within the Office of the Chairman of the Endowment that has been responsible for developing and implementing a "partnership" relationship between the Endowment and state government (state arts agencies) and local government (including community arts agencies).

Percent for art in public places laws Alternately called "art in architecture," "art in public works," or "art in city construction projects." Laws in some states and cities mandating that a percent of public construction budgets be spent on works of art. Usually 1 percent, occasionally higher.

Performing Of, relating to, or constituting an art that involves public performance.

Presenting The act of bringing before the public.

Programming As in "programming council"; an organization that develops and implements programs for the public in addition to, or as opposed to, giving technical assistance and services.

Publicly designated council A private nonprofit organization designated by a city or county legislative body as an agency to represent that community in the arts, especially in regard to such matters as receiving public monies for reallocation to arts activities and organizations, and other activities of a public nature. Designation is usually made through a formal, recognized process.

State arts agency A unit of state government that normally grants state and federal (mostly Endowment) funds to arts organizations. State

arts agencies often develop plans; provide technical assistance; and sponsor touring programs, artists in the schools programs, and so on. All 50 states and six U.S. jurisdictions (such as Puerto Rico and Guam) have official state arts agencies. With the exception of the Vermont Council on the Arts, which is a private nonprofit organization, all are agencies of state government. These agencies award grants and provide services to arts organizations, artists, local arts agencies, and presenting organizations. In addition, eight regional groups have been formed by the states. These groups have administered programs and services that are most efficiently carried out on a multistate basis. Also referred to as state arts council, state arts commission, and the like.

SMSA Standard metropolitan statistical area; a county containing a city with a population of 50,000 or more, plus contiguous counties socially and economically integrated with the central county.

Sponsoring The act of assuming responsibility for some program.

Touring programs Programs to make the best of American art available to the largest possible number of people, as in dance; presenters have been able to apply for up to 30 percent of the participating companies' minimum fees. Grants are made through state arts agencies or other coordinating organizations. These grants have been available in several arts areas.

United arts fund A combined appeal conducted on an annual basis, raising operating funds for a minimum of three different cultural organizations, and implying some degree of restriction on each organization's own fundraising. Some are connected with specific arts centers. There are two major types of drives—those that are corporate only (appealing just to the business sector), and those that are communitywide. There are more of the latter.

United Way Known as United Way of America, formerly Community Chests and Councils, Inc.; provides national, regional, and local programming support and consultation to United Ways in the areas of fundraising, budgeting, management, allocating, planning, and communications. (Usually does not include arts organizations.)

U.S. Conference of Mayors Cities with populations of more than 30,000, represented by their mayors, may attend this conference. Its purpose is to promote and improve municipal government by cooperation between cities and the federal government; it provides educational information, counseling, and legislative services to cities. It was founded in 1932, has 830 members, and is located in Washington, D.C.

Volunteer Lawyers for the Arts and Volunteer Accountants for the Arts
Organizations, both formal and informal, of citizens in the professions of law and accounting who have demonstrated a special interest in assisting artists and arts organizations through the use of their professional skills. There are also programs of business people who assist the arts through the use of their professional skills.

Voucher programs Ticket subsidy programs started more than a decade ago by Theater Development Fund of New York City. Related programs in other cities.

List of Abbreviations

AAA American Arts Alliance

AAE Alliance for Arts Education

ACA American Council for the Arts

ACUCAA Association of College, University, and Community Arts Administrators

ASOL American Symphony Orchestra League

CACI Community Arts Councils, Inc.

CART Community Artists Residency Training program

CEMREL Central Midwestern Regional Educational Laboratory

CETA Comprehensive Employment and Training Act

FEDAPT Foundation for the Extension and Development of the American Professional Theater

HAI Hospital Audiences, Inc.

HEW Department of Health, Education and Welfare

HHS Department of Health and Human Services (formerly HEW)

HUD Department of Housing and Urban Development

NACAA National Assembly of Community Arts Agencies

NALAA National Assembly of Local Arts Agencies (name of NACAA from mid-1982)

NAPNOC Neighborhood Arts Programs National Organizing Committee

NASAA National Assembly of State Arts Agencies

NEH National Endowment for the Humanities

SMSA Standard metropolitan statistical area

WPA Works Progress Administration (1930s)

Introduction

Even though it wasn't the first time in American history that the federal government had been involved in support of the arts, the establishment in the 1960s of the National Endowment for the Arts and Humanities marked a special moment in the cultural life of America. Within a short time, with this extra incentive, those states that did not already have state arts agencies developed them.

As if this activity would not cause enough change in the arts support systems, community fronts were changing as well. As history tells it, the focus for dramatic change amid a proliferation of arts activity in the past 15 years has been in the cities, towns, and rural areas throughout America, bringing new levels of awareness and participation, of involvement and advocacy.

A new type of agency, the community arts council, with roots laid some 20 years before, started to take hold in every conceivable setting. It, too, was not a new concept, but one simply given impetus by the events. Why? Partly to collate and to coordinate some of the activities of the total arts community whose strengths and needs, as a whole, were greater than those of its individual parts; partly to service those needs (most especially the ones of the newest members); and partly to link arts interests to the interests of the total community in every possible way. Sometimes with grace and subtlety, sometimes with impact and power, the councils have played an important and increasingly recognized role in the communities. They

have laid the groundwork for change in some interesting ways that are new to the arts. The clues for methods and processes for achievement are in other fields, such as education, health, welfare, and government itself.

The issues that have faced arts councils are many; the ways in which councils have responded are even more diverse. The "typical" arts council, like a butterfly, is not easily netted. The minute we think we can describe *the* prototype, we meet a different kind in a different community, functioning perfectly well and successfully.

The examples in this book are gathered from research gathered from the first 30-odd years of the arts councils' existence. For every example today, there may be other prime examples tomorrow. There have been well-known festivals in Oklahoma City and Baton Rouge sponsored by the arts councils of those cities, stable municipal agencies in the Far West, and well-run private councils in many of our communities in the past that are not mentioned. That does not mean they are not as good as others; the proliferation of particular activity does not allow mention of all.

For example, although everyone knows that there is a history of support for the arts in New York City, and that New York City has a department of cultural affairs and several arts councils, this book has examined the scene in other communities of the United States. The special histories of the arts institutions and organizations in New York City, and of the support of them, have been and will continue to be the subject of separate reports and books.

Because of the nature of the community arts council, it will survive with community leadership and a willingness to weather hard evaluation so that it is flexible and timely. Those rhythms are oriented by the values of a city in a given time — its economic health and priorities. If the economic health is seen to include the arts, the council's work will be more highly valued. The private boards or public commissions must take a stance on issues with the vision and creative support that keeps symphonies going or theater doors open. However, this is the challenge of the community council movement.

This book is, in part, a synthesis of profiles of agencies and a discussion of some of the issues that are facing them, based on interviews with those who have been involved.

The facts have been gathered in a moment in time at the beginning of the 1980s; they do not stand still for the currency of a publication. The majority of interviews were done during the years 1980 and 1981; therefore, cognizance of the possibility of "datedness" has been paramount. Facts and figures serve as a background for trends — which are more important than old figures. All development seems slow, but the span of time seems short. It has been saturated with change at an unprecedented pace in this field. The relentlessness and vigor challenge the most energetic manager.

The total implication for communities of the New Federalism is unclear as 1983 budgets are being implemented. In the arts areas, where the final federal budgeting for 1982 was cut about 10 percent after projections far more devastating, 1983 is the year in which cuts of new dimension and impact will be felt. What is clear is that communities will have important decisions to make about priorities. The thrust of a community's volunteer commitments will affect the arts as every other nonprofit effort does. What are the coordination efforts needed in this framework?

The book is an attempt to draw some conclusions that should be of interest to citizens of every community. It would be difficult to be an isolationist about the impact of the arts over the past 15 years. The goal of the book is to bring to greater public awareness current issues involving communities and the arts. Until now, documentation has been scant — mostly in the form of research studies and articles for professional consumption.

Those who have encouraged the writing of the book have seen a wide-ranging audience for whom it might be useful and/or interesting. Included are students of the arts and arts administration; the professionals in the field managing arts organizations of all sizes; legislators on all levels; boards and civic groups responsible for and responsive to the needs of the cultural nonprofit sector; business persons; social historians; and members of the general public, who have come to accept the arts as more a part of their daily lives than ever before.

Part I

THE SETTINGS

1

On the Dream

Every movement needs a missionary. One who carries the banner unstintingly from the first days, through all the struggles in communities large and small, on the national and local frontiers. One who is constructive and positive, cutting through all of the hesitations, fears, stops, and starts. One who is a motivator of others. One who retrenches when the battlefield changes. One who carries a single philosophy so far-reaching as never to be quite attainable in real terms, but who articulates the vision. Such a missionary of the arts council movement is Ralph Burgard. There are others who believe as unswervingly, whose contributions over the years have been parallel, who have a similar message. And it is, perhaps, dangerous to single one out. However, by so doing, one can get a glimpse of what the leadership has been like — and of some of the characteristics that have been part of the vitality of the movement.

Ralph Burgard was among the first arts council directors, and his enthusiasm is as strong today as it must have been when he became involved on the ground floor of the movement and as Director of the Winston-Salem Arts Council in 1955. He came to this special aspect of the arts almost by accident, and certainly by happy circumstance.

Lying stoically in a Buffalo hospital bed in 1952, surrounded by sand bags to cure a detached retina, he first considered leaving his field of advertising for arts administration through the suggestion of Ralph Black, then Manager of the Buffalo Philharmonic Orchestra. This conversation led

3

Burgard, upon recovery, to take a job as Manager of the Rhode Island Phil-
harmonic Orchestra. This was a beginning for his arts career. From the
Rhode Island group, he moved after two years to assist Ralph Black himself
with the Buffalo Philharmonic.

It was through these music circles that he met Helen Thompson, who
was Executive Secretary of the American Symphony Orchestra League
(ASOL). Through her interest and training as a social worker, she saw how
some of the values and strengths of coordinated programs in health and
welfare might be transferred to the arts field. It was then no surprise when,
at her instigation, a whole session at the 1952 ASOL national convention in
Erie, Pennsylvania, was devoted to discussion of the plans for coordinated
arts programs in cities.

In 1954, the ASOL persuaded the Rockefeller Foundation to pursue a
study of coordinated arts programs. When the survey plans began, there
were only a handful of groups and 15 were included in the study; only five
years later, there were 60.

In 1955, through his contact with Helen Thompson, Ralph Burgard
had to choose between the potential job of manager of the Buffalo Orches-
tra, or a job as Director of the Winston-Salem Arts Council; he picked the
Arts Council position. "There was a broader perspective — working with
individuals, various cultural institutions and the entire community — that
intrigued me then as it does now; I have never regretted my decision," says
Burgard.

As Director of the Arts Council of Winston-Salem from 1955 to 1957,
and then as Director of the St. Paul Council of Arts and Science from 1958
to 1965, he guided each community in building major arts centers and un-
dertaking annual united arts fund campaigns. He has been helping cities
plan their arts community futures ever since. Many councils will refer to
their broad structure as "the Burgard plan," characterized by several tiers of
involved individuals and organizations making decisions *with* the council.

It was Helen Thompson's concern for a broader perspective that led
the ASOL to invite community arts councils to the annual conventions of
community orchestras from the mid-1950s to the mid-1960s.

In 1959, the arts councils formally incorporated, calling themselves
Community Arts Councils, Inc. (CACI), but continued to meet annually as
a section of the ASOL convention.

In the mid-1960s, through her role as Special Studies Director of the
Rockefeller Brothers Fund, Nancy Hanks, later Chairman of the National
Endowment for the Arts, commissioned many papers on several subjects,
including the arts.

By this time, there were several state arts councils as well. All of these
events gave impetus for a national office to implement some of the recom-
mendations of the Rockefeller report as well as to provide assistance to the

growing number of state and community councils. To accomodate the state councils, CACI's name was changed to Arts Councils of America (ACA); a national office was established in New York City; and in 1965 Ralph Burgard became the first Director of ACA (later, Associated Councils of the Arts, and currently the American Council of the Arts). There was debate and discussion then, as there has been recently, concerning ACA's role — whether it should act as a service agency for its constituent groups or as a national spokesman for national cultural issues. Ralph Burgard's feeling has been that the local constituency is very important. "Without the local and state arts councils, there is no organized constituency to back up the national organization," he has said. ACA led early arts advocacy efforts to involve the local, state, and federal governments in the arts. This group has been instrumental in creating some widely quoted documents in recent cultural history. Some in particular are the results of the Louis Harris polls of the 1970s and 1980, which showed that Americans not only cared about the arts but were willing to pay for them.

The arts council movement has grown immensely. Today there are more than 1,000 local community organizations, and every state now has an agency. This diverse constituency was not easily serviced by one group, and so the National Assembly of State Arts Agencies (NASAA) and the National Assembly of Community Arts Agencies (NACAA) were spawned from ACA.

Burgard resigned from ACA in 1970 to pursue independent research in the United States and Europe concerning new ways of bringing together the arts, sciences, and people. Among many endeavors, he has completed studies on museum extension programs and arts programs in new towns for the National Endowment for the Arts, conducted seminars on cultural decentralization for cultural ministries in Europe, and completed major cultural plans for 17 cities and counties in the United States.

What does this mean? It means that for cities such as Winston-Salem and Charlotte, North Carolina, and counties such as Westchester (New York) and Santa Cruz (California), he has done the following:

- Analyzed the arts and science programs sponsored by cultural institutions, recreation departments, and college and school systems.
- Recommended programs to strengthen existing cultural groups.
- Instituted new programs that help bring together the arts, sciences, and people.
- Recommended new physical facilities where needed.
- Suggested the best organizational structure to carry out these plans.
- Recruited influential leaders to implement the recommendations.
- Outlined the budgetary requirements.
- Helped raise the funds to help implement the recommendations.

Underlying these plans is a zeal that persuades the most apathetic. At a meeting of arts councils from all over the state of Indiana, Burgard spun it out:

> Only spiritual and creative concerns will allow people in the industrial nations to survive physically and psychologically. The survival of people in a technological world is at stake. Technology alone will not nourish the soul.
>
> The arts are not the exclusive province of cultural institutions; creative instincts are found in all human beings, each to one's own measure, and cultural policy in every city must reflect this condition.[1]

With an emphasis on the individual as spectator, participant, and community celebrant, Ralph Burgard proposes that there be a greater encouragement of talent and skills. Schools should recognize the ties between the arts and the development of perception, which, with language and numbers, constitutes the way we acquire virtually all of our knowledge.

"The old reasons for community — religion, defense, and the marketplace — simply don't hold any more," says Burgard. "The need to be entertained is one of the major reasons people will come together in the 1980s; celebrations bring people together, and they are comparatively low-cost, high-visibility programs."

Thus, the mission of the community arts council can include the following: strengthening existing cultural institutions with new support dollars, public relations, and more audiences; assisting school systems to improve education through arts in education programs; assisting individual artists; making opportunities in the arts widely available to all constituencies — ethnic, racial, or social; and integrating aesthetic concerns into the decision-making process of local governmental agencies. This latter objective would use cultural resources, in part, to help local government develop neighborhood identity and pride; revitalize downtowns; and use public celebrations to bring together people who ordinarily are divided by race, age, religion, or income barriers.

Community arts councils, the vehicle for missionary work in the early years, were more apt to be service organizations and less apt to be program-oriented unless such an orientation was of direct benefit to the member organizations. Today, privately incorporated councils must decide how much independent programming is desirable, and public commissions, now expanded far beyond their original concern for civic design, have to define new functions that make sense within the expanded activities of city or county government.

The arts were first used in local projects in the late 1960s to relieve racial pressures that were exacerbated during hot summer months in the nation's major cities. Now there are programs of all kinds — directed to save

buildings, improve the physical beauty of the community, and bring people together. All are within the fabric of community concern. All are of concern to local government.

Expanded cultural institutions, the new dimensions in cultural programming, and the more sophisticated attitude of local government create a need for a comprehensive cultural policy in every community. Ralph Burgard believes that this is where we are today. As a tribute to his work, he was honored by NACAA (as of 1982, has become the National Assembly of *Local* Arts Agencies, or NALAA) at its second annual convention in Boston.

NACAA developed when the communities' constituency of ACA grew to such dimensions that the agency, torn by the services and advocacy functions described earlier, could no longer properly serve this growing group. By 1970, when Burgard resigned from the helm of ACA, the number of community arts agencies was 250, but by 1980, it was more than 1,000.

After opening an office in Washington in 1978, NACAA has established itself as the organization to look to for opinions about local arts agencies. In November, 1979, after years of surveys, research studies, and a task force as part of the prelude, the community arts council message was effectively presented to a meeting of the National Council on the Arts. NACAA staff members, surveying its membership for the most current facts, presented the overall impact of these agencies that have "created a climate for the arts to grow." With the help of slides about the work in Syracuse, New York; Bassett, Nebraska; and San Antonio, Texas, and with the ambassadors of those agencies at hand, they persuaded the Council that community arts councils had a major impact on cultural development in America.

Some of the Council members waxed eloquent afterwards. The presentation was not oversold — no one claimed that arts councils had changed the lives of our major institutions significantly, or that it had caused the proliferation of single-discipline groups such as dance companies, operas, ballets, and symphonies in every section of the United States. But arts councils *have* provided new arts opportunities for people of all ages, strengthened the work of smaller and medium-sized organizations, and sponsored tours of high-quality performers and exhibitions to benefit everyone. And if they haven't done it themselves, they have been the catalyst for others to do it. In addition, they have provided grantsmanship assistance, management workshops, consultant programs, and direct cash support.

"In many communities, arts councils have been a rallying point for all cultural forces," Ralph Burgard agrees, and increasingly, these agencies are being seen also as coordinator and local distributor of public funds.

The ultimate goal is to integrate aesthetic concerns into the decision-making processes of local government. Because the individual artist is of critical importance to this process, the local arts council should have a pro-

gram to assist local artists. This, says Burgard, takes influence and sophistication.

In the long run, Burgard believes that the creative forces in human nature will assert themselves in spite of apathetic public policies toward the arts.

> Creative desires are found, in varying degress, within every human being; *they are a condition of being human.* We have only to look at our children to realize that without any prompting from us, without the inspiration of a museum, a symphony, a set of by-laws or an arts consultant, they will make up dances, draw happily on sheets of paper, relate the most astonishing stories, or sing for hours. Engagement in creative activity will not automatically cure the personal alienation which appears to be the inevitable by-product of industrial societies, but it can reawaken the ancient sensory responses and provide people with personal inspiration, enjoyment, and a pride in self-accomplishment which work, family, and friends may not furnish.[2]

NOTES

1. Ralph Burgard, speech made at a meeting of Indiana Assembly of Arts Councils, Indianapolis, Indiana, May 1, 1980.
2. Interview with Ralph Burgard, Boston, June 1980.

2

The Contexts

This book is about the local arts agency, and how the local support group fits into the cultural picture.

Searching for ways to coordinate local arts activities and train new community leadership in the mid-1940s, the visionaries in part looked at the models from health and welfare—for example, the Community Chest —and adapted those elements that were applicable to the arts, creating the first coordinating arts agencies.

In 1965, the Rockefeller Report on the Performing Arts called upon the local community arts councils to look at the "common problems" of the dance group, the symphony, and the opera.[1] There were about 100 of these coordinating agencies then.

By the 1980s, they existed in cities, counties, and communities of all sizes, from the smallest to the largest; the total number is estimated to be more than 1,000. The job of coordinating had grown far beyond the job envisioned in the 1960s to the challenge of the 1980s. It had grown beyond supervising arts phone lines, directories, and calendars to the administration of laws and citywide programs. Some have remained private agencies; others have remained private but have functioned as public services overseeing the allocation of monies and the enactment of laws. Others are local government agencies. Some have emerged with primary programming functions, private and public fundraising functions, and facilities management. There is no one model even within categories. Community leader-

ship and timing have played important roles as one measures strengths and weaknesses — and images. This book details the history of these curious and interesting agencies.

One might even say that their survival and strength is critical to the survival of the arts community as a newly defined community extending and expanding the definitions traditionally given the arts. For the coordination of local support, financial and civic, becomes even more important in the face of pressures and community priorities. Properly understood, these agencies could have a substantial role in developing local advocacy not only to support the symphonies, dance companies, and operas, but the emerging smaller groups that serve artists, literature, jazz, crafts, or chamber music. Keeping the totality of the arts community visible and championing the smaller arts groups are important functions.

The evolution of any agency type occurs in a historical and sociological context. Arts councils have taken hold where citizens have seen the need and potential impact of the arts, where they have seen the proliferation of arts opportunity, and where they have had a desire to fill gaps in cultural programming offered local citizens. This was starting to happen before activities at the national level began, for the National Endowment for the Arts legislation of 1965 reflected these interests — it did not cause them. The local activity has been the backbone of the arts movement. The state councils, brought to full number, stature, and importance in the years following the federal legislation, have been important in the system of support for the arts and will have to find more ways to relate to the local agencies sucessfully. Given the attitudes of the administration in Washington at this writing, there is even greater incentive to do this.

The arts council movement has gained its momentum from several sources over more than 30 years. Most of all, there is a pragmatic tradition in American communities that has caused community leaders to seek cooperative solutions in the nonprofit fields (health, education, welfare, housing, the arts) to promote efficient administration and eliminate overlapping functions. The sociological ferment of the late 1960s and early 1970s brought to the surface the special needs of new arts constituencies and a broader concept of arts services, which the traditional arts agencies could not meet. As the state arts agencies matured, they felt the need to have local arts agencies to represent their interests on the local level and help administer state programs. In the middle and late 1970s, the Comprehensive Employment and Training Act (CETA) programs and more formal decentralization efforts by 12 states stimulated the growth of local agencies. Finally, toward the 1980s, there was the growing realization by city and county government officials that an organization that could deliver arts resources (institutions and artists) on demand could help revitalize neighborhoods and downtowns.[2]

America has seen "the grand ideas" of the 1960s and 1970s swell and diminish; expanding the arts was part of that visionary period. In the reordering of priorities through a range of crises such as the energy shortage, the problems of employment and unemployment, and economic woes, the new awareness of the arts emphasizes the new values and options for the use of time. The arts opportunities in the community (arts festivals, theater, music, dance, visual arts, and crafts exhibits) look like viable options for expensive travel. They also place those values in the forefront of action by creating a reevaluation of local cultural opportunities. The strength of independent spirits and the private nature of values lend substance to a feisty response to the 1981 federal mandate.

The growth of the local council reflects not only the organizational needs of the arts, but individual needs. There are those who have newly awakened interests in the arts and no place to focus, or are intimidated by the narrowly based institutions. The council is often the place where they have gained the confidence to explore other contexts.

The arts councils have identified most clearly the meaning of a broad base for the arts, taking the first risks of public exposure for many art forms in new places. They have given confidence to some institutions to try to interest new publics, sometimes in ways so subtle that the institutions themselves are not always aware of the genesis of the idea or source of support for the idea.

This is not a history of cases; rather, it is one of function, and of type of impact. It is about opening doors and filling gaps until the leadership of a community sees an arts council as integral to the local arts scene. Without that leadership, organizations remain special interest groups, not integral to the institutional base. In many communities, councils have come and gone; the larger cities, where conditions are the most complex and priorities are often set in a temporal and volatile context, have been especially difficult arenas within which to plan with ongoing commitment. The arts council or commission will be bright and shining for stretches of time; it will also often be dimmed quickly and politically. Private councils have existed in cities of all sizes. The private councils with contracts for services from local governments will be models to watch. In any case, the search for the art council's place in the local community structure has been part of the evolving organizational type. There are groups of community councils that are strong at this moment, and there will be others that are strong in the future. There have been some that have come and gone in recent years.

For the Endowment, the policy of formal recognition and support came after almost a decade of committee review and study on community arts agencies. It came in the closing minutes of the February 1981 meeting of the National Council on the Arts, the advisory body of the National Endowment for the Arts.

One of those who had worked hard behind the scenes was "thrilled because we had gotten this far" but expressed almost wonder at the incredibly slow, costly, and demanding process of achieving a simple policy statement. It had taken Clark Mitze's work; the Mary Regan report; the James Backas report; Joseph Golden's work; subcommittees and task forces created in 1969, 1972, 1974, 1976, 1977, and 1979; David Martin; Henry Putsch; NACAA; NASAA; the Congress; the National Council/NASAA Policy Committee; and Council's Policy and Planning Committee many years and several hundreds of thousands of dollars to reach this point.

In the Harris poll of late 1980, 51 percent of the people surveyed were willing to be taxed more for the arts. They had become enthusiastic participants and had increased the audience numbers in recent years. They felt that arts education should be an inherent part of basic education of every young person. A miniscule number of school systems could attribute change to the result of such sentiment; the arts are still low-priority items in the educational system.

These supporters are natural advocates if newly focused and motivated. The arts councils are "naturals" to pull it together if they can gather the muscle and clout needed to lead communities through the process of defining priorities and possibilities. There are examples of where this has been done successfully, but nearly always each has some special components peculiar to that community—the numbers and sizes of institutions. Recent figures show that more than $85 million has been generated in public dollars for the arts in the largest 50 cities and more in smaller ones. In over 50 cities, there have been united arts funds; other cities have active committees linking business people and the arts.

Volunteers, educated and oriented to new advocacy tasks, will help the public support the local arts and focus that effort. There need to be definitions among needs; the operating needs of an arts center differ from the needs of the individual arts groups housed there; projects and operating supports differ—and who supports the local artist?

The new coalitions—of public and private sectors, labor and business, large organizations and small—are necessary for the arts to survive. To this time, the local arts councils have concentrated on making the community aware of the arts and their needs. Now, as the focus of support transfers to the local and state level, the spirit of that refocusing needs to be absorbed.

Over the more than 30 years of its development, the local arts council has done a great deal to bring the public and the arts together. This has been achieved in the context of such developments as greater government support on all levels and changes in life styles that include more flexible work hours and greater leisure time. In the future, those leisure-time hours, in the wake of the development of home entertainment centers and narrowcasting on television for the arts consumer, will be an even more impor-

tant consideration. It will be important to watch as people and communities set priorities for the use of leisure time.

Arts councils are sometimes accused of being populists — supporting "amateur" as opposed to "professional" arts. In fact, they strive for balance: They provide funds and support for major cultural institutions, the professional artist, and improved standards for avocational or outreach arts programs. Most try to avoid the stereotyped attitudes held by "elitists" and "populists." The arts council priorities will continue to be in community planning, in advocacy, and in working with all segments of the arts community and the public.

A large order. But it will be only then that understanding will allow greater implementation of the systems that have been found to be beneficial, and where the sentiments reflected in the polls can be put to useful and creative action.

The following chapters examine the evolution from the early years of arts council development to the concept of a fully recognized partnership: federal, state, and local.

NOTES

1. Rockefeller Panel report on the future of theater, dance, and music in America. *The Performing Arts: Problems and Prospects.* New York Rockefeller Brothers Fund, 1965, p. 49.

2. Conclusions reached after many discussions on this subject with persons such as James Backas and Ralph Burgard from early 1980 to March 1982.

Part II

ON HISTORY

3

The First Thirty Years

BEGINNINGS

THE SETTING

1940s survey. Electric Interchange. Information. Ideas. Potential. Only beginnings bring forth such rapt attention and such energy. Later, 1956. Several cities, East to West. Providence, Rhode Island; five two-hour seminars. Temperature well over 100°, no air conditioning, over 400 people at the convention, and only one elevator operating. "Miserable as the body was, I found myself swept up by the arts council dream."[1]

There are many who suppose that the current community arts movement was thrust into being by the coming, in the mid-1960s, of the National Endowment for the Arts. Not so. The ferment and activity out of which the government usually makes responsive moves was present in the arts as in other areas of humanistic activity for many years prior to 1965. Such formal developments as a congressional act only follow quite naturally. Actually, the need for a new public support system for the arts was felt almost as soon as the short-lived Works Progress Administration (WPA) disappeared entirely in 1943, and certainly was on the horizon with post-World War II planning.

In fact, there were, before the present time, at least three eras identi-

fied with increased activity in community arts — pre-World War I, the WPA, and the 1950s. The first instance, the Teddy Roosevelt era, saw activity related to the emergence of little theaters, community choruses, and community bands; many municipal arts commissions; the development of the settlement house as a neighborhood arts center; and university extension programs in the arts — all of which accompanied the vitality of the political and social activities of the day. Many public schools started to require music and art instruction. Originating in this era, the community music schools (now called community schools of the arts by their national guild), mostly due to respect for age and structure, have an institutional aura — more aligned with the traditional arts institutions than with the present community arts movement.

The second growth period has been recognized as the WPA arts era, when the artists' unemployment program set in motion arts activity of unprecedented density and in many forms. But, as was said, the short-lived activity all but disappeared with the withdrawal of federal funds, for it had not really taken root.

The third period in this century is represented by the so-called explosion of popular culture of the 1950s. The characteristics motivating it seem related to a search for value and meaning in life and the presence of a spiritual vacuum — no particular focus. Community-minded people supported the arts, and in the 1950s they seemed here to stay — sheer numbers created some impact. Some say that the base was broadening then. They would also ascertain that there was enough breadth to cause Congress to support the legislation that created the National Endowment for the Arts in 1965.

Prior to this century, there were some parallels in American cultural development to the twentieth-century movements noted above. The evolution of the public education system and public library system relates to a search for knowledge and increased leisure time, as conditions grew more stable in the colonies. The lyceum of the period between about 1826 and 1839, "to diffuse useful knowledge or information and improve public schools,"[2] and local mutual educational associations engaged the educational leadership of the day, many of whom were the town and village leaders. The development of such enclaves is one thing, but the development of a state and national system makes one respect the tenacity of those early people, for transportation and communication were a great deal more difficult than they are today.

The development of the library systems as we know them today is a separate and complicated subject. However, one form of library emphasized the "provision of scholarly newspapers and magazines as its essential service while also sponsoring frequent cultural and recreational programs as another aspect of its activity."[3] That was the athenaeum. The history of each athenaeum varies according to city and leadership, but the one in Boston, established in 1807, "remains the most impressive of them all, and pro-

vided the model for many more, including those still in existence in Salem and Philadelphia."[4] It is true that in some of our smaller towns today library sponsorship of cultural activities is quite common. However, the arts council movement, per se, seems to have no roots in base of fact with these prior aspects of our cultural history.

One more historical reference needs to be made: that to the Chautauqua, which swept rural and suburban America between 1874 and 1925. "No other major sociocultural movement in America was built up so painstakingly — half a century in the building — and vanished so swiftly and completely."[5] It is estimated that in 1924, 12,000 towns participated, and 35 million people are thought to have participated. Its "permanent" hold on American life was widely acknowledged by writers and analysts. But times change. Cars, highways, and bus lines could get people to cities. The movies provided continuous entertainment, and radios were soon in almost every home. People didn't need to stir from their own firesides to hear great orchestras, concerts, and lectures.

But never after would rural America be the same. Community leaders, "as an inherent aspect of their duty as leaders," were required to see that the best things in life should be made available to their towns. The talent, which was eclectic at best — lectures and productions of all kinds — represented the total range of cultural possibility, and the quality was uneven. But horizons were expanded, and the cultural seeds were planted in a way that meant there was no turning back. Adult education, practically unknown before the Chautauqua movement, took some of its direction from the pattern of follow-up courses originated at Lake Chautauqua, and by the end there were summer schools, extension courses, and correspondence study throughout the nation.

> The name Chautauqua, in a restricted sense, applies to this institution and the lake its grounds adjoin. But the use of the name has not been so restricted. Other enterprises, some closely, some at best remotely related, have called themselves Chautauquas. These enterprises fall into two main divisions. Imitative assemblies quickly sprang up in fixed localities in all parts of the country, and Chautauqua as parent cordially shared its name with them and gave them its support. By contrast, the travelling tent companies that brought circuit programs by rail or truck or automobile to thousands of American towns and villages during the early decades of the twentieth century simply appropriated the title of Chautauqua. To literally millions of Americans, "Chautauqua" has meant these circuit companies rather than the institution in New York. Many who still retain memories of the circuits, with vague if any knowledge of the assembly whose title they adopted, ask what Chautauqua was, how it started, and whether it still exists.[6]

Although the arts council development has not been the "tent" circuit, some of the spiritual seeds were well sown in this era, and the move-

ment in rural and small communities has some of the same elements of the Chautauqua. One of the main functions is to bring to rural America the cultural offerings available in the cities. The systems for bringing artists and touring companies are far more complex; the costs are higher and fund-raising is multifaceted, but the local leadership must still act in the spirit of civic consciousness. No longer can the whole endeavor depend on a few private individual sponsors.

The Chautauqua movement as a national phenomenon disappeared almost overnight. Remnants as solid as Chautauqua, New York, and re-vivals such as that of Chautauqua, Devil's Lake, North Dakota remain. Some of the tangential and deeply rooted needs of rural communities are still served by the bevy of sponsored events. The traveling theater group, speaker, or musician is only updated by the present transportation and sponsorship systems, which in some ways make life easier but in many ways change the whole ambience. The distinctions and subtleties of the lyceum and Chautauqua movements extend far beyond this discussion but are ir-relevant to the arts council movement.

Today's renaissance of the arts in America is much more complex. This is attributed to the alterations in the traditional work pattern and re-tirement possibilities, which lead to greater numbers of leisure hours. And it may also be attributed to the need for spiritual renewal and clarification. Broadening potential participation in the arts and redefining values are in-herent in all of the eras, but this one, perhaps learning from the experiences garnered before, seems to have a better handle on institutional arrange-ments that might be of assistance to survival.[7]

The community arts council fits into this picture. There were several ways in which communities became concerned with planning in the arts area. The most concrete comes from the Junior Leagues of America's leader-ship in exploring the possibilities for planning and coordination, as the councils of social agencies had been doing for the fields of health and wel-fare. It developed out of the feeling of frustration whenever local Junior Leagues, upon investigating the possibilities of new community projects, found it difficult to identify the resources and unmet needs in the cultural field. Virginia Lee Comer, during many of the years (1936–49) she was on the national Junior League staff (the national organization is now called the Association of Junior Leagues), spearheaded a move as Senior Consult-ant on Community Arts to help communities organize themselves locally to meet the potential in this area of community activity. The publication, *The Arts and Our Town*, which appeared in 1944, was a community survey manual still valid today. But communities had to mobilize their own forces to do the work and use the results. They did in places as divergent as Van-couver, British Columbia; Corpus Christi, Texas; Louisville, Kentucky; Wichita, Kansas; St. Paul, Minnesota; and Binghamton, New York. The

survey was the first to assemble facts, to show what cultural facilities existed, and to encourage their fuller use. Secondly, it was to reveal gaps and thus to point the direction for new programs.

The survey was inclusive, examining

> all aspects of participation in the arts and also opportunities for appreciation of them, and included agencies whose sole purpose is to provide cultural opportunity, such as museums, and those whose programs may touch cultural fields, such as radio stations and civic clubs. In addition, organizations of large groups of people such as housing projects, unions, churches, etc., have been included, since they are channels through which large numbers can be informed of existing facilities and services and may themselves have developed activities.[8]

Art councils started to emerge from this community planning — permanent coordinating organizations, tailored to the needs of their individual communities. The arts were unexplored territory in terms of cooperative effort. Miss Comer, with strong arts training, saw that when such a cooperative effort emerged, it might relate directly to other overall planning bodies such as city planning commissions or councils of social agencies, and fill a need whenever a community was moved to open up more creative and re-creative opportunities to more people. She discussed its uses for the leisure-time divisions of the councils of social agencies and improvement of cultural facilities. She projected that an arts council

> may well emerge as a familiar channel through which cultural agencies can become familiar with each other's programs, can plan and work together to stimulate people's appreciation of and participation in the arts, and [can] mobilize public opinion behind such cultural projects that need citizen backing. As such a council strengthens creative activities within itself, it will inevitably touch other planning organizations, serve them, and in so doing contribute to a rich and well-rounded community development.[9]

Unlike the organizational pattern of the Community Chests and Councils, the structural pattern for which was laid out by a central office in New York, the arts council development was molded to suit each community. There was as much diversity recorded in arts council activity in the early days as there is today. Thus the seeds were sown all over the country. Miss Comer's energy and consultation was sought from then on, and, directly or indirectly, much of that early history is the story of her travels and influence.

In notes that documented her thoughts upon leaving the Junior League staff in 1949, Miss Comer wrote,

> The task of strengthening the arts in our society becomes more imperative every day. From observation of numerous communities of every character —

old and new, large and small, industrial and suburban — in all parts of the country, certain general conditions are discovered that limit the effectiveness of the artist and the arts.

Although there are many evidences of brilliant leadership, by and large a lack of understanding of the community in which they function is true of the individual artist, the teacher, and those professional and lay people responsible for cultural agencies.

Even laymen well versed in the economic and social conditions which affect education, health, and welfare may fail to relate this knowledge to an understanding of the cultural situation. Unfortunately, evidence strongly points, also, to a lack of preparation for practical guidance on the part of many professionals.

Too often the individual artist is unable to appraise his environment and make a realistic evaluation of what he may expect from it and how he can most effectively pursue his creative activities within it. Too often he is without knowledge of techniques which would help in creating wider public interest (hence markets) for painting, sculpture, etc., and more understanding attitudes toward contemporary design, painting, and architecture.

Our social pattern rests on collaboration between layman and professional in a somewhat intricate community organizational structure. A poor understanding of this structure and how the arts may be related to it leads to many needless frustrations for creative artists and failures for organized programs.

Another adverse condition, found almost universally, is the isolation in which each of the arts and each cultural agency exists and functions. An understanding of the relationships between the arts is vital for aesthetic and technical reasons, but it is also important to the healthy growth of the arts in the particular community setting. As it is, there is little realization that there are problems, solutions to these problems, and potential resources which can be shared with benefit to all areas such as financing, program planning, building a wider public, and the all-important task of interpreting the arts.

It would seem that students who plan a career in any of the arts would benefit in life and career situations from the ability to analyze a community and to understand their professional relationship to it. A knowledge of organizational and developmental techniques which they could apply or pass on to the laymen would be advantageous.[10]

Although the Junior Leagues of individual communities have, over the years, individually involved themselves in cultural life through significant projects, there was no single or national influence as great as that of Virginia Lee Comer's work in those beginning years. That influence was additive, not a national mandate, and without her single-mindedness there might not have been a sense of national leadership at all. [It is not insignificant to note, however, that her position at the national Junior League offices was filled by Miss Kathryn Bloom, who continued the work. Miss Bloom's further contributions to the arts, especially arts in education, are documented elsewhere in this book (see Chapter 20).]

Individuals who have developed management skills through their Junior League work on community projects have become volunteer and professional leaders of arts councils as part of their personal interest and development even now, and would acknowledge the training ground provided by League opportunities. But the diversity in the development of arts councils became so great, and the field so large, that this thread of influence is only one among many through the years. In the 30 years since Miss Comer did her work, the League has sought to broaden its own image, has struggled to identify its own place in the broader community, and is still involved in those struggles today. There is little relationship between the League's efforts and the arts council's search for identity and place in the same community.

The thread that continues to nurture the newly developing organizational type came from the same field of social work mentioned earlier by Miss Comer. The coordinated arts programs developing in cities with community orchestras came to the attention of Helen M. Thompson, who started as editor of the newsletter of the ASOL and later became its Executive secretary. Because of her own professional training in the field of social work, she immediately saw the relationships between the value and strengths of coordinated social work programs and the new cultural development. In July 1950, when she became the Executive Secretary, it seemed "logical to widen the ASOL study of existing coordinating arts programs with special reference to the effect of these programs on the orchestras affiliated with them."[11] By 1952, an entire session of the ASOL national convention was devoted to discussion of the coordination efforts in several communities. By the next year, the Rockefeller Foundation, making its first ASOL grant, paid for a three-part study, one part of which was a survey of coordinated arts programs — their function and structure, and whether or not they offered logical solutions to the problems of symphony orchestras and other arts groups.

Representatives of all known arts councils were invited to hear a preliminary survey report at the 1955 ASOL convention, which thus became the first annual conference of arts council representatives. Among the outcomes of the convention were a service program for arts councils, inclusion of arts councils in subsequent conventions, and voting membership for them in the ASOL. These were critical moves in nurturing the embryonic efforts in the first decade of arts councils, which numbered more than 60 by 1958. A 1958 ASOL study emphasized 16 councils, but conclusions reached showed the potential strength of such coordinated community effort for most communities. At the 1955 convention, this potential strength was already recognized:

What we are studying is the organized effort, through planning, to balance, coordinate, and expand the cultural activities of the community and

thereby to raise artistic standards and broaden the opportunities for public participation. . . .

What are the factors which have precipitated the organization of these councils? In the main, there appear to be five.

First there is the simple and obvious difficulty that if you have a number of organizations in the community all scheduling exhibitions, concerts, recitals, and lectures without knowing what the others are doing, you're bound to run into conflicts which do harm to everyone. Hence the need for some sort of clearinghouse for dates has provided the opening wedge for cooperation in many communities. That's what happened in Albany, and, over on the other side of the continent, that's where a beginning has been made in . . . Santa Barbara.

A much more significant factor, secondly, has been the recognition that there are serious inadequacies in the cultural life of the community.

A third precipitating factor is the wish to extend already existing cooperation into new fields.

The need for new sources of revenue and the belief that such sources can be tapped through joint fund raising have been a fourth factor in bringing arts groups together. This clearly was the reason in 1949 for organizing the United Fine Arts Fund of Cincinnati and for the creation the same year of the Louisville Fund.

The fifth of these precipitating factors is the common need for space, for physical plant — auditorium, galleries, classrooms, exhibition halls, and offices. The construction of a community arts center is common cause on which divergent groups can unite.

Those appear to be the chief circumstances out of which arts councils have developed. They are obviously not mutually exclusive, and can all be operative simultaneously; but usually one or the other of them has been dominant.[12]

The speaker concluded that there was no "neat formula for creating an arts council." More than 25 years later, there still isn't. Three examples cited at the 1955 convention show how some emergences might be described.

Consider Quincy, Illinois, an industrial community and farming center of about 50,000. . . . Somewhat isolated as it is, with no city of comparable size within a radius of 100 miles, it has created its own cultural life, and a remarkably rich one. A symphony orchestra, [a] chamber music society, a flourishing art club, and several other groups are active and work well together. For the most part the cultural leaders are friends, have known each other for years, and serve on each other's boards of directors. So the creation of a council was a natural outgrowth of a cordial spirit which already existed. Organizing the council presented no real problems. They agreed on the desirability of a council, drafted a charter and by-laws, and got themselves incorporated. Of course there was leadership, and it was exercised largely by one individual, but the council in Quincy could almost be said to have come into being over the teacups.

It was a Junior League survey of the community's cultural resources back in 1949 which provided the impetus for the council in Wichita. This booming prairie city of nearly 300,000 grew 46.4 percent in the decade between 1940 and 1950 and has one of the highest literacy rates in the country. When the arts survey report was published in 1950, recommending the creation of an arts council, it was placed in the hands of every important cultural and civic leader in the community. One month later a general meeting was called, with invitations going out to all the cultural groups. There the matter was discussed and it was agreed to form a council. Accordingly an interim committee was appointed to work out organizational details. The following spring at the first annual meeting, by-laws were adopted, officers elected, and the Community Arts Council of Wichita was on its way.

In one other city, the leaders of a number of the cultural groups became convinced that something had to be done to end the chaotic state of artistic activity in the city. Representatives of the leading arts organizations were called together under the aegis of one of the most venerable and well-established of these groups, whose prestige in the community was unassailable. Some of those in attendance appear to have come less out of belief in the desirability of cooperation than through fear of missing out on something. Indeed, it is reported that at least two of them were not even on speaking terms. Yet the leaders persisted, and at length through patience, diplomacy, and the sheer logic of the situation a council was born. It is a heartening thing that in that city the old animosities are reported to be dying out under the spur of a common task.[13]

These observations were only the first of about a half dozen studies over the next 20 years that would show continuous and steady growth in the numbers of arts councils, and the diversity among them.

Thus between 30 and 40 years ago, the roots were laid for the local arts council movement in America. The name "council" first came into use in England. As the explanation goes, to assure that the arts would not be among the first casualties of World War II, the Council for the Encouragement of Music and the Arts (CEMA) was organized by the Pilgrim Trust, a private organization, shortly after the beginning of the war. One of its purposes was to see that art exhibitions and productions were taken to people who otherwise would not have them, being cut off by wartime conditions. After a very short time, the government "took a hand" in the operation, and early in 1940 the Ministry of Education took over the entire program. The successor to CEMA was the Arts Council of Great Britain, chartered as "a separate entity responsible to the Parliament through the Chancellor of the Exchequer, but otherwise completely independent and basically an agency that channeled arts grants in such a way that they will do the most good for the most people."[14]

The oldest cooperative arts venture in this country began operation in 1927 in Cincinnati, when Mr. and Mrs. Charles P. Taft were instrumental in founding the Cincinnati Institute of Fine Arts "for the purpose of stimu-

lating the development of art and music in the city of Cincinnati." The purposes of this organization have perhaps been emulated by virtually every arts council since. "It is the function of your institute to see that organizations already in existence are developed and given proper financial support, that their work is coordinated and directed in the most effective channels, and that new organizations are formed where other fields can be opened up."[15] Unlike the Arts Council of Great Britain, but in the American tradition, private monies were thought of as the full source of funds at that time.

And it was that way in America all during the emerging period of the 1940s and 1950s. What did happen in the 1960s, as the state and federal governments become more involved in developing extended support mechanisms for the arts, is that local governments began to consider administrative commissions whose functions were very similar to that of the private councils. San Francisco's, which was established in 1932, predates such commissions. This is not to say that there was no interest anywhere else on the part of local government in arts coordination until this time. The 1958 ASOL survey reflects such interests in Louisville, Kentucky; Waterloo, Iowa; and Binghamton, New York, and it must not be forgotten that some city government committees reviewed designs in their cities from the turn of the century. Still other cities have supported arts institutions with tax exemption and abatement. The contemporary local public agency as it is described in this book is a counterpart of the local private agency, and it is different mostly by virtue of technical structure, not function.

DEFINITIONS AND FUNCTIONS

Thus from a seemingly unlikely combination of activities, the community arts council movement began. It began almost simultaneously in a variety of communities, and it began as a group of organizations primarily concerned with the coordination and welfare of the arts organizations in the communities. If there are questions of the nature and function of these agencies in an arts era that is continually redefining itself, one must try to deal with questions that have never really been addressed. One of them is the nature of "community arts." We talk about them continually, and yet there are as many definitions as there are conversations. It is essentially easy to identify the broadest functions of the institutions for the performing and exhibiting arts. The oldest are about a century old; the newest are now emerging. Historically, their directions and policies were set by the few for the many and reflected the wisdoms of those who served on their boards of directors or gave money to support them. These institutions have definitions and functions that most of the public understands.

Until the early 1970s, "community arts" did not exist as an independent term. Until that time, it was always connected to an art form, as in "community symphony," "community theater," or "community chorus." It referred to an organization that served those citizens who wished to participate avocationally in an arts activity. The director might be paid; the participants were not. As noted, these organizations got their start in the early decades of the century. They also catered to a predominantly white middle- or upper-middle-class clientele.

"Community arts" emerged in the early 1970s as a generic term to cover all of the other organizations that had been formed — many in the troubled 1960s or later through CETA programs — to serve racial or ethnic populations along with what were eventually termed "special constituencies": senior citizens, teenagers, the hospitalized, and prisoners. There has been little or no communication between these two fields except occasionally through an arts council.*[16]

There are certain characteristics attributed to community arts groups. What are some of them? They are indigenous or grassroots, neighborhood, local. They provide the opportunity for participation and enjoyment. Process is important, as is working with the best available talent, professional or not. No standards are ultimately set, but quality is usually sought and many times attained. The emphasis is on the doing; there is little long-term policy making and sometimes there is no permanent home, although many community theaters, galleries, and other organizations pride themselves on the small physical space that is "home."

The community arts council is caught by the image conveyed by these characteristics. The community of the arts council is a total community, not one to stand only for the special interests of a segment of the community. Their dreams are of reaching all populations, and including all art forms in their range of interest — not that they have been able to achieve this in all cases, but this is the philosophy.

In an attempt to clarify a common terminology for the council-type agency, NACAA, the national service organization, has made a distinction between those multidisciplinary agencies that have as their purpose the provision of services and support to artists and arts organizations within the community (local arts agencies), and the recipients of such services and support, always referred to generically as community arts organizations.

*In fact, the Neighborhood Arts Programs National Organizing Committee (NAPNOC), a national organization open to neighborhood arts organizations and other groups and individuals who support the neighborhood arts movement, was organized in part precisely because such individuals felt that their community arts agencies had little in common with arts councils. The latter, they felt, were establishment-oriented and served either the wholly professional organizations or the establishment avocational groups such as the little theaters and community symphonies.

In 1982, NACAA changed its name to NALAA. A National Endowment for the Arts Task Force on Community Program Policy of 1979 agreed, for purposes of clarity, to use the term "local arts agency" to encompass the greatest range of support systems currently available at the local level. A local arts agency is defined as follows:

> a public or private not-for-profit organization, whose primary purpose is to provide a support system and network to develop, deliver, and sustain arts activities in the community. Its primary function is to provide some or all of the following services: support of individual artists, promotion of arts activities, grant making, space provision, and central administration services for arts organizations. A local arts agency often serves as a forum for citizens' opinions and acts as an advocate for public and private support of the arts. In addition, a local arts agency may sponsor programs in cooperation with local and neighborhood organizations, or on its own as a catalyst for audience development and new programming.[17]

These local arts agencies have a number of names, all indicating allegiance to these basic purposes — institutes, foundations, associations, federations, commissions, agencies, or cultural departments. No two are exactly alike.

In discussing the laboring over definitions, Charles C. Mark, veteran *Arts Reporting Service* editor, and one who has been a participant in and observer of the 30-year history of the arts council movement, recently identified the problem as one of trying to make a functional definition. He pled for a conceptual definition, such as this one: "a local arts council (agency, commission, allied council) is a nonprofit or governmental planning agency providing certain services to more than one art form and the community." As he says, "Whether a particular council raises money or provides facilities, offers programs or management services, it is all encompassed in the definition."[18] Since functionally these agencies have worked to support and advocate for the arts in the communities "to create a climate and conditions in which the arts can thrive,"[19] it is no wonder that the ways in which that has been accomplished vary widely, depending on the particular community's makeup and needs.

Each local agency deals with the realities of its local context, which normally includes the possibilities of large and small arts organizations and of arts in towns, neighborhoods, schools, businesses, and a range of social service agencies (such as senior citizen and handicapped centers — all of the real potential audiences. The councils that have identified needs of the community but lack a supply of arts organizations or artists have sought ways to bring them. They have identified what might be possible to in-

clude, and the communities have sometimes realized what it might develop what is needed indigenously because of local energy and interest.

The definition of "the arts" even in the 1960s was much more limited than it is today. Because of the long and illustrious Western tradition in painting, sculpture, music, dance (ballet, mostly), and theater, these were "the arts." One of the biggest contributions of the community arts council over the last 30 years is that it is this type of organization that has striven to bring more and more art forms and publics into the mainstream of the arts and to bring public awareness to their importance, while not diminishing the importance of the older, well-identified arts and arts institutions. They have, in addition, been proponents of a better life for artists; they have struggled to find employment, homes, studios, and markets while giving them the wherewithal to maintain a professional stance. The development of technical assistance to both organizations and individuals has been a major area of arts council concern.

The arts council has been a communications link between the arts and the public, the arts and business, the arts and government, and the arts and media in community after community. The arts council has been a catalyst for public discussion about the arts and arts issues, which had previously been seen as matters mostly for the private board rooms. Articulation has been forced through public hearings and the like, such as when local governments were asked to write about the inclusion of the arts and culture within the scope of city government.[20]

Historically as well, arts councils have broadened their own functions, which at first seemed to include mainly service to the arts organizations themselves, but which now encompass the relationship of the arts to community life.

Because of this broader view, councils have often been "on the line" about quality and quantity. The best councils are interested in nurturing the best, in developing the best processes, and in bringing opportunity where it is lacking. They have found that the "best" can include jazz, crafts, and many ethnic forms. They did not create these "community arts"—they have simply included them in their definitions of "art." Thus, if there is any confusion of terms, it arises mainly around the limits imposed by the term "community arts" and the total community. The arts council is interested in both.

While working to create an environment for these community arts to thrive, community arts councils have not forgotten and have often provided services important to the older and more established institutions. They encourage and give opportunity to both old and new, small and large; they try to be an example of good management. Yet their leadership constitutes a new management field that has been defining itself at the same time as it is being examined as a model.

FUTURE DIRECTIONS

The first 30 years in the community arts council movement mainly comprise a prologue. There has been a multitude of projected responses to apparent needs, more questions than answers, and much conceptualizing. The problem now is how to create some enduring processes without limiting continuing experimentation and response to the needs of individual communities.

The local councils have grown to this point of time through indigenous development — from communities' own perception of what is needed to enhance the state of the arts. As we have noted, "the arts" may mean many things: traditional, well-endowed, and large institutions; a bevy of smaller organizations of nontraditional art forms; very traditional ethnic art forms; individual artists of all kinds. The composition and proportion of one facet to another changes from community to community.

Arts councils have sprung from chambers of commerce, Junior League interest, foundation interest, citizen interest, and government interest. They have evolved from the formation of arts festivals, arts and crafts associations, training programs such as the Community Artists Residency Training program (CART), and other catalyst activities. Councils sprang up from community interaction; rarely were they mandated. (However, in 1980, with the development of the Arts Lottery in Massachusetts, arts councils were mandated in each statewide jurisdiction. Over 300 arrived, born with the lottery legislation.* Similarly, in California, many councils have developed simultaneously (as stipulated by the State Arts Council's incentives for state-local partnership planning.)

The size and age of a city, its management structure, demographics, topography, traditional support systems, local corporate commitment, foundations base, educational structure and system, and population stability and mobility are all going to bear upon its particular arts council's structure and function. In rural areas and countywide service systems, the problems of distance, isolation, differing town personalities, priorities, and activities create circumstances quite different from those in urban settings.

Other factors — age of populations, school systems without arts specialists, high tourist potential, permanent or impermanent populations, expanding or contracting population base — will affect the way the arts and artists live in that community, as well as the expectations and focus of the council.

*In 1982, after the first year, the Arts Lottery was in need of rethinking, even though about $37,000 was distributed to Boston and an average of $734 each to the towns and cities, depending on population. See Charles C. Mark, *Arts Reporting Service*, no. 288, March 22, 1982.

The arts are nowhere on an island off to themselves, no matter how strong the private sector is. There are still places where the traditional support systems are so strong that the private sector alone can support institutions, but these are rare and due to become even rarer as the 1980s progress. It will be an educational process to find out how to deal with the combined private and public support potential as wisely as possible. It will take sophistication on the part of boards of trustees, an educated citizen advocacy, and a look at the ways in which other human service areas have addressed such issues. The arts are only the latest segment of human concern to have to face the challenge.

We know these things to be true, for the arts council, moving from its earlier concern for the arts organizations, has been one major testing ground. Many times they have been the agents of change in the community, and there is a growing reliance on them for advice, expertise, and technical assistance, not only by arts groups and civic community organizations, but by governmental agencies. They have been, and should continue to be, enmeshed in the fabric of governmental affairs. More and more, it is being realized that cultural affairs should be part of governmental affairs.

It is laborious to spend more time than absolutely necessary on definitions, because it becomes abundantly clear that the community arts service agencies that are the concern of this book have had somewhat the same range of services and functions since the beginning. The difficulties expressed in regard to definitions beg the questions that are really important.

It takes time for any impact of any sort to be felt, absorbed, or expressed by those unrelated to the effort. The public sense grows slowly — many times, too slowly. In their first years, councils have come and gone before there was a strong enough public sense of their presence.

All of this begs the ultimate definition for local agencies — local initiative. The declaration of purpose in the congressional act that brought the National Endowment for the Arts into being discusses, first off, the importance and primacy of this initiative and the proper and appropriate order of things, including the federal government's proper concern.[21] Without local community concern and activity, there is no appropriate action on other levels. That's what it's all about.

NOTES

1. R. Philip Hanes, Jr., "Arts Councils of America: Progress in Review," in *The Arts: A Central Element of a Good Society* (New York: Arts Councils of America, 1965), p. 140.

2. Cecil Hayes, *The American Lyceum: Its History and Contribution to Education* (Washington, D.C.: U.S. Department of the Interior, 1932), p. 31.

3. Elmer D. Johnson and Michael H. Harris, *History of Libraries in the Western World* (Metuchen, N.J.: Scarecrow Press, 1976), p. 202.

4. Ibid.

5. Victoria Case and Robert Ormond Case, *We Called it Culture: The Story of Chautauqua* (Freeport, N.Y.: Books for Libraries Press, 1948), p. 2.

6. Theodore Morrison, *Chautauqua: A Center for Education, Religion, and the Arts in America* (Chicago: University of Chicago Press, 1974), p. vii.

7. Edward Kamarch, "The Surge of Community Arts," *Arts in Society* 12(1975): 6–9.

8. Virginia Lee Comer, *The Arts and Our Town: A Plan for a Community Cultural Study* (New York: Association of Junior Leagues of America, Inc., 1944), p. 7. Reprinted by permission.

9. Virginia Lee Comer, "The Arts and Your Town: The Junior League Explores a New Field for Community Planning," *Community: Bulletin of Community Chests and Councils, Inc.*, November 1946, p. 6. Reprinted by permission.

10. Notes from Virginia Lee Comer's historic materials. Used by permission.

11. Leslie C. White and Helen M. Thompson, eds., *Survey of Arts Councils* (Charleston, W.Va.: American Symphony Orchestra League, 1958), p. 5.

12. Kenneth Brown, "Arts Councils — What and Where They Are" (speech to national convention of ASOL, Evansville, Indiana, June 17, 1955), pp. 1–2.

13. Ibid., p. 3.

14. White and Thompson, *Survey*, p. 9.

15. Ibid.

16. Definition formulated in conversation with Ralph Burgard, February 26, 1982.

17. National Endowment for the Arts, Task Force on Community Program Policy, "Report for Discussion no. 104" (August 1979).

18. Charles C. Mark, *Arts Reporting Service*, no. 245 (June 23, 1980).

19. National Assembly of Community Arts Agencies, *Report to the National Council on the Arts* (Washington, D.C.: Author, 1979).

20. National League of Cities Task Force on the Arts, "Cities and the Arts," questionnaire set to 450 cities, 1977.

21. National Foundation on the Arts and Humanities Act of 1965, Section 2 (Public Law 209 — 89th Congress, as amended through October 8, 1976), p. 1.

4

Into the Eighties

THE NATIONAL GROUPS AND COMMITTEES

What were mere words in the original federal legislation creating the National Endowment for the Arts have become recognized as much more than that today. Local initiative is what it is all about; the rest would be folly without it. In some sense, everything is local — all arts institutions, artists, arts activities. Federal legislation usually reflects what has been happening in our communities, and how people feel about it; the arts are no different from any other area of human need when it comes to this aspect of government response. Thus when, in the 1960s, there was official federal legislation having to do with the arts, it evolved from community activity. The mandate was to "assist America's artists and arts organizations and to bring art to as many citizens as possible." By the 1980s, what had begun as a small government concern had become accepted as an appropriate part of government policy. Through the impact of the many programs carried out by agencies on all levels of government, changing the attitudes of legislators and affecting legislation, the role of the arts in government had been validated.[1]

At the time the Endowment came into being, there were 18 state arts agencies and over 100 local arts councils. By the end of 1967, all 50 states and three special jurisdictions had established state arts agencies. "The mood reflected was a new optimism, but there was by no means a common

currency and/or program, and the fledging organizations on all levels had to have the zeal and the commitment of missionaries."[2]

On the local level, the present trend could be characterized as one in which the local agency is realizing its role in completing the jurisdictional network, which up to this time has been preponderantly state and national. This means that attention has become more and more focused on those public or publicly designated arts agencies at the local level. The private agency, as well, has become public oriented in its services — to such an extent that activities such as coordinating arts organizations' schedules and calendars only scratch the surface of available services to arts organizations and the public.

With the federal government agency, the states' agencies, and the local organizations developing simultaneously, it was a matter of first things first, though.

The first mention of community arts councils by NEA occurs in the justification for the first appropriations made to the National Foundation on the Arts and Humanities in October 1965 by Roger L. Stevens, then Chairman of the National Council on the Arts and the new Chairman of the just-established National Endowment for the Arts, and the others present:

> The heart of the program is a partnership between the federal government and private resources, state and local governments, and institutions responsible for the arts and humanities. The objectives are . . . to support programs and projects of artistic and cultural significance, encourage creativity, and make the arts more broadly available across the nation. . . . Since 1949, nearly 100 cities across the country have formed community arts councils. The effectiveness and efficiency of these councils [have] been amply demonstrated in the past. It is planned to provide assistance through small matching grants for special projects in order to strengthen and encourage efforts in these progressive cities.[3]

So far as anyone is able to determine, the program was not undertaken. In a prepared statement that repeated to a large extent the contents of the budget justification, Stevens does not repeat the reference, which seems interesting in retrospect.[4]

The interests of keeping the communities issue before the Endowment and Congress was not a new thing. When the Endowment first came into being, the present Office of Partnership was the State-Community Office. In a description and evaluation of one of the first grants for the arts in small communities ever given by the Endowment in 1966 (awarded to the Office of Community Arts Development, Wisconsin Idea Theater, Extension Arts, University Extension, the University of Wisconsin, Madison), the assumption was made that democratic, grassroots arts are a basic goal of arts developers and community arts leaders.[5]

The arts council was, in this project, the vehicle seen for the propagation of new ideas and the organization of arts in the experimental communities. Councils were seen as the mediators of change in their communities — groups that could see both the past and future. They were seen as meeting grounds for those concerned with community welfare and interest in the arts, as well as those from disciplined arts commitments. The councils were advised to define their areas of influence according to the subtle human relations considerations unique to each situation.[6] The process for assessing the arts needs of the community was almost the same as that laid out by Virginia Lee Comer for the cities in the 1940s[7]:

> As the community is awakened to its opportunity in the arts, it becomes a laboratory through which the vision of the region is reformulated and extended. And as the small community discovers its role, as the small community generates freshness of aesthetic response across the changing American scene, American life and arts are enhanced.[8]

The research study later done on this program points to some interesting and prophetic materials for arts administration and arts councils. The organization (or individual) whose goal is community arts development must define the role clearly. "It is to create an additudinal readiness for the arts in a democratic framework — it cannot expect to bring about the grassroots changes alone."[9]

But the Endowment, in those same years, was assisting in the development of all the state councils, and this community portion of the network was out there developing and proliferating — *mostly* on its own. There was just not enough money for everything, and at the Endowment, the program was changed in the early 1970s to reflect more accurately the federal-state programming. "Community" was deleted from the title.

It was in other areas of the Endowment's work that the major contributions would be made over the 1970s. Through programs known as Expansion Arts, City Spirit, and Architecture and Environmental Arts, cities and communities throughout the United States began to feel the impact of the Endowment's community effort.

NACAA was founded in 1971, under the umbrella of ACA, to give community councils, commissions, arts centers, and united arts fund organizations a national voice (much in the same way CACI had earlier developed under ASOL — and then into the Arts Councils of America in 1965). It has maintained a continuing relationship with the Endowment as an advocate for the community councils and agencies as direct client in much the same way as the states' agency has.

Until 1974, when NASAA opened an independent office and established itself as a professional national organization, it too was under the

aegis of ACA. The North American Assembly of State and Provincial Arts Agencies (originally including Guam, Puerto Rico, the Virgin Islands, American Samoa, the Canadian provinces, and Mexico) was organized in 1968 within the framework of ACA. Now known as NASAA, it is an association of state government arts agencies. The assembly provides a forum for discussion and exchange of information and experience pertinent to its membership, and seeks to develop and recommend policy in the field of arts and government. By 1967, all of the state arts councils had developed, and by 1969–70, when the first directory of state arts councils was published, there was a clear record of how far they had come in the five years since the establishment of the National Endowment for the Arts.

> In short, the congressional belief in 1965 that "public support of the arts is in the public interest" was then unanimous. . . . Indeed this universal acceptance and ratification by all the states is strong testimony . . . of the permanent enactment of the National Foundation on the Arts and the Humanities Act of 1965.[10]

Several state arts agencies expressed at that time the fact that they owed their existence to the Endowment — the "stroke of genius in providing $25,000 nonmatching grants to the states to conduct arts surveys."[11] Eighteen states already had councils when this was done, but those that rallied around this point got on with it then. Charles C. Mark, current consultant and editor for *Arts Reporting Service*, was the first person behind the desk in the State-Community-Operations Office (later the Federal-State Office, then the Office of Partnership) at the Endowment, and it was his job to counsel the emerging state councils in the years between 1965 and 1967 — those developmental years. His was substantial and important work.* In 1974, as noted, NASAA incorporated as a professional national organization and set up a Washington office that serves as a liaison between the state art agencies, federal agencies, the National Endowment for the Arts, the Congress of the United States, and other arts service organizations. It provides a reporting service to all members on Endowment policies, procedures, and programs, and coverage of legislative matters dealing with the arts. It also serves as an initiator and clearinghouse for research and information on the state agencies.

When NACAA was considering a move in the direction of establishing a professional national organization apart from ACA in 1978, John Everitt, now Director of the Arts and Humanities Council of Tulsa, wrote to John Blaine regarding its future: "The time has come for community arts agen-

*In the framework of diminished federal emphasis in the 1980s, the building of the state network gains impact and importance beyond that originally imagined.

cies to stake their claim to their rightful future in the American Arts Community."[10] That probably accurately summarizes the mood of the state arts agencies in a similar situation in 1973. In the same month that Everitt wrote to Blaine, ACA members received a letter from Michael Newton, the group's President, reflecting on 1973 when NASAA developed its own independent status, and the fact that NACAA was considering the same step. He favored the direction: "ACA can best devote itself to identifying and serving those needs of the arts that cut across the traditional arts disciplines."[13] (The director of NASAA at the beginning of the 1980s had a background with the performing arts, with the Arts Council of New Orleans, and with the Board of Directors of NACAA as Vice-President. If ever there was a moment of potential focus on mutual progress and understanding, it could be expected at this point.)

The frustration on all levels about how to recognize the local development — its pace and dimension — is nowhere better exhibited than in the Endowment's own deliberations on communities. Although the Endowment from the start was to make 20 percent or more of its funds available to state arts councils (three-fourths of the total to be distributed in equal amounts to all, and one-fourth to be at the Endowment's discretion), there was no clear mandate about communities. However, local groups have had access to the individual arts discipline program grants on a merit basis, equal to that of other applicants for support programs and services. In 1980 it was possible for a community council or city department of cultural affairs to apply for appropriate program, project, production, and service funds from 39 Endowment programs. (Of course, they would be considered on a merit basis in competition with all others.)[14]

The question has been one of recognizing the federal-state-local partnership and enabling it to become a reality. At its meeting in September 1980, NASAA issued a position paper that urged the Endowment to recognize the substantial evidence warranting its full attention to communities. When asked for support for the idea, the state arts agencies could themselves recognize this goal only after most of their own priorities had become better defined. Most of their budgets were over $1 million at this point, and it had taken this time for them to mature to the point of acknowledging their direct responsibility for the organizational growth and development of the community arts agencies. In a few states this has long been a priority, but 36 states (twice the number of the years before) attended the session at which the statement was formulated.

The National Endowment for the Arts has commissioned three studies to look at the community issue since 1976. Most have been politely or summarily shelved. In 1980, though, pressure for action was coming from another source — the Congress of the United States. In passing the reauthorization bill that would assure the Endowment of its existence from 1981 to

1985, Congress was for the first time specific about encouraging the Endowment to be more responsive to arts activities at the local level. The law, which establishes the agency and sets down its general operations mandate, asks for the involvement of state governments in the local efforts so that state and local arts activities will be coordinated. Even though this really only legitimizes the efforts made over the past years by NACAA, and in 1980 by NASAA (as well as by the Endowment's Office of Partnership itself), it also pushes for some response by the National Council.

The National Council on the Arts had been faced with policy decisions on behalf of communities before, but had deferred actions to new task forces or study developments through the years.[15] In asking why, one finds as many answers as there are individuals questioned, but some attributions include the following:

1. The lack of a handle on the who-what-where of the local arts agencies who were asking to be served directly. The sheer growing numbers were scary to a federal agency. NACAA was seen as representing them. But the community arts agencies are greater in number than any single-discipline group, and even the task forces appointed by the Endowment to represent them had consensus troubles.

2. Lack of support from within the Endowment staff itself. Through the years, many of the disciplines have included direct access to Endowment programs competitively, and the staff (and almost anyone who was asked) didn't see a need for additional and separate access. Early tensions existed between such programs as CityArts of Expansion Arts, which hadn't proved itself, and the Office of Partnership.

3. Confusion and power plays among the Endowment staff members, and tensions in the field causing the rejection of some possibilities that might have become a beginning point.

Example: Taking the 1977 Endowment in-house study commissioned through the Chairman's office, James Backas had been appointed to "think through the whole range of community arts activity from the point of view of fundamental policy. It is Endowment-wide in scope and of first-magnitude importance to the Endowment."[16] Among its recommendations, the study called for the possibility that state arts agencies, the community arts agencies within the states, and the local governments would develop a statewide plan that would be funded through a second-tier block grant program. Planning grants would be available to stimulate the planning process. The program would work with agencies in SMSAs (standard metropolitan statistical areas). At the time (fiscal year 1976), 36 state arts agencies assisted 669 community arts agencies with Endowment Federal-State Community Development Grants, matched by state funds. All other Endowment pro-

grams reached 98 community arts agencies directly. Of these, 41 were City Spirit facilitator programs, Expansion Arts programs, special projects, and grants from other programs of the Endowment.[17]

Example: A 1978 Federal-State Panel recommended that staff members develop a pilot program of direct grants to community arts agencies ($250,000) on an invitational basis.

The reasons cited prevented these recommendations and/or programs to progress. This period, between mid-1977 and mid-1978, was especially chaotic, with the first shift in top-level administration at the Endowment since 1969.

The period of the transition between Nancy Hanks' and Livingston Biddle's leadership was an uneasy time at the Endowment. There were the natural power plays, the old and the new, the reorganization. And in that reorganization, something happened to some of the city programs. Although the City Spirit program director's contract was to expire anyway, and it was easy just to let the program go, the fact is that it had no great support and in many places was not understood, except in the cities and communities that had gotten some funding to implement a planning process. There was never a clear communication about the value of the program to the program offices at the Endowment itself, even though the City Spirit staff tried hard to explain it. The small amount of money in cities and communities was spent on a process that isn't always definable in the same terms as performances and exhibits. The fruits of labor in many of those cases has come later, and built from the City Spirit opportunity.

4. NACAA's immaturity and lack of focus until 1980.

5. NASAA's immaturity and lack of focus on community arts agencies until 1980.

6. Lack of real support for community arts at the National Council level (exceptions, of course, such as Lawrence Halprin and Gunther Schuller, exist). The voices for the major institutions and the professional artist have been stronger and steadier.

7. Deterrents that focused attention on some Housing and Urban Development (HUD) programs, such as Livable Cities, which might have generated many times the amount of money, using the Endowment itself as a cosponsor.

The idea of linking up the arts and urban revitalization grew out of the work done by the Endowment, specifically the Expansion Arts program, the Livable Cities category (not to be confused with the HUD program) in the Architecture and Environmental Arts program, and City Spirit — in all of which there had been experience involving the arts and community revitalization. Thus when HUD, in 1978, as part of President Carter's national urban policy, seemed enthusiastic about a proposal called

Livable Cities, it was not surprising. On Capitol Hill, the item, one of the first initiatives to get a hearing, was proposed at $20 million for three years; it dwindled to a $5 million authorization, but never got funded. The fact that it would have been guided by criteria drawn up by the Endowment and applicants selected by a jointly appointed panel is important in the movement that makes connections among federal agencies for the benefit of communities.[18]

8. Pressure from the media, such as a New York *Times* article and following editorial in late 1980 (the accusation was that the large institutions and individual artists had been getting less money year by year). There has never yet been a media spokesperson for the community arts' side. With the support and initiative of such council persons as Charles Eames and Larry Halprin, Nancy Hanks had some support for community programs, such as City Spirit and the Architecture and Environmental Arts program. In fact, some were generated at the Council level. Livingston Biddle, a libertarian, had wanted to do something for communities. He saw to it that the communities had at least one formal representative and one spokesperson at the National Council level with the appointment of Jessie A. Woods, former director of the Urban Arts program in Chicago. After the NACAA presentation to the National Council in December 1979, he announced that "we are committing ourselves to a decision."[19]

This was done through the Office of Partnership. But the search for options, done through an exhaustive outside study of the Endowment's history of policy making for communities, proved ill-focused for the charge and purpose and unproductive in the end.

Succumbing to the pressures described, Mr. Biddle's tenure was marked by more delay. The only new community program came from the Office for Special Constituencies—an advocacy program to make the arts more accessible to handicapped persons, older adults, veterans, and people in hospitals, nursing homes, mental institutions, and prisons. With about a $400,000 budget, it supported model demonstration projects.

In February 1981, the National Council Policy Committee reviewed the report of Henry Putsch, Director for Partnership, to be discussed more fully in a later section of this chapter (see pp. 91–95).

The question of assisting the local community arts agencies (both "community arts agency" and "local arts agency" are used by the states to designate the public, private, and publicly designated private organization options) by fostering their arts support function, and of encouraging an effective state-local support partnership, is complex; the states see it working through successful state-local planning. In each case, distribution of statewide funds would necessitate the establishment of a procedure defining eli-

gible community arts agencies and appropriate evaluation criteria. The more militant NACAA view through the years, however, had been to re quest direct access to the Endowment. In 1980–81 the realistic view was that access for these types of funds probably would be developed only with joint state-local planning and become implemented through the states. NACAA, more mature and realistic in the 1980s, will probably live with that reality if, in addition, a new program of assistance is developed within the Endowment's Office of Partnership. The purpose would be to foster the development of a state-local arts support partnership characterized by strengthened support for the arts at both the state and local levels.[20]

By 1982, Frank Hodsoll had become the new Chairman of the National Endowment for the Arts and was expressing interest in the Endowment's relationship to local arts agencies. In speeches at meetings in Racine, Wisconsin on CityArts and at the mid-June NACAA convention in San Antonio, Texas he reported this to the field. He indicated that in 1983 some pilot programs for local arts agencies might be developed based on three options, which would include a combination of the CityArts approach: direct negotiations, competitive applications from states for grants to support local arts agencies, and state-local challenge grants on a 3-to-1 match basis. This last incentive program would have to be matched by a combination of new state-local dollars.

As recently as 1976, in an Endowment Community Arts Project Steering Group meeting, one member stated the consensus opinion of many over the years: "A discouraging part is that we have no feel as yet about what has actually resulted other than the setting up of councils and the budgets of councils. What have those councils done? You cannot look down there and see what happened."[21] The question of sheer numbers has always been a problem, but it is the diversity of profile that has made it difficult for those who want definitions.

The issue of community program policy is described as being "like the cat who was pushed from the top of the World Trade Center eight times only to crawl back up again."[22] It has surfaced and resurfaced for 15 years. The high point for communities probably was the day in December 1979 when the National Assembly of Community Arts Agencies made a presentation on community arts agencies to the National Council on the Arts, which was hailed as one of the best presentations ever and certainly the clearest one on community arts agencies. With focus on three representative councils — San Antonio, Texas; Bassett, Nebraska; and Syracuse, New York — a positive image was created.

In summary, there have been many sheaves of paper and many tapes of discussion devoted to the subject. A program of direct and sustained support is yet to be determined.

What the presentation did, however, was to point out that if one begged the figure of 2,000 councils, one could rely on the fact that local arts agencies exist in most major cities as well as in towns of 1,500 people. They are city, county, regional, and rural. Some operate with multimillion dollar budgets; others are run by volunteers "who reach into their own pockets for postage stamps to send notices of coming events to their neighbors." "The word has spread from city to city and county to county that the best way for the arts to thrive in the community is to form an arts commission." The same report, hailed especially by Gunther Schuller, the celebrated composer and conductor, one of the National Council members listening to the presentation, attributes this growth to the fact that "they've worked."[23] Discussion among Council members showed greater understanding and enthusiasm, although not without caution on the part of some. The caution about numbers and impact was expected; the enthusiasm was a breakthrough.

But at least there was a fair look at the catalyst agency that has generated new and more monies for the arts on the local levels and developed new and diverse audiences. Some arts councils have championed the needs of individual artists when no other local organizations have given it any priority (this is not to diminish the role of artist associations and galleries, etc.), and they have caused communities to improve their arts attitude through high-visibility activities that have caused greater understanding and participation. It is a short step from these goals to cities' viewing the arts as vital, points of pride, revitalization tools, components in economic development, and images for good living. From the pictures of the opening of the Civic Center managed by the Cultural Resources Council of Syracuse and Onondaga County, through the downtown events in San Antonio showing thousands of people enjoying the work of outstanding American performers, to the efforts of the inhabitants of Bassett, Nebraska to see that equally fine opportunity become a part of their lives, the story was shown clearly and graphically — and could be projected in comparable settings throughout the United States.

From 1974 to this year, NACAA's opinions, recommendations, and pressures have been sought and felt in different degrees and for a variety of reasons. As early as 1974, there was a recommendation for a pilot demonstration program of monies to community agencies to administer to the arts. A year later, the united arts funds requested an Endowment matching grants program (monies requested must be matched by equal amounts of local monies — a common procedure) and got it. And if one were to examine the interests and priorities of NACAA after it became a national professional service organization in 1978, it is clear that the agenda has been a similar one — to gain access to direct Endowment funding for communities in order to complete the full partnership. The Office of Partnership replaced the Federal-State program to clarify more specifically the particular concern.

NACAA also played a role in assisting the 1980 Congress to strengthen the community position through stronger wording in the reauthorizations bills for the Endowment affecting the 1981–83 budget.

Response from everyone who had a handle on community arts to a piece of proposed legislation in 1977 for "small groups and struggling artists" sums up the problem and the inclinations. The pleas were to acknowledge the local networks more strongly and to use state and local agencies to help reach those goals of nurturing every group's emerging potential, rather than to ask the Endowment to grant monies to some estimated 10,000 groups ineligible for direct Endowment support. Decisions by Congress on the 1980 reauthorization and by NEA finally created the possibility of a process of direct access for community or local arts agencies to complete the network. It would take more time for the wheels to be greased, but with states such as California, North Carolina, New York, Minnesota, and Maryland in some sort of gear, there certainly would be a place to start. The program characteristics were spelled out in the NASAA and NACAA recommendations to Congress and the Endowment in the fall of 1980; they include planning and evaluation built into the process of determining criteria and eligibility.

With the responsibility for developing the public link thrust upon state and community councils, the opportunity to develop a strong network exists as never before. The community arts councils have been saying through the years, "We can go it alone— don't blunt the local initiative," but with maturity and common interests identified, they and the state arts agencies can work through to strengthen the partnership concept. No one group is really independent of the others in the support fabric.

This struggle, which has consumed a great deal of NACAA's attention, has been important. When one knows that in 1978 there were some 1,500 community orchestras, 800 community opera companies and college/university opera workshops, 490 contemporary music ensembles, thousands of choral groups, and numerous chamber orchestras and music festivals that did not have direct access within one discipline (Music and Opera) at the Endowment, one realizes that a clarification has been needed. In this discussion of direct access, the reference is only to the service councils and commissions who would give assistance to others, distribute monies, and complete the support group network. These discipline groups are indeed community arts groups, and the councils would encourage their development.

There has been some mention earlier of the Endowment programs that community councils have had access to all along. Arts councils, functioning as catalysts for the arts that combine the talents and resources in a community, have had accessibility to three design programs, five dance programs, four media programs, and many others that are included in the

Civic Handbook of Grants Programs offered by the Endowment (1980). Among them, there are a few that should be singled out for their special place in bringing the arts to the attention of cities. In many instances, such programs have caused local arts councils or agencies to develop. Often the local arts agency has been an applicant.

The Expansion Arts program of the Endowment, seeking to assure that every American will have access to the arts, has, since its inception in 1971, addressed more closely than any other Endowment program the question of how the Endowment will provide for the "cultural needs of all of those Americans whose aesthetic viewpoints are unique to their own richly diverse cultural roots and are not served by the other more recognized arts organizations."[24]

Complementing an ongoing neighborhood arts programming effort has been the CityArts program, under Expansion Arts, *providing support in cities in partnership with local municipal governments.* This program, applied for by invitation only, was envisioned to *stimulate new local tax dollars in support of the developing arts organizations.* The maximum request was $50,000. In the first year, arts councils or city arts agencies in Atlanta, Buffalo, Charlotte, Dallas, Miami, San Antonio, and Seattle matched their Endowment monies and further distributed the total dollars to local groups through a system of public review. In Cleveland, one of the second-year cities, the monies stimulated the first tax funding the arts had ever had there. (Because the city was at the time in financial default, Cuyahoga County, which was interested in developing an arts policy, matched the monies.)

The Expansion Arts philosophy was that this was a beginning of "a relatively young movement within the Arts Endowment — to develop creative relationships between the federal government and municipal agencies. There is a logical, though not formal, relationship between CityArts and other programs such as Livable Cities, City Spirit, Federal-State, and the advocacy effort of other NEA offices."[25] This is a direct-access program. The monies have been given to arts councils or commissions for redistribution for "developing and neighborhood groups." The purpose was to create incentives for new local tax monies for these groups.

President Richard Nixon was perhaps the first to promote the Endowment image as a valued resource when in 1972 he requested some 80 federal agencies to consider how they might support the arts and how the arts could contribute to a more effective accomplishment of their own missions. By directive, the Endowment was to receive their replies.

In 1967, the Endowment's Architecture and Environmental Arts program was initiated, and in its first few years worked with a small staff and budget. William Lacy and Robert P. McNulty in 1973 designed a more effective way of delivering the services, guidance, and expertise that have be-

come expected over the years. A *White Paper* articulated what was proposed.

A large number of the agencies sought assistance in their use of design, and the Endowment developed a strong assistance program in response. Concurrent requests emphasizing cultural facility planning, percent laws for arts purchases in city and state construction, and adaptive use of buildings were pinpointed as areas where Endowment advice and counsel were more often sought than grant support was. National theme programs such as City Edges, City Options, and Livable Cities encouraged cities to look at their local environment. The *White Paper*, backed by National Council members Charles Eames and Lawrence Halprin especially, and most importantly by Nancy Hanks, then Chairman of the Endowment, proposed that the Architecture and Environmental Arts program be allowed to use flexible methods of giving the assistance that was being requested — such as consultants and contacts, in addition to grant making.

The *White Paper* clearly identifies its prime client as a city or a public body vested by its citizens with authority over design and capital expenditures, and whose designs in turn affect the design quality of the citizens' surroundings. The gap in funding to localities from other federal grantors has been in the planning areas, because such agencies as HUD, Health, Education and Welfare (HEW; now Health and Human Services, or HHS), Transportation, and the Economic Development Administration (EDA) of the Commerce Department use the categorical grant approach — funds available for certain stated reasons only. The conceptualization and planning funds are usually not provided. The reason, then, is clear for the interest on the part of those other federal agencies in City Edges and City Options. The Endowment was acting more and more as a resource in the design and development of capital programs. And because the requests always outnumbered the possibilities of acceptance and assistance, the Architecture and Environmental Arts program moved to prepare materials that would help cities make decisions.[26] Architecture and Environmental Arts was devoting more and more staff time to nongranting matters that would affect a range of urban issues, ranging from preservation of usable spaces to city planning responsibility.

All of these activities tend to emphasize the importance of arts and arts-related activities in the city. The program has tried to be effective in pinpointing communities where the dollars available would influence quality of design, aesthetic planning, and conceptualization, as well as heighten consumer awareness of the values of good design.

These are subtle things, and in themselves might fall on deaf ears. But more and more, with the decay of our cities and blighted lands everywhere, they are beginning to cause notice.

In a recent book, *How Small Grants Make a Difference*, neighbor-

hood programs in Pittsburgh, Savannah, Milwaukee, Jersey City, and Boston, and programs in the downtowns of Fernandina Beach, Florida; Troy, New York; and Galveston, Texas are profiled. A little money (the range was $8,000 to $50,000), in each case, was made to go a long way. The Endowment support "enabled these groups to think through their projects before they were launched, and made it easier for them to raise money from other sources once they had had a chance to show their seriousness of purpose."[27] These particular grantees told their own stories in hearings before the U.S. House of Representatives Subcommittee on the City,[28] and showed how they were assisted by the federal agency to help themselves. The hearing highlighted community initiative, the Endowment's sensitivity to local conditions, its minimum red tape, and its willingness to take risks.[29]

> Fernandina Beach had lots of plans, a lot of dreams awaiting a great windfall, which came in the form of an Economic Development Administration grant (to implement the downtown master plan). We feel, however, that the grant behind the grant — the National Endowment for the Arts grant for redesign of our downtown public spaces — was most effective in bringing our dreams to reality.[30]

A spin-off of the Architecture and Environmental Arts program is an organization called Partners for Livable Cities, now directed by Robert McNulty, who put much of the advocacy program at the Endowment in place from 1972 to 1978. Partners for Livable Cities, like several other service organizations rooted from Endowment activities, is now under cooperative agreement and has a yearly "goods and services" contract. Publications such as *The City and the Arts: The Civic Handbook of Grant Programs* and *Reviving the Urban Waterfront* are included in recent services.

Over the years, program areas at the National Endowment for the Arts have changed names to clarify current function. The Architecture and Environmental Arts program has become the Design Arts program to focus on its primary role in promoting excellence in design. Total funds obligated by the Design Arts program (fiscal years 1966–80) came to $29,782,367. In 1982, the figure was about $5 million.

Another source of impact for the idea of arts and the cities is the Endowment's City Spirit program. When arts organizations talk of "weaving the arts into the fabric of everyday life," often they do not have an idea of how this might be done for more than the duration of a festival. City Spirit, under the Special Projects division of the Endowment, existed from 1975 to 1978 and taught communities how to start to do this. In that time, a few arts councils were stimulated into life, and many communities — large and small — were aroused to arts action. Altogether, 180 grants were made.

City Spirit saw "the artists as animators to facilitate artists as commu-

nity leaders or activists."[31] In 1974, when people were not oriented to the notion of process, the program suffered from difficult and frustrating descriptions and interpretations. Confused communities were not able to understand what the Endowment really wanted from an applicant. The purpose was to stimulate interaction among people, and it really didn't matter what type of organization the catalyst was — arts councils, parks and recreation divisions, or even, as in one town, a drop-in center. The program was about bringing people together to interact in defining projects and long-term relationships — the projects were merely a rallying point. City Spirit was societal; Architecture and Environmental Arts was physical and environmental.

The program, although it went through several phases in defining its intent, basically was able to respond when cities as diverse as Durham, North Carolina; Keene, New Hampshire; Cambridge, Massachusetts; San Antonio, Texas; and North Tahoe, California were ready to plan with their communities. In these and other places, arts councils did develop or become strengthened and have been going strong; City Spirit was part of a process that took hold. The grants were never large, and ultimately a pool of resource people and facilitators assisted communities with these processes. New people were brought into the field through the strength gained by local leadership, one notable example being the present Director of the San Antonio Arts Council. Others who were involved were influenced by the process, probably identifiable as a brainchild of Lawrence Halprin, who served on the National Council in the 1970s.

In closing the Endowment City Spirit program, its Director, Burton Woolf, made an attempt to transfer the best of City Spirit to coordinators of community arts from the state arts councils. Three sessions on facilitation of diverse groups and community process were given for about 60 persons.

The City Spirit program and the advocacy program from Architecture and Environmental Arts were among the least well-financed programs of the Endowment. Perhaps, in their influence, they have had impact far beyond the dollars spent. Conceptualization and process are not always highly visible, but cities and communities from the smallest to the largest have felt their influence.

The final report of the City Spirit program in San Antonio capsulizes this influence:

> City Spirit has been instrumental in developing new relationships which have important implications for the future. The relationship established between the city and the Arts Council under City Spirit has had the effect of establishing a major public agency for the arts. Our budget increased from $16,000 in [fiscal year] '75 to $140,000 in [fiscal year] '76. City funds are now being used for basic operating cost, and the major institutions have developed

a stronger sense of public responsibility and service. There has been a notice-able increase in cooperation among all arts organizations. City agencies are working together in coordinated programs. The arts are now being included in the overall masterplan for the city. The importance of the arts to the economic and social development of San Antonio is now recognized by every responsible political and business leader in the city. A dialogue has been established be-tween struggling neighborhood arts programs and established institutions. . . . Perhaps most important, the arts in San Antonio have been significantly strengthened through increased community awareness and participation, and a number of new public programs have been created reaching new audiences and involving new segments of the community.[32]

Another rational influence on cities during the 1960s and 1970s was ACA. First, it worked hand in hand with the U.S. Conference of Mayors on the resolutions on the arts that set forth principles as guidelines for city ac-tion. It was the only group that could, as it did in Seattle in 1976, bring to-gether city and county officials with officials from the National Endow-ment for the Arts and the staffs of the national organizations that represent the arts to exchange thoughts, meet and greet socially, and simply set the stage for working together. This was at a time when the ways of accom-plishing this were not yet solidified. As time went by, and the local public sector, led by the mayors of New Haven (Frank Logue, Jr.), Atlanta (May-nard Jackson), and Seattle (Wes Uhlman), focused its thoughts, it became clearer how important that ACA annual meeting was when 500 representa-tives met to discuss needs and the priorities of community arts councils.

ACA has always been "the gatherer of people" through its many workshops, seminars, and large annual meetings — a total of over 70 be-tween 1960 and 1981. However, there had been an enormous effort made to study the state of the community council for the Seattle meeting. ACA (then still the umbrella agency for communities) had been commissioned by the Community Arts Agency Project Steering Group of the Endowment to coordinate the exploration of issues and the development of background materials concerning community arts agencies. NASAA, NACAA, ACA, and the Endowmnet all produced papers, which were discussed at the ACA and NACAA meetings in Seattle and the NASAA meeting in Atlanta immediately following. The future leadership among officials of the local public sector heard the deliberations, and later developed *action* task forces on the arts at the National League of Cities and the U.S. Conference of Mayors.

Michael Newton was president; David Rockefeller, Jr. and Louis Har-ris were chairmen during this era of ACA when so much of this kind of ACA activity was being sponsored. It was at the Seattle meeting that the community councils first felt the need for an independent professional or-ganization, which was accomplished three years later.

It was something about the makeup of ACA — its board image (well-heeled and glamorous), its New York City office (far from the rest of the country), its unfocused image — that caused the community field to feel unserved. However, a review of their seminars, meetings, and publications attests to ACA's being at the forefront of ideas and able to bring disparate resources to focus on common arts and city issues. One example was an Arts and City Planning Conference, where "The Arts and City Livability," "Arts Amenities in Comprehensive Plans," "The Arts and Economic Development," "The Arts and Urban Design," "The Arts and Transportation," and "The Arts and Social Services" were discussion topics.[33]

ACA publications should also be given special notice. Some were significant in simply gathering all the speeches at the national meetings of the mid-1960s — Marya Mannes, William Schumann, Harold Taylor, Nelson A. Rockefeller, Samuel B. Gould, Erich Leinsdorf, and W. Willard Wirtz, among others, discussed their views on the arts in relation to corporations, government, labor, education, and industry. These and others talked of art center management, arts leadership, the changes in the wind, and the realities of the day. There were the ACA *Cultural Affairs* magazines of the late 1960s and early 1970s, packed with the same kind of thoughtful material. Michael Newton's ACA-sponsored publication, *Persuade and Provide*, was the story of the St. Louis Arts and Humanities Council, told so that other communities might follow the model. There were the guidebooks and cookbooks for community arts councils, starting with Ralph Burgard's *Arts in the City* of 1968.

But the Louis Harris surveys of public opinion on the arts in 1973, 1975, and 1980 called *Americans and the Arts,* have had greater distribution and have served to provide facts in favor of support for the arts more widely perhaps than any other published material. Many speeches and publications since that time have used the quotable facts as support data. This ACA influence cannot easily be forgotten.

ACA has taken the initiative in developing new possibilities for art involvement and working on expanding the resources available to the arts. That it would hold the Arts and City Planning Conference discussed above at the same time as it held one on Rural Communities shows the span and range of its concern.

It could be said that there would have been no ACA if, in 1955 at the ASOL conference, a plenary session on arts councils and a well-attended workshop, scheduled for two hours but lasting until well after midnight, had not excited those in attendance. Thus began the first national conference of arts councils. Ten people represented seven of about 20 councils then in North America. With foster parents in the Junior League, the ASOL, and the Rockefeller Foundation (for the study including community arts agencies), the first five years were a period of growth and nurturing. In

1960, there were enough arts councils to support a national organization; CACI was born, and George Irwin of Quincy, Illinois, was elected president. With arts councils popping up like mushrooms after a summer rain, CACI was called upon for help in developing plans for capital fund drives, budgeting, the general administration of cultural centers. As CACI began to advise in this very complex field, and state arts councils began to develop as well, the name was changed (1965). The first office of ACA, with a former Director of the St. Paul Council of Arts and Sciences, Ralph Burgard, as full-time executive director, was established in space provided at the Rockefeller Brothers Fund, one of the first funding sources for the group. Even at this time, the ASOL was helping by providing the convention staff and allowing community arts council news to go out in the ASOL newsletter. Board members of this group included R. Philip Hanes, Jr. (then President of the North Carolina State Arts Council), Nancy Hanks (then Executive Secretary, Special Studies Project, Rockefeller Brothers Fund), Charles C. Mark (then a consultant to the National Council on the Arts), and others whose combined energy and concern for communities was important throughout the next decades.

The future of ACA in 1965 was seen as an opportunity "to build a private counterbalance to the federal body which had just been created"; "we must not let this chance pass us by," said R. Philip Hanes, Jr., in his speech as President of ACA at the annual meeting in 1965.[34] He was addressing the joint conference of ASOL and ACA. The conference convened at a time when public concern for the arts had reached a new peak as a result of several related but independent developments. During the months preceding the meeting in Washington, the long-awaited Rockefeller Panel report on the performing arts was published, the National Council on the Arts was established, legislation establishing a National Arts and Humanities Foundation was passed by the Senate and debated in the House, and at the beginning of the week in which the conference was held, the White House hosted a festival of the arts that attracted nationwide attention.

A total of 900 delegates from 40 states assembled for the meeting to which Hanes addressed his remarks. The mandate for ACA stated by Hanes was indeed important. It was overlooked too many times by the very constituency ACA was serving. Could the states and community constituency be served well if ACA were to be a "private counterbalance" to the Endowment? The dilemma of what those services should be and how they should manifest themselves brought many tense discussions in a field trying to define itself in all aspects of its being. When the state councils organized professionally, the act only culminated many years of rather unfocused discussion on what ACA should and might do specifically for the states. The same was true for communities; it may be a natural evolution that the clientele saw reasons to want independent service groups.

ACA was and is today a resource for information and contact. Its

seminar schedule is enviable; its publications are of professional value; its constituency is loosely defined. This is much the way it has been over the years. The arts field has wanted to know what ACA really stood for — not that it stood for everything and everyone.

During the intense period of determining how to coalesce around the budget cuts recommended in 1981 on the national level, ACA, guided by a Special Counsel on National Policy, emerged with new strength and leadership *because* it became identified with a broad range of leadership for the arts, not just state or community or institutional arts. During this period, with ACA in some leadership role, the Coalition for the Arts created a unified voice and worked together as an arts lobby. ACA has also been oriented over the years toward leadership from the private sector especially, and it could gather some important testimony for the arts from the presidents of prestigious corporations as well as foundation leaders. Milton Rhodes, Executive Director of the arts council of Winston-Salem, North Carolina, was made president of ACA in 1982.

The development of community arts councils and local arts agencies is so interwoven with the threads of influence discussed in this section of the chapter that at times such groups are both the cause and the effect of action. Does a council grow from a City Spirit experience, or is the council the applicant for the program so that the community can develop and expand? Both can be true, and are.

The discussion has been about the ways in which cities and communities of all sizes have become aware of the arts so that the role of a community council can be better understood. The councils themselves have been making some communities aware, since they were there long before any public sector was seriously interested.

What has come first, second, or third is not as important as the fact that the message has been the same — that the arts are central to a good life and a good community image, and may be the key to success in some civic endeavors as well.

Those who run our communities — our elected officials — began responding to this realization in 1974. The Resolution of the National League of Cities and the U.S. Conference of Mayors in that year set forth these guidelines for city action:

1. Arts are essential services — equal in importance to other central services.
2. Every city ought to encourage a public agency specifically concerned with the arts.
3. The physical appearance of the city, its architectural heritage, and its amenities should be acknowledged as a resource to be nurtured.
4. Cities should be encouraged to establish a percentage of the total

cost of every municipal construction budget to be set aside for
purchase or commission of works of art.
5. No American should be deprived of the opportunity to experience
or to respond artistically to the beauty of life by barrier of circum-
stance, income, background, remoteness, or race.*

In 1975, there were more specific guidelines giving attention to the
employment of artists, and by 1978, there had been developed fuller iden-
tification of the specific problems of accomplishing these guidelines, as
set down in the 1978 Cultural Resources Policy of the National League of
Cities. Also, by that time, the National Conference of State Legislators, the
National Governors' Conference, and the National Association of Counties
had made similar statements.

Resolutions don't always mean very much, but the concentration of
these resolutions and the action committees that followed their declaration
are impressive. Leadership in these efforts was given by several who be-
lieved that what they were doing in their cities in the arts was important for
other cities. Wes Uhlman, who as mayor of Seattle had spearheaded his
own local efforts by using the arts to revitalize a severely depressed city,
had introduced the "Quality of Life in Our Cities" resolution at the 1974
meetings. It was the first of such documents and the one that influenced all
of the others. The former mayor of New Haven, Frank Logue, Jr. (at the re-
quest of Phyllis Lamphere, Councilwoman from Seattle and President of
the National League of Cities), chaired a Task Force on the Arts, with the
responsibility of having the arts "permeate city government: transporta-
tion, housing, human resources, CETA, etc." The task force "heightened
the awareness of mayors and city council people on the potential role of the
arts as a cultural force, as an economic development force, and as an edu-
cational tool, particularly useful for children who resist the usual educa-
tional channels."[35]

Beginning in 1977, the arts played a prominent part in the National
League of Cities conventions, not only in the resolutions that were adopt-
ed, but in visual arts, music, and dance presentations in and around the
conference, and in their use in emphasizing the cultural attractions of the
cities in which the conventions were held. Through these meetings a ques-
tionnaire was developed and distributed, which in and of itself brought the
arts to the attention of local elected officials throughout the country.

Six months after the National League of Cities Task Force began to

*All resolutions on the arts passed by the National League of Cities, the U.S. Conference of
Mayors, National Conference of State Legislatures, and National Association of Counties be-
tween 1974 and 1978 can be seen in their entirety in Luisa Kreisberg, *Local Government and
the Arts*, (New York: American Council for the Arts, 1979), pp. 191–96.

function, Mayor Maynard Jackson of Atlanta introduced a resolution cre-
ating an arts task force in the U.S. Conference of Mayors. If Uhlman, Logue,
and Jackson had not been increasing community consciousness of the arts
in their own communities, they might not have been able to convey the
message so successfully to their peers in these national settings. "Within
New Haven, Frank Logue sought to increase community consciousness of
the arts and expand the arts audience and to take the arts to the places
(murals in the welfare department and schools, dances and musical per-
formances in libraries and other public buildings, etc.) where they would
be seen."[36]

The U.S. Conference of Mayors moved to create a Standing Commit-
tee on the Arts in 1978 in Atlanta. Jackson, who has successfully chaired
the Arts Task Force, was its first chairman. The publication *Local Govern-
ment and the Arts* is an outcome of his efforts. Working with its own board
members such as Maynard Jackson, ACA, with assistance from the Ford
Foundation and the Task Forces of the National League of Cities and U.S.
Conference of Mayors, could generate the resource material. The book is
arranged in terms of the arts' relation to the following: economic develop-
ment, real estate and construction, tourism, public image, employment,
transportation, public safety, and human resources. Those subjects are on
the priority list of every mayor. Reinforcement and repetition lead to belief.

The survey of over 450 cities' definitions of their cultural needs
formed the data base for the "Cities and the Arts" questionnaire circulated
by the National League of Cities in the fall of 1977, and culminated the at-
tempt to document statistics and attitudes. There were four major con-
clusions:

1. Cities have given steadily increasing support to the arts in a multi-
 tude of ways, largely unrecognized.
2. Before the WPA and large-scale federal support, municipal sup-
 port was the largest support and was most consistent.
3. City support has taken a multitude of forms.
4. Grants of city money have also meant pressure to "bring the arts to
 the people."[37]

The themes laid out and documented in this resource continue to de-
velop. But what has been the role of the local arts council or commission?

It seems clear that the most successful instances of municipal agen-
cies have occurred in the largest urban areas of the country, and that small-
er and medium-sized cities usually rely on privately incorporated arts
councils that were founded to serve the needs of those communities; the lo-
cal governments are usually apathetic. Once the population rises above
500,000, the issues become too large for local government to ignore, and

the need for a public commission to represent the arts' interests becomes
apparent. Both public and private local arts agencies can exist side by side
in larger cities, each with their own complementary agendas, as we know.
This is discussed in a later chapter. It is interesting in the light of this that
almost all of the 50 largest cities are receiving some sort of municipal arts
support (see Table 1). These municipal agencies, stimulated by a need to
focus on the common problems and interests of larger cities, formed the
Municipal Arts Federation in 1981. The organization works with NALAA
and has evolved from an urban symposium sponsored by the Cultural
Commission of the City of New York in 1978.

The public interest groups, such as the U.S. Conference of Mayors,
National League of Cities, City Managers' Association, Association of
State Governments, National Governors' Conference, International City
Managers Association, and the National Association of Counties were of
interest to the National Endowment for the Arts for their broader constitu-
ent representation and testifying base. The Endowment urged the devel-
opment of the task forces and staff officers and gave some dollars to help
them become reality. The resolutions could be useful as evidence of sup-
port, and the key also to keeping the arts before the cities.

But the articulation is only a beginning — the easiest part. The stimu-
lation of a well-planned policy would be the ultimate that one could hope
for; unfortunately, too few localities have really accomplished this.

STATES AND COMMUNITIES

The state arts agencies are important to the development of community arts
services, and at the same time community agencies can greatly strengthen the
programming of and support for state arts agencies.

The National Endowment, therefore, urges state arts agencies to provide
encouragement and the means for the growth of community arts agencies. In
addition to research, publications, consultants, and other technical assistance,
efforts might well encompass imaginative program ideas.

The Endowment recognizes that many state agencies support community
arts services through state legislative funds and the Federal-State block grant.
However, within its ability to do so, in fiscal 1974, the Endowment on a pilot
basis will consider grants to state agencies to augment programs for commun-
ity service improvement.[38]

Just as it might be said that "very few of the state agencies were active until
the Endowment began its block grant program to the states in 1966,"[39]
the Endowment's program called Strengthening Community Services
(1974–76), urging state arts agencies to work cooperatively with com-
munity arts agencies to develop plans that provide encouragement and the

TABLE 1
Municipal Art Appropriations[a] in Fifty Largest U.S. Cities

City	1975 Population Rank	1980 Per Capita Rank	1980 Expenditure Per Capita[b]	FY 1980	FY 1979	Percent Change
Atlanta	30	20	$1.25	$ 546,000	$ 505,000	8.1
Austin	47	22	1.11	334,000	358,000	−6.7
Baltimore	7	11	3.23	2,835,193	2,631,568	7.7
Baton Rouge[c]	46	21	1.13	350,000	350,000	0
Boston	19	27	.73	465,000	465,000	0
Buffalo[c]	32	4	7.37	3,000,161	2,846,028	5.4
Charlotte[c]	50	14	2.72	1,015,192	797,021	27.4
Chicago	2	38	.19	578,450	123,772	367.4
Cincinnati	31	34	.36	149,850	174,850	−14.3
Cleveland*	18	—	—	—	—	—
Columbus	23	30	.47	250,000	150,000	66.7
Dallas	8	15	2.42	1,968,210	2,400,000	−17.9
Denver[c]*	26	2	8.26	4,000,026	3,801,000	5.2
Detroit	5	39	.18	245,377	832,463	−70.5
El Paso	33	37	.31	121,000	96,000	26.1
Fort Worth	39	16	2.27	819,354	503,484	62.7
Honolulu[c]	13	39	.18	126,500	108,000	17.1
Houston	6	18	1.38	1,830,627	1,611,318	13.6
Indianapolis	9	29	.55	433,000	350,000	23.7
Jacksonville	20	32	.44	248,500	264,300	−5.9

(continued)

55

TABLE 1 (*continued*)

City	1975 Population Rank	1980 Per Capita Rank	1980 Expenditure Per Capita[b]	FY 1980	FY 1979	Percent Change
Kansas City	27	42	.06	28,080	27,614	1.7
Long Beach	43	43	.02	5,000	5,000	0
Los Angeles	3	31	.45	1,218,577	1,226,963	−.7
Louisville[c]	42	12	2.87	964,250	940,000	2.6
Memphis[c]	17	19	1.28	941,726	822,528	14.5
Miami[c]	38	25	.80	1,150,000	945,000	21.7
Milwaukee[c]	14	1	8.77	8,875,402	7,215,399	23
Minneapolis	34	36	.32	120,000	90,000	33.3
Nashville	29	38	.19	87,000	55,000	58.2
Newark*	41	—	—	—	—	—
New Orleans	21	7	3.57	2,000,000	2,100,000	−4.8
New York	1	8	3.54	26,500,000	24,203,000	9.5
Norfolk	49	9	3.49	1,000,000	900,000	11.1
Oakland[c]	45	3	8.20	2,710,127	2,462,133	10.1
Oklahoma City	37	44	0	0	0	0
Omaha	35	41	.07	25,000	25,000	0
Philadelphia	4	6	5.50	9,980,000	9,750,000	2.4
Phoenix	15	35	.34	222,594	203,515	9.4
Pittsburgh*	28	—	—	—	—	—
Portland	40	23	.92	328,741	226,277	45.3
St. Louis[c]	24	13	2.86	2,745,000	2,545,000	7.9

56

San Antonio	11	17	1.47	1,143,271	1,082,782	5.6
San Diego^c	10	24	.88	681,799	686,799	-.7
San Francisco	16	28	.59	390,777	354,943	10.1
San Jose	22	26	.75	418,000	378,000	10.6
Seattle	25	10	3.25	1,584,000	1,310,000	20.9
Toledo	36	40	.08	30,000	27,000	11.1
Tucson	48	33	.42	125,000	78,000	60.3
Tulsa	44	5	6.03	2,000,000	1,750,000	14.3
Washington, D.C.^d	12	—	—			
Totals			—	$84,590,784	$77,777,757	8.8

Source: Appropriations figures provided by the Municipal Arts Federation of San Antonio. Reprinted by permission.

Note: This is a list that includes only direct subsidy; therefore, convention centers that may be used for arts activities in many cities are not included.

a "Municipal appropriation" is defined as local tax-based financial contributions by city and/or county governments to support organizations and facilities in the arts within a municipality. Except where noted, all support is derived solely from city government sources. Capital funds for construction of facilities are not included. Also not included are funds to support zoos, libraries, parks and recreation programs, or arts programs by school districts.

b Per capita funding is based upon 1975 U.S. Census population estimates. Where both city and county funds are included, the county population is used as the basis for determination.

c Certain cities, by agreement, share support for the arts with county government. Where both city and county funds are used, the cities are [listed].

d Washington, D.C., receives its primary support through the District of Columbia Commission on the Arts and Humanities, which is included in state agency appropriations by the Endowment.

* Information not presently available. As of June 15, 1978, there were no functioning municipal arts agencies in Cleveland, Denver, Newark, or Pittsburgh.

[*Author's Note:* David Cwi, who heads the Cultural Policy Institute, Baltimore, Maryland, suggests in a 1982 survey that includes data from among America's cities that local public support of the arts is at least $300 million annually. Refer to "City Arts Support: Status and Issues," Cultural Policy Institute, Baltimore, Maryland.]

means for the growth of community arts agencies, served as an "incentive for the state agencies to move into a more active and direct involvement with their communities." It caused many states to "define their community development programs, and, in so doing, to develop more concrete approaches to assisting their communities," according to a study on the subject done in 1976 called *Community Development through the Endowment*.[40]

In April 1982, in *Completing the Circle: State/Local Cultural Partnerships*, Ralph Burgard points out: "With much national attention focused on the issue of decentralization, twelve [state] arts councils have quietly established, particularly in the past three years, decentralized grant-giving programs in partnership with their local arts agencies. The local matching requirements often attached to these grants are also generating millions of new dollars for the arts."[41] Those states are Alaska, California, Illinois, Maine, Maryland, Minnesota, New Jersey, New York, North Carolina, Ohio, Pennsylvania, and Texas. However, seven of these programs have only been established in the last few years.

"No reliable statistics are available at this time concerning the amount of new funds generated at the local level by state regranting programs, but . . . it has been estimated that between $6,000,000 to $8,000,000 of additional funds has been generated [in 1982] at the local level through state/local partnership programs." In his study, commissioned by NASAA in 1981–82, Burgard discusses the details of some of the partnership programs; the pros and cons, reservations, benefits, and major features of successful programs; and issues that surface. In the study, he also says that two state legislatures, those of Minnesota and New York, "either ordered their state arts agency to produce a partnership plan, or took a strong stand for more local partnership in decision making." The other plans were stimulated either by the Endowment's Community Development program, or initiated by the state arts agencies themselves.[42]

The states that applied earliest for those first Endowment funds were those that already had well-developed systems for community arts agencies. The funds were used in multiple ways, ranging from the specialized assistance of the staff person hired with this money in New York State to work in community development (with special emphasis on per capita funding and the decentralization of the grant-making process) and in Michigan to help the one-project Artrain committees turn into continuing multifunction organizations, to funds for the state associations of community arts agencies — unions of community arts agencies within a given state that sponsor statewide conferences and meetings, and improve communication. Of the 34 states that used these funds, 19 regranted some of the funds for salaries; in these cases, administrative positions have been funded on a declining scale while the local organization takes over total funding of the position.[43]

Alaska and North Carolina targeted their development programs at stimulating local government monies. Both required that matching funds be in cash drawn from local government units. This assumed that the community arts councils were well enough developed to sensitize their public officials to the arts. It also caused

> much increased public awareness of the arts and a special kind of credibility as news coverage shifted from the arts columns to other pages of the paper. Perhaps greatest of all, it showed that local governments were willing to contribute to the arts if properly approached, and could see the direct benefit to the community.[44]

In Maryland also, local governments responded to a matching grants program. (In fact, the Maryland State Arts Council was the first to begin a statewide decentralization program through 24 country arts councils.) The 1976 report recognized some of the potential problems:

- When dealing with relatively new arts councils, there is a danger of giving (and expecting) too much too soon. States and communities should first develop the expertise necessary to carry out the programs and should base the programs on thorough, well-developed plans.
- Government money is not necessarily a good thing. Many communities are leery of the multiple strings attached.
- These programs have opened up many new private and public funding sources. In doing so, they have challenged community arts agencies to professionalize themselves and to make themselves financially accountable to these new local sources of funding.

The report also warns that

> most importantly, community development is a slow process. The groundwork being laid this year may not show concrete achievements for many years. Or, as one person said, "Getting a community arts agency *really* ready takes a long, long time."[45]

There are several states that historically have encouraged community council development. Today, the importance of a state-community relationship has been discussed a great deal over the past several years; most states recognize that if they have not looked at the importance of such a relationship, it will be incumbent upon them to do so in the future.

The Minnesota State Arts Board distributes one-third of its budget to regional arts councils, which distribute the money they receive. This one-third is allocated on a per capita basis to those 11 councils who only function for this process.

The Arts Service Organizations Program of New York State and many

others are directed toward "local arts agencies that provide community arts programs and services to cultural groups, individual artists and the general public of the state. It also supports multiarts service organizations," while recognizing the diversity of both service organizations and community arts agencies.[46]

In discussing the community development aspect of the New York State Council's work, the staff person during the 1973 period indicated that there was a feeling that the impetus for development must come from the local community and that it was only effective when it did. The ownership was built in, and in the successful council situations, he felt that this was easily discernible. The state council played a nurturing role. It could be encouraging, could help with planning, could give technical assistance, and could also provide some funding. The stages of development were important, he felt. He remembered also that 1973–74 was a "good" time at the New York State Council; it was the time of the big increase from $18 million to $34 million, an unprecedented amount for a state budget.

Therefore the philosophy of nurturing was well in place when, in 1975, New York State passed its per capita law. The groundwork had been laid, and the state had already made some commitment to local growth. Those close to the situation admit that the local development picture is not necessarily smooth or settled. In 62 counties, there has been at least one council — sometimes many more than one — and the total is about 125. The sense of complication might be illustrated by the fact that the East End Arts and Humanities Council covers five of ten small townships in Suffolk County, and that the other five have local arts councils — or the fact that within New York City there are a half dozen ethnic councils; numerous neighborhood councils; huge councils for Queens, Staten Island, the Bronx, and Brooklyn; and some countercouncils.

Until 1982 in New York State, decentralization had been a pilot multidisciplinary program, unlike the situation in North Carolina, where the Grassroots Arts program provides a system through which state funds can be distributed among its counties on a per capita basis. (Grassroots Arts monies are the only portion of the money that is distributed per capita.)

In New York State, the development of community councils — and there are strong ones in big cities (Buffalo), ones that manage county facilities (Syracuse), and ones that are countywide organizations (Chautauqua and Westchester) — was encouraged by the State Council, but it was not the first priority of the Council. Given New York City and the rest of the state to contend with, the strength of major international organizations and all of the traditional support mechanisms surrounding them, New York's situation is unique among states. One is reminded of some of the problems that affect all New York State affairs — large cities versus rural communities (New York has vast rural communities far beyond the state's usual image);

upstate versus downstate; major organizations and community organizations; big cities, smaller cities, towns, counties. The configuration is mind-boggling. The Decentralization program has been in its pilot stage, and was available in 1981 only in limited areas of the state. Through the Decentralization program, local regranting agencies (arts councils, county governments, or regional advisory panels) administer on behalf of the State Council the local regranting of some state funds. Nonprofit organizations requesting $3,000 or less for cultural projects may apply either to the Council or to the appropriate regranting agency, but not to both. What is interesting is that while most of the local regranting agencies are local arts councils, other entities, such as library systems, are also doing the regranting.

Julianna Sciolla of the New York State Council reports in the Spring 1982 *NACAA Connections* that "Decentralization is now understood and accepted as a small but important part of the Council's funding program. . . . the Council promoted the program from pilot status to a formal department, and the chairman of the Senate's Special Committee on the Culture Industry of the New York State Legislature issued a supportive and encouraging report on the program."

Some states envision decentralization through the strong statewide organizations that have developed, such as the state alliances of community arts agencies. Equivalent service groups include those for orchestras, dance, theater, and crafts.

In New York State, the residents of each county receive arts funds on a per capita basis (55¢ in 1981), which come from a portion of the total state monies. The issues involved in per capita distribution are important ones, for every state has its populous and less populated areas. Bringing all of those issues around democratization of the arts, access for whom and where, and major institutions versus community arts to the fore, those in community arts believe that it has been very important for New York State to distribute some of the money outside New York City itself, for instance. In all cases, the per capita funding comes from a *portion* of the funds available, not the *total* amount.

An interesting reflection concerns the beginnings of the Arts Development Services, the Arts Council in Buffalo, New York, in relationship to the per capita funding requirement. The State Council, particularly interested in distributing the newly legislated monies in the western part of New York State, urged Buffalo to undertake a voucher program that would be a good mechanism for distribution. While the voucher program itself is discussed in Chapter 20, it was this initial and continuing state interest in the program that helped that local council gain its first momentum.

Important statewide trends for the future center around such new ideas as the Massachusetts Arts Lottery and California's State-Local Partnership program. Understanding the philosophy of development that char-

acterizes such states as North Carolina will also be important. Although the Massachusetts Arts Lottery has had a short life of a little over one year, it is worth noting some of the plan's features. Max Friedli, first Director of the Massachusetts Arts Lottery Council, states:

> The experiment of blanketing is an entire state with community arts councils is unique worldwide, and its significance goes far beyond the Arts Lottery scheme. . . . Regardless of how much money the Arts Lottery generates . . . the new arts councils have a viability and independence of their own. They have the option to solicit other public and private funds and, just like any other full-fledged community arts agency, they may not only regrant, but may also run their own arts programs and provide services locally.[47]

Even though a special Arts Lottery Council (a new overseeing state arts agency) was established and given the responsibility of administering the Arts Lottery program, many of the local councils were born overnight, which is anathema to every planning process known and promoted by those who hope for the deeper indigenous roots in such development.

Friedl continues to explain:

> The Arts Lottery Council is funded with 3 percent of the Lottery's proceeds, and its relationship with the local arts councils is also fashioned after the Federal-State Partnership program [of the National Endowment for the Arts]. Twice a year, after the local arts councils have received a projection from the State Treasury of approximately how much they can expect in Arts Lottery funds, they will forward a spending proposal to the state-level Arts Lottery Council. The Council, in turn, will compare each summary proposal with its guidelines, certifying payment if acceptable or returning the application for review if something is amiss. . . . Arts Lottery proceeds may be used, without any matching requirements, for seed money, grants to individual artists, capital outlay or operating expenses.[48]

In the article, Friedl detailed the six-year development of the lottery idea, which was modeled after the lottery for the arts in New South Wales, Australia, where the proceeds had paid for the construction of the Sydney Opera House.

The Arts Lottery of Massachusetts has been completely separate from the State Council on the Arts and Humanities, which has its own programs and services.

The California Arts Council and the California state legislature have established a State-Local Partnership program designed to encourage local cultural planning and decision making and to reach previously under-served constituencies. The objectives of the State-Local Partnership program are to achieve the following:

A. provide a mechanism for more effective local arts planning and to co-ordinate such planning with state programs;

B. develop rural and suburban areas which have not fully participated in arts programs;

C. expand the private sector support for arts at the local level;

D. give local government agencies the opportunity to assist the California Arts Council in improving the efficiency of arts programming;

E. provide a more stable base of support for the arts at the local level;

F. provide a potential decentralization mechanism for other California Arts Council programs;

G. prevent duplication and overlap between federal (administered through California Arts Council), state and local program funds;

H. provide for increased employment of artists;

I. stimulate the local economy.[49]

A block planning grant of $12,000 (nonmatched) has been made available to every county (57 of 58 have accepted the grant) to help them do the following:

- develop a plan for the county or city for arts programming.
- develop a review mechanism for local grants programs.
- Monies were envisioned for annual revisions. The monies were spent on consultants and professionals to direct the planning process. Materials to assist in this process were developed and made available.[50]

Following the planning there are to be local priorities grants, matched on a one-to-one basis, which are to be divided according to a formula. Need and effort are factors to be evaluated for grant making. Local plan approval has to be obtained through the following bodies:

1. The County Board of Supervisors.
2. All local matching agencies for the Local Priorities Grant.
3. The city council of any city which has at least 20% of the total county population. In this case, the plan will be developed jointly by the city and the county. If the development of a joint plan is not possible, then this city may withdraw from the county planning process and submit its own separate plan to the [California Arts Council]. If this is done, the city will receive its own Block Planning Grant and Local Priorities Grant, with the funds for these grants subtracted from the county's grants in proportion to the percentage of the county population inhabiting the city. However, all cities are strongly urged to work within the county planning process if at all possible.
4. The city councils of 50% of the total number of cities in the county. In addition, this total number of cities must have a combined population representing at least 50% of the total county population inhabiting incorporated areas of the county. If a city with 20% of the total county

population has withdrawn from the county planning process, it will not be included in this approval procedure.

5. After review by [California Arts Council] staff, the plan will be approved by a majority vote of the California Arts Council at an open public meeting.[51]

This process has included everyone in the development — clearly a different concept from the Massachusetts Arts Lottery development. The guess is that a variety of agency types will develop in the California picture to handle the implementation of the plans. Existing ones will be used as well.

These statewide arts community development plans are new, and will flesh out in the early 1980s. It will be interesting to see their influence, if any, and the results of their efforts.

In North Carolina, the community development policy has nurtured a special groundwork that makes communities ready to take advantage of all the assistance that is available, such as the targeted programs that a federal agency such as the National Endowment for the Arts has offered over the years (e.g., City Spirit, Challenge Grants, and a CART program). As a state, North Carolina has built strength because the goals for community development have had priority. It would be fair to say that North Carolina has been relatively unimpeded by the struggle between major institutions and community needs that has unquestionably played a part in every other state and community with such institutions. In the next section of this chapter there is further discussion of North Carolina, where the institutions are the community — the community of the state.

Will the search for new sources of funds — as demonstrated by the Massachusetts Arts Lottery — create so many new and temporal bureaucracies as to create in its wake only the chaos of new arts organizations formed just because there are new sources of money and new distribution systems outside the federal-state-local partnership? Will the "populists" who created such agencies be disenchanted and disenfranchised along the way? Is it clear that such systems do not become immediately orderly and flawless? Is there a shortcut to finding good and knowledgeable people to give the time to help make decisions that will affect their communities about the arts?

Finally, can planning systems created today, such as the one in California, absorb all of the best information about planning and put some local systems in place that absorb what North Carolina's community development has been all about — local incentive and local challenge, both in community planning and financial commitment? And will the major institution understand its part in the community as that develops?

Some believe that the future for the states lies in the resolution of their

relationship to the community councils. The story is old — the federal government is very willing to relinquish its power to the cities, creating a tension with the states, which are not as happy to relinquish power. The secret is in the state's not being paternalistic.

As someone said in North Carolina, "It all depends on people. The people make the difference." If that be so, let us hope that the right people are in the right place at the right time.

To place the state philosophies on community development in some perspective, there should be some discussion of the government support picture in general. In mid-1982 it is, at all levels, in a state of flux. However, according to NASAA statistics, the fiscal year 1982 appropriations for states and territories totaled $123.6 million, an increase of 12.2 percent over fiscal year 1981, continuing a steady increase in support for the arts by state governments, since they were all in full gear by the late 1960s. It is important to note that the effects of the changes made and being considered during 1982 by the Reagan administration have not yet shown themselves, but can be expected to do so by 1983, when competition for state monies will be at a higher level. Federal cuts mean a great deal to states such as New Hampshire, Washington, and Oregon, which are sustained by one industry (such as the lumber industry in Oregon) and less to states such as New York, California, Massachusetts, and others sustained by multiple economic factors.[52] The states' increase has been offset by a drop in the National Endowment for the Arts appropriations — and it would require a 34.1 percent increase in fiscal year 1983 appropriations at the state level to offset federal cuts envisioned. This would simply maintain, not increase, the level of support for the arts at the two top levels of government.[53]

TABLE 2
Percent Increase (or Decrease) in Government Arts Support

Fiscal Year	Federal Government	National Endowment for the Arts	State Arts Agencies	Total
1980	17.4%	3.4%	29.6%	12.5%
1981	14.0%	2.7%	7.2%	4.5%
1982	10.4%	(9.9%)	12.2%	(0.9%)
1983	4.5%	(29.5%)[a]	10.0%[b]	(11.2%)[b]

Source: "State Appropriations: Will They Be Enough?" by Robert Porter, ACA Update, Volume 3, Number 2, 1982. Reprinted by permission of the American Council for the Arts. Copyright 1982.

[a]Proposed federal budget.
[b]Estimated for comparative purposes.

ONE STATE: A FRAMEWORK
FOR COMMUNITIES—NORTH CAROLINA

Every situation is unique. Every community has its own idiosyncrasies and characteristics that make it not quite like the next one. The same is true of states and their communities. Thus any models are really only to be understood in a context; they are not really transferrable in anything but outlines of philosophies and programs. If one were to choose one state with a strong community view that has included the arts in its philosophical priorities, one would choose North Carolina. It is a microcosm of the styles of the movement — its strengths and weaknesses. The community arts movement there preceded the state and federal movement; there were more than a dozen community councils in existence when the North Carolina Arts Council emerged in the 1960s. The communities could even have been said to have influenced the policy setting on the state level. That did not happen elsewhere, and for that reason alone North Carolina would be noteworthy. The creation of the North Carolina State Symphony Orchestra, Museum of Art, and School of the Arts are also indications of the priority for the developmental arts in that state.

THE SETTING

The annual retreat of the Community Arts Council of North Carolina — "Quail Roost," near Rougemount, North Carolina, a meeting and conference facility surrounded by 90 acres of gently rolling field and forest land. * *Informal, casual, task-oriented, the group works through a mire of issues mutually affecting them by day; they share their talents in the evening. Guitar in hand, the Community Development Director, a professional musician, sums it up:*

ADMINISTRATOR'S BLUES

Here I sit behind a desk in a black and white room
Between two filing cabinets that seem to echo my doom
I'm an in-basket case in an institution of gloom

They bring me in the mail — each day a stack that's nine inches high
Letters, flyers, brochures, newspapers, and memorandi
If my name were Evelyn Wood I might give it a try

*I attended the annual retreat of North Carolina Community Arts Councils in December 1980 to absorb the philosophy and address the North Carolina issues. The following section evolved from the material gathered through discussion and/or observation and reading.

The phone rings in the morning, the phone rings in the afternoon
It even rings on weekends, in the middle of my favorite cartoons
Well, it's nice to be needed but sometimes I wish I just pushed a broom

Applications, surveys, report forms and questionnaires
Budgets and financial statements — it's hard to bear
All these goddamn facts and figures can go to hell for all I care

(Break)
I used to talk in language people could understand
Subject, verb, object — my, it was grand
But it has come to my attention that my facility for verbal expression has been
 negatively
Impacted by the jargon and verbosity of the bullshit-spewing bureaucracy
A part of which I am

The blues ain't such a bad thing, they let you see the other side
They punch you in the gut when you've become too satisfied
But if I don't get my grant I believe I'm gonna die

(Optional)
When I was just a young boy they asked me what I wanted to be
I said, "I think I'll be an artist and contemplate the beauty I see"
Well, it's a long, long way between your daydream and reality

But as tough as I have it, at least I'm doing something I choose
And I guess I'm doing good for others while I'm paying my dues
But until that day when I'm set free
And become everything God intended for me
I guess I'll be a victim of the administrator's blues
Administrator's blues
We've all got something to lose

<div align="right">John Le Sueur, Jr.*</div>

Before the North Carolina Arts Council was started in 1964, there were already the North Carolina State Symphony Orchestra (begun in the 1930s), the North Carolina Museum of Art (organized in 1956), and the North Carolina School of the Arts, all established as state institutions — unique statements about North Carolina's commitment to the arts. There are not many state legislatures that have set aside public funds to found arts institutions for its people. The first two institutions existed long before the Arts Council was created. Today, the North Carolina Arts Council is organized as the Division of the Arts Council in the Department of Cultural Resources,

*Community Development Director, North Carolina Arts Council. Copyright 1978. Used by permission.

with Theater Arts as one of its sections. The State Symphony and Museum of Art report directly to the Secretary of the Department of Cultural Resources. The other two divisions are those of the State Library and of Archives and History. (The School of the Arts is under the department relating to higher education.)

"To be tenth in state population (5.5 million), and not have a city larger than 408,000 (Charlotte) nor to be able to 'name a town,' means that the population is really distributed in workable chunks. People are accustomed to organizing in order to accomplish, and they are in the driver's seat. They know the legislators well, and keep them on their toes," explained the present Arts Council Director, Mary Regan. The early Arts Council chairmen appointed by the governor had a community orientation. Phil Hanes, the first, had already been a leader in Winston-Salem; Sam Ragan, another early chairman, was from a small town. The guiding philosophy, when the incentive monies for states came from the Endowment during the late 1960s, was to fund for development, not for flashy programs as some states did. That was an early, conscious decision — to help small groups develop in little and solid ways.

From other states, one hears the comment, "You know North Carolina's uniqueness." All the important factors seemed to come together for North Carolina — people, philosophy, policy, timing, and long-range wisdom for what seemed right, given the known characteristics. There was, as one leader explained it, a feeling that the arts are included in part of the old idea of the cultured person. The idea that money and education hone a commitment to community, which includes a commitment to culture, is deeply rooted in the North Carolina leadership. It did not really matter whether it was Museum of Art leadership, or State Symphony leadership, or Arts Council leadership. While it is true that in most cities, this community commitment has not given the arts council priority equal to that of other cultural commitments, it probably has in more places in North Carolina than elsewhere. And it has been going on longer.

Although a rich variety of artistic effort in North Carolina was reported in the Arts Council survey of 1967, and the state government spent at that time nearly $2 million in support of the arts, it was noted that

> The greatest threat to the growth of the arts in North Carolina is complacency. This state has received much national publicity concerning its artistic growth. Many people around the country, and especially throughout the South, look to North Carolina as an example of what a state ought to be doing to support the arts. This kind of publicity and the admiration it often engenders is a source of much gratification. But, before we decide that we have become the Athens of the New World, or at least of the South, we should listen to our own artists and art educators. There is not a single art form in this state in

which professional practitioners of that art do not see great weaknesses. While it is clear that, in terms of production and support, some art forms are stronger than others, they *all* have great need for improvement — often in the quality of the work produced, but even more often in terms of financial support. Specifically: only a handful of professional artists in any art form in this state make a living from their art; the quality of amateur activities, both in the arts and in the support of the arts, is very uneven; education in the arts from the public schools through adult education leaves very much to be desired; business and foundation support of the arts has only barely been tapped.[54]

The Arts Council proposed programs to remedy these declared problems, including professional touring in the performing arts, which would assist in bringing top-flight professional performers to areas of the state that were rarely, if ever, exposed to such quality. There was emphasis on improving artistic and teaching skills for public school teachers of the arts. Programs would begin the state process of improving opportunities for professional artists, developing audiences, expanding the role of the arts in all levels of education, and closing the gap between artists and the business community.[55] Improving the level of amateurism was also included as a goal.

On the community level, arts council leadership started in Winston-Salem in the late 1940s:

> After five or six years of concern and several half-hearted attempts, the arts community of Winston-Salem founded the Arts Council in August 1949. There were eight participating member organizations at that time: the Piedmont Festival of the Arts, the Arts Committee of the Junior League (which had in 1946 approved a $7,200 commitment to get the Arts Council started), [the] Civic Oratorio Society, [the] Maids of Melody, [the] Winston-Salem Operetta Association, [the] Winston-Salem Little Theatre, [the] Children's Theatre Board, and [the] Winston-Salem Symphony. Three other groups had to wait for their boards to approve their joining the new organization: They were [the] Civic Music Association, [the] Mozart Club, and the Arts and Crafts Association.
>
> The mission of the Arts Council, from that auspicious day in 1949 until 1970, was to serve those members and new ones which subsequently joined. Membership now stands slightly over 40.[56]

In 1970, the Arts Council's long-range planning committee found that it was not meeting the needs of the total community. A change in focus, from the membership to the community at large, was felt to be in order. This philosophical concept and policy is critical to the future of arts councils everywhere. In Winston-Salem, it was evolutionary and the result of study. Many councils have found themselves inhibited by a membership-only focus, if their raison d'etre is to serve the total community. It has been

one of the hardest concepts for some cities to accept. But its meaning is enormous. Becoming community-based has probably allowed better fund-raising to take hold, and has caused a much wider community involvement. In Winston-Salem (population about 200,000), where over $450,000* was being raised in the annual United Arts Fund drive, there were over 7,000 donors in 1979 out of a city population of about 61,000 family units. Not only were ten of the city's arts organizations funded from this source, but it supported the Council's base administrative budget ($100,000); an Urban Arts programming arm of the Council, which works with new and neighborhood groups ($25,000); and a Projects Pool from which one-time awards are made ($70,000). These later programs, developed since the change in focus, have been concrete evidence of the Council's reaching out. The programming arm of the Council produces such things as an international festival highlighting the diverse ethnic heritages in the community (the Mayfest), Out-of-the-Bag concerts (weekly rock-pop-bluegrass concerts in a downtown mall), and art instruction for youths who cannot afford classes.

In 1977, stimulated by the tensions between professional arts organizations and community/participatory arts advocates, the Winston-Salem Arts Council studied its future with the assistance of an outside consultant familiar with the community and of 120 community representatives. A countywide Cultural Action Plan was developed: Basically, it recommended ways to help the Arts Council develop new funds and reach new audiences by expanding services and programs. It also recommended a major expansion of the physical facilities available for cultural activities, which would complement, if not spearhead, revitalization of the downtown area.

In order to accomplish the goals of renovation and expansion of facilities used for arts activities, the Arts Council tapped several sources of federal funds and their own unique social business community.

> It has gone through two phases in its development, one as a service organization to its arts institution members, and a second as an aggressive programmer for the general public. It is entering a strong new phase as it tries to renew its role as a major support agency for the other cultural organizations of the city and continues to stimulate arts services for a broad and diverse public. These are its new dimensions.[57]

The Winston-Salem Arts Council has earned the right of its reputation. Here is a good example of the community leadership taking the ball and, from the beginning, giving the council the clout and sanction needed to forge ahead. From one of the Council's past presidents comes this statement:

*United Arts Fund figures after this increase steadily, but reporting includes capital development funds in subsequent years.

Creative activity involving the arts and sciences is essential for survival; not a frill, not a luxury, not to be indulged if the budget allows, but a bedrock condition, of psychological salvation for young, old, white-collar, blue-collar, rich, poor, black, white, illiterate, or educated. This is our challenge.[58]

One of the remaining weaknesses cited by Milton Rhodes, who has helped to direct this Council for about a decade, is that the Council is still reaching only 10 percent of the population.

While the four main functions of the Winston-Salem Arts Council may be fundraising, direct services, liaison, and facility maintenance, it has long been a supporter of downtown redevelopment and a catalyst for such, and, in fact, has taken a leadership role. It also seems no small item that R. Philip Hanes, Jr., long a local, state, and national arts council leader, is a leader in the downtown effort. The expectation was that Winston Square could become a national model of downtown renovation and revitalization through the arts. It certainly is an example of federal aid to the arts' generating private investment in downtown redevelopment. The impressive thing is that the support is coming not just from high-income corporate executives; it comes as well from impoverished minorities — not only R.J. Reynolds Tobacco Company, but from the NAACP and neighborhood groups.

The success of Winston-Salem has probably set a standard for the arts councils in North Carolina that, consciously or unconsciously, has had its impact on the success of the councils of the other larger communities, and more subtly on the smaller ones as well. In one sense, all of North Carolina is one big community; the fact that leadership in one place has said that it is possible and permissible to include the arts councils among civic leadership roles does make a difference. It makes it a bit easier to gain the commitment of the corporate individuals who can envision themselves in the role. Because of the range of its services and programs, the Winston-Salem Arts Council has also provided a training ground for staff and a model for services and programs. Most councils have over the years evolved from service organizations for their arts institution members to aggressive organizations with concern for the general public and the city as a whole. The broadening of the first role as a support agency has stimulated the need for more services.

And although no two cities are exactly alike, there are leaders in every town, community, and city larger and smaller than Winston-Salem, and the arts councils should have as great a chance to capture their commitment of time and energy today as any organization. That is the key to the successful private community council. The quality of involvement of key leaders will make the difference between promise and fulfillment.

Winston-Salem's leadership may have a mythical quality about it by this time, but the story of the city's selection as the site for the School of the

Arts in 1965 stands as a fairly good indicator of the nature of its leadership. The school was sought by the state's cities, each of which promised funding to back up their dreams. Winston-Salem raised $1 million from 5,000 donors in 48 hours just before the arrival of the site selection team — a hard act to follow. The school is there, needless to say. So when people talk of the Athens of the South, the flowering of the arts, the fulcrum for arts activity that is Winston-Salem, it is with admiration, respect — and a wee bit of jealousy.

North Carolina has eight of the nation's 50 or so united arts funds, most of which are run by some type of arts council. As defined recently by Michael Newton in the 1980 *United Arts Fund-Raising Manual,*

> a united arts fund is a combined appeal conducted on an annual basis, raising operating funds for a minimum of three different organizations, and implying some degree of restriction on each organization's own fund raising. . . . Some, such as Lincoln Center in New York and the Performing Arts Council of the Music Center in Los Angeles [of which Newton is presently President] are connected with arts centers and provide for the immediate constituency of those centers. In general, though some variations exist, there are two types of drives: those that are corporate only, and those that are community-wide. Corporate appeals, of which there are fourteen, solicit only the community's corporate or business sector. In this instance, the funded organizations are free to approach everyone else, including individual donors and foundations, on their own. The balance of the drives is community-wide, meaning that fund raising from the private sector is carried out on a unified basis similar to the United Way in the field of health and welfare.[59]

North Carolina's eight drives are patterned after the second model.

In Charlotte, North Carolina, an area of 408,000 people, 57 percent of the proceeds ($660,600) from the 1980 United Arts Fund drive came from corporate solicitation. Some impressive numbers were the more than 1,000 firms that became involved and the 1,200 volunteers, including 300 from one corporation alone — the First Union National Bank. The effectiveness of this drive has increased over the years, but it has been much more vigorous since 1975, when a Cultural Action Plan was developed that achieved the necessary business commitment to the importance of the United Arts Fund drive. Total pledges have since increased. In 1980, the Charlotte Arts and Sciences Council ran the United Arts Fund drive for its 55 affiliate organizations, seven with budgets over $150,000, topped by the Charlotte Symphony Orchestra's $1 million (the largest budget). Their emphasis, in addition to basic fundraising, has been to help arts organizations become more professional and aware of opportunities. What does that mean? It means playing an advocate role (the arts are good business) and making a good living climate (the arts are smaller organizations, and individual artists, too).

The Culture Action Plan changed people's thinking, says the leader-ship. By the same token, when members of the business community get in-volved, they are demanding and deserving of a certain level of manage-ment and performance among those they fund. There has been an overall improvement in quality, quite discernible and yet subtle — better graphics, better marketing, better performance. This also comes from competition. The continuing improvement of the smaller groups plays a role.

The Charlotte Arts and Sciences Council, as with the best all over the country, has become used as a county and city clearinghouse even though it is a publicly designated private agency.

There is one big frustration, almost all agree: As a council becomes more successful, there is greater difficulty in getting the operating dollars it needs to continue to be as successful as it is. The problems lie in the things the council should be doing for itself — developing the advocacy for the council's own work and enough staff members to do a good image-making and professional job. Since the Endowment City Spirit grant that prompted the Cultural Action Plan in 1975, Charlotte has been able to make good use of the federal Endowment programs such as CityArts, which was the cata-lyst for more local neighborhood arts dollars, and a Challenge Grant of $500,000 in behalf of five affiliate organizations.

Every North Carolina community contacted mentioned the desire and need for more minority leadership in their communities. Charlotte felt that there had been momentum gained in this area. An article in *Grassroots and Pavement*, a national journal of arts in America's neighborhoods, re-flects this.

> The North Carolina Cultural Arts Coalition, organized in 1977, was creat-ed to counteract the imparity in the distribution of state and federal dollars earmarked for arts programming; to develop black entrepreneurship and patronage in the arts; to provide visibility and technical assistance to black art-ists and arts organizations; and to assist black artists and arts administrators in finding employment in their chosen careers. To date, [the Coalition] has been responsible for 45 black artists and arts administrators getting full-time posi-tions in the arts. A highlight of the recent annual meeting was an excellent col-laborative workshop with the North Carolina State Arts Council on federal and state grantsmanship.[60]

In Durham, in 1980, when the local Arts Council was 25 years old, even though programming attendance for Arts Council events had been 50 percent minority, there were only three minority representatives on the board of 34. The staff of eight had three minority persons. But the problem goes beyond the Council. Even though the largest wholly-black-owned in-surance company in the nation is located in Durham, blacks have not been in the mainstream of city leadership.

Ten years ago, a local businessman characterized Durham as a "hot

dog" town; recently Anna Kisselgoff, dance critic of the New York *Times*, noted that it is a town where "arts are basic." Someone else described Durham as the place "where it was about to happen" because of the influx of new people into the area who valued what the community has to offer.

Some exciting events have been based in Durham over the past years. The American Dance Festival moved from Connecticut College to Durham for its summer gathering; it involves 500 students, dance critics, and the Endowment's Dance Touring groups. The Festival has planned a year-round format, which will serve to expand the concept of Durham as a focal point for dance. The plans are bound to have a profound impact statewide. Dance has been a difficult art form for the smaller communities of the state; perhaps now some concentrated efforts of a new kind will help bring people to a new awareness of dance. The Durham Arts Council is carrying out the community component of the current residency aspect of the Festival.

The Duke University Artists Series, started over 50 years ago, is the oldest in the country, and almost every major performing artist has appeared there. But it is felt that there is a need for even more exemplars in every art form and that the stimulus should come from the area which "houses more PhDs per square inch than anywhere else in the country." There has been, in the estimation of some, a need for more professional artists in the area. Some seem to be moving in.

However, the Durham Arts Council is best known for its work in the neighborhoods. Its social service programs have met with great success over the last five years — in the city Parks and Recreation Department's 17 neighborhood centers, in hospitals, and in prisons. So well received were the programs for the health care facilities that the Duke University Medical Center now has an office of cultural services! The media, in particular, tending to cover the human interest stories connected with the neighborhood program, have helped the Arts Council become known as the "antipoverty agency in the arts." This is important when the city, facing a deficit, was considering cutting support to all noncity agencies. Because of their strong neighborhood work, which represented services not provided by other government agencies, the Arts Council support did not get cut.

The Council's location is in downtown Durham, in an historic building that began in 1907 as a school and later (1924) became City Hall. By occupying the building, which is also being used for low-cost studio space, the Council is participating in turning the downtown around. It also has been a proven fundraiser, exceeding its goal in 1980 and expanding the number of corporate and individual contributors by over 50 percent.[61]

Because the concept of the Council's work has become more inclusive, the board has been strengthened — a board now working for urban development and the arts as well. But in this city of about 100,000 (155,000 in the county), attracting the best leadership can be a problem, given the mo-

bility of the university population. The town is composed primarily of these persons, of the corporate group that works in Triangle Park, and of a major work force of blue-collar tobacco workers.

Fundraising has also been the hallmark of the Greensboro United Arts Council. In recent years, in addition to the United Arts Fund drive, the Council has led the fund raising to restore the turn-of-the-century Carolina Theater for the Performing Arts, and to renovate a building for an arts center with 20 classrooms/studios, four exhibit areas, and six dance studios. The Council has also been involved in an arts plan for the city.

Problems center around the mobile population characteristic of a community with seven universities. "We make an effort to bridge the old town-gown problem, but there is a long way to go," says the Arts Council Director. Given the disparate population, the Council's major future roles will be to increase awareness levels and to bring that population to a sense of community through the arts.

Two of the six categories of programs suggested in the statewide study of 1967 revolved around teachers — strengthening skills, providing trips for teachers to the Washington and New York museums, and professional performances in the public schools. Today almost every North Carolina community council has targeted the arts-in-education area a priority. Adult audience development in the smaller communities was found to be so difficult that all they could do was "keep one step ahead of what they are used to seeing." They felt that the hope lay with the children.

"Kids are the way to the parents, anyway." The Durham Council has, since 1972, nurtured and coordinated a nationally unique partnership with the city and county schools. Until 1979, the Arts Council had assumed the cost of the coordinator. After that, the coordinator, housed at the Arts Council, has worked for the school system and the cost is split, with the county paying half and the city and Council each paying one-fourth. One of the purposes of the Council is to seek to use artists and cultural institutions to make Durham a more livable community. It assists school officials in improving the quality of education through effective use of artists and art programs, which develop the perceptive skills of children by involving them and their teachers in creative activities.

The Winston-Salem/Forsyth County school system has had one of the strongest programs in arts in education, with special assistance from the JDR 3rd Fund, but the role is clarified thus: "We can go in once a week, but we cannot educate; the schools do that."

In 1967, the North Carolina Arts Council survey said in every nice way possible that the education systems were lacking in the arts experiences for the children. There was a long road ahead, and many needs for improvement were indicated. The same is still true today. The community arts councils, however, have tried in some of the best ways to improve, help, and

cooperate. But they can only build the best cooperative programs with artists, provide opportunities for teachers, and attend board meetings to monitor the arts budget. School administrators and school boards must develop curriculum, policy, and priority changes; the schools must do the educating.

In a typical set of instructions from the Toe River Arts Council for its Winter Arts program (which has received funds from two county boards of education and a joint grant from the North Carolina Arts Council and the Endowment), the schools are told such things as times and ways in which the artist will meet and plan with faculty, expectations in terms of scheduling, and the ways in which the artist will be available to students and faculty. Exhibits of the artist's work and presentations to such groups as PTAs are part of the program. Both the school and the artist evaluate activities so that there can be continuing cooperative efforts between the Arts Council and boards of education. The Arts Council also has provided performing arts consultants, and some live music, dance, and theater performances.[62]

The Toe River Arts Council's program has been the only arts programming in one of its counties; in the other, they have had three music specialists and one art specialist in the schools. About 5,800 students in two school systems benefit from these programs. The Toe River Council has sponsored classes in many art forms for children of all ages and organized residencies in the community. "Efforts in arts education were designed to reach every school child in Mitchell County and Yancey County through the formation of a bicounty arts education committee which planned the comprehensive arts program."[63]

In developing special events, programming was aimed at natives of the area, with several bluegrass performances and a visit by the Appalachian Bookmobile. The philosophy here, as in many of the other arts councils, was that what was presented should be of high quality, but that developing audiences for unfamiliar art forms is a slow process, and that there should be an emphasis on what appeals to the people who live in the area. What may appeal to directors and entrepreneurs may not appeal to the people, but the arts council is the vehicle for stretching the opportunities and expanding the horizons, and the leadership continually searches for the acceptable starting places. Whether the community council is the one in the Toe River area 50 miles from Asheville, covering a two-county, 28,000-person area in 1,200 square miles of territory, or the Macon County Arts Council in economically deprived mountain country with a permanent population of 19,000 that swells to approximately 30,000 in the summer, the needs are immense.

One of the older North Carolina councils — the Community Council for the Arts — serves Kinston, a town of 21,000, and Lenoir County, which has a population of 55,000. With an annual budget of about $100,000, the Council has spent better than 50 percent of it for programs for young peo-

ple. In an attempt to reach children of all ages and economic backgrounds, the efforts are divided into professional performances, Community Youth programs, and the Artist-in-Schools programs. The Kinston Art Center, home of the Community Council, houses the Children's Art and Nature Awareness Museum. Established in 1979 as a community celebration for the International Year of the Child, the Children's Museum opened to audiences who have enjoyed wall hangings, paintings, sculpture, and a hologram from a New York museum.

A description of the Council's activities characterizes the focus and philosophy of the work of this community council.

> Arts councils care about kids. For over 15 years, the Community Council for the Arts — formerly known as the Kinston Arts Council — has established programming for children as one of its primary goals. . . . We believe today's children are tomorrow's artists, musicians, dancers, scientists — citizens.[64]

The Community Council budget (Table 3) shows funding projected from several public levels and several private sources of funding.

The concept of developing a central cultural arts facility as an integral part of larger efforts to shape a new role and identity for downtown has not been the province only of the arts councils in the larger communities of the state. Besides Charlotte (Spirit Square), Winston-Salem (Winston Square), Greensboro (the Greensboro Arts Center and the Carolina Theater), and Durham (the old City Hall), Fayetteville (population 63,000) and Cumberland County (250,000) have been developing a thorough and long-range planning process through most of the 1970s. The Arts Council there was central in assisting a professional feasibility study for an arts center, which looked into such aspects as event demand, financing sources, location, and management. In addition, it is the agent for a further study exploring service requirements for a central arts facility, evaluating possible sites, and planning the potential financing of the facility. They expect to continue to include broad citizen participation in the final "idea" stage, building on the planning completed thus far. At all stages, professional design consultants have been involved. "Although the Arts Council is the agent for the grant, this building is not just an Arts Council building. It's going to serve all of Cumberland County.[65]

Most of the community councils described thus far, and by far the majority in North Carolina, are private agencies. In Morgantown, on the other hand, a unique connection has developed between the public and private sectors, as the Director of the Arts Council has filled two roles — one with the private Council and the other as the Director of Recreation, Parks, and Cultural Arts for Burke County. This dual arrangement really ties the two organizations closely together.

TABLE 3
1980 Budget, Community Council for the Arts, Kinston, North Carolina

Source of Funds	Amount
Grants:	
City	$24,300.00
County	20,000.00
N.C. Arts Council	—*
Local government match—city	5,000.00
Local government match—county	5,000.00
Grassroots Arts bill	6,249.00
Summer intern	1,400.00
General Grant Outreach	—*
Jazz touring	525.00
Jazz touring—local match[a]	1,225.00
Gifts and contributions:	
Membership	9,000.00
Donations and memorials	250.00
William S. Page Foundation	100.00
Dividends and interest:	
Lucy S. Hood Endowment	125.00
Jenkins-Tapp Foundation	600.00
Jefferson-Pilot	24.00
Classes:	2,500.00
Projects:	
Holiday Happening	7,200.00
Fine Film Series	2,228.00
Spring Arts Festival	3,000.00
Bright Leaf Festival	500.00
Professional children's performances	1,000.00
Other projects	1,300.00
Art center operations:	
Rent	600.00
Miscellaneous	1,000.00
From savings accounts[a]	1,557.32
Total	$94,683.32

Source: Community Council for the Arts, Kinston, North Carolina, "Budget" for period ending September 30, 1980.

[a]To be taken from funds placed in savings at end of fiscal year 1979–80 for Jazz Program and Projects.

*Not available.

These councils are, as well, the agencies in their particular counties that have been nominated by their county commissioners and approved by the North Carolina Arts Council as the local distributing agent for Grassroots Arts funds. The local distributing agent is the state Council's partner in providing state funds for arts development to local arts organizations. The North Carolina Arts Council has played no little part in developing the philosophy of a basic arts delivery network and community partnership program.

The four persons who have headed the North Carolina Arts Council since its inception agree on several things:

Important ideas and policies in North Carolina have been that the arts should become truly a part of people's lives, and that the better artists should be able to earn a living. (This differs vastly from the attitude in a state whose top priority would be to sustain the major arts organizations.) In order to accomplish this, the emphasis has been on community development. The philosophical base is to start where the people are and to make progress without being condescending. But in order to accomplish the goals, there have really needed to be people working in every community to promote, coordinate, and fund the arts. The state cannot impose anything — it can simply give good assistance.

Edgar Marston was the Executive Director of the North Carolina Arts Council during those formative years of 1968–74. (The first Director, Robert Brickel, was there for two years, and supervised the basic state survey.) It was then that the philosophy growing out of the study findings had to take hold.

Marston has said, "If we were going to get people truly involved, it had to be in every facet of their lives and we had to get every community organization involved in the arts, too." Systematically, there were meetings of the superintendents of schools (140 of a possible 150 attended), recreation departments, church leaders (who saw that 10,000 copies of the Art Council booklet were distributed), home extension programs, community colleges, and technical institutes. From these meetings evolved the Visiting Artists program, funded in part by those institutions (about $1 million per year). Marston explains that the state had to realize that new constituencies would organize and that it had to happen in an atmosphere of partnership. If it were not carefully done, it would be seen as patronage.

The councils that had been in existence for some time (some for 15 or 20 years, such as the ones in Winston-Salem and Durham) were generous with their expertise and served as consultants all over the state. It was a two-way street, and the state, too, learned a lot. Many of the state administrators were involved in the arts themselves, so that there was understanding at high levels. There was, in fact, a time when the State Budget Director was a former musician, the State Treasurer was particularly interested

in museums, the Revenue Director was an opera buff, and the Chairman of the State Board of Education was an artist. And one cannot forget that $3–4 million of state money was already being spent for the arts in support of the State Symphony, the Museum of Art, theater programs, and the School of the Arts. The Johnny Appleseed movement of the community arts councils was started in North Carolina in a richly supportive context.

North Carolina's community leaders, mentioned earlier, whose well-founded philosophy made its mark in the development of the policy of partnership between the state and communities and between state arts council board and staff, made the difference. It was they who rejected the "flashy" concepts some other states were developing, and said, "Let's develop it in communities — let's lay a groundwork."

This, then, is also the background for such state-initiated programs as the Grassroots Arts program, which is a partnership program between the councils and the communities. It also explains the fact that when Endowment monies were given to states in 1973 for communities, five already had a policy in place that was sympathetic and able to use the money for community development. It explains how a local arts council might be able to stimulate a local government challenge grant and help the whole community benefit. It explains how a local council and community college and/or school system might be able to plan together. It explains a lot.

It explains about the steppingstones to greater depth and responsiveness to community needs over the years. The communities were readied by their own statewide consultants for such opportunities as the National Endowment for the Arts City Spirit program and later the Challenge Grant program. These concepts of planning and coordination were not new; they could give new dimension and vigor to future directions and could galvanize new leadership in that process.

How important is it that the state enacted a law that some monies had to be allocated according to population (currently about ten cents per capita)? It has stimulated the growth and stability of arts councils. While there has been an effort to create a local support group in every county, 45 of the 100 counties still do not have them. There has been a special effort toward meeting the needs for strong management in community councils, exemplified by a state salary assistance program that gives diminishing amounts toward the director salaries on a two-thirds, one-half, one-third formula for three years. This has assisted the establishment of some professionally run councils. As in everything that is just beginning, some communities used this plan too soon and mistakes were made. Timing of its use is of major importance.

There is in North Carolina an Association of Community Arts Agencies, which represents these local community councils to the legislature and private interests. It gives the councils a forum through which they can

make their needs and reactions known. Through its efforts, the Grassroots Arts Fund (the per capita fund) has been greatly increased over the years. The 1980 Association meeting in North Carolina was about survival in the 1980s. It wasn't labeled "Survival," but when the groups divided into smaller discussion sessions, the urban problems session and the ones on management and funding were well populated. The session on programming was eliminated; there were no takers. There were models of every kind of programming all around: The Durham neighborhood program, the business lunch program in the Greensboro Arts Center introducing business employees to the center (their chief executive officers sent the invitations and picked up the bills), the Talent Bank of Charlotte, and the many successful local festivals are just some examples. Ten years ago at such a meeting there would have been show-and-tell sessions about how to accomplish these programs. But now the concern was the future — how to keep the good things going, stem the worst problems, and plan for stability.

While North Carolina is one of the few states where the communities as a whole have successfully developed local government dollars, generating collectively about $2 million per year (it should be remembered that there are about 50 cities with populations of 25,000 to 50,000 people), the Assembly felt it necessary to look toward new sources. (Of note: Although the number of local governments involved has been growing steadily, greatly encouraged by the state challenge grants, only slightly over half of the communities were holding or increasing their local support. This shows the temporal nature of public monies and the never-ending efforts needed to be sure they continue.)

North Carolina has been looking at a hotel/motel tax, which connects tourism to the arts and which has been a successful source of revenue in other parts of the country; instituting such a measure would take a statewide effort. "We pay it when we go out of the state; why not have people pay when they come in?" was one response. More remote sources, such as oil rig monies to be spent on the arts and open-space development, could be applicable to the needs of some of the cities planning new arts facilities and uses of space.

As a "community" of councils, the representatives shared notes on how much pressure they could exert in the private sector. They compared what the levels of bank giving were, so that they might be able to use that information from community to community. It was not the "how-to"s, but the community-to-community peer pressure that was the topic of discussion. That is a different level of inquiry than is seen elsewhere.

The importance of community in the state of North Carolina caused one of the former North Carolina Arts Council directors to take the helm of a community council *after* heading the state Council; it was not seen there, as it might be viewed elsewhere, as a lesser position. The state leaders have

also been national advocates for community council development and needs among their peers, the state arts councils. The fourth Director, Mary Regan, took a short leave in 1976 to do a report on the Community Development program within the National Endowment for the Arts Federal-State Partnership program, giving her a special and in-depth understanding of the nationwide picture before becoming her own state's leader. The Community Development program, used well, has been envisioned as an incentive for state agencies to become more directly involved with their communities. Few have used it with as much insight as North Carolina has.

North Carolina is a microcosm of the problems of arts councils as well. To begin with, there is the problem of quality. Buttressed by the expressed goals of supporting, bringing, or providing programs of the highest quality, since it is not possible to have a major museum or professional performing arts company in every region or small community, planners are constantly thinking of ways to transport the communities to the facilities. Buses and planes to major collections and museums, and to events such as the American Dance Festival in Durham, the Eastern Music Festival in Greensboro, and the Music in the Mountains Series near Spruce Pine achieve this. The events at the universities may bring 25,000 people who subscribe or attend at a reasonable fee.

There are also the turf problems. Older, single-discipline organizations have captured the interest of the town leadership in old patronage patterns. Symphony orchestra leadership, whether the community is one of 350,000 or one of 20,000, has been of particular community concern. The specifics of the tension vary, but in one city it was a conflict between the council's Pops Festival and the symphony; in another, it was a question of the acceptance of the arts council by the symphony; in yet another, it was a conflict between a museum and the arts council. It was suggested that a state task force be formed to look at realistic numbers of organizations and budgets.

Then there are the other problems concerning community leadership. In cities with college populations, otherwise mobile populations, or a high influx of new people, the arts council leadership may be problematic. In the cases of old councils, keeping the leadership renewed and invigorated is equally difficult. For the newly professional councils, the transition from volunteer to paid council staff is not easy (often the first paid staff person comes out of the volunteer ranks). Delineations of roles is particularly difficult because the tasks do not always differ; they may simply be of a more complex nature.

The North Carolina Arts Council has kept its eye on the goals set so early by those first council boards. Several of its programs *have* assisted the

better artists in earning a living, and the arts *have* certainly become more a part of people's lives. In one small community, the arts and water — two essential human services — are discussed in terms of who will take responsibility for their support. In the media, the dialogue is about the arts' being traded for water. The city asks the county to take care of the arts if it agrees to take over the responsibility for the water. In another community, an editorial suggests a cut in the garbage pickup so that dollars may be given to the arts.

On December 11, 1980, the Raleigh *News and Observer* ran the following article:

> A North Carolina art group has won a federal tax exemption over the objection of the IRS.
>
> The exemption for the Goldsboro Art League had been denied by IRS officials who claimed the League was a commercial enterprise because it operates two galleries where art works are sold.
>
> The League appealed that ruling and was upheld by the U.S. Tax Court in a ruling made public Wednesday.
>
> The court notes that the Art League conducts classes and engages in many educational activities.[66]

The North Carolina community development policy has indeed taken hold; it is spirited, tenacious, and confident that it can keep improving the quality of offerings in a state that takes a person 14 hours to drive across. The communities' leaders themselves have evidenced this confidence as well. In Fayetteville, the board said "no" when the less-than-acceptable dinner theater invited the Arts Council to be the recipients of the money made from a benefit at the theater. The nude paintings at the gallery in a small Bible Belt town were upheld as acceptable; and the work of an avant-garde composer in Durham was supported by the Arts Council board, even though there might be the typical public controversy over the work.

The story of North Carolina is the microcosm of the story of the community arts council movement. Almost everyone one talks to attributes the success to the involvement of "the right people." That will be true of success anywhere in any field. The building of a network of peer support is a factor that makes the total effort more effective. The give-and-take between community and state, and sincere efforts to work through problems that have surfaced over the years, have been conducive to highly motivated and successful work. There is a feeling of caring and nurturing. And while some have become national leaders, their leadership role in their own state and communities has taken precedence. The results are evident, and they provide a framework for the arts council movement.

STATEWIDE AND REGIONAL ORGANIZATIONS

The community arts councils' development has been surrounded by that of two other organizational structures that have affected community-level development directly and indirectly — the regional organization network and the statewide service organization network, of which the assemblies or associations of community arts councils are a part. They are supportive in different ways.

The eight regional organizations — which include in their membership all but four of the 56 state and territorial arts agencies in the United States (not included are Washington, D.C., Texas, Puerto Rico, and the Virgin Islands) — have developed organically from the regions themselves. Those regional organizations include the following: Affiliated State Arts Agencies of the Upper Midwest (ASAAUM — Iowa, Minnesota, North Dakota, South Dakota, and Wisconsin); Consortium of Pacific Arts and Cultures (CPAC — Alaska, California, Hawaii, American Samoa, Guam, and the Northern Marianas); Great Lakes Arts Alliance (GLAA — Illinois, Indiana, Michigan, and Ohio); Mid-America Arts Alliance (MAAA — Arkansas, Kansas, Missouri, Nebraska, and Oklahoma); Mid-Atlantic States Arts Consortium (MASAC — Deleware, Maryland, New Jersey, New York, Pennsylvania, and West Virginia); New England Foundation for the Arts, Inc. (NEFA — Connecticut, Maine, Massachusetts, New Hampshire, Rhode Island, and Vermont); Southern Arts Federation (SAF — Alabama, Florida, Georgia, Kentucky, Louisiana, Mississippi, North Carolina, South Carolina, Tennessee, and Virginia); and Western States Arts Foundation (WESTAF — Arizona, Colorado, Idaho, Montana, Nevada, New Mexico, Oregon, Utah, Washington, and Wyoming).[67]

These organizations, cooperative ventures of the state arts councils, have been publicly endorsed but private arts organizations, "encouraged and funded by the federal government (National Endowment for the Arts) but initiated, developed, and under the governance of the states comprising the regions the organizations were created to serve."[68] They exist to provide multistate services that can be best offered by a regional organization. The distinguishable feature is that they are voluntary and state-initiated, not federal regional offices. (The National Endowment for the Arts has had liaison persons assigned to regions of the United States as links to all organizations in those areas. This activity has been unrelated to the regional organization development.) The organizations were building momentum as the 1980s began, and no one can determine the level of their impact. They are collectively "committed to the concept of cultural regionalism; moreover, they believe that all art, whether tribal dance or Mozart, is made available to people in isolated communities and in rural areas most effectively through cooperative regional efforts."[69]

Because the community council is often the local coordinator of touring and sponsoring programs, which seem to be the kernel of the activity of most of the regional organizations, there is a real and important relationship between community and regional groups, most especially in the case of smaller community councils. The touring programs' styles fall into two types: a tightly controlled and block-booked "national touring program" of major companies, and a less controlled "regional touring program" where sponsors have a broader selection of more affordable events from which to choose. Most combine the two. Because of the cutbacks in funding, especially for the touring programs, the emphasis in the future is bound to be on the "necklace tour," which will emphasize that which is closer to the home base of the performing group. (It should be noted that whereas traditionally colleges and universities used to be the primary sponsors of cultural events, local arts agencies now have become equally important as sponsors. Many jointly book an event; the college provides the facility, and the coordinator is the council.) The regional organizations are, depending on the specifics, also available for training and other kinds of services to local and state agencies.

One of the first statewide community arts council meetings expressly to coordinate matters between community arts councils and a state arts council may well have taken place in Springfield, Illinois, in 1972. It was to advise the state council on the needs of local arts councils. At that time, there were 18 local Illinois councils, including one of the oldest in the country, the Quincy Society of Fine Arts. The Illinois Arts Council had had advisory panels in each of the arts disciplines for some time, but it had never had a committee devoted solely to matters concerning community arts councils until then. Today, about half the states have such a group, usually called an assembly.[70]

The relationship is not usually so close as it has been in Texas, where the Executive Director of the Texas Assembly of the Arts Councils has been an employee of the state Council, in charge of developing councils.

The most important first steps in the development of one of the strongest alliances (the one in New York) were taken very carefully, and with the involvement of those who needed to be involved in the process and development of a statewide agency. An early survey included questions about the establishment of such a group, its expectations, purposes, and structure. "When the steering committee members started saying 'we' instead of 'I,' it was an important step forward," remembers the Executive Director of the Alliance of New York State Arts Councils, Inc., Lee Howard (also a former president of NACAA). As most alliances, this started as a volunteer organization (1975). The credibility was built by stating what the group would do in the areas of communication and education, and then by accomplishing it. The most experienced persons from the arts council network in the state

were generous in sharing their knowledge with emerging organizations as advisors, panelists, and workshop leaders.

The concrete evidence of success is subtle — the higher level of questioning, the kinds of requests, and the behaviors of the arts council staffs and boards are the indicators that there has been a growth and change in the level of sophistication. The main areas of service have been in the educational workshops and in communication and information on programs, services, and legislative matters. The area of advocacy has been especially important for the councils, a logical network for information and action; the Alliance of New York State Arts Councils, Inc., has worked with the Concerned Citizens for the Arts in the state in a cooperative way.

It would be wrong to indicate that these alliances have always "gone along," or agreed with their state agencies in small and large matters. In some cases the power struggle has become real. In the state of Alabama, the state arts agency, in response to "the input of the collective voice," ceased to support the Alliance organization. "There is a gnawing fear that if anyone speaks out for or against any arts issue, funding would cease for that spokesman, that the withholding of funds is an effective silencer."[71]

The trouble may stem from the fact that it is natural on the part of some state arts councils to feel the power of the assembly constituency, and to fear some loss of their own power. In some cases, the reaction has been to cut assembly dollars; but the assemblies have been almost totally dependent on those dollars. Solving the greater problem of the development of nongovernmental support for such a statewide group is a very difficult task.

In the face of extreme budget cuts, due to an across-the-board state dollar crunch affecting all state agencies, the Ohio Arts Council urged its alliances to band together somehow to economize on communications, travel, meetings, and the like.

In Michigan, a faltering economy was also forcing the state council to make cuts, especially in the special projects and minigrants program. The Michigan Association of Community Arts Agencies encouraged the formation of the Michigan Arts Forum, an informal association of the state's arts service organizations to bolster advocacy efforts. The Michigan Association has purposes similar to the Alliance of New York State Arts Councils and issues a monthly newsletter *Re:*, covering information of importance to nearly 100 councils.*

*A year after the reports of the cuts cited, the Michigan Council for the Arts, in the face of even more general economic problems in the state, embarked on a new program that would serve minorities, the handicapped, and economically and culturally disadvantaged citizens. This state, at the same time, was reaffirming the need for programs for touring, market development, facilities improvement, rentals, planning, and cultural preservation. (See Charles C. Mark, *Arts Reporting Service*, no. 289, April 5, 1982.)

In Michigan, two-thirds of the funding for the Association of Community Arts Agencies in 1980 came from the state council. The other third was from dues and earned income from workshops, with a very small amount from outside sources. Desirable goals would reduce the dependency on the state council.

Another problem identified with the statewide assembly groups has to do with the lack of new blood in the leadership areas. They tend to draw leadership from the ranks of those already heavily involved. But the huge time commitments needed for travel and meetings are big investments in addition. The Michigan leader estimated this load to be 70 hours a month just for this volunteer effort. He was also a new appointee to the Michigan Council for the Arts and a board member of NACAA, quite apart from his job as fine arts producer at Michigan State University's WKAR-TV. Most of the organizations begin as volunteer organizations, but there comes a time when there is a need for a professional staff appointment, as there has been in New York, Kansas, Alabama, and Texas.

The Association of Community Arts Councils of Kansas has served on contract with the Kansas Arts Commission to provide community development services and encourage arts programming at the local level throughout Kansas. This is far different from the role as an independent organization envisioned by some of these groups. As a liaison with state and federal government, foundations, and the business community, the Kansas group, or any other group with that role, has an especially difficult time criticizing "the hand that feeds it." The programming role of the Kansas Association has been different from that of its Michigan and New York counterparts. One year, through its assistance efforts, the Dance Theater of Kansas Touring Ensemble played to 23 communities (56 percent with populations of less than 10,000), the Raymond Johnson Dance Company was presented to 7,824 people in four communities, and 15 prominent Kansas artists were involved in an art exhibit that toured 11 cities and was seen by approximately 10,000 people. The goals ranged from increasing public awareness for the art form, to introducing ballet, to providing residency opportunities. Each program's goals were clearly delineated, and the results of the program were evaluated.

These are just examples. Through the assistance of the Association, the booking opportunities of the Kansas Arts Commission (Kansas Touring Program and Traveling Visual Arts Program) and the Mid-America Arts Alliance (national artists come through their sponsorship to a five-state region for concerts and residencies, as well as regional tours of outstanding artists from those states) are made known to the communities. The range of all of these opportunities has been wide — the 1981–82 roster included the TASHI chamber music ensemble, the Dance Theatre of Harlem, the Gregg Smith Singers, the Kansas City Philharmonic, and the Missouri Repertory

Theater. In addition, there were major exhibitions and alternative exhibits. The National Endowment for the Arts Dance Touring program has enabled sponsors to book professional dance companies. The 1981–82 roster included about 90 companies of all styles of dance. Any community-oriented not-for-profit organization could be a sponsor for these residencies; community councils were only one group among them. Others were symphonies, drama groups, parks and recreation departments, churches, museums, and school districts. While the state associations do not coordinate these events, they give assistance to the communities that wish it, and act to stimulate the programming of these events.*

The important activities of communications through an arts newsletter, the educational workshops, and the normal range of technical assistance reflected in most assembly community activities have been stressed. The budget of the Kansas group had authorized several staff lines to fill what seems to be an "adjunct" role under contract with the state council. The travel expenses across the state for both board and staff are the largest expense and could never be assumed by volunteers.

Only those on site over a period of time can estimate the value of the model of the Kansas Association. There are constant turf and dollar questions that surface as the budget situation at the state level becomes tighter. At this writing, this organization is faced with a severely cut budget and reorganization. Because the Association was organized "from the top," the state, not the arts councils, has determined its role. The organizations served, perhaps, have had too little investment in what happens to the Association.

The independent status of the assemblies allows them to be much more responsive on the whole than any government agency can be. Most leaders reflect this philosophy, no matter what the nature of the relationship with the state agency is. Whether newer associations of community arts agencies — those in Ohio, Wisconsin, Tennessee, and Missouri, or others more recently begun — will be called upon to have greater adjunct roles in the state as the economy dictates legislative budget reductions remains to be seen.

There are bound to be constant turf and dollar questions under the surface, unless the associations find independent livelihoods and serve their community arts council clientele with regard to key issues relating to communities at state and federal levels.

States have organized their advocacy efforts in a variety of ways.† Some of the most interesting and effective have been interdisciplinary in their structure.

*There have already been alterations in the touring planning, as it has been known, for in FY 1983, Endowment monies for dance are to go more directly to companies instead of through presenters and other conduits.

†There were 29 state advocacy groups at last count.

The history of the California Confederation of the Arts reflects some of the reasons for the development there of a nonprofit statewide interdisciplinary arts service organization. It came into existence during the period when the California Arts Commission was abolished and the California Arts Council was being newly created. It was a period when many leaders in the arts community of the state realized they must unite in order to represent themselves effectively to the governor's office, the state legislature, and the public at large. In 1978, the confederation helped prevent the California Arts Council from being abolished by the state legislature in the wake of Proposition 13, and successfully worked to increase the budget of the California Arts Council by 600 percent between 1978 and 1979.

The Confederation is a statewide arts service organization representing all the arts and artists in California. All sizes and types of arts organizations — groups for the visual and performing arts, community arts councils, theater councils, the Association of Museums, and Artists Equity, to name a few — are included. Support comes from government, foundations, and business grants, as well as membership dues and donations. Some unique components seem to be present in this statewide organization, because it sees itself as an *arts service* organization as well as an advocacy group. Because it is a 501•C•3, only 20 percent of the budget and assets may be spent on advocacy activities.* It has become the resource for information, technical assistance, and advice on funding, legislative activities, economic data, and technical assistance. Such a centralized resource aids artists and arts organizations in developing managerial skills, their audiences, and more effective use of their time and materials.

In California, there are also arts discipline service organizations statewide. The services described in other states are sometimes provided by the arts council itself or the individual service organizations. There is, in addition, often a statewide citizens' advocacy group that is not a 501•C•3 organization, so that its full agenda is given over to lobbying. All such groups give specific instructions to their clientele about generating public opinion, addressing their remarks specifically to individual artists, arts administrators, boards of directors, audience participants, and volunteers. There are a variety of differing ways that each group can effectively communicate the needs of the arts in personal and general terms.

The California Confederation's other services include serving as an information clearinghouse, publishing a newsletter, and sponsoring or co-sponsoring seminars or workshops on arts topics of interest to *all* the arts

*While both 501•C•3 and 501•C•4 organizations are tax-exempt, nonprofit organizations, there are differences in their ability to lobby, and contributions are tax-deductible to C•3 organizations only. In the process of organizing or restructuring, the best advice is careful review of the legal implications of both designations.

disciplines as well as to the individual artists. Sensitive to avoiding any duplication with the four-discipline (symphony, dance, theater, museum) statewide service organizations and with Artists' Equity, the Confederation's seminars, such as the ones on the federal regulations concerning access to the handicapped, try to be of interest to all the arts. The organization sees itself moving into the network of arts education organizations — the Alliance of California Arts Education and the California Connection.

The oldest of the statewide advocacy groups is probably the Concerned Citizens for the Arts of New York State. It has been chaired by Amyas Ames, who had organized and chaired the Partnership for the Arts, which was formed in 1970 as a national advocacy group.

Some groups have looked at new sources of revenue. A major force behind the passage of the first tax check-off bill (beginning in 1982), which creates through the Oregon Arts Development Fund the opportunity to designate $1, $5, $10, or another specified portion of one's tax refund for arts support by checking a box on the form, was the Oregon Advocates for the Arts. The monies placed in the fund are administered by the Oregon Arts Commission. (In the first year, a similar program raised nearly $350,000 for the Nongame Wildlife Fund in the same state.)[72]

Minnesota Citizens for the Arts, Inc., BRAVO in Virginia, Citizens for the Arts in Pennsylvania, Indiana Advocates for the Arts, and Ohio Citizens Committee for the Arts, among others, are all broad-based groups. They have been effective and instrumental in raising their state allocations to the arts by over 500 percent in some cases, depending on the years cited.

In Minnesota there are two groups, one a member group dedicated to insuring that all residents of Minnesota have access, enjoyment of, and education in the arts; and Minnesota Citizens for the Arts, whose efforts are entirely political. Minnesota Citizens for the Arts has focused on the state arts appropriation, and also pursued other avenues of public funding such as the 1 percent for the Arts bill, arts-in-education programs, and various county, local, or federal concerns. In recent years, this group worked to assist Minneapolis in advocating exemption from the 3 percent city sales tax for amusements and admissions, and for the increased dollar support for the Minneapolis Arts Commission. It is one of the few cases of a statewide advocacy group taking up the cause of a community arts commission. In Washington State there are also multiple advocacy groups with a similar mode of operation.*

*For information on some of the advocacy programs and strategies for developing solid advocacy efforts, there is the ACA resource monograph on the subject. It offers commentary and practicum, including a discussion of voter education, political activity, and the Internal Revenue Service. Because information about these groups is just now starting to be documented, the resource material for the present volume was gathered through a questionnaire sent to existing statewide advocacy groups.

In Ohio, the Ohio Citizens' Committee for the Arts was given its first home within the offices of the Cleveland Area Arts Council because of CAAC's willingness to undertake this effort. The citizen leadership was developed, and after the first year, a much broader formal statewide structure formed. To insure broad statewide support, it was felt important to move it from the state's largest cities and highest arts impact areas. Thus, the offices were, by the third year, ensconced in the smaller community of the Committee's new Chairman, and a part-time staff person was hired to assist the management of a growing undertaking.

Some of the citizens' committees for the arts are very small and strictly voluntary. In those states, the groups are very frugal and very focused. In New Hampshire, there has been concentration on more money for the state arts council, on a .5 Percent for the Arts bill, and on improving communication and the power of the constituency. The leadership has been mostly arts managers and individuals from statewide arts organizations who saw the need and had the "greed" for dollars.

Many of the citizens' committees, without staff, newsletters, or multiple ongoing purposes, become somewhat inactive between budget years or important legislative sessions. Statewide organizations take much effort to keep going on a volunteer basis.

The arts of the community have not yet developed an ongoing constituency, which makes the efforts of the Minnesota Citizens for the Arts' activities in behalf of the Minneapolis Arts Commission unusual. It is true that in critical times, when public budgets have been up for review, almost every arts commission has been able to call upon an arts representation to orchestrate a presentation in its behalf. Sometimes, that has not been possible, because private citizens and leaders of traditional arts organizations have not been used to responding to other than the traditional private support programs. The councils have represented in many instances the first link that the arts community has had with the public sector on arts issues.

TOWARD A FEDERAL-STATE-LOCAL PARTNERSHIP

In February 1981, at the very moment that the Reagan administration was announcing the broad sweep of its economic policies for the first time, and after more than ten years of discussion and more discussion, study, and restudy, the National Council on the Arts adopted a policy concerning local arts agencies. With no money, and no hope for quick implementation, the Council resolved that it is "appropriate to assist local and community arts agencies to improve and strengthen their financial and service support functions for arts of the highest quality and to do so in a cooperative relationship, a partnership, with their state arts agencies."[73] In the *Report to the President* from President Reagan's Task Force on the Arts and Humani-

ties of October 1981, Henry Geldzahler, Commissioner of Cultural Affairs in New York City, the only local arts agency representative on the ad hoc committee, had made sure of the inclusion of local arts agencies in the recommendation that the endowments and states "work out a federal-state relationship that will take into account the complex nature of the current relationship and the need for more effective use of federal funds."[74] In both cases, the recognition of the need to include policy regarding the local partnership was not a high priority, but was attended to when the group was reminded that it made sense and seemed timely.

In persuading the National Council to create a policy, Henry E. Putsch, then Executive Director for Partnership, NEA, distilled the thousands of pages of related studies and of related Endowment policies and programs mentioned briefly in preceding chapters, and included a synopsis of the present activities of the local arts agencies themselves. It seems appropriate to print, for a wider public, part of this documentation.

> A summary of the common themes running through past reports and recommendations . . . [relate to] steps that encourage and assist local arts leaders to:
>
> - develop and implement publicly accountable policies and programs for support of all the arts;
> - increase both financial and service support for the arts at the local level;
> - plan for the health of the artistic and cultural life of the total community;
> - provide support for the arts in ways which are consistent with the purposes, goals, and standards of the Endowment's legislation, operating policies, and programs;
> - cooperate and share responsibility for support of the arts with the state arts agencies and the National Endowment for the Arts;
> - address such other standards and criteria for eligibility as are, from time to time, established by the National Endowment for the Arts and the state arts agencies.

The following policy statement and program recommendations have been drafted with these themes and past studies in mind and in response to those conditions and circumstances described in the background material that appears after the recommended policy and program statement.

II. RECOMMENDED POLICY AND PROGRAMS

A. *Recommended Policy Statement:* The National Council on the Arts has reviewed the development and role of local arts agencies in the United States and finds that:

- the arts support function of local arts agencies is a beneficial, significant,

and integral contribution to the arts in the United States and the artistic life of American communities;
- the state arts agencies desire to work in cooperation with local arts agencies to assure more effective support for the arts at the state and local level;
- the purposes and goals of the Arts Endowment are consistent with a program to encourage support for the arts at the local level as part of a broadly conceived national policy of support for the arts;
- the Congress of the United States has authorized and urged the National Endowment for the Arts to provide programs to encourage support for the arts by local arts agencies;
- greatly increased private and public support for the arts at the local level and the highest standards for providing that support are necessary for the arts to reach their full potential for touching the lives of Americans, for achieving and maintaining excellence and aesthetic diversity.

In view of these findings, the Council believes it is appropriate to assist local and community arts agencies to improve and strengthen their financial and service support functions for arts of the highest quality and to do so in a cooperative relationship, a partnership, with their state arts agencies.

B. *Recommended Programming:* In order to address the above policy, it is recommended that the Arts Endowment:

1. Develop a new program of assistance for local arts agencies through the state arts agencies. . . .
2. Establish, within the Office for Partnership, professional "State-Local Partnership" staff to develop the program and, as feasible, to provide a clearinghouse of information, technical assistance, and planning assistance to local-state arts support efforts; to identify and encourage model demonstrations of cooperative local-state arts planning, funding, and service projects and programs; to work with other agency programs to maximize opportunities for Endowment response to the purpose and goals of this policy; and to provide liaison functions for local arts agencies with other federal agencies.

The above recommendations are put forward without prejudice to existing practices that allow direct access to the individual arts discipline programs of the Arts Endowment on a competitive, merit-of-project basis consistent with the appropriate program guidelines, purposes and goals, as well as direct access to state agency programs. . . .

A positive response by the Council can encourage the growth, development, and effectiveness of local arts agencies for the purpose of providing increased financial and service support for artistic achievement of the highest quality in their communities.[75]

The National Council voted unanimously to endorse this policy statement, which is excerpted from "Towards a Federal-State-Local Partner-

ship" advanced and recommended by the NACAA Board of Directors, the NASAA Executive Committee, and the National Council on the Arts/NASAA Policy Committee.

As one leader said, "Now we can begin. If the states, the accepted partners of the Endowment, are behind it, and the communities relate to them, the communities will be accepted partners too."[76]

Why didn't it happen earlier? Influential factors include community arts agency, NACAA, and NASAA maturity; timing; and the long transition at the Endowment involving old and new personnel as the Carter administration moved into Washington and put the new Endowment administration into place. This latest policy decision has come when similar elements are in play, however. Even though the 1980 Congress and the states had urged the Endowment to formulate a communities policy, there was a new Congress with different priorities. The year 1981 was spent in preserving the national work that had just begun. The federal cuts were symbols of the need to keep the base broad and to work together. The states, caught in their own individual state struggles for funds and in the reality of cutbacks in the federal monies used to stimulate the state support, continued their interest in working with communities successfully. Thus again, timing was a problem.

In March 1982, at a CityArts conference at Wingspread (Racine, Wisconsin), Frank Hodsoll, then the new Reagan-appointed Chairman of the National Endowment for the Arts said: "The CityArts program is the only real Endowment response to date to the larger, and unsettled, question of how the Endowment can and should relate to local arts agencies." While pointing out that the program had not been perfect, he added, "This federal-local partnership gets at the heart of both national and local concerns. . . . it gives smaller and often experimental arts groups a degree of recognition that they probably would not have otherwise. The partnership helps those organizations build new audiences for their performances and exhibitions. The local matching requirements become a catalyst for the arts groups to seek out new private funding sources within their own neighborhoods and communities. And the return is often greater than simply new donations. New personal commitments of concern and interest are made by private citizens which often can have a value far beyond the dollar amounts given." Hodsoll pointed to the development of larger "artistic pools" and "audience pools" from which the older, better-established arts institutions can draw. "There is an elusive but vitally important, link between the smaller emerging arts endeavors and the larger and more traditionally supported arts institutions."[77]

The word "decentralization" is a key word in partnership discussion and means a variety of things. Primarily it means giving away money to smaller units — regional, county, or city agencies — for redistribution for

the arts. The federal government in general is interested in decentralization. But there is a natural tension at the state level, whose business it is to distribute money. Money is power, and giving monies for redistribution is giving away power. In the 1980s, partnership will mean many things, including sharing power. The National Council, in its policy statement, is redistributing power. In order to meet their challenge successfully, states and communities are looking at this issue with new candor.

APPENDIX: CHRONOLOGY OF MUNICIPAL INVOLVEMENT IN THE ARTS*†

1723 Williamsburg, Virginia — The first recorded American theatre and dance school goes bankrupt. City officials later persuade "gentlemen subscribers for the play house" to donate the building for use as the town hall.

1730s Charleston, South Carolina — Theatrical entertainment overcomes an earlier puritanical stigma. Charleston city officials show such favor to the drama they permit the use of the courthouse for performances, including the first known opera in America.

1790 New York, New York — John Pintard, a distinguished citizen, persuades the Society of St. Tammany to found a museum in City Hall. The collection, consisting largely of Indian artifacts, was later sold to P. T. Barnum for his display of curiosities.

1813 Washington, D.C. — Benjamin Lathrobe, dismissed by Congress after a decade as the first public architect in the U.S., asserts: "I am bidding an eternal adieu to the malice, backbiting, slander, trickery, fraud, and hypocrisy, lofty pretensions and scanty means, boasts of patriotism and bargaining of conscience, upstart haughtiness and five thousand other nuisances that constitute the very essence of this community. The more you stir it, the more it stinketh." Lathrobe sums up his experience in one sentence: "Government service is a ruinous connection."

1816 New York, New York — The City Common Council votes a recommendation that citizens visit the exhibitions of art dealers. The Council also commissions portraits of heroes of the War of 1812 for a collection in City Hall.

1825 Baltimore, Maryland — The city becomes known as "The Monument City," having erected the first monuments in America to Christopher Columbus in 1792 and George Washington in 1810.

*Source: Excerpted from "A Short History of Municipal Involvement in the Arts," in Luisa Kreisberg, ed., *Local Government and the Arts* (New York: American Council for the Arts, 1979), pp. 7–9. Reprinted by permission of the American Council for the Arts. Copyright 1979.

†Note: It is important to note that local public support of the arts long preceded the development of the arts council agency as an organization. In some communities, there has been a long tradition of support to individual institutions such as art museums and symphonies by line-item municipal budgets. By and large, the newer public monies generated have been for broader distribution or for citywide activity such as arts festivals, or have been related to percent laws.

1870s — Local governments begin a new phase of art patronage by assisting museum development. Between 1870 and 1910 municipal and state governments contribute 40 percent of the total funds spent for museum buildings.

1871 Albany, New York — A joint committee of New York's American and Metropolitan Museums calls on the state legislature to pass enabling legislation permitting the city to use public funds for the construction of private museums. After protests by Boss Tweed's henchman Sweeny that the museum must belong to the people, the legislature creates a partnership under which the city puts up its own buildings for the museum to occupy, thus originating the now commonplace partnership between a nonprofit corporation and a municipal government.

1886 Taunton, Massachusetts — The Supreme Court (Hubbard vs. City of Taunton) upholds the right of a city to pay for band concerts. The case is decided on the basis of a state law permitting towns to appropriate monies "for armories, celebrations, and other public purposes." The latter is construed as admitting music.

1893 Claremont, New Hampshire — Civic leaders propose a new town hall containing an opera house. With the community split over the issue, the pro group clandestinely meets on election eve and tears the roof off the old hall. The proposal passes and a new town hall, two-thirds designed as an opera house, is finished in 1897.

1900 — Conscious of the poor appearance of cities and public buildings, municipalities across the country begin to create art commissions to advise on the visual aspects of public policy. Among these cities are Denver, Los Angeles, and New York.

1907 St. Louis, Missouri — The City Art Museum of St. Louis, the first to be supported entirely by public funds, is established under the art museum law of the state of Missouri. The mayor of St. Louis complies with the law only after a group of citizens secure a court order compelling him to do so.

1908 New York, New York — The Municipal Art Commission is given an operating budget of $7,500. The Art Commission is the only department of city government beside the Board of Estimate on which the mayor sits as a regular member.

1912 Portland, Maine — Through the gift of a pipe organ, Portland establishes a model of municipally supported organ recitals imitated by at least ten other cities and one county. The city appropriates $12,000 a year to be used by the Portland Music Commission "to make it possible for every resident of Portland and the visitors within the city to hear the finest music produced by a master on the finest of musical instruments, and to encourage general musical activities."

1914 Chicago, Illinois — The city becomes the first to actively develop a municipally owned and acquired art collection. Through the Committee for the Encouragement of Local Art, it purchases contemporary art by Chicago artists. After four years of existence the collection includes nearly 100 paintings and pieces of sculpture. Appropriations are made on the recommendation of the mayor. Four years later the Finance Committee kills the project.

1915 Baltimore, Maryland — The city organizes the first municipal orchestra in the United States. Mayor Preston declares, "The people of Baltimore are entitled to municipal organizations which provide for aesthetic development, just as they are entitled to municipal services in education, sanitation, and public safety."

1919 Detroit, Michigan — The board of directors of the Detroit Art Museum agrees to turn its collection over to the city in return for an adequate building and op-

erating funds. The private corporation is dissolved and replaced by a board appointed by the mayor, making it the first museum both municipally owned and operated.

1920 New York, New York — Commenting on the relationship between art and politics, a spokesman for the Metropolitan Museum declares, "Let us give Tammany Hall the credit due it for the support it has given the Metropolitan."

1923 Philadelphia, Pennsylvania — The city council allocates the earliest recorded municipal grant for opera in the United States: a $15,000 appropriation for a local opera company organized the same year. Local demand for opera is not yet sufficent to justify its support by taxation, and after a few seasons the appropriation is withdrawn.

1925 — A survey conducted by the National Bureau for the Advancement of Music finds that in 327 municipalities, a total of $1,254,481 had been appropriated by city governments for music during the preceding year.

1926 Philadelphia, Pennsylvania — Harry A. Mackey runs for election as mayor, making municipal support of music one of the major planks of his platform. He wins the election and establishes a Municipal Bureau of Music.

1930 — City appropriations to art museums reach a new high. Twenty-seven municipalities spend a total of two and a half million dollars for art.

1931 Charleston, South Carolina — The city passes a zoning ordinance "to preserve and protect historic places and areas in the Old Historic Charleston District."

1932 San Francisco, California — The San Francisco Opera Association begins performances in War Memorial Opera House, the first municipally owned and operated opera house in the United States.

1935 San Francisco, California — An amendment to the city charter is passed permitting a tax to support low-cost symphony concerts. The proceeds are used to purchase concerts as opposed to direct subsidy, making San Francisco the most important example of this type of support in the country and setting a precedent for subcontractual cultural services.

1936 New York, New York — The High School of Music and Art, the first public school in the United States exclusively for artistically gifted children, is established through the efforts of Mayor LaGuardia's Municipal Art Committee.

New Orleans, Louisiana — The Louisiana Legislature authorizes creation of the Vieux Carre Commission by the city of New Orleans for the preservation of such buildings "as shall be deemed to have architectural and historical value." Architectural controls and a tax exemption are included.

1939 — Federal contributions to museum construction, WPA art centers, and museum projects encourage most municipal governments to restore cultural budget cuts of the 1930–1934 period. Support from municipal funds becomes the second largest source of museum income. Laurence Coleman, Director of the American Association of Museums, states, "the regime of the wealthy benefactor and socialite is giving place to that of democratic support."

Helper, Utah — Barney Hyde, town butcher and city council member, proposes that the city of Helper appropriate the sum of $225 plus twenty-five dollars per month for the building and maintenance of a WPA community art center. The motion passes a council vote. Five months later, Mr. Hyde is elected mayor, and Mayor J. Brackson Lee of neighboring Price demands, and gets, an arts center for his town also.

1940 — A survey reveals that 50 percent of municipalities having populations of 300,000 or more contribute to the income of museums in their cities.

1942 — As many as 70 percent of large cities now patronize art by supporting art museums.

1945 Los Angeles, California — The city begins a program of municipal support for local contemporary artists. Under the direction of the Department of Municipal Art, the city takes an active part in staging an annual Art Week and lends support and cooperation to art clubs and artists sponsoring the event.

1948 Flint, Michigan — Flint's mayor delcares a Flint Civic Opera Week, "so that the people of Flint may show appreciation for the fact that our city has been recognized throughout the Nation as the outstanding leader and pioneer in the movement to establish completely civic opera in our own language in the cities of the United States."

1940s — The first community arts councils are formed in the late 1940s in Winston-Salem, North Carolina, and Quincy, Illinois, among others, to "coordinate efforts among arts organizations and focus community attention on the activities of the groups." By 1980, the number of councils has grown to over 1,000, and their functions expand to include focus on other arts needs in the various communities — facilities, programming, service, and technical assistance among them. The councils develop as both public and private agencies and become the major link between the arts and different segments of the community.

1950 Louisville, Kentucky — Mayor Charles Farnsley, concerned over the perennial financial crises suffered by his city's arts organizations, calls together community cultural leaders and suggests they undertake a united arts fund campaign. As a result of increased funds, the Louisville Symphony Orchestra begins a program of commissioning, performing, and recording an impressive number of new musical compositions.

1953 St. Paul, Minnesota — In response to a 1950 community-wide survey recommending better arts facilities and the development of new audiences for local arts programs, the city passes bond issues allocating $1.7 million for an arts and science center.

Nationwide — The American Association of Museums reports a two-thirds increase in municipal support to museums over the past fifteen years.

1959 Philadelphia, Pennsylvania — The city passes a municipal " % for Art" ordinance requiring "a maximum of 2 percent of public construction costs to be spent on art." The long-established Philadelphia Art Commission is charged with implementing the law and coordinating the process of selecting artists and approving their designs.

1960s Flint, Michigan — The city fathers establish a municipal musician-in-residence, concert pianist Coleman Blumfield, "to let his good works spread about the city." His contract calls for two concerts a year and demonstrations at school assemblies. He performs free of charge to standing-room-only crowds.

1963 Detroit, Michigan — The mayor exercises the authority of his office by increasing the appropriation for school and public concerts from $50,000 to $70,000 a year. This helps break a deadlock in union contract negotiations that had threatened the Detroit Symphony 1963–1964 season.

1964 Detroit, Michigan — The director of city planning tries to attract practic-

ing artists to contribute towards the visual design and adornment of the city through an unusual provision of free studios, called Common Ground.

Nationwide — The American Symphony Orchestra League reports seventeen major orchestras receive more than a million dollars from city and county governments.

1966 Waupun, Wisconsin — The Waupun Area Arts Council persuades the city government to renovate the city hall auditorium to use for plays and concerts. According to Mayor Glen Wilson, "It's the best investment we ever made because now people really use it."

1968 Boston, Massachusetts — The Mayor's Office of Cultural Affairs is formed to bring the arts to a wider spectrum of city residents. A resulting project is Summerthing, a ten-week neighborhood arts festival operating in more than a dozen Boston neighborhoods.

1970s New York, New York — The city responds to the urgent need for low-cost living and work space for artists. SoHo, a declining manufacturing center filled with nineteenth-century cast iron architecture, is rezoned for artists' residences.

1971 Seattle, Washington — The Seattle Arts Commission is established through a municipal ordinance prefaced with the following statement: "The establishment of a Seattle Arts Commission to promote and encourage public awareness of and interest in the fine and performing arts *is essential to the public welfare.*"

St. Louis, Missouri — Attendance surveys reveal that St. Louis museums draw twice as many county as city residents while only city residents are taxed for their support. Voters pass a bill which brings the county into the tax base for the city's two museums and zoo. For the first time, county residents choose to carry their fair share of support for cultural institutions located in the city.

1974 — The United States Conference of Mayors passes a resolution on the arts and city government. It recommends that the arts be recognized as an essential city service and made available to all citizens.

1975–1976 — The Bicentennial celebration and a growing interest in revitalizing urban cores encourage a growing trend for local government to institutionalize support of the arts.

1977 — The National League of Cities surveys over 450 cities, asking them to define their future cultural needs. The responses stress programming for a wider variety of audiences, more and better facilities, and administrative and funding help from local governments.

NOTES

1. James Backas, "The State Arts Council Movement" (background paper for the National Endowment for the Arts National Partnership Meeting, June 23–25, 1980), p. 2.

2. Ibid.

3. U.S. Congress, House, Subcommittee of the Committee on Appropriations, *Supplemental Appropriation Bill 1966: Hearings,* 89th Congress, 1st session, 1965, pp. 25–26.

4. David B. H. Martin, (material prepared for the Office of Partnership, National Endowment for the Arts, 1980).

5. Maryo and Peter Ewell, "Planning for Grassroots Arts Development: A Research

Study of Nine Communities in Transition," *Arts in Society* 12(1975):92.

6. Robert Gard, "The Arts in the Small Community," *Arts in Society* 12(1975):82–91.

7. Ibid.

8. Maryo and Peter Ewell, "Planning for Grassroots Art Development," p. 94.

9. Robert Gard, "The Arts in the Small Community," pp. 82–91.

10. Lyman Field, "The States: Partnership in the Public Interest," *Cultural Affairs*, Spring 1970, p. 18.

11. Ibid., p. 19.

12. Letter from John Everitt to John Blaine (March 27, 1978).

13. Michael Newton (letter to ACA members, March 1978).

14. Andy Leon Harney, ed., *The City and the Arts—A Civic Handbook of Grants Offered by the National Endowment for the Arts* (Washington, D.C.: Partners for Livable Places, 1980).

15. Studies and task forces created by the National Endowment for the Arts for Communities Program examination in 1969, 1972, 1974, 1976, and 1979.

16. Letter from Nancy Hanks to Milton Rhodes (April 22, 1977).

17. James Backas, *A National Program for the Development of the Arts at the Community Level* (Washington, D.C.: National Endowment for the Arts, 1977).

18. Larry Chernikoff, "Livable Cities," *The Cultural Post* (Washington, D.C.: National Endowment for the Arts, October 1978).

19. Reported to the NACAA Board by memo, December 1979; quoted from Livingston Biddle as he announced that a person would be hired to develop alternative courses of action.

20. National Assembly of State Arts Agencies, position paper on Community Arts Program of the National Endowment for the Arts, *NASAA Newsletter* September 27, 1980, p. 7.

21. Ann Day, "Community Arts Agencies Project: Overview and Points for Discussion" (position paper examining the relationship of the National Endowment for the Arts and community arts agencies, June 1976).

22. "NEA Community Program Policy Not Yet Dead," *Alliance News*, December/January 1979, p. 1.

23. This report never appeared in published form. It was presented as a slide/talk presentation, then taped and distributed to arts councils all over the country who wished to use it.

24. Van Tile Whitfield, *Policy Paper on Expansion Arts* (Washington, D.C.: National Endowment for the Arts, 1978).

25. Letter from A. B. Spellman to John Blaine in response to questions about CityArts (January 1978).

26. Robert P. McNulty, *The White Paper: Architecture and Environmental Arts Program* (Washington, D.C.: National Endowment for the Arts, 1973).

27. Pamela Baldwin, *How Small Grants Make a Difference* (Washington, D.C.: Partners for Livable Places, 1980), preface.

28. Ibid.

29. Ibid.

30. Ibid., p. 63.

31. Quote from conversation with Burton Woolf (July 1980).

32. Arts Council of San Antonio, *Summary report: City Spirit, San Antonio 1976* (San Antonio: Author, 1976).

33. Robert Porter, ed., *The Arts and City Planning* (New York: American Council for the Arts, 1980).

34. R. Philip Hanes, remarks made before the 11th National Conference of the ACA, June 17, 1965 (recorded in *The Arts: A Central Element in a Good Society*).

35. Interview with Frank Logue, Jr., 1980.

36. Ibid.

37. Luisa Kreisberg, *Local Government and the Arts* (New York: American Council for the Arts, 1979), p. 10.

38. National Endowment for the Arts, *Federal-State Partnership: Programs and Funding Information (July 1, 1973–June 30, 1974)* (Washington, D.C.: Author, 1973).

39. Backas, "The State Arts Council Movement," p. 5.

40. Mary Regan, *Community Development through the Endowment* (Washington, D.C.: National Endowment for the Arts, 1976), p. 18. (a report)

41. Ralph Burgard, *Completing the Circle: State/Local Cultural Partnerships*, (Washington, D.C.: National Association of State Art Agencies, 1982).

42. Ibid.

43. Regan, *Community Development*, p. 11.

44. Ibid., p. 15.

45. Ibid., p. 16.

46. New York State Council on the Arts, *Program Guidelines (1980–81)* (New York: Author, 1980), p. 46.

47. Max Friedli, "The Arts Lottery: A Piece of the Public Action," *American Arts*, January 1981, p. 13.

48. Ibid.

49. California Arts Council, "State/Local Partnership Program Guidelines 1980–81." Sacramento: Author. Reprinted by permission.

50. Ibid.

51. Ibid.

52. Charles Christopher Mark, *Arts Reporting Service*, no. 281 (December 14, 1981).

53. Robert Porter, "State Appropriations: Will They be Enough?" *ACA Update*, February 12, 1982, pp. 10–13.

54. North Carolina Arts Council, *The Arts in North Carolina 1967* (Raleigh: Author, 1967), p. 106.

55. Ibid., p. 107.

56. Robert A. Mayer, "The Local Arts Council Movement" (background paper for the National Endowment for the Arts National Partnership Meeting, June 23–25, 1980), p. 94.

57. Ibid., pp. 6–10.

58. H. Vernon Winters, *Annual Report*, Winston-Salem Arts Council, 1978.

59. Michael Newton, "Pros and Cons of United Fundraising for the Arts," in *United Arts Fund-Raising Manual*, ed. Robert Porter (New York: American Council for the Arts, 1980), p. 1.

60. "Clipboard," *Grassroots and Pavement* 2(2)(1981):17.

61. Durham Arts Council, *The Arterie* (Durham, N.C.: Author, 1980), p. 3.

62. Toe River (North Carolina) Arts Council, "Winter Arts Program" (brochure, 1980).

63. Toe River (North Carolina) Arts Council, "Activities Report 1979–80."

64. Community Council for the Arts, Kinston, North Carolina, slide presentation (Raleigh Civic Center, March 1980), pp. 1 and 4.

65. Fayetteville/Cumberland County (North Carolina) Arts Council, "Facts of the Matter—Design in '80" (brochure, 1980), p. 37.

66. Raleigh *News and Observer*, December 11, 1980.

67. James Backas, "The Regional Arts Organization Movement" (background paper for the National Endowment for the Arts National Partnership meeting, June 23–25, 1980), p. 2.

68. Ibid., introduction.

69. Ibid.

70. "Illinois Arts Council and Community Councils Meet," *ACA Reports*, November/December 1972, pp. 11–12.

71. Marlo Bussman, "Position Paper" (Alabama Assembly of Community Arts Agencies, 1980).

72. *ACA Update*, November 12, 1981, p. 9.

73. Nan S. Levinson, *Local Arts Agencies* (Washington, D.C.: National Endowment for the Arts, 1981).

74. Presidential Task Force on the Arts and Humanities, *Report to the President* (Washington, D.C.: U.S. Government Printing Office, 1981), p. 14.

75. Henry E. Putsch, *Towards a Federal-State-Local Partnership: Policy and Program Recommendations for Strengthening Support for the Arts by Local Arts Agencies* (Washington, D.C.: National Council on the Arts, 1981), pp. 2–20.

76. Personal communication, Washington, D.C., December 1980.

77. Frank Hodsoll, (address given at CityArts Conference, Wingspread, Racine, Wisconsin, March 9, 1982).

Part III

CREATING A CLIMATE
IN WHICH THE ARTS
CAN THRIVE

Part III is about what has been happening primarily in the 1970s and early 1980s, from the point of view of the arts councils — not as they are perceived by their communities, not as they are perceived by the arts discipline organizations. It is an attempt to focus their story as they tell it to their own clientele: the services, the programs, and the real and subtle ways they have been responsible for bringing the arts to a community's conscience and consciousness.

It is the story of the daily struggle to focus on the place of the arts in people's lives.

5

Services from A to Z

Reflecting upon the establishment of the Cultural Arts Council of Houston in 1978, John Blaine explains:

> The city wanted a means of providing support to cultural organizations and activities within the city without having to go through the political machinations that were beginning to be too time-consuming. The city was also aware of the need to provide support to more than the highly visible cultural institutions. The city saw the importance of recognizing and assisting emerging cultural groups and to give some feeling of the possibility of survival and flourishing to people who only had an idea.[1]

The reasons given for the development of the Houston Council lie behind the development of many arts councils. Created by the Chamber of Commerce, the Council has emerged as a credible focal point for discussion on the parts of all the people who are concerned about the arts: "the Arts Council has rightfully earned a reputation for a place where people can meet and talk and be heard and where action will take place."[2]

While Houston and other cities deal with the influx of people moving in and ensuing housing, business, and service needs, some cities are dealing with the opposite syndrome, characterized by age and diminishing populations. All are going through the process of developing a partnership between the private and public sectors to build a strategy for preserving and promoting the greatest assets of their cities. One city leader has called the

arts the "enterprise zone." At the airports, the bus stations, and in the city magazines, travelers are told that the arts are why they're in the place they're in.

Whether it is the Ice Cream Festival in St. Louis, sponsored by the St. Louis Arts and Education Council, or the Bumbershoot of Seattle, one of the most successful fall festivals, the public enjoys and invades arts festivals. "The festival generates economic activity in the city, and assists in increased exposure for the arts groups,"[3] according to those in Atlanta who have sponsored festivals of jazz, dance, and film. John Blaine talks about the humanizing effect. "We need times when we can relax together and smile at each other and look at something with wonder, astonishment or even amusement."[4] Communities large and small would agree: They have been a priority of arts councils in places such as Buffalo, New York; Springfield, Ohio; and all across the nation.

Sponsoring festivals may not be everyone's cup of tea, but in New Orleans, for example, the festival sponsored by the Arts Council was the first multiarts festival the city had had. As the Council sought to increase public participation in as innovative a way as possible, it opened people's eyes by breaking new ground, such as being instrumental in commissioning New Orleans' first abstract piece of art. Such public artworks have in many places become city symbols — as the public and private sectors, more confident now, commission readily.

The Greater Louisville Fund for the Arts and the Fine Arts Fund of the Cincinnati Institute of Fine Arts are the country's oldest united arts funds. The Cincinnati organization had simply been a foundation for the first 20 years from its founding in 1927 to 1949, when it became a united fund, and has expanded the number of funded groups in recent years. In Louisville, just down the Ohio River, the mayor assisted in forming the fund. The fund has raised substantial monies for 13 arts groups since its inception, and recently was consultant to the state in the building of a new facility to house four of these groups. This fund has a subsidiary service division, the Community Arts Council, which serves as a community resource and information network and offers a wide range of programming, consulting, and technical assistance to artists and arts groups.

Thus some of the older organizations have tried to accommodate new needs as they have arisen. Newer councils also have found the need to change focus to accommodate the community being served. From 1973 to 1976, the Greater Philadelphia Cultural Alliance (founded in 1972) produced a special series of "Philadelphia Festivals" that were, for the most part, large public celebrations that highlighted the city's cultural institutions and individual artists. Since 1977, the organization has functioned solely as a service organization for institutions in the cultural community.[5]

"When you've had an impact, the community starts to look to you for

all sorts of things," say some of the directors of councils with budgets of less than $75,000 and a high impact.[6]

And so the arts thrive. For whom? By whom? Where? "Everywhere," explains the leadership. Let's explore that in greater depth.

"The arts have been strong in these towns historically — a lot goes on, but it has lacked visibility and coordination. Thus it has been easy to enhance," said the director of a regional council where neighborhoods are towns and the arts council is developing a base for greater citizen cooperation in the arts at all levels. "We represent the diverse cultural expression and needs of an area, and are in the unique position to serve the public while speaking for the arts as a whole."[7]

In New Hampshire, a Bicentennial committee, designated to administer funds that were used in arts-related programs in 35 towns (85,000 people spread over 100 square miles), developed into the Grand Monadnock Arts Council. A study, proposed at the Bicentennial celebration's conclusion, indicated that people living in that region considered the arts to be extremely important to their quality of life. Most felt that there were not enough arts performances or facilities for creative activities in their communities. The committee cosponsored a Business and Arts Conference with the Business Committee for the Arts, Inc., a national organization that encourages such meetings. Business leaders told their peers about the need for business support. A third program, attended by 100 arts organization board and management members, representatives from town and state government, the press, and educators, gave the regional council its encouragement for further development. From these activities, an independent regional arts council was evolved over a three-year period. The council spearheaded new state legislation to allow funding from the towns. In 1980, the city of Keene and eight of the 35 towns had given money to the Council, with some way still to go.

In Fredonia, Kansas (a community of 3,150 people), three local enthusiasts came back from a State Arts Commission meeting in 1965 and decided to try to start a council. They saw the needs then as starting a summer arts program for children and bringing in some high quality performing groups. In 1979, well ensconced in a 108-year-old house of hand-hewn stone, a state historical site, they felt as entrenched as the Chamber of Commerce. Funding comes from the private sector and the local school district, from the city and the county, as well as from state, national, and regional sources (individual and corporate). Local participation amounts to about two-thirds of their funding. By 1979, it was found that each person in the community had taken part in at least three events: "The people don't just sit and listen — they do it."[8]

In the same state, major dance and theater companies, such as the Martha Graham company and the Joffrey Ballet, have come to Manhattan

through its Arts Council. Kansas State University has provided a strong community base for arts programming. In Manhattan, the facilities for such performances allow the possibility of these types of touring companies. The people in Fredonia have to work around school schedules in school auditoriums; there is no community building with a performing stage. However, there have been community programs, including printmaking, a poet-in-residence, a residency for a glassblower, and performances by the Wichita Brass Quintet.

In Riverhead, New York, the high number of older people with professional skills makes it possible to accomplish the goals of a local arts council. This Council, as in Fredonia, Kansas, is housed in an historic home. It is located in a town of 20,000 and serves a total population of 400,000, in an area where the arts were once thought to be a summer activity — meaning that it was for the wealthy who had the time and dollars to come to the shore and to participate in the arts. The Council has involved many people in the projects that they have done, and have, along the way, changed the image of the arts. The downtown center has not only brought the people to it, but has involved them in the development — laying out the garden and so forth. The arts center was a sign — the first — that something positive would happen. The arts have made history come alive, and they represent events around which people gather. The parlor of the old house, the home of the Arts Council, is used for monthly art exhibits, and now seven banks have monthly art shows and want more. There have been professional workshops for the visual artists. Among their activities, they have sponsored performances of the caliber of the American Ballet Theatre.

The banks in Dodge City, Kansas, have also become interested in the arts through the activities of the Arts Council. They ask what the Council would like them to sponsor, and these events have ranged from a visit by a muralist to a performance of the Oakland Ballet.

Arts councils begun in the 1970s emerged for reasons very similar, yet greatly extended beyond those reported in the 1950s — to coordinate and stimulate the arts activity, to deal with common problems, and to serve many publics. These roles have multiple ways of translating to service and function.

Arts councils can serve a lot of people or a specific clientele — the general community or the arts community, or both simultaneously. Their services can be as basic and ordinary as membership and mailing lists, duplicating and accounting services, or as complex as computer systems and the coordinated calendars. They can be as basic as fundraising and as complex as advocating and educating; they can be as basic as counseling artists and as complex as coordinating a private and public system around their support. The services can relate to facilities and to presenting the arts

and/or programming. The following chapters describe in greater detail some of these services, which are varied indeed.

NOTES

1. Charles Ward, "A Positive Outlook for Cultural Arts Council" *Houston Chronicle*, April 13, 1980.

2. Ibid.

3. Discussions with Tom Cullen, City of Atlanta, Department of Cultural Affairs, 1980, 1981.

4. Ward, "A Positive Outlook."

5. Greater Philadelphia Cultural Alliance, *Annual Report*, 1980–81.

6. Interviews with small arts council directors, 1980.

7. Interview with Sara Germain, Director, Grand Monadnock Arts Council, Keene, New Hampshire, 1980.

8. Interview with Joan Bayles, Fredonia, Kansas, 1980.

6

Fundraising

Local arts agencies have been established through local initiative in communities throughout the country for the purpose of supporting the arts. They currently represent a significant source of financial, administrative, promotional, and other service support for professional arts institutions, individual artists, neighborhood arts groups, and nonprofessional arts organizations. They are committed to play an increasingly effective role in creating a climate and the material conditions in which the arts can thrive.

The 1979 membership survey conducted by NACAA showed that, overall, such agencies were providing more than $70 million in grants and services for support of the arts. Those dollars assisted the following groups or types of efforts:

Professional arts institutions and programs (symphony orchestras, dance companies, museums, etc.)	30%
Arts services (promotion, facilities operations, arts in education, etc.)	27%
Individual, professional artists (including those funded by CETA)	18%
Cultural pluralism (festivals, folk, ethnic, and minority programs)	16%

Nonprofessional arts activities (community theater, choruses,
etc.) 9%

A similar profile using data gathered in December 1980 for a current-
year sample of 12 cities and counties ranging in size from Chicago (popula-
tion 3,369,357; current operating budget $3,297,673) to Salinas, Kansas
(population 37,714; operating budget $165,000). The sample shows an in-
teresting relationship to the 1979 NACAA figures above:

Professional arts institutions and programs	40.0%
Arts services	15.2%
Individual, professional artists	31.0%
Cultural pluralism	9.3%
Nonprofessional arts activities	4.5%[1]

In the last decade, the number of local arts service organizations that
perform the united arts fund function has increased to more than 51 in 27
states. In 1981, these groups raised more than $31 million (see Table 4). A
united art fund raises money for the operating support of at least three
separate arts organizations, which are in some way restricted fom individu-
ally approaching the donors to the combined campaign. North Carolina,
where the private council movement started early and has stayed strong,
has eight such councils, more than any other state. The united arts fund
service organization that raises monies for the arts in a federated or joint
appeal serves to solidify the private sector around this activity. The concept
of getting the community behind one gift for the arts has the advantages of
reducing the number of solicitors and of placing the responsibility for allo-
cations with persons who have made it their sole business to know the arts
community. Problems can come when the drive that generates monies does
not keep up with the individual organizational needs in the community.
For those communities, there are, in general, significant amounts raised;
without such a concerted effort, the results might not be nearly as im-
pressive.

Of the over 51 united fund drives, about one-third are in one of the 50
largest cities. In those cities, a few have another agency servicing the arts,
usually called a council; it may be private, as in Houston, but in some cases,
it is a municipal agency. What does this say about the needs in these cities?
Probably only that they are sufficiently diverse that no one agency can han-
dle them all.

United arts fund organizations range widely. There are those whose
sole purpose is to raise monies from the corporate sector alone, such as the

TABLE 4
A Ten-Year History of United Arts Funds

United Arts Fund	1972	1973	1974	1975	1976	1977	1978	1979	1980	1981
Alamance County, NC	—	—	—	—	—	—	—	—	26.2	30.0
Atlanta, GA	626.8	637.9	643.0	749.0	749.0	763.6	956.0	960.7	1115.2	1322.4
Battle Creek, MI	51.7	53.4	55.1	57.3	74.5	90.0	105.5	108.6	124.1	132.1
Binghamton, NY	102.3	123.8	134.8	139.7	157.8	181.8	159.1	165.6	2129.4[a]	2865.1[c]
Business Arts Foundation, NJ	—	—	—	—	—	—	—	—	400.0	400.0
Canton, OH	161.8	161.0	184.3	228.4	217.4	245.1	270.0	286.7	298.0	326.5
Charlotte, NC	241.4	250.6	257.5	297.4	271.6	372.6	512.7	580.1	660.6	740.7
Chattanooga, TN	—	—	—	—	348.7	368.7	389.6	405.2	425.4[b]	451.5
Cincinnati, OH	618.4	1079.3	1003.3	1031.0	1112.0	1261.4	2009.2	2244.9	2447.3	2745.9
Colton, CA	—	—	—	—	—	—	—	—	—	278.9
Columbus, IN	—	—	—	45.0	44.0	43.0	74.9	72.9	75.6	80.0
Corporate Theatre Fund, NY	—	—	—	—	—	—	—	—	125.0	154.0
Dayton, OH	—	—	—	—	234.0	234.3	301.3	330.0	418.0	485.1
Duluth, MN	—	—	—	—	—	113.9	128.4	140.9	162.0	162.5
Durham, NC	28.4	23.1	33.2	29.9	—	34.9	—	90.3	113.6	138.1
Dutchess County, NY	—	—	—	—	—	—	—	—	81.0	103.4
Erie, PA	74.8	72.6	67.7	74.8	101.5	101.5	—	266.9	238.4	163.6
Fargo, ND	—	—	—	—	—	—	151.2	117.0	108.2	103.0
Fort Wayne, IN	149.7	184.4	180.3	181.0	193.0	225.2	284.0	287.5	287.5	295.6
Fort Worth, TX	243.4	211.0	234.0	413.7	480.6	651.5	743.0	720.0	836.9	850.0
Goldsboro, NC	—	—	—	—	—	—	—	—	20.0	32.7
Grand Rapids, MI	124.8	150.3	162.5	198.2	210.0	195.0	260.0	285.0	285.0	308.0

City										
Greensboro, NC	133.0	115.0	146.0	164.6	180.0	189.0	—	286.5	322.7	347.0
Hartford, CT	332.8	339.0	365.4	419.8	443.4	530.0	551.6	649.0	743.0	859.2
High Point, NC	—	—	—	—	16.1	24.1	52.5	54.5	38.4	70.5
Houston, TX	—	465.0	440.0	465.0	515.3	585.3	673.0	731.1	731.1[c]	796.0
Hutchinson, KS	11.2	12.2	12.7	11.8	9.4	9.0	—	19.9	—	—
Ithaca, NY	—	—	—	—	—	—	—	—	—	32.1
Lawton, OK	—	—	—	—	—	—	—	52.7	72.2	81.4
Lexington, NC	—	—	—	—	—	—	—	16.9	—	—
Lincoln Center, NY	1204.2	1283.2	1477.4	1496.3	1685.4	1742.2	2116.9	2549.7	2855.2	3326.5
Lincoln, NE	—	—	—	—	—	30.0	45.7	39.0	50.0	n.a.[d]
Los Angeles, CA	1850.0	1800.0	1785.0	1850.0	2475.0	2570.0	2938.9	3564.6	4091.3	4868.7
Louisville, KY	400.0	450.0	486.0	493.0	536.5	605.0	705.0	800.0	1021.0	1225.0
Manchester, NH	—	—	—	43.1	43.2	53.3	60.0	80.0	87.0	102.0
McPherson, KS	—	—	—	—	8.8	10.9	9.1	9.7	9.7[c]	13.6
Memphis, TN	154.4	157.7	210.0	206.4	320.0	252.0	327.2	428.9	517.0	600.0
Milwaukee, WI	789.0	918.2	1075.0	1138.8	1350.0	1553.0	2040.0	2199.3	2313.9	2449.9
Mobile, Al	112.6	130.8	134.2	137.2	114.8	131.7	128.4	132.0	81.0	n.a.[d]
Natl. Corp. Fund for Dance, NY	—	—	—	—	—	—	—	—	450.0	500.0
Oklahoma City, OK	319.9	280.3	356.0	382.4	450.4	450.0	525.0	641.7	754.2	1007.7
Providence, RI	239.4	255.0	271.1	250.0	252.1	243.2	146.1	157.5	144.6	130.0
Rapid City, SD	—	—	—	—	20.4	26.3	32.6	36.1	41.2	51.8
Reno, NV	—	—	—	—	—	—	—	—	45.0	—
Rowan County, NC	—	—	—	—	—	—	—	—	—	21.0
San Diego, CA	129.0	108.0	105.0	550.8	646.7	715.0	251.1	312.7	388.8	466.7
San Jose, CA	—	—	—	—	70.0	—	90.0	122.4	155.7	145.7
Seattle, WA	259.9	252.9	268.0	300.0	442.5	464.3	566.1	661.4	783.0	876.5
Springfield, MA	—	—	—	—	—	—	—	242.0	302.7	325.9

(continued)

113

TABLE 4 (continued)

United Arts Fund	1972	1973	1974	1975	1976	1977	1978	1979	1980	1981
St. Louis, MO	1007.0	1075.0	1400.0	1411.4	1512.7	1590.0	1708.0	1903.6	2004.0	2134.0[e]
St. Paul, MN	1041.5	1046.7	1108.7	1114.0	1300.9	1300.8	1224.8	1450.0	1450.0[c]	1349.0
Wausau, WI	—	—	—	—	49.3	60.9	65.0	86.0	79.8	86.0
Westchester County, NY	—	—	—	280.0	220.0	329.0	415.0	420.0	555.0	451.2
Winston-Salem, NC	142.1	183.0	216.3	227.3	295.9	316.5	391.7	430.6	6719.2[a]	6936.6[a]
GRAND TOTAL	10549.5	11819.4	12812.5	14387.3	17152.9	18664.5	21408.5	25150.6	28335.5[f]	31628.4[f]

Source: Robert Porter, ed. United Arts Fundraising: 1981 (New York: American Council for the Arts, 1981). Reprinted by permission of the American Council for the Arts. Copyright 1982.

Note: All figures in thousands of dollars.

[a]Figures show cumulative totals from three-year united arts fund/capital fund drive.

[b]This figure has been adjusted from the 1980 report to show an additional amount raised of $20.2.

[c]Figure is repeated from previous report. Respective drive was not completed at time of completion of report.

[d]Not available.

[e]This figure is the latest reported figure as of 11/1/81. . . .

[f]Total does not include figures referred to in footnote [a]. If included for 1981, the new total would be $41430.1.

Corporate Council of Seattle, and those for whom broad-based fundraising is only one of many activities like the united arts fund councils described in Chapter 4. Those with the focus on fundraising alone would probably be reluctant to be called arts councils. For purposes of these discussions, they are, however, one of the council species.

Although it started as a foundation in 1927, the Cincinnati Institute of Fine Arts became a united arts fund in 1949, making it, along with the Louisville group that started the same year, the oldest of such organizations. In 1949, Cincinnati raised $250,000; in 1982, the total was $3,000,000. It raises the greatest united monies, aside from the Lincoln Center Fund and the Performing Arts Council of the Music Center of Los Angeles County. Cincinnati has a population of 400,000; the SMSA population is 1,500,000. Since 1975, starting with General Electric, 45 corporations in the community have instituted payroll deduction plans, and 10 percent of the total campaign is gained from these gifts, which range from $1 up. Of the total of 25,000 donors to the Cincinnati Fund, 17,000 give at their place of employment, and 23,000 are individual donors. From 1949 to 1978, the Fund distributed operating or sustaining monies to four major arts organizations; since then, the number has increased to eight, and 30 to 40 project grants a year were instituted to emerging or smaller organizations.

The united arts fund councils tailor their structures to serve the needs of their particular communities. The breakdown of those drives — their policies, procedures, and administrative characteristics — is included in yearly *United Arts Fundraising* monographs by ACA. For instance, in 1981, 15 of these funds solicited individuals at their workplaces. Of these, some only solicited executives, some all employees. There were ten involved in payroll deduction plans to raise monies. In 1981, 34 funds solicited the general public mostly by telephone or direct mail. Government appeals were made by 46.8 percent (36.2 percent of which include all or part of these in their campaign) and private foundation appeals by 68.1 percent in that year.[2]

The ACA monographs also analyze the use of the funds and the allocations for symphonies, operas, dance, theater, museums, visual arts, etc. These charts are worth examining for those interested in the intricate details of the united arts funds, but show that while most funds distribute monies to symphony and chamber orchestras, fewer have supported visual arts groups, and still fewer arts centers.

Typically, the roots of united arts funds, like those of the Greater Hartford Arts Council, come from the business community itself as a conduit for its patronage. In 1980, $743,000 was raised there by 860 contributors for 34 arts groups.

Michael Newton points to the fact that "from the united fundraising effort may emerge a strong community council that can carry out many

other valuable functions in the community."[3] He also points to the fact that the united arts fund many times is not only a salvation for the small or medium-sized organizations unable to attract a board of top community leaders, but can present an opportunity for their development as well. The small or medium-sized organizations are the major arts council constituents.

One former state and community arts council administrator, now in the professional fundraising business, sees the private council functioning more and more in the fundraising area. The real contribution of the arts council in this field is that it has sensitized the community to the needs of the smaller organization, so that there is an understanding that they are important. The arts council, in his opinion, will lean toward fundraising for the smaller organizations, while the larger ones, already expert anyway because of the large amounts of money they must raise to exist, will do their own private fundraising. In many cities, they do so now; it is in the cities with united fundraising that this would be a shift.

Some of the united fund administrators are looking at incentives for fund allocation to stem the complacency that develops when organizations learn to depend on funds that they think will be available indefinitely. Some of those incentives might include assuring an increased audience by a stated percentage; reaching so many schoolchildren; and so on. Some of the incentives sound like reasoning from the public sector — affecting accessibility and outreach.

Critics of united funds feel that there is a need for an even better way to stimulate the best corporate giving. Some point to the avenue of employee deductions used by United Way and by ten united funds.

Some arts councils that have not chosen to undertake united fund drives may have done so because of the problems attributed to such drives, such as weaker giving of special individual gifts, allocation process problems that occur, atrophy on boards of benefiting agencies, and the amount of hard work needed to put the drives together.[4] Problems can come when the fund drive does not keep up with the organizational needs in the community. In some cities, it is surely true that more can be raised by the individual support groups than for the arts collectively. Even in the case of many of the challenge grants to a group of organizations under an umbrella, the matching monies are usually sought by each group individually, just as the proposals have been written and planned individually. With all organizations, large or small, there will be the need to plan well, to write solid proposals, and to be responsible for carrying out well-managed organizations and programs. The smaller organizations will always need help. They will never have enough staff members to cover all skills expertly.

The policy of what organization is eligible for funds and for what

purposes (sustaining or project) differs as the structure and purposes of the fundraising agency are laid out.

There are some agencies that have focused only on specific kinds of fundraising, or fundraising for a small number of institutions, for most of the years. As has been said, even these are reassessing their policies, faced with new pressures on the private sector. (Most such would not call themselves arts councils, even though some arts councils function as united fund drives.)

The St. Paul-Ramsey (Minnesota) Arts and Science Council was started in 1959 and began the United Arts Fund of St. Paul, raising funds for six arts organizations. Since 1980, it additionally provides operating grants to smaller arts organizations with funds set aside from its Arts Development Fund. Added as well were service and planning functions to help the groups become self-sufficient. Since 1978, over 400 artists and 78 organizations have been individually assisted.

Fundraising for the arts in Seattle is intriguing because there are two public arts councils (Seattle and King County) and several organizations in the private sector raising arts monies. Particularly interesting have been the divisions of labor, the understood roles, and the kind of leadership each group has had. They have, in essence, "picked every pocket."

The Seattle Arts Commission, with a budget of about $900,000 in 1982, is a city agency that has evolved from an older municipal group. It has contracted for millions of dollars of services from artists and arts organizations over the years, and performed a wide range of services. The King County Commission, working in the area around Seattle, was formed in 1967 and operated as a voluntary agency until 1972, when its first director was hired. Funds are provided to arts organizations for the purchase of free services for the public, as well as reduced price tickets and program activities in the performing arts, visual arts, community arts, literature, and media. The commission produces a catalogue of performances and workshops to make the services known. The major regional institutions are provided funds by formula.

The Seattle Corporate Council for the Arts (listed as a united fund) is operated as a nonprofit agency for the business community to process corporate contributions for the arts. It offers its members a comprehensive and equitable means of distributing dollars to the arts. As with the United Way, this is for sustaining dollars only, and contributors will not be further solicited by recipient arts groups for additional sustaining dollars. The Corporate Council guarantees a "return on investment" by careful scrutiny of art groups' fiscal and budgetary performance and by equitable distribution of dollars. It does not fund special projects, capital drives, endowment drives, or individual artists. In 1979, the Corporate Council provided 17

percent of the collective contribution needs of the Puget Sound arts community; in 1981, it generated $876,500. Their ultimate goal is to provide from 20 to 25 percent of the collective need. "Ongoing support is vital, but not glamorous."

The Downtown Seattle Development Corporation has a "fundamental commitment to the arts" through direct funding for projects, in-kind services, and such programs as free concerts and events called "Out to Lunch." Program dollars are raised from more than two dozen businesses. Unlike sustaining funds, which usually come from the corporate contributions divisions of the corporations, these funds come from marketing and public relations areas. There are acknowledged publicity and public relations values for the corporations in their "giving."

Since 1963, a volunteer group of arts patrons in Seattle called PONCHO has raised close to $4 million through an annual auction (it raised $237,250 in 1980). Its leadership are patrons of the arts and corporate leaders. No policy for distribution is spelled out to the applicants, but applications are reviewed by a rotating 11-member review committee. The grants are varied — for capital, operating, and program expenses. PONCHO has mostly funded projects, but its members essentially divide the dollars any way they see fit.

One cannot speak of Seattle's systems of support for the arts without mentioning in the same breath the group behind the groups, Allied Arts, Inc. "They are where you go if you want to *do* something," says one of the city's leading citizens. They have pulled everyone in that city into support for the arts. But their definition of their concerns is a broad one, and over the years has included the beautification of the city and the saving of a marketplace, as well as being key to the development of the Seattle and King County Arts Commissions. "They broke up the old businessman's network; they had vision and knew how to get to the heart of a budget and the appointments. This is exactly the key to their success," says one of their most ardent admirers. The Allied Arts Foundation, a separate organization whose sole function is fundraising, has mostly supported small and emerging arts groups.

In Seattle, then, with two public councils, more than three private fundraising groups, and a citizen advocacy support group, most of the possible fundraising roles are covered.

More cities are starting to divide up their fundraising functions. Such cities as St. Louis and Atlanta each have two arts agencies; one is a united fundraiser, the other a more public arts council group. In Atlanta, a third group is developing to gain support for smaller arts groups to complement the fundraising of the Atlanta Arts Alliance, which concentrates its effort on the Atlanta Memorial Arts Center and its five major arts institution units. In addition, a new public agency, The Fulton County Arts Commission,

has started to administer public monies. We will perhaps see more of this phenomenon as the pressures for fundraising in the private sector increase.

In the private sector, it should be noted that in cities with strong foundations and corporations, the possibilities for innovation and local initiative always exist. The Lilly Endowment has often served as a focus for generating public cultural projects in Indianapolis. There is the example of the Cleveland Foundation and its work in behalf of a challenge grant for six performing arts groups in Cleveland and Playhouse Square. The agreement between the McKnight Foundation and four major arts organizations in the Twin Cities to establish a $20 million investment fund is another example. The foundation will provide $10 million, and the groups will provide the other $10 million. They will all share in the proceeds proportionately, except for $100,000 to be given to smaller organizations.[5] These efforts represent important commitments to local cultural stability, apart from the efforts of arts councils.

There are some private arts councils that function to allocate public monies to arts organizations. One of the largest private councils to do so is also one of the newest (formed in 1978) — Houston's — with a 1982 budget of about $3 million, of which $2,779,575 is for allocations. Allocation monies are generated from part of the hotel/motel tax. This allocation process is the major function of that agency, as it is in Columbus, Ohio, where the Greater Columbus Arts Council will distribute hotel/motel tax money of $425,000 to $475,000 in 1982. In Columbus, 20 percent of the hotel/motel tax is designated for this purpose by city code.

Chapters in two different publications, "Alternatives for Public Financing of the Arts,"[6] and "Funding Local Arts Outside the General Fund,"[7] summarize the ways in which public funds have been generated for the arts in different communities. Although arts councils, because of their newness, have not always been the force behind the generation of public funds in the past, some have evolved from them and have been the beneficiaries, along with the arts organizations in the community. The generation of each source of funds has complicated details not worthy of reporting, unless one is researching them for local adaptation. Each locale has laws both in common with others and unique to its location.

Now that the arts in some communities have benefited from sales taxes (Erie County, New York, and Birmingham, Alabama), liquor taxes (Huntsville, Alabama), racing taxes (Tampa, Florida, and Aurora, Illinois), tobacco taxes (Birmingham), property taxes (St. Louis; San Francisco; Hennepin County, Minnesota; and Chicago), hotel/motel taxes (Chicago; San Francisco; at least 56 Texas cities[8]; and Columbus, Ohio), bonds (Dallas, Charlotte, Salt Lake City, Minneapolis, and Chicago), cable franchise money (Atlanta), revenue-sharing funds (Dodge City, Kansas), and the percent for art laws discussed in another chapter, arts councils of the fu-

ture will be involved in generating those that are appropriate for their given community.

There are few examples of councils that have really done the key job of pulling the private and public sectors into a partnership in regard to their arts support. It's not that there has not been a desire to do it on the part of some, but, rather, that there is an inability to cross the threshold well. As commissioners of several large city councils have said, "It would be competitive if we solicited the private dollar; that is the purview of the arts institutions themselves." The united fund councils have generally focused on the individual and corporate gift, and some have been able to gather government funding as well, but not in significant amounts. And yet, the potential is probably greater for the private council to build the bridges between sectors, for they represent the greatest ongoing strength and ongoing community leadership.

Examples of private-public relationships of significance come from cities such as San Antonio and Buffalo. From a private role, reorganization in San Antonio (which grew out of basic research and planning for a National Endowment for the Arts City Spirit grant) caused the agency to assume a quasi-public or designated role. The city was giving $450,000 to three organizations in 1975; as of 1982, there are about 40 organizations receiving over $2 million. A purpose of the Arts Council is stated to "increase support for and development of the arts for the people of the city to become involved in the arts." Business and corporate support has increased by almost 500 percent.

In Buffalo, the Arts Development Service, a publicly designated private arts council, receives monies from both the city of Buffalo and Erie County. It also has been the coordinating force in generating a county allocation to the area's arts organizations of now more than $4 million, and regrants monies from the state to these organizations.* This was one of the first sites for the Endowment's CityArts program.

The secret of Buffalo's success has been good solid private leadership and commitment, innovative and sound management, and, therefore, local respect and trust — credibility, which is the key to the link with government. The success has been attributed to subtle personal relationships that can work when action is needed. The whole organization reinforces local pride. Although a public agency has been brewing, it is believed that the service role of the Arts Development Service is so strongly respected that there would be no attempt to overlap. "It would be the role of a commission to implement laws," a former director of the Service points out.[9]

*The Arts Development Service helped them generate *new* monies; there were line-item grants to some larger cultural institutions before the development of the Arts Development Service organization.

It is the private council that can be middleman to the various sources of funds. An example of a private council with a major fundraising function is the Council for the Arts of Westchester County (New York). Their united fundraising initially solicited only corporations, but it has now expanded to include individual and public funds. Recently, some 50 arts organizations, with budgets ranging from $1 million to $1,000, received monies. Many councils have developed active business and arts communities as part of their services to stimulate awareness of need for corporate response.

The agencies that do fundraising best most likely find themselves friends of the major arts organizations, who receive the funding assistance as do the smaller organizations. The local public funds these organizations receive (when they are not line items of long standing) have usually come about because the arts council has pulled together the funds and developed a process for allocation.

When all is evaluated, however, this relationship with larger institutions is somewhat tenuous for most arts councils. In the Buffalo situation, the issues of sanction from those major institutions were taken care of in the beginning "when the clout on the council board settled the credit issue with their peers." Their membership in the council was sought so that they would form part of a "collective voice."[10]

There was a great deal of importance attributed to this "collective voice" in planning for the first tax monies that Cuyahoga County (the county in which Cleveland is located) would give to the arts. Beyond the Cleveland Area Arts Council's initial work, this collective effort has remained one continuity for future planning, and the amounts have increased annually.

Almost all cities with arts councils, especially those that are not united arts funds, have mentioned their desire to be more involved with the major institutions. In the smaller communities, these desires are mirrored. But the number of organizations are fewer, and their needs are on a different scale.

Fundraising makes arts councils useful to the arts organizations and forces them to explain the arts to the public. And yet there have been some that really have not seen this as *the* primary function. These councils have been busy meeting other needs of the community.

NOTES

1. Henry E. Putsch, "Background for Recommendations," Section III of *Local Community Arts Agency Policy Development* (Washington, D.C.: National Endowment for the Arts, 1981), p. 6.

2. Robert Porter, ed., *United Arts Fundraising: 1981* (New York: American Council for the Arts, 1981), p. 3.

3. Michael Newton, "Pros and Cons of United Fundraising for the Arts," in *United Arts Fundraising: 1981*, ed. Robert Porter (New York: American Council for the Arts, 1980), p. 6.

4. Ibid., pp. 7–9.

5. Charles C. Mark, *Arts Reporting Service*, no. 260 (February 9, 1981), p. 4.

6. Marcelline Yellin, "Business and the Arts," in *A New Kind of Currency: A National Conference on the Role of the Arts in Urban Economic Development* (Minneapolis: Minneapolis Arts Commission, 1978).

7. Luisa Kreisberg, ed., *Local Government and the Arts* (New York: American Council for the Arts, 1979), Chapter 13.

8. Cultural Arts Council of Houston, "1980 Hotel/Motel Tax Survey" *Houston Arts*, Summer 1981, p. 11.

9. Maxine Brandenburg, former Director, Arts Development Service. Personal communication, 1980.

10. Ibid.

7

Technical Assistance and Training

Among the major services provided by arts councils have been programs — usually workshops — in arts management training. These are usually designed for those already in the field, and have proven to be in great demand. Many of the arts councils also perform technical services related to fundraising to help their constituent artists and arts organizations gain expertise and sophistication in the fundraising areas. These range from technical assistance on how to prepare grant applications to short courses in accounting and organizational management. Such workshops have been given as well by the national service agencies — ACA and the Association of College, University, and Community Arts Administrators (ACUCAA). In addition, single-discipline organizations have been able to get help from specialized service groups such as ASOL or the Foundation for the Extension and Development of the American Professional Theater (FEDAPT) or the Western Association of Art Museums (WAAM). Some state and regional groups have been conducting workshops, as have statewide assemblies of community arts councils. There never seems to be enough help to meet the needs of those who face the everyday problems of being the all-around manager of the single- or multifaceted, single- or multipurpose, single- or multidiscipline community arts organizations. A council like the one in Westchester County, New York, can report having sponsored over 70 workshops for artists and arts organizations.

Some of the more unique training programs have been Cleveland's Continuing Education program (extended and part of the program of the

Greater Columbus Arts Council at Ohio State University); Sacramento's program to help artists; the training programs of the Cultural Alliances; and the County and City Planning program being implemented by the state of California for community planning.

The Studies in Arts Administration program at Ohio State University's College of the Arts evolved from a three-year pilot program developed at Cleveland State University and implemented by the Cleveland Area Arts Council through a grant from the William J. Donner Foundation for professionals in the field. In Cleveland, the program involved year-long internships with five major arts organizations. In Columbus, courses were taken for credit or audited, and given in cooperation with the Greater Columbus Arts Council. At present, this council is conducting a similar program at Franklin University. These types of programs have a problem "taking hold" in an ongoing sense due to funding and personnel changes. Beneficial study might be focused on how community-generated programs, if desirable after a pilot phase, can create ongoing institutional support.

The Sacramento program, which takes an experienced team around to constituents for sessions on the "Fine Art of Survival," is aimed at the serious artist. The message is to "get yourself organized. Get out and do your own selling. And hang in there."[1] These sessions are presented by lawyers, accountants, and other arts administrators. While Sacramento's program is exemplary, there is hardly an arts council that doesn't provide some sort of assistance in the form of workshops for artists and arts organizations. The need is so great that there is always a ready audience for the information. The quality depends on the quality of planning and the expertise brought to the sessions. There is a wide range between the best and the worst of them. Perhaps some of the best have been given by other organizations, such as Poets and Writers, Inc. (New York City), the New Organization for Visual Art (NOVA) (Cleveland), and the Artists' Foundation (Boston) — organizations set up specifically to assist individual artists. The arts councils assist them in a multitude of technical ways, probably best in sessions on grantsmanship and organizational matters (such as board-staff relations), especially for the small and medium-sized organizations. Any major organization that has been around a while, having had to deal with these issues for a long time, probably has access to expertise more suited to its particular discipline from its own peer group.

The Sacramento and Columbus councils see as a priority being an effective and efficient source of technical assistance in arts management. They have gone about it in very different ways. But both provide a lot of individualized consultation on organizational planning and development, as well as personal management seminars for individual artists.

Important differences mark the priorities of these and other organizations (usually known as "cultural alliances"), the best known of which are

the Greater Philadelphia Cultural Alliance, the Massachusetts (formerly Metropolitan) Cultural Alliance of Boston, and the Cultural Alliance of Greater Washington (D.C.).

The alliances differ from any commissions or councils in that they are not involved in funding arts organizations or programming for the community — *they are in business to serve the cultural sector*. The advocacy role of the alliances is also important, as they try to keep their memberships informed and educated on critical issues affecting them, and to represent and articulate their collective interests effectively.

The Massachusetts (formerly Metropolitan) Cultural Alliance of Boston* has developed an extensive program of workshops and symposia designed to teach and train the cultural administrator in management skills. One series, made possible by a grant from business (the First National Bank of Boston), consisted of 32 workshops and comprised a "significant and coherent management training program at low cost." The range of subjects covered include the expected ones, such as obtaining grants and funding, as well as some less often available, such as "trustee development" (which examines ways to "improve the workability of your board"). Costs were reasonable but substantial enough (about $150 for members and $225 for nonmembers) to insure a serious clientele. The Cultural Alliance of Greater Washington has a similar program. In Philadelphia, the services include a Matching Gifts and Rebate Plan being cosponsored by the Greater Philadelphia Cultural Alliance and the Western Savings Bank, which encourages greater individual support of nonprofit cultural institutions. This employee benefit program enables bank personnel to join cultural institutions at discount rates, as well as to make contributions to the institutions that will be matched by the bank.[2]

The package of services provided by each of these organizations is impressive. Examples of those provided by the Washington group include a cooperative purchasing plan with discounts from 25 to 60 percent; health and welfare insurance; a cooperative mailing service; legal liability insurance for directors, officers, and trustees; and a management development program. Arts councils have traditionally offered some of these services, but the alliances have concentrated on getting in, negotiating, and planning the service with outside professional businesses, and then on getting out instead of providing the service themselves. Theirs becomes a communication and monitoring role. Communications about these services is important, but remains one of the problems. If an artist needs them but hasn't read the material, it's as if it did not exist.

Cultural alliances must ultimately survive through the support of their memberships, but since they are serving nonprofit organizations that

*In its evolution to the Massachusetts Cultural Alliance, the group reflects its new services, which are statewide.

are not revenue-bearing, the funding potential is small. Although every organization, large or small, can use these services, the small ones need some of them most and have the least money.

NOTES

1. William Glackin, "The Fine Art of Artistic Survival," Sacramento *Bee*, September 30, 1979, p. 3.

2. Greater Philadelphia Cultural Alliance, *Annual Report* ("Collective Services"), 1980–81, p. 5.

8

Facilities

Facilities can mean opportunity. They can symbolize the rebirth and redevelopment of neighborhoods or an entire city downtown area. They can represent the spiritual and physical meeting place for a community. They can be the focal point for increased and concrete economic values of a business community. They can mean opportunities for local artists, arts organizations, information and performance exchange, and exhibits. They can create hope, and more than that, ongoing support for artists. They can be the places where all people in a community feel good about coming together. The sum is really greater than any of its parts.

Arts councils have looked at the needs for cultural facilities in their communities since the beginning. Some, over the last 30-odd years, have been integral to the development of arts centers and/or facilities. Some have been instrumental in helping to raise private or public funds in behalf of purchase, renovation, or construction. Some have been tenants, and some have been owners and managers. A smaller number are responsible for year-round programming and management. Some, and more in the future, will see the relationship of the arts facility to the total image of the city.

In response to a request from HUD, an *Analysis of State and Local Government-Supported Cultural Facilities and Resources* was done in 1978 by the U.S. Conference of Mayors and NACAA. Even though the study was done too quickly to be thorough (involving only 11 percent of the

Conference of Mayors membership and ten experienced community arts consultants), it showed the task of determining the number, nature, and use of publicly owned facilities in the arts to be monumental. Neither the arts nor the municipal officials had reliable data; original research would be needed in many cities. The research was further complicated by the difficulty of defining "arts and cultural activities," "arts attendance," and "parks attendance," and of determining the "arts attendance" in a multipurpose facility. The comprehensive study that would attempt to answer these questions still awaits undertaking. However, the *Analysis* did show that

> community arts agencies and local government have, however, become closely related in most communities in recent years, and the relationship is expected to become much closer in the future. Cities need arts agencies to help keep the "art" in arts activities; arts agencies need the cities for financial survival.
>
> Many community arts agencies remain completely independent of local government, but most are seeking support from their local officials, and there is a clear trend toward increased cooperation.[1]

Except in a few stellar situations, arts councils have not embraced total philosophies that look at the arts in relationship to the whole city, physically and spiritually. In Winston-Salem, where there is a long history of the Arts Council's involvement,

> officials are optimistic that the arts can help the city even more by attracting investment and stimulating economic renewal. The city's commitment to the construction of a culture block has already brought promises from corporations to refurbish businesses and hotels. Investors recognize that theaters, galleries, and other types of performing space mean good business.[2]

This concept goes beyond that of individual buildings or complexes and includes studies such as the one focusing on the design and feasibility of the establishment of a Performing Arts District in San Antonio through the reuse of historically significant theater buildings.

In large urban centers, arts centers have often been built with public funds and are publicly operated. In medium to small communities, however, most arts facilities are privately owned and operated by nonprofit community organizations. Local governments often channel federal funds from EDA, CETA, and other agencies into them, but they remain essentially private operations. However, there is a trend toward more public financing and ownership of arts centers. Arts groups are finding that private contributions are not sufficient to cover inflated capital and operating costs.

There was an overall opinion by those surveyed that unless arts facilities were adapted appropriately, new construction was preferable. All too often adaptation of facilities for the arts is "like trying to fit a regulation football field into a 90-yard lot. It comes close but it doesn't make it."[3]

The location of the council itself may have some relationship to its image in the community. This was expressed by the media in Cleveland, regarding the housing of the council in the Old Arcade, Cleveland's premier landmark. The tenancy of Community Programs in the Arts and Sciences (COMPAS) at Landmarks Center in St. Paul is seen as symbolic of historic pride.

The Winston-Salem Arts Council, for instance, maintains the Hanes Community Center, which includes office space for member groups, a gallery, a theater, and an orchestra rehearsal room. In Greensboro, North Carolina, the Sternberger Artists' Center was a gift to the Arts Council from the Sigmund Sternberger Foundation; the home was converted to individual artists' studios. The Arts Council itself occupies the old Greensboro *News* Building left vacant in 1976. The building was purchased and is maintained by the city but is used by the United Arts Council and its seven funded members. There are six rehearsal studios, eight classrooms, office space, a printshop, a conference room, three large workshops, and four public galleries.

In both cities, the councils have been involved as well with the renovation of spaces for the arts. In Greensboro, the space is the Carolina Theater; in Winston-Salem, the project is Winston Square, focusing on the renovation of several contiguous buildings and open spaces in the center of town, expanding Hanes Center, and constructing a concert shell, all of which will assist the major professional arts institutions as well as community groups. Another Carolina Theater in Winston-Salem is also being made into the Roger L. Stevens Performing Arts Center.

Initially the endeavors of the St. Paul-Ramsey Arts and Science Council included the promotion of cultural activities and fundraising for the Arts and Science Center, which became the home of the Council and some of its agencies. Although the Council has a coordinator role, has developed some centralized services, and acts as a cultural advocate, the management of that facility has been a part of its function.

Four United Arts Fund agencies are housed in St. Paul's Landmark Center, the old Federal Courts Building, saved from the wrecking ball weeks before its scheduled demolition (the council itself subsequently moved to Landmark Center). The Landmark Center is the newest member of the United Arts Fund, and the Council has been instrumental in assisting it to gain its new life. The 1981 program projection included a full schedule of arts events, some sponsored by the four tenants.

In Fredonia, Kansas, the Fredonia Arts Council, Inc., was given a

hand-hewn stone nineteenth-century building; in Riverhead, New York, the East End Arts and Humanities Council uses the parlor of its headquarters, a historic downtown house, as a gallery.

Facilities, by the nature of their ownership and management structure, can cause an arts council to seem privately or publicly oriented. One must look carefully at the ownership-management structure, which can be complex, to understand the arts council's role.

About 12 united arts fund councils manage arts facilities. But major programming responsibilities and decisions are usually made by the resident groups.

At times, funding drives for organizations housed in arts centers or complexes are organized as one. Examples of this include the Atlanta Arts Alliance, which raises money to operate the Atlanta Memorial Arts Center and its organizations – the Atlanta Symphony Orchestra, the High Museum of Art, the Alliance Theater, the Atlanta Children's Theater, and the Atlanta College of Art. The Arts Alliance raises less than 15 percent of the total operating costs, the balance of which are covered by admissions, memberships, divisional special fundraising events, and income from endowment and government grants.[4]

In some cases, the council is more than manager and landlord; it is the major programmer. One significant example is the Cultural Resources Council of Syracuse and Onondaga County, Inc. The development of the Civic Center and its operation and programs, which the Council manages for the county and city, is well documented in the book *Olympus on Main Street,* by its director, Joseph Golden.[5] The Council has been in existence since 1966, the Civic Center since the mid-1970s. The council, which is private, has a management contract with the county, which owns the building, to staff, program, and promote the Center – a three-theater complex that houses many of the community's arts groups. Thus the Council has become integral to the arts programming of the city and county. It is responsible for filling time and seats, and, in very concrete ways, for the health of the arts in that area.

This multiple character makes the Cultural Resources Council unique among arts organizations, for it performs three roles: that of an arts council, a theater manager, and a presenting organization. Its roles are developed along several lines: professional programs, community support services, and community education programs. In concrete terms, those programs, which bring about 300,000 annually to public events, range from performances of professional companies like the New York City Ballet, to a 13-event program of music, dance, and theater styled for the smaller 463-seat Carrier Theater. This theater has been used for a jazz festival; a high school drama festival; programs such as *Jacques Brel* and *Albee Directs Albee;* live Youtheater; and special series films.

In one recent year, the Civic Center theaters and related spaces were used 1,417 times (3.87 times per day) for concerts, plays, films, meetings, workshops, lectures, graduations, and other events. Two major activities of the Cultural Resources Council occur outside the Civic Center — the Festival of Nations, an annual event held at the 8,000-seat Onondaga County War Memorial, and "On My Own Time," a program for visual artists in business and industry, which culminates in an exhibit and reception at the Everson Museum of Art.

"Essential to all programs is a good public image developed by strong institutional promotion, effective marketing devices, and ongoing audience development activity that attempts to reach a broad base of community residents," the Center reports. The philosophy is "to bring the best young solo artists, theater companies, and dance companies into the community, and additionally, to provide a wide range of styles, attitude, and talents," and "[to supply] young audiences . . . with the best programming available."[6] There is programmatic backup for the philosophies expressed.

The Cultural Resources Council of Syracuse and Onondaga County provides services for the general public (such as calendars and directories); services to the arts community (such as mailing lists of about 30,000 and a resource library); and services to special audiences, such as the program in cooperation with Welcome Wagon, or Passport to the Arts — a subsidized ticket program for the disadvantaged and children from city and county schools and agencies. In addition, through the cooperation of the Syracuse and Onondaga County Youth Bureau, children from 40 agencies have been introduced to the arts.

The community programming service is one geared to "growth."

> Growth as seen in increased participation by agencies/institutions/businesses/individuals involved in the programming; greater acceptance by the local community and media of events as they happened at the Center or elsewhere; greater recognition of the programs by those outside the community; and finally, and perhaps most important, the positive impact of the arts on personal growth.[7]

Clearly, the Cultural Resources Council has links to all segments of the community it serves, as it manages and programs for audiences from 39 counties and 184 communities in New York State.

In San Francisco, there are now four neighborhood buildings owned by the San Francisco Arts Commission. The agency, hit by the impact of Proposition 13 and the demise of CETA, has been further taxed by problems of bringing the buildings up to code and dealing with maintenance and supplies. Basically seen as a trade-off for the city's attention to the major institutions, the neighborhoods were excited by the idea of centers

where the arts would be housed, and practical matters were overlooked. "There should have been a total inspection and analysis," everyone agrees. The centers have never really had enough to operate on. The present directors of the community cultural centers have been working to develop "Friends of" groups to provide support and raise funds for operating the centers. This effort would be coordinated centrally, and the hope is that they will develop into real citizen advocacy and support groups.

Facility management contracts must be carefully conceived, with well-developed budgets and realistic projections. Unfortunately, situations like the one in San Francisco are echoed in many cities where there are recreation centers. Most arts councils have not been involved in ownership or facility management, but city budgets notoriously leave the operation, maintenance, and programming needs far underbudgeted. Therefore, money is rarely available to program the facility to capacity, and the situation becomes very frustrating for the people in the neighborhoods and for those who could assist with the managing and teaching there. Some arts councils have tried to fill some of these neighborhood programming needs with monies from other sources.

The arts councils have been important in some cities in helping old spaces come to new uses for the arts — beginning with schools, storefronts, and single-theater renovation — and in conducting facility studies. A few coordinating groups have been involved in the fundraising for and managing of major arts centers, such as Atlanta's Memorial Arts Center. Community arts councils may more often run smaller ones, where there are needs for art classes, rehearsals, and performing opportunities.

Some of the attention to arts centers also emerges from revitalization of old significant structures in the downtown areas, as mentioned in connection with several North Carolina cities, or the construction of new buildings in many American cities. While peripheral to these developments in many cities, councils have been very involved in others, such as Louisville, Kentucky, where the council has served in an advisory capacity.

The arts council's commitment to the spirit of downtown renaissance can be reflected in small yet significant ways. In Cortland County, New York, the Arts Council, as part of its message, includes the fact that it has made a conscious decision about locating itself downtown in an abandoned historic building. It was involved in assessing reuses of the building, and in the five years that it has been there, the first floors, at least, in the other buildings have become reoccupied on the downtown strip. In Riverhead, New York, not only has the development of a downtown center brought people to it who have participated in all parts of its development, even in laying out its garden; but the center has been a catalyst for changing people's attitudes and thus for revitalizing the whole city.

In Atlanta, three former school buildings near the central business

district are now being used by various cultural organizations, with the encouragement and support of the city's Department of Cultural Affairs: the Atlanta Neighborhood Arts Center, Inc., which serves as a strong arts and cultural outreach facility for the community; the Spring Street School, now the home of the Atlanta Ballet, the Vagabond Marionettes, and the Georgia Lyric Opera Company; and the Forest Avenue Consortium, a multidisciplinary association of alternative arts organizations.

In Atlanta, the preservation activities of the Department of Cultural Affairs have been a priority, with many restoration efforts. Technical assistance is available as well, putting representatives of the private sector in touch with owners of historic properties and providing advice on construction standards, architectural design standards, tax benefits, and funding sources.

Some councils have been key in bringing in Challenge Grants and planning monies from the National Endowment for the Arts; monies from such sources as the Department of the Interior (Land and Water Conservation Fund, the Heritage Conservation and Recreation Service, and Urban Park and Recreation Recovery Program); HUD and EDA (Urban Development Action Grant, or UDAG); and Community Development Block Grants, for development and redevelopment in some of these instances.

In recent times, the concept of revitalization has been intimately related to the total city image, to spiritual renewal, and to the arts as a vehicle of that message. The impetus for the revitalization of Galveston, for example, came in large part from the Galveston County Cultural Arts Council. Founded much as all other councils have been — to create an environment where the arts could thrive — the Cultural Arts Council set out to make itself more representative and interested in the common goal of making the city more livable. The story of the economic and cultural renaissance of the city is the story of the Council's work, as it sought planning and programming money to make things happen. This included not only supervising study teams of experts, figuring out ways in which viable buildings could be purchased and resold, and overseeing commitments to restore the facades and interiors of buildings along the Strand district, but also finally creating an "Action Plan for the Strand." As Pamela Baldwin notes, "The resulting plan demonstrates an unusually broad sensitivity not only to the Strand's aesthetic value and potential, but also to important economic, practical and social concerns."[8]

The Galveston County Cultural Arts Council was thus instrumental in restoring for both nonprofit and commercial use a significant area of the city. They stayed with this priority through most of a decade, and it has paid off. The Cultural Arts Council, by applying for well-researched grants to accomplish different stages of development planning and by working with the community's private sector, including foundations and

corporations, was a catalyst for action that represented the "best of Galveston — the living spirit that has endured depression, neglect, and destruction and emerged as the soul of a truly livable city of the late twentieth century."[9] It was not always easy going, as anyone involved in such a long-range and complex activity will report; but they tried to bring in the best expertise, the backup for preservationist views, and the contemporary ideas that would make the project viable. The spirit of renaissance grew far beyond the original concepts, and a city was "caught up" with the help of the programmed arts — living, performing, and exhibiting.

The Galveston story is a story of "the right people," but also of using the small amounts of money from such sources as the Architectural and Environmental Arts program of the National Endowment for the Arts as well. Support from the Endowment enabled a group like this to think through its project before launching it, and also made it easier for the group to raise money from other sources, once it had had a chance to show its seriousness of purpose.[10]

The Endowment grants focused on opening doors — on the wide range of possibilities for conservation and revitalization; or, specifically, on neighborhood housing and structural rehabilitation and design; or on seeing the potential of transforming a deteriorating downtown into a vital one, perhaps by starting with the restoration and rehabilitation of an old building, which would effect the motivation to do more.[11]

Only arts councils that saw the broader implications of these programs ever became involved in these grants. The mainstream of city life includes the arts, but arts councils in too many cases have avoided the mainstream. Even the many exceptions — such as Galveston; Winston-Salem; Charlotte; Durham; Atlanta; Minneapolis; Birmingham; Escondido, California; Phoenix; New Haven; Cambridge, Massachusetts; Westchester County, New York; or Troy, New York — have ranged widely in their involvement beyond the study of a project's feasibility. Some studies have never been extended to the implementation stages.

In the 1980s, the arts groups will be looking for ways to deepen the alliances beginning to develop over these broader ideas. Local governments (the cities' economic development agencies), commercial developers, and arts groups will team to form such entities as cultural districts, which can be "anything from the Federated Arts Council's tentative first steps to restore a Masonic Temple community arts program in Richmond, Virginia. . . . to the $1 billion-plus Bunker Hill project in Los Angeles."[12]

A key component of a major five-year (1980–85) program sponsored by Partners for Livable Places, called the Economics of Amenity program, is a network of pilot cities that have committed themselves to improving the quality of life in their communities, and that will enter the program with assistance from nonpublic funds and a local advisory group. Topics of the program include "Tourism and Conservation," "Public Sector Design

Quality," "Cultural Planning," "Open-Space Management," "Profit by Design," and "Natural and Scenic Resources." The program is able, through this nonprofit coalition of organizations and individuals interested in improving the quality of life through enhancement of the built environment, to extend the work that can be done with limited Endowment dollars.

Partners for Livable Places is a national resource center for information on every aspect of the built environment. In their work they emphasize the process of partnership, the importance of local initiative, and the value of cooperative learning between public and private sectors for cost-efficient use of resources.

While many reasons might be given for which cities were chosen as pilots, one of the most cogent might be the interest of the public and private sectors in the areas under investigation.

While some of the cities chosen have involved their arts councils in the work at hand, only one arts council — the Federated Arts Council of Richmond, Inc. — has been an initiator of such activities. And yet these are the very aspects of city life that might most concern community councils. The Federated Arts Council (a publicly designated private council) is working with Partners for Livable Places in coordinating the local projects, which include various departments of local government, the business community, and citizens' groups. This work has focused in two ways: on a comprehensive facilities plan for the city of Richmond to result in an arts district, and an initiative in economic development for the city of Richmond, known as Richmond Renaissance. The latter has involved the development of coordinated black and white leadership to address economic issues including cultural amenities. Initial monies, $1.25 million in community development funds matched by the same in private dollars, will be used to organize the activities.

The fact is that "the economic vitality of a community is closely linked to the quality of local amenities," says Partners for Livable Places, citing two recent studies that show "that the physical, cultural, social, and natural environments in which Americans live and work exert a complex influence on their prosperity." While cultural and built-environment groups have been saying this for a long time, there has been skepticism about the financial return.

> Partners believes that amenity is a hard issue for a hard time . . . but that in a time of inflation, a weakened economy, and government cutbacks, it is more necessary than ever before to create healthy communities that people not only live in, but can believe in as well.[13]

Thus, while various arts councils have been involved in everything from managing a small building for the arts to overseeing a "cultural plan for a community," their real power in the future may be tied to how closely

they will be involved in the cultural planning. For this hits at the heart of the ways in which the arts of the community are identified as important by those who live there. This takes a level of sophistication few have reached, for it calls upon public administration skills and the ability to know the important aesthetic factors. Few persons or councils have been able to span both needs.

NOTES

1. U.S. Conference of Mayors and National Assembly of Community Arts Agencies, *Analysis of State and Local Government-Supported Cultural Facilities and Resources* (Washington, D.C.: Authors, 1978), pp. 4–9.

2. "The Economics of Amenity Program," *Economics of Amenity News*, (December 1, 1980), p. 16.

3. U.S. Conference of Mayors and NACAA, *Analysis*, p. 12.

4. Atlanta Memorial Arts Center (brochure, 1978).

5. Joseph Golden, *Olympus on Main Street* (Syracuse: Syracuse University Press, 1980).

6. Cultural Resources Council of Syracuse and Onondaga County, Inc., *Annual Report* (July 1, 1978–June 30, 1979), p. 7.

7. Ibid., p. 10.

8. Pamela Baldwin, *How Small Grants Make a Difference* (Washington, D.C.: Partners for Livable Places, 1980), p. 51.

9. Ibid., p. 53.

10. National Endowment for the Arts, *Downtowns: Reinvestment by Design* (Washington, D.C.: Author, 1976–77), preface.

11. Ibid., introduction.

12. George Clack, "Footlight Districts" *Cultural Post*, (January/February 1982), p. 1.

13. "The Economics of Amenity Program," pp. 1–2.

9

Information, Research, Media

Many councils produce comprehensive arts resource directories of the artists and cultural organizations, performing and exhibition spaces, and other resources of the area — an extension of the idea prevalent from the beginning that, if nothing else, arts councils could be expected to coordinate the community arts calendars. Many still coordinate calendars, depending on other publications in the area. Some provide the calendar information that is published by the area newspapers. Those councils that provide a look at the events to come in calendar form many times publish a newsletter or paper, which provides fuller information about the arts events of the community and their own undertakings. Although these councils would talk of themselves as advocates for the arts, these communications sheets, distributed all sorts of ways (e.g., in Walnut Creek, California, the Arts Department has had space in the *City Scene*, distributed by the Walnut Creek Leisure Service program by mail to all 35,000 homes in the county), are information sheets by and large. Rarely is there true editorial material or discussion of issues.

Exceptions of note include *Houston Arts*, the quarterly newsletter of the Cultural Arts Council; the Seattle Arts Commission newspaper, *Seattle Arts*, which has included discussions of issues (most memorably the percent for public art laws and issues concerning individual artists); and the King County publication, which has treated similar topics from other angles. These sheets also communicate in depth about the programs and undertak-

137

ings of the councils in the Seattle area and provide information about pub-
lic meetings, hearings, agendas, and reports — the business of the arts in the
city.

 The Cultural Alliance News, published by the Cultural Alliance of
Greater Washington (D.C.) ten times a year, also has taken on issues about
the arts. Some of the articles are written by professional journalists. "Mail
Laws and Nonprofit Arts," a series on the problems that handicapped per-
sons face in gaining greater accessibility to arts programs and facilities, and
"Media and the Arts" are examples of the subjects covered.

 Such publications, while very informative, still do not reach the num-
bers of people who might make use of the information. More might appear
in hotel rooms and grocery stores. Some from the private councils are dis-
tributed free (underwritten by local business), but others are available by
membership or subscription only. In the case of city commissions, publica-
tions such as *Seattle Arts* have been available by request and free of charge.

 Publications of the various councils are used for different reasons.
Many arts council administrators have said that they are caught between
getting publications that look too expensive and "Madison Avenue," on the
one hand, and getting something that does not say by its design that its pub-
lishers are involved in the arts on the other. (Any publication of this sort
ought to look well, be of good design, and say by design that it is produced
by an arts council.) Being informative, current, usable, and ultimately
read is as much a problem to these organizations as it is to any anywhere. As
the advocates they say they are, it would be beneficial for those who pro-
duce these publications also to pose the issues. No other organizations are as
suited to this task.

 The Chicago Council on Fine Arts has issued publications to inform
Chicagoans better about a range of matters. While the *Guide to Chicago
Murals: Yesterday and Today* is a directory of the city's vast indoor/outdoor
"museum of walls" and is not intended as a definitive scholarly study of the
subject, it includes some historical material on mural art in general and the
Chicago walls in particular. Far afield from this publication is a *Guide to
Careers in the Arts* to assist people seriously considering a career in the arts.
Others include a simple listing of the Chicago museums and "Your Guide to
Loop Sculpture," a particularly handsome brochure.

 Many community arts councils have researched and published eco-
nomic impact studies, influenced by such documents as William Baumol's
1975 evaluation of the economic impact of the theater strike on New York
City.[1] Arts councils seem a natural agency to sponsor, oversee, and even
conduct some studies and surveys for their individual communities. And
they have. Many times, as in the case of the arts facilities studies in Dallas,
San Antonio, and Minneapolis, outside professional firms may be called in
to do the work that is their specialty. The San Antonio Arts Council com-

missioned a reuse and feasibility study of six historic theaters in the down-
town area — investigating the feasibility of establishing a performing and
creative arts center that would use the theaters. The Cleveland Area Arts
Council did its own feasibility study for a downtown gallery for traveling
exhibits, and also supervised a study for a film festival. In the more complex
area of preservation, the Council supervised a study on potential uses and
ownership of the Old Arcade, a commercial and office facility on the Na-
tional Register of Historic Places.

The research area that has been given most attention by community
councils has been that of economics. As a "tool" for identifying in depth and
in concrete terms the reasons why the arts should be supported, economic
impact reports have been especially useful in approaches to the business
community and legislators. As Charles F. Dambach, former Executive
Director of NACAA, has pointed out in the introduction to the report *The
Arts Talk Economics:*

> To the surprise of some, economic impact studies have shown that the arts
> play an important role in the local economy. As this report indicates, the over-
> all impact is quite significant. Employment rates, business enterprises, the
> local credit base, and the local government tax base are all affected by the
> arts. . . .
>
> Economic impact studies like these have taken their place in dozens of com-
> munities as part of the arsenal for building support for the arts in America. The
> fiscally conservative governor of a large Eastern state recently declared that he
> increased the budget for the state art agency by 45 % when he was shown that
> the state's investment in the arts would reap economic rewards. This is both an
> encouraging and a disquieting development. To the extent that economic im-
> pact information helps generate understanding of the total role of the arts in
> society and to the extent that it helps make the case for increased support, it is a
> positive development. On the other hand, there are serious risks. . . . a man-
> agement eye of economic impact could result in an imbalance in arts program-
> ming. Most of the positive economic impact can be attributed to a few major
> institutions that draw large audiences. Small, esoteric, avant-garde, and
> neighborhood programs rarely demonstrate a significant or positive financial
> return for the investment. Yet these programs are vital to the quality and di-
> versity of cultural life in the community.[2]

There seems to have been two major ways of conducting this work.
One surveys some arts organizations; the other is on a broader scale. One of
the first, involving arts organizations, has been used by the Greater Phila-
delphia Cultural Alliance and as a model by other arts agencies, such as the
Indianapolis Metropolitan Arts Council. In Chicago, the *Survey of Arts
and Cultural Activities,* done in 1977, was a broad survey (earlier studies
had been done in 1966 and 1971) and had expansive goals — identifying art-

ists, arts organizations, and cultural institutions, as well as arts needs and expectations of the city as a whole. For this comprehensive study, a total of five surveys were conducted; on the basis of the results, a series of recommendations was made.[3] Other cities and counties, such as Birmingham; St. Louis; San Diego; Worcester, Massachusetts; Toledo; and Dade County, Florida, have done economic studies through their councils.

Another model has influenced the field. In 1976 and 1977, a pilot effort was conducted in Baltimore; out of the creation of a model for assessment, the staff of the Johns Hopkins University Center for Metropolitan Planning and Research—in partnership with arts agencies in Columbus, Ohio; Minneapolis–St. Paul, Minnesota; Springfield, Illinois; Salt Lake City, Utah; and San Antonio, Texas—conducted six case studies. The variety of different types of museums and performing arts organizations of examined institutions is "an illustrative cross-section of some of the more well-known local resources in each city."[4] The project was supported by the Endowment, "with significant cost sharing and donated services by Johns Hopkins University and local sponsoring agencies."[5] A report of the total project, *The Arts Talk Economics*, is available and reviews procedures in each city and the data used.[6] It is hoped that this work in summary will "lead to a better understanding of the economic effects of various types of arts activities in alternative community settings."[7] Because the six individual case studies dealt with a limited number of institutions selected by the local sponsoring organizations (in Columbus, for example, six of 170 nonprofit arts and cultural organizations), one must be careful not to interpret the results as studies of all local artistic and cultural activities.

It is recognized that these studies are limited in nature—focused on "direct dollar flows represented by the institution's local expenditures for goods, services, and labor, and the expenditures of its guest artists and audiences."[8] Because of the limited, cautious, and conservative nature of the estimates, these studies uncovered only the tip of the iceberg.

The Johns Hopkins studies are not intended to be interpreted as judgments passed by the examiners on the role of the institutions involved, or as indications of support preferences. In other words, the individual cities involved need to use judgment and caution in interpreting the facts. There have been other economic studies, including those in St. Louis and Washington, D.C., and in New England.

In an article in the *Wall Street Journal* (July 14, 1978), Stephen J. Sansweet said, "Based on state and local actions to date, it seems clear that most officials see the arts as an area that is not only expendable, but one that doesn't have a constituency that will fight back."[9] A month later, in Syracuse, an emergency meeting of the boards of directors and staffs of eight area cultural organizations was, it would seem, staged almost as if to refute that comment. The purpose of the meeting was "to reveal the results of a re-

cent study of the economic impact on culture of the community and to discuss what actions must be taken immediately to insure that public funding of cultural, historical, and human service agencies in Onondaga County be maintained at a healthy and meaningful level."[10] It was the first time the boards of the eight county-funded agencies had ever sat down together. Although the session was to share information, it was also called in response to challenges to county funding of the arts by members of the legislature. The agencies mounted a well-focused joint campaign, "Support the Arts: Culture Means Business," to meet any future challenges. The session was not to plan any joint funding; it was rather to understand mutually the impact of the arts in that area, and to make the facts of the survey useful.[11] The facts and these people, armed with the force of concrete economic material, did convince the legislators.

In a first proposal, *Direct Support of Cuyahoga County's Cultural Resources*, submitted by 12 arts organizations under the coordination of the Cleveland Area Arts Council, the introduction emphasized the results of a recent survey showing the impact that total budgets, employment, purchasing power, and audiences had on the quality of life in the county, and also the manner in which the county was perceived by its citizens and by the rest of the country. An article in *Time*, depicting Cleveland's then dark economic and political future, praised the county's cultural assets. There were references in the proposal to the "ripple" effects on the local economy. It was part of a winning argument for the first tax monies for support of the arts organizations. Since then, the allocation has increased annually.

Some cities and counties have been assessing the state of their cultural affairs for some time, and it would be wrong to diminish the contribution of these earlier studies (done in the 1960s) to developments that came after they were done, such as the *Report of the Mayor's Committee on Cultural Policy* (1974), which recommended the restructuring of the coordination of New York's cultural affairs. Many communities, such as Chicago and Syracuse/Onondaga County, had formerly studied their cultural affairs. These more recent studies are interesting in that some have been used for the specific ends indicated.

One impressive example of careful work is the feasibility study for the creation of an arts center done by the Huntington (Long Island, New York) Arts Council. While the study showed that the arts center would be feasible, the Council, after assessing the amount of money available and needed to accomplish such a feat, decided *not* to go through with the project. "It was feasible at what price? The other major organizations had performing halls, so it just did not seem to make sense," explains the Director. The story is a rare example of denial in an era of expansion.[12]

In Minneapolis, a study that resulted in the expression of a need for

space led the Arts Commission to seek a project that would lend itself to arts needs and the city's economic development priorities. The Masonic Temple was identified as highly desirable, since the interior spaces were easily adaptable to dance and theater uses, and the city had plans for Hennepin Avenue to become a cultural and entertainment center. The Temple would be the catalyst for further development on Hennepin Avenue. The Endowment Design Arts funded the feasibility study for the development of the Masonic Temple as an arts center, and in 1979 Hennepin Center for the Arts opened its doors. Minnesota Dance, Cricket Theater, and eight other organizations took up residence and began to operate downtown. Commercial activity on the basement and first-floor levels has been expected to offset the low square-footage charges to arts users. The Minneapolis Council envisioned other studies or plans for use of other unused spaces for artists' studios, community arts, and small presses. One such possibility was the exploration of a program that would allow the Board of Education, through these uses, to retain and keep open schools that have been slated for closing.

Studies and planning grants to councils at various stages of their own development, many times under the auspices of the Endowment City Spirit programs, have formed the basis of concrete information for stronger and more effective council work. The Monadnock Arts Study, now published as *Marketing the Arts in a Rural Environment*,[13] proved in 1977 that

> People would like to see an increase in the availability of performing arts and cultural activities in their communities and understand the need to support these very costly activities through public funding. A substantial majority indicated that they would be willing to pay additional tax dollars to support performing arts and cultural activities.[14]

Thus, the potential function of research by arts councils themselves, or research conducted under their supervision, has been verified. In one sense, if a council were consistent about studying community need, research would be an ongoing function. Specialized research takes professional assistance, but councils seem more than willing to seek it.

The media have found the work of arts councils a difficult subject to get a handle on if the work is not heavily "program-oriented." The elements of human interest in festivals, classes for special constituents, and the visits of dignitaries are easily covered; the services and advocacy work are less so. Few arts councils have investigated, let alone used, the potential contributions of the local media to the achievement of their ultimate goals. Many have weekly programs, ranging from five minutes to one hour, over radio or television. They mostly cover artists or arts events of the community. Few try to deal with issues involved in the arts. One five-minute segment on

arts issues heard weekly in Washington, D.C., written and narrated by the Director of the Cultural Alliance of Greater Washington, has been particularly effective. He has discussed such subjects as the effect of the new bulk-rate mailings on arts organizations.

In New Orleans, a National Public Radio hour-long weekly radio program has involved many artists and arts institutions in its magazine format. The Arts Council there also saw the value of using *paid* spots (assuring better time slots than public service spots) on commercial radio to feature local artists and arts organizations. The arts organizations felt additionally supported by the Council through this means.

In Westchester County, New York, the Arts Council has included in its informational services public service announcements on radio that have run seven times daily on four stations. In Macon County, North Carolina, there is a weekly two-hour classical music radio program donated by the station and presented by the Arts Council.

Some councils have reported that the inclusion of media people on their boards of trustees has helped their own attempts at greater visibility, both through counsel and influence. Some discuss the fact that the local media have one reporter who is a particularly strong arts advocate and has helped the arts gain media coverage.

One council that has become involved in media work is the Department of Cultural Affairs in Atlanta. During 1981, about $5,000 (from the cable TV franchise fee) was spent for workshops with artists who might wish to make use of public access channels. The complexities of the whole area of cable television have brought out the need for expertise in telecommunications, and in the future the Telecommunications Department of the city government will work to implement such ideas. The potential for council work in the area of cable programming has been discussed by many councils. They see it as an area where cooperation and coordination of activities may be needed, where expanded awareness of cultural activities can be created, and where council expertise can assist the smaller institutions especially.*

Several types of programming can be reported — from occasional art magazine shows to ongoing reports of city programs, continuous listing of arts events, arts programs in traditional broadcast formats, documentaries, lectures, and the use of video itself as an art medium. In Austin, Texas, for instance, 14 percent of the local access programming is cultural-

*The newer Fulton County (Georgia) Arts Council in the same area has arranged for the cable TV franchise fees to be allocated to the arts. It will be used to produce programs for television, using local talent, that could be marketed nationally to produce revenue for local artists and arts groups.

ly related. Arts groups are beginning to "choreograph" or write for video and have been training the camerapersons at the local studios to be sensitive to their needs. In Bloomington, Indiana, a playwright's project has allowed playwrights to "showcase" parts or all of a new work, and to learn from the experience. Tapes are stored and can be reviewed or erased as the playwright wishes. In essence, the challenge of creating for cable, addressed properly, can be looked at as developing a new art form. Arts discipline organizations thus far have been envisioning rather narrow uses of cable in the traditional broadcast format, which is immediately inhibiting because of cost and quality considerations. However, there needs to be greater vision about the unique possibilities of the medium, and in communities small and large, that vision is beginning to be tested.

Programming of a broader nature, such as the 13-part series on the arts broadcast in New York City over Municipal Channel A and produced by the Cable Arts project of the New York State Council on the Arts, points to one kind of community council programming potential. Segments include "Art in Public Places," "Televisionaries," and programs on jazz, crafts, and dance. The goal is to demonstrate that government TV channels can be used to enhance the cultural life of the metropolitan area. It would seem that such programming might make sense to community councils throughout the country, for there will be many hours to fill and a great need to come up with high-quality, interesting, and potentially significant programs. The councils could be the catalyst for coordinating and generating this material. The potential for being helpful to cable programming, once the local political hassles over franchise settle, seems important for arts councils to examine. Many are examining this area, as cable entrepreneurs find the councils knowledgeable about the cultural scene and as arts organizations look for coordinated activities related to their needs. Cultural coalitions are considering sharing production expertise, studio space, and equipment; this is a natural development in order to plan optimum programming at minimal cost. Cultural programs, like any others, need careful planning and artistic skill if they are to be artistic and successful.

By franchise agreement,* the publicly designated, private New Orleans Arts Council is scheduled to advise the city on the distribution of about $160,000 annually over the next few years to cultural groups.[15] (Another amount will be distributed for telecommunications production through another agency.) Primarily due to the efforts of Denise Vallon, Director of the National Cable Arts Council located there, and also Vice-President of the local cultural channel, New Orleans looks like it may be the

*The Municipal Endowment Fund for Arts, Humanities and Community Services.

locus of a central resource on cable opportunities for cultural agencies.

In the short term, the National Cable Arts Council is researching the use of cultural channels for marketing arts, using not only listings but imagery to allow the public to know the daily cultural schedule at locations such as airports, sports arenas, and so on. The group is researching the development of the cultural image of a city through the use of cable, and is developing an aesthetic and practical prototype TV studio for the development and production of cable cultural programming.[16]

All of this has potential for arts councils only if there are persons on their staffs assigned to become expert about the capabilities and potential of cable television. The technical aspects of the field are complex and changing rapidly; the political and sociological ramifications are immense. "Knowledge is power" in this field — and knowledge requires time and priority.

NOTES

1. William Baumol, *The Effect of Theater on the Economy of New York City* (Princeton, N. J.: Mathmatica, 1975).

2. National Assembly of Community Arts Agencies, *The Arts Talk Economics* (Washington, D.C.: Author, 1980), introduction.

3. Chicago Council on Fine Arts, *A Survey of Arts and Cultural Activities in Chicago* (Chicago: Author, 1977).

4. Johns Hopkins University Center for Metropolitan Planning and Research, *The Economic Impact of Six Cultural Institutions on the Economy of the Columbus SMSA* (Baltimore: Author, 1980), p. 2.

5. Ibid., Section I.

6. NACAA, *The Arts Talk Economics*, p. 4.

7. Johns Hopkins University Center, *Economic Impact*, p. 4.

8. Ibid., p. 34.

9. Stephen J. Sansweet, "Proposition 13's Impact on the Arts," *Wall Street Journal*, July 14, 1978, p. 11.

10. Notice of a special meeting, to boards of directors, professional personnel, and affiliated organizations of eight arts organizations in Syracuse and Onondaga County, signed by their presidents.

11. From materials furnished for the meeting described in Note 10.

12. Interview with Cindy Kiebitz, Huntington Arts Council, 1980.

13. George Miaoulis and David W. Lloyd, *The Monadnock Arts Study: Marketing the Arts in a Rural Environment* (Monograph Series no. 4) (Dayton, Ohio: Wright State University, 1979).

14. George Miaoulis, *A Report on the Impact of the Arts in the Monadnock Region of New Hampshire* (Monadnock Arts Study) (Keene, N.H.: Grand Monadnock Arts Council, 1977), p. 2.

15. City of New Orleans Ordnance No. R-81-346, September 1981, establishing Municipal Endowment for the Arts and Community Services Fund.

16. Interview with Denise Vallon, Director, National Cable Arts Council, 1982.

10

Update on Festivals and Performing and Exhibiting Opportunities—New Places and Spaces

Performing and exhibiting opportunities, encouraged by the catalyst agencies in combination with cities, community organizations, and other agencies, are legion. The community arts service agencies have been able to put many elements together with the artists and performing groups in their communities to accomplish outreach programs, festivals, and all manner of performances and exhibits.

Festivals of every shape and variety are found in every community, from Portland, Maine, to Portland, Oregon—from the East Coast to the West Coast. In one Midwest region of the country, in June 1982, there were the following festivals: the Fish Festival, Strawberry Festival, Stitch-in-Time Festival, National Clay Week, Tri-State Pottery Festival, World's Biggest Yard Sale, Swiss Cheese Festival, and Rainbow's End Festival, most of which include arts and crafts exhibits and demonstrations as well as the usual rides, food, and entertainment. While there are, of course, many other kinds of festivals under many sponsorships, those sponsored by arts councils have usually emphasized the local and/or regional artist. Depending on budget size, in-kind contributions by the local government, and size of administrative staff and volunteer groups, these events range widely from one-day opportunities for local artists to show and sell, to multiday, elaborate affairs that include such plans as commissioning new works by artists, special performances, and invitational and juried exhibitions. Length and specifics of festivals in different cities may vary, but

often the arts council and/or commission, in conjunction with nonarts city departments, has made one of the best sponsors or co-sponsors.

It means that the nonarts departments can depend on the arts expertise for planning details unique to each performing group or artist. It is difficult for city administrators with other responsibilities to understand the difficulty of dancing on concrete, the preservation of a painting, or the aesthetics of a building and design. Through assistance, the city learns, the artist learns, and the council is an ombudsman in the jungle of arrangements. Councils generally know where all sizes and types of artists and arts organizations are, and can handle the details pertaining to them better than anyone else can. City support is needed for permits, public relations, and the generation of community spirit. But the administration of the festival needs focused attention.

The arts council can also act as a catalyst for other performing and exhibiting opportunities. There are the local and regional opportunities, as well as the sponsorship of touring companies. To say the least, the administration of these groups by councils without their own facilities is quite different from the management and programming of a facility. In the first instance, the agency may be the catalyst and not the sponsor per se; in the second instance, the agency is the sponsor. Illustrations abound for national, regional, and state touring: dance companies, theater companies, exhibits, and individual artists.

Generally, it can be said that the large urban agencies have concentrated on opportunities for the local artist. This makes sense when it is considered that often the largest groupings of professional artists are in the urban centers.

But city-wide festivals that are well planned and executed take priority and attention. The Houston Festival has a budget of nearly $500,000, for instance. In 1982, some components of the Houston Festival were the Houston Grand Opera performing *Don Carlo*; an exhibit at the Museum of Fine Arts of the works of Leonardo Da Vinci; outdoor events for nine consecutive days; and The Houston Festival Fringe, involving theatrical, musical, and visual arts organizations in performances and exhibits in alternative spaces throughout the city. There were commissions for original works in a variety of media and the official poster was selected from works submitted by five invited Houston artists.[1]

Most budgets are much smaller than that of Houston, and many of the smaller communities have used a combination of local talent and professional touring groups and residencies. The festivals in cities like Oklahoma City are a high point in the life of those communities. The specific assignment of the Arts Council in Cortland County, New York — which started when the Concord String Quartet, in residence at a nearby college campus, needed expanded performing opportunities in the area — is rarer.

Communities large and small have gathered for festivals celebrating every kind of occasion, long before the advent of arts councils. Then and now, whether or not an arts council is involved, the arts are involved. Co-ordination of such affairs takes organization and energy at the least, and usually some contact with the city or county, whose land and/or facilities the festival borrows for the occasion. Because arts councils are agencies with links to the city as well as to artists, they do become natural co-ordinators for such events. The Springfield (Ohio) Arts Council developed out of just such activity. Since 1967, there had been a summer festival in Springfield. In 1971, the all-volunteer festival group, was urged to become a year-round activity by the Ohio Arts Council. The city gives the Arts Council, a private agency, monies for the administration of the festival. By 1973, the community saw the need for continuity and professional manage-ment, and a director was hired.

The festivals *sound* wonderful. The St. Louis Arts and Education Council's Ice Cream Festival, Seattle's Bumbershoot, and the Third World Film Festival in Atlanta (22 programs of films from Nigeria, Cuba, Brazil, Senegal, et al.) are only three examples. Atlanta has had a jazz and dance festival as well, the tickets for which were gone six hours after the box office opened one year. "The festival generates economic activity in the city, as-sists in increased exposure, and therefore the companies (six local compan-ies performed for three evenings) have increased enrollments in schools," say the sponsors.[2] In Atlanta, the city's Department of Cultural Affairs has sponsored many folk, black religious music, performing arts, neigh-borhood music, and dance festivals, in addition to the Third World Film Festival. The Atlanta Arts Festival is sponsored by many groups.

In 1979, the St. Louis Ice Cream Festival drew some 75,000 people and made nearly $40,000 for the arts, and such world-shaking events as building the world's largest ice cream sundae took place. In 1980, built around the theme "Get Your Licks at the Arts and Ice Cream Festival," there was a "Lickety-Split" run and other ice-cream-related events. Many of the council's 134 member agencies have performed, and artists and craftsmen have demonstrated and exhibited.

Ethnic festivals are also among those sponsored or cosponsored by arts councils. The Director of the Cultural Resources Council in Syracuse main-tains that the Council's annual ethnic festival, the Festival of Nations, has brought dignity to all of the various ethnic groups in town. In Buffalo, the Ethnic Heritage Festival is sponsored by the private Arts Development Ser-vices, Inc. and the Junior League of Buffalo, in cooperation with the Ni-agara Frontier Folk Art Council. With a small charge, in a recent year it generated about $15,000 toward the operating needs of the Arts Develop-ment Service, Buffalo's council.

The Bumbershoot Festival of Seattle, now more than a decade old

and a free event for most of that time, has since found that a small admission fee must be charged to help defer costs. Over 90 musical acts form the base of this festival, along with a dozen dance companies, four visual arts exhibits, and a flag tournament in which the top 50 entries are hoisted during the opening ceremony. Other intriguing features have been "Now and Then," an exhibition featuring a current piece and a much earlier piece from each of 30 artists, and a photography exhibit, "Invisible Seattle," exploring the variety of photographic possibilities being employed by area artists. Seattle calls the Festival an opportunity for performers and visual artists to meet the public, and for the public to get a first-hand look at what's going on in the arts locally. It is multisponsored by the Seattle Arts Commission, the Seattle Center, and Department of Parks and Recreation, and supported by private donations and grants from other governmental agencies.

In Huntington, New York, three city parks are used for a festival offering 80 events. The Greater Columbus Arts Council Arts Festival, "Arts-Affair," involves some 400 volunteers. The council saw the need, consistent with its service role, to build in an arts advocacy role for the festival.

The Arts and Humanities Council of Tulsa "aids member and non-member groups in the development of arts and crafts exhibitions and festivals and encourages the development of exhibitions and festivals which provide local artists and craftsmen marketing opportunities."[3] One of the most interesting festivals sponsored by an arts council is the International Children's Festival, which is held at Wolf Trap Farm Park for the Performing Arts. The Fairfax County Council of the Arts has produced this three-day outdoor arts celebration for more than a decade. Proceeds from festival sales support the educational activities of the Council, such as school programs, gallery exhibits, and performances in the community. Advocacy and opportunity *are* the newer reasons for festivals. Tulsa's "Mayfest," the annual four-day performing and visual arts festival, is a celebration of spring. It is cosponsored by Downtown Tulsa Unlimited. And "Octoberfest," taken from the tradition of the German Beerfest, provides the artists and craftsmen with a "wonderful marketplace" as they are surrounded by performing artists on the banks of the Arkansas River. This festival is cosponsored by the River Parks Authority, TV station KJRH, and the Tulsa *Tribune*.

Festivals can be analyzed fairly easily. There are those that showcase local arts talent (exhibiting and performing), those that use the opportunity to bring in outside arts groups, and those providing a mixture of the two. The attempts to make both these types of festivals work financially are under constant examination, so that one finds arts councils and other groups and agencies cooperating to develop the best economic arrangements.

Opportunities for local performance and exhibit exist everywhere. However, there usually is the need for administrative attention, since no

one is employed in many institutions and corporate places to attend to such kinds of affairs; the most that is available is support and cooperation.

In most communities, it is well understood that for exhibit purposes, professional and nonprofessional artists do not mix well. The better artists, whose support is important to the quality and artistic growth of the community, have usually been identified. Sometimes galleries with ongoing exhibits are maintained separately for each.

Councils throughout the country have been the catalysts for using all kinds of spaces for performances and exhibition. While the needs of the performing groups and artists must be of paramount concern, they have been met in spaces as diverse as arcades, landmarks of all kinds, other public spaces, maxi- and miniparks and plazas, bank lobbies, and all of the traditional spaces such as storefront galleries and museums. There are exhibits in train stations, poetry on bus advertisement placards, and concerts in grocery stores. Such is the range of standard arts council programming now.

One interesting spin-off festival is Spoleto in the Piedmont, "which brings 150 performers from Spoleto Festival U.S.A. to the Greenville, S.C. area, offering residents the opportunity to hear a musical sampling of concerts presented in Charleston."[4]

There is a real benefit to seeing what the next city is doing — the exposure to other situations from which a locale may benefit. It is often felt that there is no way to teach quality; experiencing it is the only and best teacher. The Director of the Springfield (Ohio) Arts Council talks about the ideas about performance spaces and logistics stimulated at Spoleto, for instance, and adapted as part of the potential for Springfield. "It opened my eyes to new possibilities, and here, with a new City Hall downtown, all sorts of new performing spaces looked possible." All of this stimulated an exciting schedule of events including walking tours, lectures, ethnic groups performances, and chamber concerts; the excitement of the new format has generated positive responses from businesses, which have begun to sponsor individual festival "days."[5]

Not all arts commissions and councils sponsor festivals. In Chicago, ChicagoFest and the Jazz Festival are sponsored by an Office of Special Events, with which the Council works closely. So it is in some cities with parks and recreation departments. With the increased interest of recreation departments all over the country in extending their activities beyond their traditional athletic orientation, new alliances between them and arts organizations are being made all the time through the vehicle of the festivals. Typical of arts components is that of the Recreation and Leisure Services of the Department of Recreation, Montgomery County, Maryland. They employ professional artists in a variety of ways, especially in theater and visual art.

Such alliances are bound to grow, and it is evident that recreation and

parks officials have much to offer the arts in terms of funding and facilities
and resources.

> All across the country, men, women, and children are making it known that
> they want and expect the arts to be a part of their daily lives.[6]

One thing is assuredly true — that concerts in the park, and the likes
of Lima, Ohio's SquareFest/EthnicFest are events pretty much taken for
granted in the cities, towns, and communities all over America; and that
many are coordinated by the local arts council. The city and citizenry have
come to expect them, as they also have come to expect the arts-council-
sponsored exhibits and performances in the plazas and bank lobbies.

NOTES

1. Cultural Arts Council of Houston, "Houston Festival to Take Place March 18–28"
Houston Arts, Winter 1981–82, p. 18.
2. Interview with Tom Cullen, Department of Cultural Affairs, Atlanta, Georgia, 1980.
3. The Arts and Humanities Council of Tulsa, Oklahoma, *Annual Report*, 1980–81, p. 5.
4. Metropolitan Arts Council of Greenville, South Carolina (brochure, 1980).
5. Interview with J. Chris Moore, Springfield (Ohio) Arts Council, 1980.
6. Bennett Schiff, "Arts in Park and Recreation Settings" (Park, Arts and Leisure Project
sponsored by the National Park Service, National Recreation and Park Association and the Na-
tional Endowment for the Arts, 1974), p. 7.

11

College/University Relationships

The town-gown relationship is in working order only when it is to benefit the college. There is a good working relationship with specific departments, but not much with the administration. . . . However, the community has probably done more for the college than it has really readily acknowledged or recognized.

Various arts council directors

Arts councils came into the presenting business long after many, many colleges and universities all over the United States ran a fine arts series, a performing arts series, a community events series, or a public events office on their campuses. These concert series have had an important influence on college students, especially the GI Bill veterans, for whom it reinforced the idea that culture was important here as it had been among the local residents overseas. As a part of their student ticket, they were exposed to art, theater, and music.[1]

Concurrent with the development of arts councils has been the expansion of college programs to include the concepts of continuing education, lifelong learning, and adult community education of various kinds, most of which have included the arts as coursework. But these movements did not mingle with the activities of most community arts councils because, in some cases, both were "getting off the ground." In the future it seems that there is

indeed some potential for cosponsorship, as has been shown with the artist residency programs on the college campuses in North Carolina, a program supported by the colleges and universities in conjunction with the state council. This is echoed in other states. Often the community council assists in the planning and implementation of all of the resident activities. But one bellwether of the increasing numbers of councils now bringing in performances to their communities is their membership in ACUCAA.

In the mid-1970s, there was still very little recognition of the community as a resource and audience on the part of those who had been operating from the college campuses. During the last five years, the message is clearer in a number of ways — audience development being only one — that town-gown relationships are mutually beneficial and necessary.

The annual conference of ACUCAA, usually held in New York City, is an opportunity for those attending to exchange information, to grow as professionals with seminars and workshops filled with up-to-date information and problem-solving techniques, and to meet with many artist management representatives. The ACUCAA organization is one of the few places where those who in their communities have presenting roles can share concerns. There are other organizations having to do with theater and auditorium management, but even arts councils without facilities to run may benefit from the expertise of ACUCAA. On the program in 1980, for the first time, were such topics as "Your Facility as a Community Resource" and "Expanding Networks of Touring Support — The Regional Arts Organizations."

The Mid-American Alliance is just such a regional arts organization — the oldest — and when the Arts Council in Manhattan, Kansas, assisted in bringing to the local audiences the Joffrey Ballet, Martha Graham Company, and San Francisco Ballet performances, it acknowledged that Kansas State University has one of the few full-service facilities in the area able to accommodate major dance, music, and theater companies.

The relationship between colleges and arts councils is still a bit rough in many communities. Even though some may cosponsor a special events series, there are still some tensions over what colleges believe is appropriate for their participation. The concert series may be; the arts festival may not be, as an example. Many arts council directors have expressed the need for a way to break through the rather aloof traditional patterns and involve the colleges with the communities. Most have agreed that the reduction of college resources for special events, which has occurred on many campuses, may help this happen.

The councils would like to have a good working relationship with the colleges in their communities. Many establish such relationships in a variety of ways. Ohio State University and the Greater Columbus Arts Council have cosponsored "Studies in Arts Administration"; Minneapolis has used

work-study students from the University of Minnesota for research; the formal university arts management programs, especially, across the country, have used their communities for internships and field work.

At least three rather unique community programs exist that have council or university bases. The University of Massachusetts at Amherst, in providing community services (a requirement of a land-grant college), provides space and services such as postage and duplication (paid back after each year's operation) to the Arts Extension Service, part of the university's Extension Division. The major funding for Arts Extension comes from an annual Art Festival that the staff works on all year. They publish an artists' directory (paid for by the artists listed and those who subscribe to it).

The Arts Extension Service was founded in 1973 as a consulting agency for arts councils in cities and towns throughout western Massachusetts. They have expanded in response to need into seminars, workshops, publications, and the compilation of a file on individual artists and their services. At one count, the file had 3,500 names of artists, craftspersons, and performers. Over the years, the Arts Extension Service has assisted some interesting projects, most geared to the special needs of the elderly, inner-city or rural populations, and the handicapped.

The Arts Extension Service provides an example of utilizing an educational institution for community outreach services. Although extension services are old ways for expanding university service into communities, this is one of the most concentrated efforts to date in the arts.[2] Particularly noteworthy was the University of Wisconsin Department of Extension Arts' three-year program (1966–69) "to pioneer in the area of arts development in small communities."[3]

The Two Rivers Arts Council is a consortium of local arts agencies in seven counties in Illinois. It was formed as a catalyst and resource for the small communities of the counties by the Dean of Fine Arts at Western Illinois University in Macomb, who felt the university's responsibility to act as a cultural center for the region. The Council, whose coordinator divides time between arts development at the university and the Arts Council, has since 1978 sponsored an annual writing program for the elderly, a resulting book of local lore and traditions, university artists' performances in the towns, and a project to document the 68 opera houses in the region. There is a cooperation and spirit here between the college and the residents of the region that might be a model for rural arts council development.

The Arts and Humanities Council of Tulsa takes the "Humanities" portion of its title seriously, and so do the university scholars. The Council describes its growth in this area, which concerns "nearly every form of human endeavor which relates to the creation and study of philosophical, cultural and aesthetic values," as one of being a stimulator of existing agencies to cosponsor and initiate humanities projects. During the Bicentennial,

the Council generated nine months of public forums via radio and film programs in the "American Issues Forum in Tulsa." The Humanities Scholarin-residence hosts a series over radio, including interviews, readings, and panel discussions with prominent personalities in the fields of history, entertainment, literature, and politics. Twice a year, the council publishes *Nimrod* (formerly published by Tulsa University) — now more than 20 years old — an international literary magazine. The council has run the Tulsa Humanities Institute, a consortium dedicated to intense study of current issues through the perspective of various disciplines of the humanities.[4]

The arts council within the university setting has been an important advice, advocacy, and support body for almost a decade at the Massachusetts Institute of Technology. The Council for the Arts at MIT, flexible and molded to circumstances, works there as a catalytic agency to develop new support for proposed work in the arts by both faculty and students. With the backing of the top administrators, which is an important component, it attracts outside monies that might not be channeled to such an institution without special effort. Over the first seven years, about $250,000 has been raised for about 180 projects. About one-third more has been raised through matching plans for some of the monies. There has been an $18 million building for the arts on the drawing boards, which just couldn't have happened were it not for this well-honed "friends of the arts" idea, backed by the Council's organizational structure and impact on all areas of the arts. The idea could be generated in any size college setting, just as the arts council idea has been valuable to large and small communities. It takes leadership and vision. There are a few such university councils throughout the country.

This type of council starts with the potential of the arts at the university itself and reinforces that potential with community support, giving people who would not ordinarily participate at that institution an opportunity to do so on behalf of the arts — not a particular art form only.

Colleges, universities, and arts councils have mutual interests, growing from the college interests in the community and the council's coordinating and catalyst role. There should be more collaboration in the future, and more variation on these themes. Whether delivering new audiences or studies in the area of the discrete arts, arts administration, contemporary arts issues, or community events in the arts, there are natural concerns that generate points of communication and cosponsorship between arts councils and colleges and universities. With the interests in the arts stimulated, there might be new approaches and dimension to areas of study and research as well. One would hope, too, that some attention could be given to long-range efforts so that community-initiated pilot programs of value to the academic institutions might be absorbed into the institutional fabric by good mutual planning.

NOTES

1. Interview with James Backas, 1980.

2. Valerie West, "Arts Extension Service," in *A New Kind of Currency: A National Conference on the Role of the Arts in Economic Development* (Minneapolis: Minneapolis Arts Commission, 1978).

3. Federal Grants A-02042-1, A-68-0-57, and A-69-0-53, July 1966–June 1969. Grants given by the National Endowment for the Arts to the Office of Community Arts Development, University of Wisconsin Department of Extension Arts.

4. The Arts and Humanities Council of Tulsa, Oklahoma, *Annual Report*, 1980–81, p. 1.

12

Laws for Public Arts*

By 1973, when the King County Arts Commission and Seattle Arts Commission had established ordinances providing that specific portions of monies from capital improvement projects be set aside for the commissioning, selection, and installation of works of art at the site of improvement, among the communities that had preceded then in such a move were Philadelphia (1959) and San Francisco (1969). The momentum has gathered since that time, and today about half the states and three dozen cities have versions of such a law (see Table 5). There are more being established all the time.

These first communities reasoned thus:

> Whereas, King County intends to expand the opportunities for its residents to experience art in public places, thereby creating more visually pleasing and humane environments. Whereas, the county accepts its responsibility to the

*While arts commissions have been created by city ordinance, and such items as hotel/motel tax appropriations for the arts have been written into city codes, this discussion is primarily limited to the percent for the arts laws. The others are mentioned elsewhere. Each time a community has examined and created a source of funds for the arts (e.g., cable television franchise monies, hotel/motel tax monies), it becomes a potential for other communities. However, individual state and local laws are involved and need to be examined thoroughly by groups interested in implementing any of these possibilities. (See also page 243.)

TABLE 5
Percent for Art Legislation

States Having Passed Law	States with Pending Law	Counties Having Passed Law	Cities Having Passed Law
Alaska	Arizona	Broward, FL	Anchorage, AK
California	District of Columbia	Dade, FL	Davis, CA
Colorado	Idaho	Mecklenberg, NC	Los Angeles, CA
Connecticut	Indiana	King, WA	Palo Alto, CA
Florida	Maryland	Pierce, WA	Riverside, CA
Guam	Minnesota		San Francisco, CA
Hawaii*	Missouri		Santa Barbara, CA
Illinois	Nevada		Santa Rosa, CA
Iowa	New York		Walnut Creek, CA
Maine	North Carolina		Miami Beach, FL
Massachusetts	Pennsylvania		Atlanta, GA
Michigan	South Dakota		Chicago, IL
Nebraska	Tennessee		Baltimore, MD
New Hampshire	Utah		Rockville, MD
New Jersey	Wyoming		New Orleans, LA
Oregon			Boston, MA
Texas			Cambridge, MA
Washington			Kansas City, MO
Wisconsin			Albuquerque, NM
			Santa Fe, NM

158

New York, NY
Toledo, OH
Tulsa, OK
Eugene, OR
Portland, OR
Philadelphia, PA
Pittsburgh, PA
Wilkes-Barre, PA
Salt Lake City, UT
Bellevue, WA
Everett, WA
Mountlake Terrace, WA
Renton, WA
Seattle, WA
Tacoma, WA
Wenatchee, WA
Madison, WI
Milwaukee, WI

Source: List circulating in 1980, including data from *Arts and the States: A Report of the Arts Task Force,* *National Conference of State Legislatures,* compiled by Larry Briskin, (Denver: National Conference of State Legislatures, 1981). For more information on this and any number of other laws, such as "Artist-Art Dealer Relations Act," "Resale Royalties," "Artists' Fair Market Value Income Tax Deduction," "Artists' Live/Work Space: Local Authorization," and laws on subjects related to arts education and historic preservation, contact the legal department of the level of government involved.

*In 1982 Hawaii passed a law making it mandatory for every public school to have an artist in residence.

visual and performing artists and craftsmen who in all societies have made people more aware of themselves and their communities, be it ordained . . . The city of Seattle accepts a responsibility for expanding experience with visual art. Such art has enabled people in all societies better able to understand their communities and individual lives. Artists capable of creating art for public places must be encouraged and Seattle's standing as a regional leader enhanced.[1]

Today Seattle owns a "portable works" collection of over 200 works of art (paintings, drawings, textiles, photography, small sculpture) by Northwest artists, which are rotated on an ongoing basis throughout city-owned public spaces.[2] In King County, about $800,000 has been spent on works of art over the first eight years.

Just when some of our other cities and counties are starting to wonder whether they should follow the lead of the three dozen or so that have passed a percent for art in public places law, those cities that have had the law for almost a decade are reassessing where they are and where they've been. A percent for art in public places law legislates that usually 1 to 2 percent of public construction budgets be spent on artwork. Sometimes this is restricted to budgets for buildings only; sometimes it includes budgets for public spaces, depending on the way the law is written. The questioning has to do not only with the nature, quality, and significance of the municipal collection gathered by this process, but also with the ways it is being maintained and cared for.

In the Seattle/King County area especially, these issues are being given close scrutiny. There one of the questions is this: Should the city/county "collection" be maintained by a municipal curator? Maintenance amounts to painting when needed, for the most part, which might be done by contract with the Museum or other knowledgeable persons. In the case of an Earthwork destroyed by rain and reconstructed afterwards, other assistance has been needed.

But there is more to it. Might there be public education — tours, comment, dialogue on a regular basis? Added curatorial and educational functions?

There is also the question of the commissioning process. Local artists as well as very well-known national artists have been commissioned. Yet a recent article pointed to the fact that there was nowhere a piece by a local nationally recognized artist such as Marc Tobey, for instance. Should there be a leaning in the direction of the well-known local artist?

Then there are all of the questions concerning "public art." Who is it for — art for the public or art for the artist? The public has usually preferred the realistic pieces and might choose them over others if there were a choice. Yet representational pieces usually reflect the idiom of those living in another time and place, so the jury selecting the work prefers an abstract piece

that disturbs the public. If the piece has enough going for it, it will sustain its worth through many examinations — whether it is representational or abstract.

The laws do protect the artist and do spell out the terms of maintenance most importantly. They remind us that the work does have a creator who lives (or lived) in our midst. Sometimes there is no maintenance budget to implement intent; there must be. The percent for art in public places law lays down a context of respect for the artist as a professional in partnership in the same way as such a context exists for the architect, contractor, or developer.

The idea that artists should be involved in the initial planning of a park, a building, or a public plan takes hold more easily under the aegis of such a law. If working ideally, it allows architect, developer, and artist a chance to integrate the artwork into the total concept, not as an afterthought, as so many are prone to do.

Reassessing after a decade brings many afterthoughts to the fore. "Write good laws," say the originators; "it is much more difficult to amend than to start out inclusive. Choose juries wisely and be demanding of quality, because deaccession may be the most difficult of any concepts — unless the idea of rotation and change are built in at the beginning." It's hard to say to an artist, "We must remove the work now — we've tired of it or think it should have been different or better." It is nearly impossible. And yet, some of those thoughts are natural, since there has been a wide range of commission and implementation.

Thus, these laws present double-edged questions with no clear resolution. Under what circumstances are the public laws for public art better? Only when the public administrator is someone with judgment, background, and maturity. This has not always been the case, and then the whole concept of humanizing our public construction takes a step backward. Obviously, there are many issues to consider, and no easy solutions.

In an article, "The Question of an Ideology of Public Art," Parks Anderson, an artist and former member of the King County Arts Commission with artwork in the collections of Rainer Bank, Pacific Northwest Bell, the city of Seattle, and the Boeing Company, as well as many, many others, pleads:

> The responsibility of the arts commission is to identify and support artists and arts organizations from inside and outside this region in such a balance that artistic growth in the arts community and the community as a whole is nurtured and a sense of cultural identity, place, and energy results.[3]

In writing a good law, a community now has the advantages that those that were first had not — the ability to see how other communities have fared, and to look at the strengths and weaknesses of the existing laws.

They can address all of the main questions with multiple possible solutions and can compare situations. They know where the artists have been part of the original design team and where the artwork has been selected after the building is constructed; they will be able to weigh the problems of maintenance, process, successful juries, and systems. Arts councils and commissions undertaking these kinds of responsibilities have an obligation to take the kind of planning time necessary to do a good job.

Arts councils and commissions have been responsible for applications to the National Endowment for the Arts' Art in Public Places program. In Massachusetts, the Cambridge Arts Council has responsibility for the execution of the Cambridge law passed in 1979, which mandates that 1 percent of all city-funded construction and renovation projects be allocated to works of art. They received a grant through the National Endowment for the Arts program to support a commission to artist Richard Fleischner for a sculpture at the new Alewife subway station. The project is one of 20 commissions to artists made under a pilot project for incorporation of works of art in new transportation facilities, funded by the U.S. Department of Transportation's Urban Mass Transit Administration and the Massachusetts Bay Transportation Authority. The artist has worked with the station architects and the landscape designer since the inception of the project.

The Endowment program has assisted many communities in accomplishing such public projects, and many of the same processes that are developed for the local laws are relevant to making those projects work.

The work of arts councils in behalf of percent laws is probably just beginning to take hold. This, and the other programs, have given private corporations greater confidence in accomplishing similar aims—for a bank building, a corporate headquarters, a new shopping center. If the job is well done, arts councils are not only called upon for advice and counsel, but they can point with pride to their own good model.

> It means that the city's collection of public art will grow, adding substantially to the economic and social well-being of the city; it creates new opportunities for major commissions of important new work by artists of all disciplines; and it ensures that artists will have occasion to work closely with residents, planners, architects, engineers, and city officials towards our goal of improving the quality of life in Cambridge. . . . Cambridge's ordinance is one of the few which includes the performing arts.[4]

In Sacramento, California, a law passed in 1979 stipulates that developers as well are to expend a minimum of *two* percent of total construction costs on aesthetic improvements, and the Housing Authority is generally required to do the same. The city of Sacramento points out its "desire to expand public experience with visual arts."[5] The administrative costs of the program incurred by the city's Metropolitan Arts Division are paid out of the 2 percent.

Some ordinances do have exceptions, the schools — in some instances, being one. Others, like Sacramento, include more than just the public sector. San Francisco, since 1969, has had a 2 percent ordinance, which also requires that any public or private proposal on public land must be submitted to the Art Commission for approval. There is, by ordinance, the Art Commission Conservator who sees to the maintenance and conservation of art works in public places, as well as the city's art collection.[6] The collection was begun in 1966 with funds (about $5,000 annually) authorized for the acquisition of works of art from the annual Art Festival.[7]

There are other types of laws that have involved arts councils. They affect rezoning for residential use areas that could be rehabilitated for artists' housing, and the conversion of old spaces to work in new ways for the arts.

In Seattle and in other cities, laws have been changed. There, the zoning code involved in the establishment of an artist's dewlling and/or studio was rewritten to include greater sensitivity to the needs of the working artist. As a result of the carefully researched (from health, safety construction, fire, and community development views) ordinance allowing artists to live in areas zoned for neighborhood business and in other zones, artists have legally moved into many underutilized spaces that had begun to lose vitality. This was done under the premise that there is benefit to the city in creating downtown living space.

The Minneapolis Arts Commission study on warehouse reuse for artists' living and work space serves to help cities look at the barriers to such revitalization, mechanisms for protection from speculation, and the issues involved in making such a project business-efficient and cost-effective.

Therefore, arts councils and commissions have been both instigators and implementers of laws relating to the arts. They have also carried an advocacy role as they pursue these ways to support the arts and artists in their communities.

NOTES

1. "One Percent for Art" ordinances, King County, Washington and Seattle, Washington, 1973.

2. Seattle Arts Commission, "Art in Public Places — Discussion" (1980).

3. Parks Anderson, "The Question of an Ideology of Public Art" *Art in Public Places* (Seattle Arts Commission material), 1980.

4. T. N. Snyder (ed.), "1% for Art Spreads" *Washington International Arts Letter*, March 1980, p. 2274.

5. Sacramento City Code, Ordinance no. 4274, October 16, 1979.

6. San Francisco City Ordinance 148-74, Sec. 1.16 — The Care and Maintenance of Public Works of Art, as quoted by San Francisco Arts Commission (brochure), March 22, 1974, p. 18.

7. Differences in the percent laws are important to analyze. For a comparison of Philadelphia and Seattle, see "Art in Public Places: The One-Percent Solution," *Houston Arts* 5(1982):2–5.

13

Programming
for Someone—
Professional Outreach

Arts councils, in looking at community needs, are filling council-initiated programming roles as well as service and advocacy roles. In doing so, the considerations about the arts and the life of the community beg all of the questions concerning accessibility — and quality. Can there be both?

In no conversation I have had with an arts council leader has there been a mention of a role model or sense of history in this outreach work. It has always seemed that the community schools of the arts, most of which have evolved from a commitment to music, were a natural link. Perhaps it is taken for granted, but there appear to be only tangential relationships. Today, the membership of their service organization — the National Guild of Community Schools of the Arts — includes more than 60 non-degree-granting schools teaching music, dance, drama, and the visual arts. Most developed originally as neighborhood settlements with a priority in music.

> While their role today has changed, many of these institutions still exist to ameliorate the conditions of the urban slums. The Third Street Music School Settlement in New York City, founded in 1898, is a good example, as is Washington, D.C.'s Community School of Music. In offering alternative arts programs that are especially tailored to their clientele, the community schools of the arts . . . are attempting to respond to the real needs of the people they serve. In most cases their faculty are professionals in their field, and scholarship programs ensure that no student is denied instruction due to financial need.

164

The well-known story of Benny Goodman's fifty-cent lessons at Chicago's Hull House, an institution that helped children from poor families, is being replicated today by young, talented students all across the United States.[1]

A look at the general directions of these institutions would answer the question of why they have not related to the arts council movement. The expansion of their programs to include more than music (i.e., visual arts or links with some other kinds of institutions, such as museums), is a more recent development.

There are all sorts of issues in outreach work: what kinds of artists, training, and goals? Some of these answers have been deliberated best by other organizations, such as Affiliate Artists, Inc. or Hospital Audiences, Inc. (HAI), where there are specific community residencies, training programs, and arts services for communities. The emphasis is different in the two organizations. HAI has been an arts service for

> people in a variety of human settings, including hospitals, prisons, substance abuse treatment programs, nursing homes, psychiatric facilities, developmental centers and other rehabilitative agencies. . . . HAI responds to the arts as a basic human need. Although the arts are not presented as a therapy, involvement in the arts can be a highly therapeutic process. HAI's services are guided by aesthetic judgments as to what will best engage the minds and spirits of its clients.[2]

In some cities, as in Durham, North Carolina, the arts council has been the local coordinator. There ACCESS (formerly HAI-Durham) has been a project of the Durham Arts Council and has provided information tools — an artist registry enabling the institutions to program arts directly.

Affiliate Artists, Inc. is the national nonprofit organization that promotes the career development of performing artists and fosters new audiences and sources of support for the arts in communities across the country. Of the major programs of Affiliate Artists, some might include the assistance of a local group such as an arts council. One has been the residency program, where a young performing artist, such as a dancer, singer, instrumentalist, or mime, would reside in a community for six weeks during a year.

> While in residence an Affiliate Artist makes 80–100 appearances in a variety of informal settings — schools, churches, factories — wherever people naturally gather — giving "informances," an informal way of performing that allows the artist and his audience to know each other.[3]

Other types of residencies have included a one-week residency, which comprises a concentrated week of community appearances and a formal con-

cert or recital, and the CART program — reaching the smaller communities, initially in the Southeastern United States, where community leaders have been trained in the skills of artist residency management. Arts council professionals made up 42 percent of the CART trainees in one year.

Since 1966, Affiliate Artists has placed over 225 artists in well over 500 residencies in almost all states, and has also raised over $9 million in corporate, private, and government funds for the arts to reach over 8 million people.

Arts councils then have interacted with programs such as these in many communities and have sponsored many of their own programs, usually using local artists (the Affiliate Artists' artists are not local) to support the idea of the professional artist in new challenges and in every nook and cranny of the community.

Many arts councils themselves are programming for neighborhood arts, senior arts, arts for the handicapped, and public arts, with artists-in-residence in special programs full-time; but few are giving first and full priority to these efforts. In Cortland County, New York, the Arts Council's outreach efforts are diversified among other sponsoring and programming services, although outreach is a major emphasis.

The Walnut Creek (California) Civic Arts Department sponsors more than 80 classes each week in a system of six attractive prefabricated portable modules (approximately 10,000 square feet), and at one moment enrollment averaged 1,200 students a week.[4] Another arts council's outreach work has been described in a magazine article by Alice Fuld:

> The Grand Monadnock (New Hampshire) Arts Council's *Arts for Special Audiences* provides workshops and performances for handicapped, disadvantaged, and institutionalized people in Cheshire County. Usually, the artists go to the people they are serving. . . . [A] magician has performed in a nursing home, [a] sculptor . . . conducted a clay workshop in the county jail, clowns from the Phoenix Nest Company entertained at an institution for retarded children, and the Lincoln Elementary School recorder ensemble gave a luncheon concert at the Keene Senior Citizens Center.
>
> Begun in January 1979, with a special program grant from the United Way, *Arts for Special Audiences* has presented more than 100 events in its first ten months. Twenty-two area human service programs and more than 30 artists are now involved in the flourishing program.
>
> The project grew naturally out of the work of the Grand Monadnock Arts Council. Its [former] Executive Director, Sara Germain, described the regional organization as a "social service agency for the arts. We exist to bring the enjoyment and education of arts experiences to all the people who live here."[5]

For most programming councils, there are the issues over how to include the leisure-time artist, the "Sunday painter," and the "nonprofession-

als." Most include opportunities for those who enjoy participating in an art form to do so. Questions come about as to what happens to the art that is produced. If it is clearly a self-development program, the product is most important in relationship to the development of the person's individual skills. Exhibiting such work and casting judgments upon it may be problematic. If there is a community-wide exhibition, it is difficult for most councils to try to exhibit professional and nonprofessional work at the same show. There are a few exceptions, but in many such situations, the professional artists will not participate. Many of the smallest communities have few professional artists. Most councils settle this kind of dilemma by clarifying exhibit rules, criteria, and regulations, and by alternating exhibition spaces or having two spaces. As one of many council directors explained, "Mixing the two categories is not possible; while the first responsibility would be to the professional artists, the avocational artists want some exhibition opportunities." It is through bringing in professionals and working for continuing quality that the point is self-explanatory. Not enough, perhaps, to satisfy some.

In St. Paul, COMPAS was formed by the St. Paul-Ramsey Arts and Science Council to meet community demand for arts opportunities for all citizens. The funds for COMPAS come from a variety of public and private sources.[6] As the community arts programming agency, it conducts a wide variety of arts programs. The activities all have several hallmarks: They are participatory in all arts disciplines, decentralized to reach people where they are, responsive to community interests and issues, flexible in adjusting to changing needs of artists and neighborhoods, and creative in program design. Typical cosponsors and programs sites include neighborhood district councils; businesses; ethnic and folk culture centers; churches; historical societies; unions; housing agencies; economic development councils; institutional homes and day centers; and the St. Paul parks, libraries, and schools, as well as the Police, Fire, Probation, Port Authority, and Community Education Departments. In a given week, one could find professional artists performing at a day care center for gifted children one day and for disabled children the next; a dancer teaching at a community center in the morning and a playground in the afternoon; a weaver teaching in a high-rise apartment complex for the elderly; a poet tutoring gifted children in her home; and a muralist painting a retail shop wall.

COMPAS concentrates on providing opportunities for first-hand daily experiences in the arts. COMPAS works with every kind of agency and person and has developed some creative and innovative programming, not the least of which is a program called Intersection, involving four of the 17 neighborhoods in an attempt to look at the neighborhoods and see how the arts can be a part of them. The people within determine

the style and direction. The Neighborhood Arts program, involving work-shops, performance, and murals, is the only one that receives city funds and is run in cooperation with the Parks and Recreation Department year round.

The COMPAS model may be something that other councils should look at, since it is the *business* of COMPAS to do outreach programming. Getting across the idea that there are training, methodology, and philosophy behind real outreach programming is an idea that still badly needs to be developed. COMPAS starts with the needs of the people (or the community involved decides those needs), finds the professional artist or group that can help, and trains the professional to work in that particular situation on a full-time, ongoing basis (budget about $650,000). Time is needed for training and for the creation of real trust and continuity. This is a very important concept.

The Cambridge (Massachusetts) Arts Council moved into programming in a community where the cultural riches (as they relate to the great universities) are often retained in highly pocketed settings, so that those resources might be more broadly distributed. Encouraging the loan of art exhibits and student performances to public locales such as housing projects and community centers, the Council has caused them to be shared in this "dense, ethnic, and predominantly blue-collar city." A second priority was a concern for the "city as a broad canvas for arts intervention"; other programs have included a law mandating 1 percent for public art in public construction and the utilization of CETA funds to commission unemployed musicians, painters, dancers — artists of all types — to implement their work in neighborhood settings in collaboration with community groups. The leadership has said, "We have used the arts to address major urban problems of neighborhood identity, visual blight, institutional indifference, ethnic separatism."[7] Perhaps best known for innovative competitions juried by professional artists (used to raise the quality of the environment in spaces such as city parks and unkempt open spaces, and to elevate the level of graphic design on such things as municipal vans and rubbish trucks), the Council has tried to develop programs that capitalize on the wealth of talent that the resident artists represent.

To direct all resources toward a goal of combining the elements thus described, as well as the ethnic traditions represented by the Portuguese, Italian, French-Canadian, Spanish, West Indian, Caribbean, and Afro-American inhabitants, the Council designed a festival of one week's duration.

Never before had fifteen neighborhoods worked towards a common goal — celebrating their shared environment and enhancing it. After a week of arts events, which included the drum combo on the roof of a subway station while Cambridge poets flashed their work on the electric sign band below,

and the dedication of a piece of kinetic sculpture by an internationally known sculptor and Cambridge resident in the heart of the city's most garish commercial district, Central Square, the festival culminated in a day of neighborhood festivals followed by processions to the river bank. Here Cambridge residents viewed a river filled with floats built by the city's many architectural firms and enjoyed an afternoon of parades and entertainment donated by area artists.[8]

According to the former Director of the Cambridge Council,

> We have used the arts to address the overriding issue of how it feels to live in a city and how it can feel better, by involving the community at large in the process of addressing these issues.
>
> During the festival week, every conceivable art form is showcased, and no pocket of the city is left untouched. Leaving behind the traditional boundaries of theater, concert hall, and gallery, artists perform on street corners, on rooftops, in hotel lobbies, and in storefront windows. Every hospital, housing project, elderly and community center is involved. Artists have worked with residents for months planning and creating each neighborhood's festival participation. . . . Neighborhood groups collaborate with artists in the creation of permanent works of art, and celebrations are scheduled to dedicate them.[9]

The description of the Cambridge River Festival and the work of the Council of that city leaves one a sense of their purpose: "to broaden the relationship between the arts and the city's neighborhood by encouraging individual participation in the creative process itself and thereby increase awareness of the arts from the inside out."[10]

Yet another program of the Cambridge Arts Council called Arts on the Line — a program to incorporate the decorative and fine arts into the Metropolitan Boston Transit Authority's Red Line Northwest Extension — has involved the imagination and energies of designers and representatives of the Cambridge and Somerville communities, art consultants, architects, artists, and transportation planners, who have tackled the many issues to be faced in creating functional and exhilarating public places.[11] Funded with .5 percent of the construction budgets of the four stations committed by the Transit Authority, the process involved four selection panels and advisory committees of professional artists and museum personnel, as well as persons from Community Development, historical commissions, business, and the arts. Gyorgy Kepes, one of the 20 artists commissioned for work at the Harvard Square Station, has created "color-light space," produced by transparent colored glass, in which the waiting passenger becomes "actively engaged in the visual dynamics of motion and passage which underlie a transit situation." He has said, "Art in the subway will give you a quality of promise."

In the Cambridge story, such innovation ultimately revolves around

the commitment and quality of personal involvement by the participants, plus the history of a sympathetic transit system, which was incorporating art into facilities even before the appearance of the 1977 Department of Transportation report encouraging exactly that.[12]

In creating for the subway system, the artist must have a large scope in mind, not discrete precious objects. He must consider spaces, traffic patterns, durability, and the differences in the opportunities presented by the quiet spaces and noisy places. And the audience spans all age levels: "Perhaps the only common denominator is that everyone is there because they want to be somewhere else and no one is there to see art."[13]

In Seattle in 1977, as Peter Larsen has written,

> I knew the moment I heard the phrase that it surely described our organization's work: Neighborhood Arts! The National Endowment for the Arts, through its Expansion Arts program, was looking for cities to participate in a new pilot project, CityArts. Grand! Just step in there, show these folks what fine work we've been doing and make our bid for the pie. . . .
>
> But listen a moment . . . here is a dancer saying she gives solo performances in neighborhoods, an actor speaking of the need for rehearsal space, others talking and nodding. In fact, nearly everyone in this meeting room seems to think they're doing neighborhood arts too. . . .
>
> Motivated first by self-interest and later seduced by the logic and evolving rationale of our work, the Neighborhood Arts Task Force, an ad hoc citizens' advisory committee, began holding regular, open meetings in the autumn of 1977 to design a new arts program around the hoped-for National Endowment for the Arts grant. Three months of effort generated a document outlining a philosophy and an accompanying program we felt to be equitable and responsive.
>
> We wrote not of new arts forms, but of reaching new audiences. We wrote not of making every citizen an artist, but of fostering a larger awareness of the arts. We wrote of outreach and participation as vehicles to understanding. We wrote of gleaning private contributions to favor the health of the arts. We wrote of "process" and "involvement" as measures to be weighed as we weigh "taste" and "quality."
>
> We wrote of a format for this program which would be democratic, flexible, and evolving. We asked that an advisory panel of artists and citizens be appointed to guide the program and that regular open meetings be initiated to review progress and share ideas.
>
> Some of our ideas seemed radical to the arts establishment of 1977. Our intention was not to subvert, but rather to provide new opportunities for cultural activity.
>
> Looking now from the perspective of three years of participation in the program, I am at once satisfied and hopeful. Satisfied that the Endowment's purpose has been matched with local integrity to produce a meaningful program. Hopeful too, that as the most responsive program of the Seattle Arts Commis-

sion, Neighborhood Arts will not calcify into any static form but will continue to evolve to serve changing cultural needs.[14]

It is in the outreach areas of activity, however, that both Expansion Arts (CityArts) monies and CETA monies have served to extend arts council activities. Because the Expansion Arts monies were intended to stimulate local support of these types of programs, the arts agencies or councils in cities such as Knoxville; Boston; Baltimore; Chicago; Charlotte/Mecklenberg County, North Carolina; Los Angeles; Detroit; Minneapolis; Atlanta; Buffalo; Dallas; Miami; San Antonio; Seattle; and Madison, Wisconsin, agreed to a three-year effort to that end, to be evaluated at that time for its potential to continue — up to $50,000 per city per year from the National Endowment for the Arts.

Frank Hodsoll, Chairman of the Endowment, has reported:

> In reviewing the history of the CityArts program, it seems to me it provides a particularly effective way to respond to three, basically local, issues: (1) Effective federal assistance of emerging community arts organizations; (2) Leveraging of additional public and private money for such organizations; and (3) Provision of technical assistance to help such organizations develop managerially as well as artistically. The evaluation of the CityArts program concludes that the program has helped achieve new levels of professionalism in emerging community groups; assisted with planning, training, and management; improved the climate for the arts by strengthening the funding and access role of local arts agencies with municipal governments; offered new arts opportunities to vast audiences usually denied such access; stimulated new levels of private support and volunteerism in the arts through service on advisory panels and boards of directors of community arts organizations; served as a model for new methods of distributing arts funds within a city; and provided a new cadre of professionals — neighborhood arts managers.
>
> The results in some cities have been impressive. Taking three of the CityArts cities (Dallas, Atlanta, San Antonio), the city agencies (two public, one private) had a collective budget of $2.6 million. The [Endowment's] CityArt[s] grant to the three agencies totaled $167,500. In 1982, those same budgets aggregated nearly $3.4 million, a 31 percent increase.
>
> In 1978, the number of emerging arts groups supported by these agencies totalled about 60. Today, that number is closer to 100.[15]

In Chicago's CityArts program's first year, 65 organizations received grants ranging from $500 to $3,500 to conduct workshops, exhibits, performances, and publications. The more than 600 events directly served over 80,000 Chicagoans in 1979 alone. In 1980, 58 groups received funding for projects. These agencies supervise a process here; they do not do the programming. The primary purpose of these support programs has been to

help the smaller neighborhood groups — the centers and the performing and exhibiting groups that are professionally managed (generally with budgets under $100,000). It has not been to start new groups, although over the years, many new ones have emerged. The criteria for support usually specify a length of time for which the groups have had to exist to establish a track record of reliability, good management, and artistic quality that can be evaluated.

Since the whole idea evolved to help start a local process, it will be important to evaluate for the future how well the concept of local support for these smaller groups really takes hold. How many of the cities in the pilot program have absorbed and will absorb the programs into their own budgets after the three-year period? Are the reasons for doing so compatible with the intent? What are the expectations of the arts groups? How well are they able to articulate their concerns in a focused way? Buffalo and San Antonio are among cities that have committed themselves to continuing their CityArts programs in 1982, after the Endowment grants have expired.

The use of CETA funding for artists and organizations has been among the most active debates of the 1970s. Arts organizations as old and traditional as the Wadsworth Athenaeum and as new as the arts councils all over the United States hired CETA-paid workers to work in the community. The programming arm of arts councils was boosted many times over in some cases. Some innovative and level-headed programs were initiated; some situations generated administrative disaster as private agencies could not deal with new public administrative requirements and details, and arts organizations came "out of a hat" only to find later that ongoing operational support required planning of a different sort.

> In New Orleans, in cooperation with the Area Agency on Aging, the Arts Council placed several poets in senior citizens centers and homes for the elderly, developing what became the base for a subsequent, larger-scale CETA-funded artists' program. . . .
> The major problem with the CETA program was its overwhelming administrative detail. The Arts Council was able to employ an administrator and secretary to handle it, but the Board was frustrated because it ended up costing the Arts Council additional funds beyond those reimbursed by the CETA program. The Arts Council staff was still struggling through some of the paperwork six months after the program ended. Problems or not, it did permit the Arts Council to extend the life of its highly successful senior citizens program.[16]

Other problems surfaced much earlier, because CETA funds were earmarked for salaries and employee benefits and could not be used for ma-

terials and supplies. The monies for production had to be sought elsewhere. Many directors of theater arts projects have mentioned the fact that they have had to "beg, borrow, or steal costumes, sets, and props."

It was only when the arts councils that did develop CETA programming understood their role and limitations that they could stay on top of it. In Buffalo, for instance, the Arts Development Services introduced a program of Arts Resources in the Community. Instructional kits in many art forms, developed by CETA artists, were disseminated with accompanying workshops.

It has been felt by some that those using CETA funds were not in a sense opportunists; "we used dollars to get personnel instead of getting leadership, and the good people will be found anyway." Too often, artists were used who should not have been put into 40-hour weeks and under authoritarian situations, and who were indignant about this. Some agencies found that it wasn't so difficult finding artists for the earlier project-oriented CETA programs, but that the later regulations made it difficult to find qualified people, and the training requirements were difficult.

> In 1978, when the 95th Congress approved legislation to extend CETA for four years (through fiscal year 1982), it drew in the focus and limited program participants to those who are unemployed, underemployed or in school, *and* economically disadvantaged. Under the earlier provisions of the act, most participants could be either unemployed or disadvantaged. The 1978 amendments also emphasized jobs and training for welfare recipients.[17]

For many city arts commissions, large CETA programs became the rule of the day in the years between 1974 and 1979. In Chicago, by 1980, over $1.5 million of a $2.5 million-plus budget was CETA-funded. An artist-in-residence public service program employed 108 artists for 1,137 performances and special events, 1,531 workshops and residencies, and 260 projects that reached people in child care centers, schools, senior citizen centers, handicapped centers, and the neighborhoods.

Between 1975 and 1980 in Seattle, artists were asked to propose projects that could be funded under CETA. From several hundred applicants, the Seattle Arts Commission chose about 50 to work on short-term five-month projects. They were paid $476 a month for a 26-hour work week. Seattle also used CETA monies to subsidize dancers working for the city Parks and Recreation Department and to support the Seattle Symphony Orchestra.[18]

Speaking from first-hand knowledge about the Artist-in-the-City program, a photographer who documented as part of his project every art-

ist in the CETA program for more than a year wrote at the end of his tenure:

> Take fifty federally funded CETA positions. Fill them each year with art-
> ists who have designed projects to be carried out for the benefit of the city and
> its citizens. Administer the program with a maximum of flexibility, allowing
> the artists the independence they need to achieve their ends. That's the Artist-
> in-the-City program, and it seems almost too good to be true. But it is true, and
> it's been working since 1975.[19]

The program has been phased out.[20]

The Department of Cultural Affairs in Atlanta was organized in 1975
with funding provided through the Atlanta CETA. As with other programs,
individual artists were given employment with the city's arts organizations.
In 1978 alone, the Department administered 150 CETA arts positions. The
placement record of Atlanta's CETA arts participants in permanent em-
ployment (the whole point of the training role) has been over 80 percent —
above the national CETA averages.

The Council for the Arts in Westchester County, New York, came up
with a creative way to recoup some of the personnel losses from CETA in a
way new to the arts. By working through the On-the-Job Training Pro-
gram, sponsored by the local chambers of commerce, and the Private In-
dustry Councils, which deal with permanent jobs only, half the salary costs
for the training period were picked up; after this period, the new employer
had to absorb the full costs.

In general, though, if the agency is a city agency, there is no problem
with the philosophies of the CETA program, which fits right in with other
unemployment programs. If the council is a private council, there are some
basic dilemmas. Too many artists did not become placed in jobs related to
their arts careers after the CETA programs. Too many programs left or-
ganizations dependent on the positions filled by CETA workers, struggling
to adjust budgets to support these positions once CETA monies were with-
drawn. There has been too much uncertainty. And, if everyone is totally
honest, too many artists, whose main qualification was unemployment and
who did not have professional experience before, still find themselves un-
employed after.

Arts councils took on these programs because they filled two needs:
(1) they created employment for artists, and (2) they made the arts accessi-
ble to everyone — those constituents who had been no one else's priority.
But they were high-risk programs and did not solve the long-range prob-
lems.

The San Francisco Art Commission has had, over the years, exciting
neighborhood arts programming concepts. The Neighborhood Arts pro-
gram came into existence in 1967, in the period of "a spectacular revival

that thrived outside the mainstream of the established institutions."[21] It has been recognized for forging new innovative methods. Over the years it has moved from functioning as a festival coordinator, to providing technical support service, and finally into offering greater assistance for individual artists and emergent groups, through program development for each of the neighborhoods and citywide community arts planning.

If ever there was programming that, at its height, pervaded every nook and cranny of a city, this was it. Operating funds for this program, the largest of the commission's programs, came from the commission, the Hotel Tax Publicity and Advertising Fund, the Zellerbach Foundation, the San Francisco Foundation, the Evelyn and Walter Haas, Jr., Fund, and the National Endowment for the Arts. The program's four main categories of activities have been these: cultural centers; public service arts (workshops, performances, and other services by professional artists); arts support services (use of studio, workshop, rehearsal, and performance space—stage, sound and light equipment with accompanying operating staff, publicity, and the Scrounger's Center for Reusable Arts Parts Recycling Center used by artists and arts groups); and special programs (music and dance concerts, plays, play and poetry readings, lectures, seminars, and demonstrations, and participatory events for children, seniors, and the disabled, regularly scheduled in each of the cultural centers and other community facilities). Arts exhibits, thematic festivals, and ethnic celebrations on a neighborhood and citywide basis have been held throughout the year.

Also in San Francisco, there is a unique support system developing for neighborhood arts. The need for it came about when, in the mid-1970s, revenue-sharing monies ($5 million) went into the construction of the new symphony hall, and half that amount again was given to purchase neighborhood cultural facilities. As too often happens, no monies were set aside for ongoing administration or maintenance; the support for the neighborhood programs was to come from "neighborhood leadership." Thus, at each of the four centers purchased and renovated by the city, there is now a "Friends of" group that has committed itself to supporting the programming at these facilities. A consortium of the Friends groups is developing to solidify their common efforts and goals further. There is hope that these groups can seek private monies that would not be given to a city commission. The "Friends" are people related to the individual communities.

The leveling problems a Proposition 13 can have on a small agency in city government, the elimination of CETA, and the fact that San Francisco public monies are only a portion of the operating and administrative costs have all had their impact.

In San Francisco, municipal support of the arts is a long-standing tradition. . . . A rather broad, inclusive definition [is] given to the arts. Due to the

structure of San Francisco city government, no one authority has administrative control over all arts institutions or arts-related activities. Many noncity agencies receiving municipal dollars operate on varying fiscal years.[22]

The funding for the arts in San Francisco is very complex, and sources of funds for arts are diversified. Thus, long-range planning, given all of these complications, is very difficult to focus on.

In December 1970, the scope of projects was somewhat limited. Programming expanded with the tremendous CETA influx (San Francisco was one of the very first cities to adapt CETA for artists) and the taking on of the commission-built centers. In 1980, the core office staff was almost entirely made up of CETA employees. The total group of CETA workers was once 140. Today the program is tighter and the budget and staff are smaller.

The concept of outreach, then, has become extended to neighborhoods, to passers-by, and to every part of the community — anyone who might conceivably come into contact with the arts. The value of these outreach programs has been debated ad nauseum. Too often they have come and gone with government monies because they have represented opportunities. Only when the motivations and goals are clear, and an advocacy is developed based on understanding the artistic values, will there be support of an ongoing nature, putting these programs in more than the category of "democratic thought and social action." There has been too little leadership really able to do more than articulate in uneasy tones the questions of the injustices and inequalities.

NOTES

1. Charles B. Fowler, "On Education," *High Fidelity/Musical America*, July 1977.

2. Hospital Audiences, Inc., *HAI News*, Fall 1979, p. 4.

3. Affiliate Artists, Inc., (brochure, 1981).

4. City of Walnut Creek (California) Civic Arts Department, "Civic Arts, 1979" (a background fact sheet, 1979).

5. Alice Fuld, "Arts for Special Audiences," *Community Focus*, February 1980, pp. 14–15.

6. Community Programs in the Arts and Sciences, "Arts in the Community" (brochure, 1980).

7. Pamela Worden and Ronald Lee Fleming, "Neighborhood Value: Reinvestment by Design," *Public Management*, August 1977, pp. 14–17.

8. Ibid., pp. 16–17.

9. Pamela Worden, "The Arts: A New Urban Experience," *Challenge*, February 1980, pp. 17–21.

10. Ibid.

11. Cambridge Art Council, "Arts on the Line/Art for Public Transit Spaces" (brochure, 1980).

12. "Design, Art and Architecture in Transportation," (Report to the Secretary of

Transportation (Washington, D.C.: U.S. Department of Transportation, September 1977).

13. Cambridge Arts Council, "Arts on the Line/Art for Public Transit Spaces," introduction by Hugh Davies.

14. Peter Larsen, "Neighborhood Arts" (Seattle Arts Commission material, 1977).

15. Frank Hodsoll (address given at CityArts Conference, Wingspread, Racine, Wisconsin, March 9, 1982).

16. Robert Mayer, "The Local Arts Council Movement" (background paper for the National Endowment for the Arts National Partnership Meeting, June 23–25, 1980), p. 35.

17. National Urban Coalition, *Understanding CETA* (Washington, D.C.: Author, p. 4).

18. Stephen Brown, "The Public Artist Returns," reprinted in U.S. Department of Labor, Employment and Training Administration, *The Partnership of CETA and the Arts* (Washington, D.C.: National Policy Institute, 1978), p. 7.

19. Charles Adler, "F-Stops with Artists," *Seattle Arts*, September 1980, p. 1.

20. Karen Gates, *Seattle Arts*, May 1980, p. 1.

21. San Francisco Arts Council (brochure), p. 26.

22. Luisa Kreisberg, *Local Government and the Arts* (New York: American Council for the Arts, 1979), p. 143.

Part IV

IDEAS AND OPINIONS

The chapters that follow are based on discussions with some of those persons who have been important to the history reported in this book, as well as on their written pieces and speeches. Each of these individuals, in some way, has influenced the community arts council field that serves the arts today.

All interviews were based on the same set of questions. In the course of conversation, the interviewees carried the answers in the direction of their individual interest and emphasis. The following inquiry forms the framework for some of the thoughts reflected:

1. Generally, what do you see as the place of the arts in the community?
2. How do you see the growth and development of arts councils?
3. How do you see the role of arts councils?
4. Has their role changed from the first days? How so?
5. What are your views on leadership in the arts council movement at present?
6. What are the largest issues facing local councils today?

Their responses are reflected in the following chapters.

14

The Washingtons and Jeffersons

THE PEOPLE: IRWIN, HANES, AND NEWTON

GEORGE IRWIN: Cautious builder—the George Washington.

Irwin Paper Company, Quincy, Illinois; Peoria Paper House, Inc., Peoria, Illinois; and Decatur Paper House, Inc., Decatur, Illinois: Personnel Director 1950–69, Chairman of the Board 1961–69. Quincy Symphony Orchestra: Founder and Conductor 1948–64, General Director 1964–67. Quincy Society of Fine Arts (a community arts council founded in 1947): Board Member, Founder, and first President 1948–78. Illinois Arts Council: first Chairman 1965–71, Member 1965–75. Museum of Contemporary Art, Chicago: Member, Board of Trustees 1967–74; Life Member. American Symphony Orchestra League, Vienna, Virginia: Board Member and Officer, 1952–67. American Council for the Arts, New York: Honorary Board Member; a Founder, former President, and Chairman 1961–73. Council on Foundations, Inc., New York: Board of Directors and Executive Committee 1966–72. Business Committee for the Arts, New York: Founding Board Member 1968–71.

R. PHILIP HANES, JR.: "The secret is involving people"—a businessman's view and champion of the private sector.

181

Textile Company Executive, Winston-Salem, North Carolina. National Cultural Center for the Performing Arts 1962–65, by appointment of President Kennedy. National Council on Arts: Member 1965–70, by appointment of President Johnson (Advisory Music Panel: Member 1970–72). North Carolina State Arts Council: Chairman and Founder 1964–66. Arts Councils of America: President 1964–66. American Council for the Arts: Vice-Chairman and Founder 1966–69. Kennedy Center for the Performing Arts: Board Member 1975– , by appointment of President Ford. Business Committee for the Arts: Member 1977– , Board of Directors 1980– . American Symphony Orchestra League: Director 1958–61. Alliance for Arts Education: Director 1976–

MICHAEL NEWTON: "Practical wisdom by which far-fetched ideas can be made real."

Performing Arts Council of the Music Center of Los Angeles County: President, 1979– . Associated Councils of the Arts: President, 1974–78. Arts and Education Council of Greater St. Louis: Director, 1966–72. Kansas City Gilded Cage and Circle Theaters: Founder and Producer, 1958–66. American Council for the Arts, Board of Directors, 1972– . Author of *Persuade and Provide: The Story of the Arts and Education Council in St. Louis*, 1970.

1. *Generally, what do you see as the place of the arts in the community?*

GEORGE IRWIN: When the community can say, "We are proud of *the arts*," not just the symphony or dance company, it will have happened as it should. The sum is greater than the parts. The arts need to be thought of as an integral part of the community, as are the Boy Scouts, the "Ys," the hospitals.

PHILIP HANES: It usually is not possible to revitalize a central business district without the arts. You can do the cosmetic things, but in so many cases it can be proven that the arts are critical to revitalization.

 The day the Arts Council won [in Winston-Salem] was on the occasion of the dedication of a new building which was to house the Arts Council, United Way, and the Chamber of Commerce. John D. Rockefeller [III] spoke, and when he spoke, he emphasized the arts more than anything else.

MICHAEL NEWTON: What the *Americans and the Arts* [Louis Harris] studies demonstrated to a suspicious and unbelieving art world was how the audience for the arts and the numbers of participants in the arts has grown. No longer are the arts the province of a band of pil-

grims distinguished by the paucity of their numbers and the purity of their thought. Suddenly we came to recognize what the lines at our museums, the demand for tickets at our theaters, the explosion of dance, . . . are telling us — that a new generation of better-educated, more affluent Americans have different expectations of life — and among these expectations are the arts.

2. How do you see the growth and development of arts councils?

GI: Community arts councils traditionally gave assistance to other struggling organizations, and represent "a breath of spring" and demonstrate the benefits that accrue when there is a community that works together. They have come a long way since just doing calendars, which still may be very appropriate if they are *arts* calendars instead of being only dance [or other single-discipline] calendars. They are more mature and sophisticated. The arts are about challenge and change, and arts councils, if they do not pretend to be everything to everybody, will have limitless possibilities and even greater impact in the next 30 years.

PH: Arts councils take on the pattern appropriate to their communities. Intuition tells me that arts councils, while developing at a rapid rate, have also affected the growth of such things as business support for the arts. The arts council is a vehicle for getting people involved. It often involves people who might not have been reachable by individual arts organizations.

MN: Arts councils or commissions run the gamut from being first rate to being unrepresentative and ineffective, from being powerhouses to having few assets other than a mimeo machine and an out-of-date mailing list. Some are private, some are public, but that is no clue as to how effective they are. How can you know? The best are representative of artists, of the people for the arts, of small organizations and of major arts organizations. These agencies can be especially useful if you want to know how to involve artists.

3. How do you see the role of arts councils?

MN: [In a discussion in St. Louis in 1978 on "City Government and the Arts," Newton, then President of the ACA, outlined needs to which arts commissions should address themselves:]
> a. The city as a governmental agency needs to make its own statement of concern about the arts.
> b. Coordinate what the city itself does in the arts.

 c. Make joint approaches to federal and state agencies on behalf of those needs and opportunities.

 d. Develop resources that exist within the city itself.

 e. Offer accessibility to existing arts opportunities to those who lack them by reason of age, education, transportation, or other handicaps.

 f. Ultimately the single most important role of many of the commissions that now exist has been in acting as an advocate within city government to assure that the potential of the arts and needs of the arts are taken advantage of and understood in every aspect of the city government's own functioning.

The role of the arts councils commissions is changing.[1]

PH: The private sector must remain strong. In the United States, the government dollars should be the least important.

GI: Community councils need to have their major base a private support one so that they remain free to work flexibly. If they are government agencies, there will be a tendency to be expedient and bureaucratic. There are great amounts of money that can be generated in a community — there is no automatic low limit; most people think too small. Business support for the arts has grown amazingly in the last 15 years and most importantly will continue to grow, but arts groups must continue to earn that support.

PH: Arts councils give the businessman (who had previously had little contact with the arts) opportunities to look the field over and select his focus. One report shows that if one puts a price tag on the donated time, it would equal the dollars given by the corporate community, and that the more time given the more dollars given. Most people usually try to get the money first. But if someone is donating time, they soon begin to give dollars, go to concerts, etc.

4. *Has their role changed from the first days? How so?*

PH: The early founders of the arts council movement played entrepreneur. That kind of person should get out and leave it to the professionals. The "good old boy" days are over.

GI: The arts councils must "know their communities in order to know themselves." They should not try to do everything; rather, decide what are the right things for them to do. There is a uniqueness to each community — it is not just a small version of a big city.

MN: [in his book with Scott Hatley, *Persuade and Provide*] During its early

years the council wrestled with the problems of survival. . . . Tomorrow's task is to dramatize the problems and opportunities which lie ahead. The challenge is to determine where the community's true interests lie and then to present a program which is reasonable in both the short and long term. The goals must be finite and attainable. Only the promise and the vision must be infinite.[2]

5. What are your views on leadership in the arts council movement at present?

GI: The community leaders should find the arts council boards a valued position and serve on them. Creative talent is always needed. The trick is for the artist or creative individual to recognize his role. The degree of awareness differs — and the creative person can often help others to see. Arts groups must remember that they don't make art — artists do. The individual artist must not be overlooked.

MN: We need to find ways to orchestrate the voices of all concerned citizens to insure that legislators at the national, state, and local levels know of our needs and the services the arts can perform. This is a place where community leaders can be most helpful.

PH: Leadership is developing in young business persons.

GI: Those coming into the field have come with a social awareness brought on perhaps by the events of the [19]60s. There is greater sophistication in some ways, and a better quality arts management person in some ways, but the zeal and missionary enthusiasm are not around as in the [19]50s. There are better-paying jobs — and of course more of them. The present crop is not motivated as much by commitment, adventure. The feeling I have is that the training institutions are turning out fuzzy thinkers, more pedantic leaders. The vision is not there.

6. What are the largest issues facing local councils today?

GI: There should be a dedication to quality, to standards in artistic and business management. The arts groups must earn the support of business, media, and local government by acting in a mature, administratively efficient manner. However, [they should] be prepared to take an occasional risk or chance, especially in support of the individual artist. Better planning goals are commensurate with the mature agency.

MN: It is vital that each of us ask whom we are intending to serve. Are we to serve arts organizations? Or artists? Or the public for the arts? I believe that increasingly the answer is that we should serve all three in-

terests, and our board should reflect that concern . . . people from government, business, labor, minorities, education, philanthropy, all geographic sections of the community and representatives of all major sources of income. But you would be surprised how many of the old-style delegate boards still exist and in so many cases destine their agencies to proceed at the pace of the slowest.

PH: The successful councils have concentrated on board members who can give or get. These councils understand management. The councils which have loaded the board with artists have problems because the artist does not usually understand management. They really get in the way of arts council progress.

MN: An arts commission can be a body which reviews everything that is being done by the city government to see where the arts could have a role to play.

NOTES

1. Michael Newton, "City Government and the Arts" (speech given in St. Louis, 1978).
2. Michael Newton and Scott Hatley, *Persuade and Provide* (New York: Associated Councils of the Arts, 1970), p. 230.

15

Special Perspectives

JAMES BACKAS

As Special Consultant to the Chairman of National Endowment for the Arts from 1975 to 1977, James Backas had among his special responsibilities the development of a federal policy toward art at the community level. In 1977, Backas became the first Chief Executive Officer of the American Arts Alliance, Inc. (AAA), a national organization representing art museums, dance and opera companies, symphony orchestras, and theaters to the White House, Congress, and federal agencies. AAA was established by professional artists and arts institutions to develop unified positions on national issues, legislation, and policies as they affect the arts, and to convey such positions to the national arts community and to legislators and government officials in Washington.

Backas has also been Executive Director of the Maryland State Arts Council, and wrote background papers on the regional and state arts organization movements for the June 1980 National Partnership Meeting, sponsored by the National Endowment for the Arts and the National Assembly of State Arts Agencies in cooperation with the National Assembly of Community Arts Agencies. He has since written several other papers and articles related to arts policies. In 1982, Backas became Executive Director of the Southern Arts Federation.

His experience gives him a special perspective on the total scene. His main theme is that "Government funding is going to happen and will be ac-

cepted and expected at the local level." Backas says that since there will be
more government funding from several sources, more grant-making pow-
ers at the local level are needed; this will create more pressure for there to
be local agencies that can carry out government purposes. He points out
that while these can be private agencies, there must be a good working rela-
tionship with government if arts councils expect to function in this jurisdic-
tion.

With that function will come accountability and the need for the arts
council to concern itself functionally with the taxpayer, the arts consumers,
and the arts producers. The local community will have to deal with the rea-
sons to convince the governmental agencies that the local agency is serving
a public purpose. This means that arts councils will become integrated
with the totality of governmental concerns, and there may be clashes with
the traditional thinking that "everyone" must be covered in the sense of en-
titlement monies and per capita distributions.

The "pioneer days are over." There is all the more need for dreamers
who can be passionate in their endeavors but who can accommodate the
need to be homogeneous. Arts councils have to give up the freewheeling
personal selection systems for a sense of responsibility for the public.

"We must be outraged by artistic mediocrity and social inequity —
and [change] must be accomplished within the political system, which will
give the arts dollars, prestige, stability, *and* responsibility," Backas has said.

Reflecting on the contribution of arts councils to the total cultural
renaissance, Backas reminds us that this contribution is not an accident. It
has been bubbling up from under. Government agencies did not make it
happen; they only nurtured it — the growth would have happened anyway.
In his interview he points out that historically, after World War II, many
GIs — thousands of young people — were changed culturally.

> The traditional indifference to art in America was given a good challenge
> when the American GI saw that the arts were important in other countries to
> people like himself. There was local pride in museums and opera companies;
> this was part of their identity. On top of this, the GI Bill allowed him to go to col-
> lege for two to four years, and there he was exposed to cultural events through
> such [activities] as the college concert series. He was exposed to art, theater,
> and music as part of his student ticket. Thus, the availability of junior colleges
> and higher education in general, coupled with more leisure time and prosper-
> ity, made the circumstances right for his turning to the arts.

The National Endowment for the Arts and state arts agencies were
created in response to this need. They did not create the need, but they
were able to make things happen because of the need. Local councils make

things happen; state arts agencies and the Endowment are reactive organizations, "but things cannot happen without the voice of the people."

Arts council directors must be able to identify valid artistic purposes and combine them with valid public purposes — the job is to know the "law for thing and to see that it does not run wild and abuse the arts and the artist." The ingredients for a successful council are good administration, imagination, ability to get things done, and a special sensitivity to art.

NANCY HANKS

Nancy Hanks, whose current role is as a trustee of many corporate and foundation boards, served as Chairman of the National Endowment for the Arts and the National Council on the Arts from 1969 to 1977. She came to that role with a full recognition and knowledge of the community arts council movement. As Executive Secretary of the Special Studies Project, Rockefeller Brothers Fund, and as Project Coordinator of the Rockefeller Panel report in 1965, *The Performing Arts: Problems and Prospects*, she included in that study mention of the potential of community councils:

> In an increasing number of cities, arts councils are playing an important role in coordinating various individual arts organizations and practices. Some of these are private bodies, a few are public. [Many] are so new that no formula for that organization can be laid down. But it is clear that a community arts council should keep in close touch with the local government. It may be possible that an arts council could, in some instances, be organized as a municipal arts commission. It is in serving as a bridge between the local government and as an arts commission — whether through formal statutory arrangement or informally — that a cultural officer can play a particularly constructive role in the development of the arts.[1]

> If arts councils in cities and states can focus attention on common problems and bring the representatives of various art forms together to help solve them, then it is possible to hope that these efforts can be expanded to embrace regional and national cooperative efforts.[2]

Hanks came to the Endowment, then, with a greater background in this area than either her predecessor or her successor. During the eight-year period of her leadership, most of the active community programs were launched.

Before she took on the Endowment role, she was a board member and then president of ACA. In reflecting upon her involvement there, she felt

she was asked onto that board because she believed in community arts agencies and the importance of diversity.

Commenting on that belief, Hanks has discussed the fact that community arts councils must emphasize that diversity and keep the grassroots involvement. She feels that the primary goal of community councils today must be to create local dollars. The roles have changed because communities have changed. "In 1965, the main focus was keeping the orchestra going and alive. Today we want to keep the orchestra alive for many reasons." That is because the perception of the arts in the community is different today, and there is a much broader definition of the arts through such circumstances as the use of public spaces and downtown plazas, the expansion of leisure time, and the return to pride in the community. "You cannot celebrate your community without the arts," she has said.

The arts councils must know their arts and know their community, and must "help create the environment for community discussion and action about the inclusion of artists and minorities, about the dollars involved. The relationships between the arts and the community will be different for every community. The arts councils must provide public education to help people understand the continuity of the arts — the plurality, variety, and alternatives."

"The arts are key; arts councils are not key." Arts councils must move with the times and be flexible; there will never be a day or time when they do not fight politicization every day and do not have to talk about the importance of the arts in the community.

She tried to be a good listener and to really absorb and to respond to what she saw and heard as she traveled to various communities as Endowment Chairman. Two programs initiated under Nancy Hanks seemed to relate to bringing special attention to total communities: the City Spirit program, and the Architecture and Environmental Arts program. "Where there was a City Spirit program, communities seemed to have some tools for working together. The City Spirit involvement really planted the seeds which have remained in constant motion, but the idea of the total community working together seems to have taken hold in many cases." City Spirit, she reminds us, was a National Council idea (Lawrence Halprin was a big advocate), which gave it a certain verve.

The philosophy of the second program, Architecture and Environmental Arts, bolstered by the support of such people as Charles Eames, caused "cities to look at their alternative futures." These Endowment programs — City Edges, City Options, Livable Cities — made mayors pay attention to the arts, architecture, and environment. This and similar activities caused groups such as the U.S. Conference of Mayors to take their resolution seriously.

It has been substantiated that the communities involved in these pro-

grams would agree on the importance of these incentives for the work they accomplished with the small amounts of money available.

In discussing leadership, Hanks has made a simple statement. It must come from the community; those who are the best "are the ones who capture other people's dreams."

NOTES

1. Rockefeller Panel, *The Performing Arts: Problems and Prospects* (New York: McGraw-Hill, 1965), pp. 122–23.

2. Ibid., p. 49.

16

Local Political Power and the National Scene

THE SETTING

History Making. An informal meeting in Seattle, May 1974. Office of Mayor Wesley Uhlman.

Those Present. John Blaine, Executive Director, Seattle Arts Commission, and Alvin H. Reiss, private consultant, in town for a workshop with the Arts Commission.

Outcome. The first articulation of the importance of the arts in our cities. Preceded by "A Bill of Rights for the Arts in Our Cities" (written by Reiss for a speech he delivered in Cleveland, Ohio, 1973). The "Bill of Rights" was used by the Governor's Conference, county officials, and state legislators.

RESULTS

Three Who Became Involved

WES UHLMAN

Advocate for local governmental support for the arts; introduced resolution "The Quality of Life in our Cities" at the U.S. Conference of Mayors in 1974. The resolution was endorsed by that group and later by the

National League of Cities. As Mayor of Seattle for eight years (1969–77), did much to make use of the arts to revitalize a major city.

FRANK LOGUE, JR.

Chairman, the National League of Cities Task Force on the Arts (1976–79); Mayor of New Haven, 1976–79. Sought to increase community consciousness of the arts and expand the arts audience.

MAYNARD JACKSON

Chairman, U.S. Conference of Mayors; Committee on the Arts when issue paper, "The Taxpayers' Revolt and the Arts," was published, 1978. Mayor of Atlanta, 1973–81.

The three mayors, in various national capacities, urged the publication of *Local Government and the Arts* — "a cookbook into which mayors and city leaders can look for recipes for their own cities"[1]

"Bill of Rights for the Arts in our Cities"

In June 1974, the U.S. Conference of Mayors passed a first-time resolution on "The Quality of Life in Our Cities," drawn from the following. The resolution, introduced by Mayor Wes Uhlman of Seattle, adopted points 1, 3, 7, 11, and 14 of Alvin H. Reiss's "A Bill of Rights for the Arts in Our Cities" as guidelines for city action in the arts:

1. That city governments recognize the arts as an essential service, equal in importance to other essential services, and help make the arts available to all their citizens.
2. That the public at large, through the efforts of concerned fellow citizens and the municipal government, come to recognize that the arts are not an isolated area but part of the overall environment.
3. That the physical appearance of the city, its beauty and its amenities, be a resource to be nurtured and that any attempt to destroy that beauty be challenged.
4. That the arts be assured a firm place within the city's school system, and that local colleges and universities open up participation in the arts to all their students.
5. That grassroots arts activity at the community and neighborhood level be recognized as a vital contribution which, for many citizens, is a key part of the educational process.
6. That city government include within their long-range budgetary programs new mechanisms for increasing their dollar support of the arts.

7. That every city have a public agency specifically concerned with the arts.
8. That every city have adequate facilities for presenting the arts.
9. That every city recognize the contributions of its artists by making benefits available to them through zoning, taxation, and housing.
10. That city government regularly employ artists in their schools, libraries, parks, and public places.
11. That a percentage of the total cost of every municipal construction budget be set aside for the purchase or commission of works of art.
12. That every corporation of size, doing business with the city, have an identifiable figure whose official area of responsibility shall include the arts and environment.
13. That elected officials and those running for elective office shall view the arts as a key area of concern and shall include a program for the arts in their official platforms.
14. That working together in a true community spirit, the city government, the arts community, and the public at large shall help to effect a new manifesto, "That no American shall be deprived of the opportunity to experience the beauty in life by barrier of circumstance, income, background, remoteness, or race."[2]

THE PEOPLE: LOGUE, UHLMAN, AND JACKSON

FRANK LOGUE: [at a meeting of ACA, Seattle, 1976, regarding conventions] An invitation to the [ACA] meeting in Seattle in 1976 on Local Government and the Arts brought me, Phyllis Lamphere [Councilwoman, Seattle; President-elect, National League of Cities], Nancy Hanks, Wes Uhlman, and Michael Newton together. Ms. Lamphere, on becoming president of [the League], appointed a Task Force on the Arts and asked me if I would chair it. The Task Force was charged with continuing responsibility of having the arts permeate city government: transportation, housing, human resources, CETA, etc.

It's not what happens *at* conventions [that's important;] rather, the seeds are sown for what happens *afterwards*.

[In 1977, Bette Treadwell, a member of the staff for the National League of Cities, developed a questionnaire circulated to cities, which was the first information bank to have ever been developed. It was used in the publication *Local Government and the Arts.*]

WES UHLMAN: The Seattle experience is transferable. In 1970–71, one out of every five was unemployed during the Boeing recession, and the budget was in trouble; it was a time to look inward.

 a. The artist was important when the spiritual image of the city was low.

 b. Arts councils must change as community focus and needs change. Creative activity is pivotal and there must be care not to be too coopted by bureaucracy, but it is important to be professional, to have bureaucratic skills, and [to] know how to move within the system. The entities (arts councils) have been established; now they must be maintained.

 c. Arts power is increasing; [an] example would be when proposed budget cuts are rescinded due to community pressure.

 d. The citizen advocacy group is a powerful assistant — [it] could work with government officials, and work as a counterforce in dealing with criticism.

MAYNARD JACKSON: In something as complex as a community, sometimes we don't see how one part affects all the others. Take the arts, for example. You probably appreciate how the arts bring people together. And you already know how they open our minds to all kinds of new experiences. But the arts not only create beauty, they create jobs. Businesses prefer to locate in communities with a rich cultural life. Try to imagine your community with no music, no dance, no poetry, no theater, no sculpture or painting. You have to imagine, eventually, industry and jobs gone, too. And, after that, the people. . . .

 One of the most exciting developments I have noticed is the initiative taken by arts organizations and individual artists to reuse existing urban structures for cultural activities.[3]

Frank Logue worked on the home front to increase community consciousness of the arts, to expand the arts' audience, and to take the arts to the places (murals in the welfare department and schools, dances and musical performances in libraries and other public buildings, etc.) where they would be seen.

 The potential of arts involvement in the city feeds both images — that of the mayor, and that of the arts commission. Uhlman, when stepping down as two-term mayor of Seattle in 1977, got credit for making a city that was formerly described as a "cultural dustbin of the nation" viewed as "one of the country's livable cities." In 1967 Seattle had two theater companies. In 1980, there were 12 major companies, four dance companies, and more professional theater companies per capita than anywhere except New York City. In 1980 there were 40 art galleries, compared to only ten in 1967.

MAYNARD JACKSON: Whether the artists realize it or intend it, they help teach us and help prove to us that our cities can come alive again.

The arts represent the vitality and perhaps the very identity of the city itself. The arts are the highest expression of urban life, and the cultural enrichment that is possible in an urban setting is the highest and most eloquent justification of the city itself. The arts and the city are inseparable.

NOTES

1. Wes Uhlman, quoted in Luisa Kreisberg, ed., *Local Government and the Arts* (New York: American Council for the Arts, 1979), acknowledgments.

2. Alvin H. Reiss wrote "Bill of Rights for the Arts in Our Cities" for a speech he delivered in Cleveland in 1973. Used by permission. Final quote is from Alvin H. Reiss, *Culture and Company: A Critical Study of an Improbable Alliance* (New York: Twayne, 1972). *Culture and Company* had already distinguished Reiss as a visionary for methodologies for support from the private sector.

3. There was no personal discussion with Maynard Jackson. The Mayor's office submitted previously written statements in response to the query, April 29, 1980.

17

Practitioners

MORE PEOPLE: BLAINE AND LOMAX

Two of the leaders in the community arts council movement have come from the municipal arts agencies:

JOHN BLAINE

Studio Watts Workshop, Watts, California: Liaison Officer. "The Meeting at Watts Towers" (consortium of arts agencies): Founder 1968–72. Seattle Arts Commission: Executive Secretary 1972–78. Cultural Arts Council of Houston: Director 1978–80. Alaska State Council on the Arts: Director. National Assembly of Community Arts Agencies: Board member 1976–80; President 1978–79 (at the time it became an independent organization).

MICHAEL LOMAX

Bureau of Cultural and International Affairs, City of Atlanta: Director 1975–77. Department of Parks, Libraries, and Cultural Affairs, City of Atlanta: Commissioner 1977–78. Fulton County: Commissioner 1979–

BACKGROUND

JOHN BLAINE: If I hadn't been sent to an ACA Conference [1969] in St. Louis, I never would have known ACA. The valuable contacts led me to the Seattle job later.

ACA has root problems because it really doesn't know who its constituency is and still manifests this in many ways.

But — if it hadn't been for ACA . . .

Arts councils have grown from nothing to something. Our success and our failure is wrapped up in the fact that we are self-created, self-motivated, and molded to the needs of each community.

MICHAEL LOMAX: Every community is different; success one place would not spell out success elsewhere.

JB: On one hand, we should be politically involved and potent. On the other hand, we don't want to be politically manipulated.

ML: There is a strong connection between public officials' taking strong positions in favor of the arts and good strong public programming.

JB: The largest issue is freedom. Arts councils have to be free — have to be allowed to make mistakes, to experiment — along with having restraint. It's an arts council's job to respond, not to mold.

ML: The impact of arts councils is that they have raised the consciousness about the arts and role of the arts beyond the exhibit space, concert hall, studio. Now, they are moving into a position of translating all of this into making sure that the arts are available to everyone.

The arts council movement has been tied to the American economy, and the challenge will be to be creative and to find new sources of funding. There will be strong advocacy needed because it is going to be a matter of priorities, as is all expenditure of the public dollar.

JB: In Washington [Seattle], there was strong citizen advocacy that has maintained involvement through the years and has been a good watchdog.

ML: Acceptance is a matter of time. Arts institutions are conservative.

[From a 1978 speech:] With the economy askew, with the public reassessing government expenditures, the arts must be vigilant if we are to get all that we need, not just to survive but to prosper. I believe that in Atlanta, we have taken the relationship between the arts and politics to a somewhat different level. Our arts programs were developed in an environment which required political diligence and sophistication. Our arts program will grow because we have main-

tained our diligence and grown in sophistication. This year [1978], the Mayor is facing a $5 million budget shortfall and the only program that will not only survive but will grow this year is the city's Bureau of Cultural Affairs; it will continue this year with a 20 percent increase in funding. I don't know why. I don't care. Obviously, it's good politics. We have learned in Atlanta one key factor and that is that we have greater political clout than we thought. My election [as a Commissioner] demonstrated that someone whose singular association with the public's mind is the arts can win a very difficult election with support drawn exclusively from artists, from art institutions, and from their supporters. That is the kind of political power we never suspected four years ago when we started working in the arts.[1]

NOTES

1. Michael Lomax, "Opening Remarks" (speech at conference on "Building Our Cultural Community," Boston, December 1978).

Part V

ON ISSUES—OLD MYTHS AND NEW REALITIES

———————

18

TLC Is Not Enough

Where strong local arts agencies exist, good things are happening—not by chance, but because long-range goals and objectives have been set, and solid decisions, based on thorough knowledge of local needs and resources, are being made.

Elizabeth (Lee) Howard,
Executive Director of Alliance of New York State Councils
Former President, NACAA

CONSIDERING AN ARTS COUNCIL

Creating a climate in which the arts can thrive takes enthusiasm, gutsy and realistic planning, and the promise of quality—in addition to the people to carry out the plan.

All kinds of factors affect the range of activities that a community would wish to support and the way in which it would do so: Community size; population type and its stability-mobility factor; population age; and other demographic, economic, and topographic considerations would help make that determination. Even topography—mountains and snowstorms—affects the kind of arts community that will exist.

There are internal human-created structures that affect the arts life too—structure of city government (mayor or city manager); number and

203

types of performing arts facilities (schools, multipurpose auditoriums, public and private arts centers); strength and priorities of the education community (town-gown relationship on all matters, including the arts); the types of indigenous activities; the gaps in arts activities; the age of institutions; and the method of developing the arts support mechanisms.

Most cities of populations greater than 300,000 have a cadre of artists and arts organizations that need a full range of services. Communities of 100,000 to 300,000 often have a similar mix, but fewer of each type of arts group. They may have population mixes that are uneven; a prison or university dominance, a single industry, or a rural presence may make a population "bend" in certain directions. It may be a retirement community, where a high percentage of persons are on fixed incomes and leisure time is maximized. These are high considerations when one looks at the functions of a council.

Although there are commonalities among the functions that have contributed to a thriving community of the arts, each community's council has served best by assessing the climate that is and projecting what could be. No two are exactly alike.

It has been said that the most successful of the councils have, from the beginning, functioned with some clearly defined priorities dependent on their communities. Those priorities may have changed through the years, but, by and large, the united fundraising groups have clear priorities in the fundraising areas, and their other services surround that prime function. The same would be true of councils with facility management, artists' employment, or neighborhood arts as priorities. Many staffs in secondary areas are not big enough to attract major expertise and attention, and often such positions have been held by persons well trained but in their first arts management jobs, growing personally with the jobs. This would be less true of the largest councils, perhaps. Too, there are those examples of all-sized councils with a good balance of service and/or advocacy and programmatic activities.

A community wishing to start a council has often started from the needs of the community and from the background and expertise of the director, and will build from those components.

Smaller and medium-sized cities have usually relied on privately incorporated arts councils that were founded to serve the needs of local arts agencies. Some of the strongest councils are of this type. The local governments are usually apathetic. Once the population rises above 500,000, the issues become too large for local government to ignore, and the need for its involvement in representing the interests of the arts becomes apparent. Both public and private local arts agencies can exist side by side in larger cities, each type of agency with its own complementary agendas. One

needs also to consider the possibility of county-based or regional agencies. Some "community councils" function formally or informally as county-wide or multicounty organizations.

What aids the decision about an appropriate type of council for a community, as the community chooses among the many alternatives? The types can be listed as follows: a privately incorporated nonprofit organization whose board is elected by a membership; a public commission appointed by the local government; or a cultural office or department reporting directly to the mayor or the director of a city or county department. Occasionally, the local government will designate a privately incorporated arts council as the government's official arts agency and empower it to carry out certain functions for the government.

An issue that gets pushed when state councils start to create incentives for planning a partnership program is whether the local arts agency shall be private or public. The fact that several states require planning on the local level for evolving the local arts agency underscores the need for community planning.[1]

The public agencies have been commissions, cultural affairs offices, municipal arts departments, independent public authorities created by legislation, and even a municipal arts department as part of a recreation department. When the designation is by city council ordinance or some such permanent act of local government, it constitutes the greatest commitment to incorporating the arts into the public structure. But successful agencies have functioned in all the structures described.

Private community councils can be recognized significantly by cities; in Tulsa, three of the 11 appointees to the Municipal Arts Commission are representatives from the Arts and Humanities Council. Private councils exist in greater numbers than public agencies, but the trend, in the largest cities especially, has been toward the public agency.

The private council is sometimes the conduit for local funds and, as the publicly designated arts agency for that community, is compensated for that service. The councils in Columbus, Ohio, and Houston, Texas, are just two such examples.

There are some cities with two organizations — a municipal agency and a private coordinating group, that is, a council alliance or united fund. These cities include Philadelphia, Seattle, St. Louis, Atlanta, and Washington, D.C. Some have more than two organizations. In such instances, it is most important that the areas of responsibility and the functions ascribed to each group are clearly defined. In most cases, the municipal group is rather new, the private council having had a role for a decade or more. Sometimes the municipal commissions have no administrative budgets, and the arts council serves as secretariat.

In his 1980 background paper, Robert Mayer asks:

> What changed in New Orleans that brought into focus the need for a city governmental department for the arts when a private arts council had been created as a result of earlier city initiatives and had been designated by the city administration as its official agency? . . . The Arts Council is fully behind this direction, so that there will be a strong voice for the arts in City Hall, as well as a strong private voice in the Arts Council. . . . there can be strengths and balances in this situation, with creative tension helping to do what has to be done for the arts in the city. It will be important to preserve the integrity of each group.
>
> It could be that this situation is more related to a national phenomenon we have witnessed in the last ten years, where support of the arts is becoming a highly visible, politically intelligent platform upon which elected officials can stand.[2]

Since 1980, the two groups have merged, and the present Arts Council of New Orleans has a contract to perform certain services for the city. This two-organization movement will be interesting to watch as the arts become of greater concern to cities themselves, and as cities sort out priorities for the 1980s.

One of the most appealing structures is that of the Arts Council of San Antonio. The Council is a private organization with public designation, and it has a contract with the city of San Antonio for certain services. "The Arts Council of San Antonio has been described as a private agency which clearly functions on behalf of the city."[3] This would seem to offer the best of both worlds, one that "is a condition in which most effective community arts agencies, whether public or private, will ultimately find themselves."[4]

In examining the philosophical background behind that Council's development in that direction, one finds a clear statement of the private-public council dilemma:

> There is an overwhelming need for private arts agencies to understand and accept public responsibility and, at the same time, a need for public arts agencies of city and county government to understand their responsibilities to the private arts constituency.[5]

The contract between the Arts Council and San Antonio (Figure 1) delineates what this agency is actually going to do. It seems that this set-up is entirely possible in a city of almost any size. But all components are important to its whole.

> A measure of the success of the relationship between the Arts Council and the city of San Antonio has been in the city's financial support of the arts. In fis-

FIGURE 1
Contract Between the Arts Council of San Antonio
and the City of San Antonio

Purpose: To provide services of the official community arts agency for the city of San Antonio. To coordinate and develop funding requests and special programs in cooperation with the National Endowment for the Arts and the Texas Commission on the Arts. To work in cooperation with appropriate city officials and agencies in evaluating city arts projects and public facilities supporting the arts. To conduct research, planning, communications, technical assistance services, and special programs which will expand the cultural and artistic resources for the people of San Antonio. The Arts Council agrees to:

1. Maintain an office and professional staff to provide a central clearinghouse for information, services, and development for cultural activities in the city of San Antonio and surrounding area.
2. Act on behalf of the city in preparing and submitting grant applications to state and federal arts agencies and to receive and administer such funds as may be made available to the community arts agency.
3. Provide the services of the Executive Director to serve as Special Assistant for the Arts to the Mayor, City Council, and City Manager; to advise and assist the city in evaluating city arts programs and to represent the city at state, regional, and national meetings as may be required.
4. Compile and maintain financial and program information on every major non-profit arts organization in the Greater San Antonio area.
5. Conduct regular public meetings and surveys to determine community, institutional, and individual needs in the arts and to maintain continuing community input into arts planning and programming.
6. To provide continuing information on arts programs in San Antonio to local, regional, and national news media and to regularly publish and distribute a calendar and newsletter of local arts activities.
7. To provide technical assistance services to city departments, organizations, and individuals in preparing grant applications to public arts agencies and private foundations.
8. To initiate, sponsor, and conduct, alone or in cooperation with other public and private agencies, public programs which will further the development and public awareness of, and interest in, the performing and visual arts.
9. To work through the designated city department(s) in all matters involving fiscal control and monitoring of city-funded arts programs, to assist this department in evaluating requests for city funds, and to advise of all requests to the National Endowment for the Arts and Texas Commission on the Arts and Humanities from city departments and outside agencies receiving city funds.
10. To submit progress reports to the Mayor, City Manager, and designated city departments.

Note: Used by permission.

cal year 1975 the city provided $533,000 in support for three organizations. [In fiscal year 1982, the total city support for the arts exceeded $2 million.] . . . The city does not regard this support as a giveaway program to charitable institutions, but rather as a sound investment in the overall cultural, economic, and social development of our city and region.

We believe this pluralistic approach is a good one because it does not vest all authority for funding in one agency. The final responsibility for funding rests with the City Council, where it properly belongs.[6]

An effective government agency depends on how well the governmental organization really works and how integrated the arts agency is within it — the potential political and temporal nature of being one of the public family.

Basically, a government agency provides easier access to other government monies and in-kind services (covering such items as office space, equipment, supplies, publication, and production). The private agency probably has greater independence and flexibility, as well as better access to private funding sources. Philosophically, the best of both worlds is bridged by the San Antonio model — a services contract with annual evaluation. It leaves intact the sense of innovation inherent in the arts, and minimizes political aspects of the agency.

Some municipal agencies have had swift and bewildering changes of function and focus. Ground is lost; confidence is destroyed; programs and services are aborted. If the agency's work has really become one with the city services, new personnel can replace the old and carry on. The development of some such agencies, however, has been so tenuous and young that the solidarity has not been built in. In one city, a confident plan was reported in an interview two weeks before the cultural affairs department was wiped out by budget cuts.

How does solidarity develop? It takes a concentrated period of time and certain favorable circumstances for a government agency to develop and become institutionalized. One way is for there to be a proprietorial interest in arts institutions by virtue of municipal ownership of an art museum and other cultural facilities, which many times has preceded the formation of the arts council. In Atlanta, the Commissioner of the Department of Cultural Affairs has served in the mayoral cabinet. In many cities, such as Seattle and Chicago, the council administers a percent for art in public places law. These roles help to give importance to the arts council function and to tie it to government process. Even then, shifts of political power can affect priorities and stability. Some are convinced, however, that sympathetic mayors are the key to solidarity; others see this only as short-term support.

The private council needs the commitment of the private community;

there is no substitute for this. The Winston-Salem Arts Council has been held out as the stellar example, and it is rightly deserving of its model role. The Council is strong because the community leadership has been involved from the beginning and has given it priority.

Other strong private councils lay down certain mandates for leadership roles. Their board must give priority to the council's work, and the members may not at the same time have primary roles with arts organizations. One particularly successful example is in Huntington, New York, where emerging community leaders are sought *before* they have made major commitments to other organizations. In Lorain County, Ohio, the council has delineated carefully designated board roles on paper, so that there is a mutual understanding before a person takes on the responsibilities.

The success of a private council is related to the caliber of involvement from the private sector — well defined and designed to keep leadership renewed. Involvement does not always mean giving money. It may mean donating significant amounts of time for committee and board work. In small communities, with arts councils run entirely on a volunteer basis or at the most with one or two part-time employees, the strength of the group depends on committed, dedicated workers. The organizational leaders in communities of all sizes worry about fresh blood and the generation of new and ongoing commitment.

The activities of the municipal groups differ in focus, but generally have to do with enacting laws, allocating funds, employing artists or purchasing art services, and commissioning works of public art. Details differ in the work of private groups — the Atlanta Arts Alliance, the Arts and Education Council of St. Louis, and the Corporate Council in Seattle are all united arts fund types, for instance. Some of those differences are important, but basically the private groups all work to raise funds from the private sector for the arts organizations.

The Seattle Corporate Council's work is specifically related to the business community. It processes corporate contributions to the arts; offers its members a comprehensive and equitable means of distributing dollars to the arts; prevents duplication of solicitation by recipient groups; and, uniquely, offers sustaining support — unrestricted dollars to be used to offset general operating costs. It does not fund special projects, capital drives, endowment funds, or individual artists.

The other organizations solicit funds more widely — from individuals, foundations, and corporations. In Atlanta, in one year, for instance, more than 2,000 people and businesses contributed. In addition, as a separate endowment campaign, there was a Challenge Grant from the National Endowment for the Arts and a $250,000 challenge grant for symphony endowment from the Andrew W. Mellon Foundation. Including these two gifts, over $5 million has been received for endowment. The Atlanta funds

have been solely for those organizations housed in the Atlanta Memorial Arts Center: the Atlanta Symphony Orchestra, the High Museum of Art, the Alliance Theater, the Atlanta Children's Theater, and the Atlanta College of Art.

The Arts and Education Council of Greater St. Louis, one of the older community councils (formed in 1963), was, in the early 1980s, a federation of 130 cultural and educational organizations in the metropolitan area. Eleven of these organizations benefit directly from the Arts and Education Fund Drive (in 1980, over $2 million). The other regular and associate members make use of central services provided by the Council, such as common mailing lists, printing services, computer services, workshops, and interagency program cooperation. All regular members are eligible to apply for special project grants, the money for which is raised through a two-phased "Camelot" auction, a Gala and Collage, a summer festival, and other activities conducted by the Council. Over $2 million was raised from this source in its first ten years. There are still other agency and community needs supported by Council fundraising efforts, and the Council's funds for these programs have been generated from the whole range of public and private funding.

The establishment of the Arts and Humanities Commission by the city of St. Louis in 1979 was to help attract federal money designated for cultural enrichment into the city, and to encourage neighborhood planning for cultural events. The Arts and Education Council had already attracted to the St. Louis area not only Endowment Challenge Grant and Expansion Arts monies, but Mid-East Area Agency on Aging money and Elementary and Secondary Education Act Title V monies. The Arts and Education Council report of 1978–79 expresses the hope that there will be collaboration, not competition, with the new group, and that the new group will reciprocate.[7]

Seattle is one city where the activities of the private and public groups seem to be as defined and diversified as they are anywhere, even to the point of indicating which group will get money from which source within a corporation — from the marketing budgets interested in high-visibility programs (e.g., the Downtown Development Corporation — concerts and murals), or from the corporate contributions for sustaining funds.

Still another private group in Seattle, PONCHO, runs an auction and selects the recipients of the monies according to the will of the selection committees, mostly on a project basis. They have been known, however, to knock on doors of small groups seeking interesting recipients. Allied Arts of Seattle has, through its foundation, funded some of the smaller and experimental groups.

Robert Gustavson, Director of the Corporate Council for the Arts, summarized the increased pressures on Seattle's private sector in 1981:

> Hard and sometimes unpopular support choices are going to have to be made to ensure the proper maintenance of a well managed and well balanced cultural life for our future. Trying to spread limited corporate support dollars over too many ambitious and well-intentioned recipients will only mean that *none* will be funded properly, and none will be able to achieve the programming and quality our city will require in the future.[8]

The Cultural Alliance of Greater Washington (D.C.) represents a private agency that services the needs of the arts themselves, basically through partnerships with the business sector. These have included in the past such things as insurance plans and recently the development of a proposal for a real estate coventure, in which the Cultural Alliance would assist in developing and then in managing cultural facilities.[9]

Thus it is clear in the cities with both public and private arts agencies that the private groups usually focus on the private sector, which most city agencies are careful to avoid. On the other hand, the public agencies have seen themselves as potentially more successful in soliciting public agencies, such as HUD and HEW (now HHS). They point to the advantages of being a unit of city government in relating to other units of government; such relationships are more difficult when a group is working from the outside. Most envision working with neighborhood groups and incorporating the arts in all city planning. Many envision the enactment of a percent for art in public places law, which will need them for administration.

These plans all work, until the public agencies are bypassed by the mayor when it comes time to study neighborhood groups, left out of critical revitalization planning, and omitted in ways similar.

Both public and private dollars will be harder to raise in the future. There obviously is a lot of ground to cover, and expertise should be used wisely and appropriately; expectations should be realistic (on the part of agency executives as well as the public). There is neither room for duplication nor need to leave gaping holes. It will be incumbent upon all such organizations to clarify the role for themselves and for their clientele.

ROLE AND VALUE OF COMMUNITY PLANNING

The solidarity of community arts agencies depends on various factors that emerge through comparisons, study, and discussion.

The private agency must have the support, both in the planning stages and in the implementation and functioning of the organization, of leadership from the private sector. In older cities of any size (over 500,000 — or even 350,000), this sometimes seems difficult from several standpoints. The age of arts institutions is directly correlated with the solidarity of the

city's traditional power base, and these institutions have engaged the major arts leadership. Although this moves slowly on to new generations (and the descendants of the old-line supporters are not necessarily the new supporters), it is difficult to engage the priority interest of the private sector's leadership for the new arts agency. The exceptions seem to be those cities in which the private sector has been strongly supportive of united arts funds or performing arts centers. New corporate leadership may emerge because here is a fresh opportunity — free from all the traditional forces. Buffalo is a good example of an older city of substantial size with a strong private service council. It made sure of strong community and corporate leadership in its early development. Most of the public arts council groups have not depended on the traditional private support makeup.

The private council, like private support for the arts, has dominated the arts council scene since the beginning. The majority of arts council organizations still remain private councils. This would be an expected American development, since arts support has strong private roots. If one remembers also the arts councils' roots in the Junior League's missionary work and the American Symphony Orchestra League's early interests in this development, it is natural. In the context of human services patterned after community development services, the philosophy has gradually changed. The activities of arts councils have become a mixed bag. It is the public sector's mandate to be accessible, to contract for services that affect large numbers, and to integrate planning into city planning. The trend in the larger cities is to serve the arts in this context. This has not been natural to the arts, but public monies lead councils to face this dilemma, which is both philosophical and problematic. In very few communities have the private and public sector worked together in the harmonious way that one would hope for in the future.

The private council development is only as strong as the town leadership, the city patrons, and the corporate leaders have seen to it that it will be. In many of the smaller communities, the advent of the coordinating force in the arts has meant that the arts (other than the few indigenous groups) have been available for the first time; in other areas, it has meant that the schools will have some arts programming, whereas before there was none; and in some areas, it has meant that fine touring programs have become available for the audiences of small communities and towns. It has raised the quality of the indigenous work and has brought it out of the woodwork for others to evaluate; it has raised the awareness of artists who want to better their opportunities as to just how and where that might be accomplished.

One characteristic of the successful councils is that they have continued planning procedures far beyond the initial process. In Winston-Salem, in the 1970s alone, there were plans committed to paper three

times. The internal long-range planning committee has been made up of persons from both within and outside the history of the council. In Durham and Charlotte, City Spirit grants spurred planning for the future, but the grants only continued a process that had been going on since the councils were started. All organizations need continuous evaluation by their own leadership to be sure that their direction and functions are in line with community needs and expectations. This process is often shortchanged or overlooked; sometimes the organization never quite gets around to doing it at all. But it is one of the secrets of the success of these councils. For they have involved their community leaders in the process, and when the results are in, the community leadership is committed to the actions recommended.

It may surprise those who want to diminish the value of such time spent that the oldest and one of the most venerated councils — that of Winston-Salem — was still talking about the uncertainty surrounding its scope and purpose in 1976 after 25 years in operation. Some of its needs and recommendations concerned criteria for judging worthiness of different programs, concerns about how the Arts Council would identify and explore opportunities for new cultural development, and ways in which the Arts Council would improve its overall operation. This report was written in relationship to the Council's 1971 report. It did not sit in isolation from the work done before or the work to be done to succeed it. (It would be all too common in the public sector to start anew with every new political regime.) The private council has a greater possibility of continuity if care is taken to see that these relationships with past work is maintained.

Acknowledged tensions between professional arts organizations and community participatory arts advocates stimulated the Winston-Salem Arts Council to initiate a major study in 1977 that developed a cultural action plan for the city and county. This planning process included 120 representatives from the community. An outside consultant was contracted to chair the staff work. The results of this work focus on much greater involvement by the Council in the future of the city. Facility renovation and expanded operation for arts groups were a big part of the plans. But the plans were designed to assist the major professional arts institutions as well as community groups.[10] The Arts Council has been raising funds in excess of $9 million, including federal sources new to them, to get the job done. The Arts Council would and could never have taken on this task if it had not had the backing of major private leadership in the city, and if it had not acknowledged the problems it was having and been responsive to a need to examine them.

In a growing city like San Antonio, the private leadership is continuously redefining itself and will continue to do so. This includes the leadership roles for the arts and all other community service areas, such as health and welfare. Therefore a new type of agency, especially one that seems

similar to a social service agency, can be accepted more easily. Their support systems are understood in a total context, not only in the narrower context of the arts.

Where there has been a decision to develop a public council, the success is uneven and may depend on the given year for evaluation. For commissions, councils, or cultural affairs departments are as strong as their place in the structure of the city government family will allow. Dallas' arts office, as a division under the Park and Recreation Department, which is traditionally a part of the government structure, is not likely to blow away. Hartford's Office of Cultural Affairs, with a desk in the City Manager's office, disappeared before it got off the ground because it was not properly placed and budgeted. The planning of its functions and duties seemed similar to other plans; the planning for its administration was lacking. Titles mean nothing; administrative roles and budgets do.

The Dallas Park and Recreation Department is also landlord to the major arts facilities of the city. This certainly lends a feeling of solidarity to the situation. However, because the Park and Recreation Board can make policy, the activities of the Department are rather well insulated from the political machinations of the City Council itself. In Dallas, the planning documents state clearly that, although there is this landlord-tenant relationship, starting back in 1928 with the Dallas Museum of Fine Arts, the city role is one of assistance to and not responsibility for any individual cultural institution. That is important, for in other cities where the facilities are city-owned, the policy making is not always insulated, and there have been problems. Public agency development must look at the following factors:

1. The agency's relationship to the city family.
2. Its relationship to the arts institutions and artists.
3. Its relationship to neighborhood development.
4. Its relationship to policy making and budget processing.

Each city situation will be individual, but the relationships to be examined are similar.

Another consideration must be the source of local funds to support the administration of culture. Amounts mean little if they are not integral to the city budget. In San Francisco, much of the funding of the arts program was based on Community Development and CETA funds; the city of San Francisco has given little local tax money to support the Commission's administration. Therefore, with reductions in these federal-program-related funds, good work done is dissipated, and the dedicated staff is demoralized and depleted. It is hard to build solid staff work or strong and

sound programming if funding is shaky. There are real challenges for small-er staff and less funding, and some councils will meet this in new and inter-esting ways, but the basic problem still exists.

So, while the director of a big city program will point to the amounts of money another city commission's budget projects, the *sources* and *sta-bility* of those funds are the important considerations. Some city directors have felt that multiple sources of income are important to survival. That may have some truth, but some entity, be it the city (hopefully with citizen advocacy behind it) or the private sector's board, must map out the func-tions and responsibilities carefully. This must include who is to be respon-sible for seeing that the agency will remain alive through changes in gov-ernments, temporal budgets, and priorities of the city council. If there is no planning and little support beyond that of the current mayor, the long-range prognosis may be poor.

If arts councils can have such a wide range of priorities and struc-tures, what are the considerations a community has to make when creating its support systems for the arts? What are the community needs that they are attempting to meet? Who is trying to reach whom and for what reasons?

There is no ideal situation, because each community is different, for any number of reasons enumerated previously. Thus, in laying out the community needs that might be envisioned and the support systems and community links that have been effective elsewhere, one comes up with the possible but not the probable range of support activities. They should make sense within the particular community. Services offered have to be used; they are of no use in a vacuum.

In establishing an arts agency, there seems to be real substantiation for the success of a completely open process in the beginning—one that will ultimately cause the creation of an organization that will properly serve a given community, with an understanding of the vested powers. One National Endowment for the Arts City Spirit facilitator spelled it out when he enumerated the objectives of his forthcoming three-day visit:

(a) to create, through community participation, an organized and coor-dinated program for the arts services and support;
(b) to develop community "ownership" in the arts programming and its support;
(c) to discuss community concerns about its creation;
(d) to communicate existing community efforts and problems related to the furthering of these efforts.[11]

At such a time of setting forth, meetings with big business, small busi-ness, small arts organizations, major arts organizations, institutions of higher education, community organizations, government, youth groups,

primary and secondary schools, and individual artists need to be established, with a summary session to which all are invited. If this is done at the beginning, it gets a lot of concerns out on the table that would otherwise only grow with time if they were not resolved. Small representative groups are more helpful than large unwieldy ones; the facilitator is critical, as he or she guides open discussion to the issues at hand. The facilitator's role is to draw out concerns, receive advice, and hear complaints so that the framework for the future task is well established and future work can proceed in an orderly way. The process should end with a coordinating group established to provide leadership to that future work; if such a group does not evolve, the fear of even greater frustration turns to reality, and the result is disappointment and distrust.

While the concerns of various clients of a community arts agency appear so often as to be predictable, the process of planning is important in order to reach a common understanding and consensus about the task that that particular community has set for itself — defining the arts needs and setting some mutual future directions. The community itself must, however, define its leadership for the planning process. The base developed by this process is far more firm a foundation than that developed through a survey or by a mayor's order. It depends on the people who have led the way and who can envision the steps needed beyond those initial ones.

People can see exhibits and hear concerts, but they have trouble conceptualizing arts planning for a community. Skills for involving citizens in a planning process and leadership for doing such are lacking. The City Spirit program of the National Endowment for the Arts was committed to increasing public awareness of the benefits of involving many sectors in arts planning and of enhancing the capability of organizations to do that. But, as noted earlier, this program was somewhat misunderstood as it attempted to accomplish its goals.

In spite of a lack of many models for planning in the arts, some councils, in getting started, have done much more than gather information in a survey; none today should exist or start anew without an ongoing planning process. In the surge of realization of the importance of planning, the state of California made $12,000 available to each county for cultural planning.

The quality of the planning process is more important perhaps than who is doing it. Some commissions or councils have relied on elaborate facility studies and economic surveys to feed into their planning; some rely mostly on staff; some obtain very little community feedback, some a great deal. The important thing is that they are taking steps toward defining agency goals in relationship to community policy. When the agency is one related to the government family, there can be a comprehensive plan for the arts for inclusion in the city's comprehensive plan for human and economic development in the 1980s. These plans should be backed by "citizen

and institutional input, budget realities, professional guidance from within and outside city government, and a policy which has been defined through an evolutionary process, and which uniquely addresses the needs of the citizens."[12] How elaborate the planning process is depends on community size, need, and sophistication. And plans on paper may not be plans in action.

While the planning function is fully accepted by city and county governments, it has rarely been applied to their arts commissions. For instance, no local government has undertaken a comprehensive cultural plan showing how the arts can affect local government. There have been a few cultural facilities plans, some cultural district plans, and some have had some interesting program planning generalizations. The track records for implementing these plans, however, has not been good, for the political and other reasons mentioned elsewhere in this book. While one could hope for a local government's sponsorship of a comprehensive cultural plan showing how imaginative uses of cultural resources can help all agencies of local government better achieve their goals, the arts have had too low a priority in local government. This means that planning initiative has, by and large, come from the private sector.

The public agencies, if properly functioning within the government family, have the edge on planning initiative, for it is a natural and required part of government process. Government departments are used to reporting to mayors and councils with yearly presentations as part of their process. One must remember, however, that a cultural policy for a city, drawn up for the city legislative review system, "relates to the municipal role with respect to the total arts and cultural environment. It does not address the private sector and its various components and their relationship, such as business and corporate community, the arts community and the general public."[13]

The private agency, evolving from early structures that made it a "child of its member groups," has in most instances taken on a public service agenda that can be overwhelming if not well thought through, with activities such as festivals, neighborhood opportunities, and the sponsorship of artists in community institutions, including schools and senior centers. There were few councils that have not expressed a need to reach more people. The range of services to arts and nonarts organizations characterize the focus of both public and private councils. But how well they serve arts institutions, the arts, and community and neighborhood organizations, as well as all age groups and constituencies, is the question each answers for itself. How they do it, whom they involve, and where their priorities lie remain unique to each community. The relationship is ideally one of assistance to the cultural sectors, not of responsibility for them, and certainly not of competition with them.

With the private agencies, the planning initiative might be harder to organize for the first time, or even on an ongoing basis. In the best instances, outside facilitators, usually individuals with experience in the field, have assisted. When the process is internalized, and the long-range planning committee becomes a standing trustee committee responsible for periodic review and systematic extension of the plan that they devised in the first place, the process has taken hold. As one chairperson of such a committee has expressed it,

> What the Long-Range Planning Committee has provided is not a fixed road map for the next three years of the council's history, but a sense of direction of where the agency is going and what it is to achieve. Hopefully we have provided a solid foundation for the future of the Council with service to the arts community . . . as a major thrust.[14]

Ralph Burgard, consultant to more than 17 communities on cultural planning, outlines some of the elements of a comprehensive cultural policy for a city or county. He says that such a policy should do the following:

- recognize the essential role played by the community's major cultural institutions to conserve and transmit to succeeding generations the best of our Western cultural heritage as well as acquaint citizens with other heritages;
- stress the need for these institutions for continuing funds to maintain high standards of performance and exhibition;
- include flexible funding mechanisms to support smaller cultural institutions aspiring to professional standards in the more experimental areas of creative expression;
- acknowledge the critical role played by individual creative artists through technical assistance, public art commissions, and direct grants where appropriate;
- support the use of the arts to explore and celebrate the shared traditions of the community — ethnic, racial, social, or historic;
- assist the schools to improve the quality of education through strong arts-in-education programs for students;
- use cultural resources — artists and cultural organizations — to integrate aesthetic considerations into the plans of local governmental agencies and private sector institutions in order to create a community that is both synergistic (greater than the sum of its parts) and a celebration;
- reflect the pluralistic traditions of our country by recognizing that a partnership between the private and public sectors is essential for the successful implementation of these objectives.[15]

Communities undertaking to develop such policy need active leader-

ship to determine the organization and implementation of any planning. The cultural issues that should be addressed need to be determined and people need to be mobilized as members of energetic steering and resource committees, in order to focus the implementation of recommended programs. That leadership body, often as many as 100 in number, should come from the fields of arts, business, local government, education, and public service, with members acting in their civic or professional roles. The results of such planning have been impressive in several instances, among which are the arts councils of San Antonio, Texas; Charlotte, North Carolina; Keene, New Hampshire (Grand Monadnock Arts Council); Westchester County, New York; and Santa Cruz County, California. These councils have stimulated multiple sources of new support for the arts.

Expressed still another way, it is important to look at cultural planning as a way of creating a larger perspective with which to view the cultural impact on a community.

> "Cultural Planning" involves a meticulous assessment of how the arts can contribute to community development and conversely, how standard planning tools can help strengthen the arts as a productive and even profitable industry. . . . [In this sense,] as a movement for civic progress cultural planning can be broadly defined as an umbrella under which other community improvement programs, such as historic preservation, urban environmental design, urban archeology, and neighborhood conservation are included. . . .
> [Some of the ways to go about achieving planning goals might include:]
>
> - Initiatives that channel hotel and entertainment tax revenues to local cultural programs and institutions;
> - Historic districting and environmental review procedures that help maintain an area's unique cultural environment;
> - Local zoning ordinances and code administration procedures that encourage artist housing, public art and outdoor concerts and exhibitions;
> - Cooperative management or loaned executive programs to assist cultural organizations in marketing, operating and supporting their activities;
>
> and there are others.
> Cultural planning makes the arts an equal partner with other revitalization tools and encourages arts organizations to assess their needs in terms that can only strengthen the arts as a competitive and profitable industry. As such, it brings the arts into the existing systems of community development procedures that can be understood by local business, city officials and investors. The challenge within this new partnership will be for arts administrators to broaden their goals beyond artistic achievement and for the community planners not to compromise the arts by accepting less than the highest quality. It will require openmindedness on both sides to make this partnership work, but the benefits will accrue to society as a whole.[16]

If the arts council of the future is to fulfill a role in seeking new support possibilities for the arts, planning will be an inherent part of that role.

NOTES

1. NASAA Meeting, discussion on decentralization, Cleveland, Ohio, October 1981.

2. Robert Mayer, "The Local Arts Council Movement;" (background paper for the National Endowment for the Arts National Partnership Meeting, June 1980), pp. 31–32.

3. Robert M. Canon, "The Rise of the Private (Independent) Community Arts Agency in City Government," in *Local Government and the Arts*, Luisa Kreisberg (New York: American Council for the Arts, 1979), pp. 147–149. Updated here.

4. Ibid.

5. Ibid.

6. Ibid.

7. Arts and Education Council of Greater St. Louis, *Annual Report 1978–79*.

8. Robert Gustavson, "Corporate Council for the Arts" *Northwest Arts*, October 30, 1981, p. 7.

9. Peter Jablow, "Business and the Arts: A Creative Model" *Connections*, Spring 1982, pp. 14–15.

10. Mayer, "The Local Arts Council Movement," pp. 99–100.

11. Thomas A. Albert, City Spirit facilitation material for visit to Rochester, New York, 1978.

12. Dallas Park and Recreation Department, City Arts Program Division, "Cultural Policy and Program for the City of Dallas, Preamble" (first draft, January 1980).

13. Letter from Richard E. Huff, Coordinator, City Arts program, to Nina Gibans (May 8, 1980).

14. Elizabeth M. Ross, "Greater Columbus Arts Council Long-Range Plan: June 1979– June 1982" (report, April 11, 1979), p. 1.

15. Ralph Burgard, "Towards an American Cultural Policy" (paper written during the Northeast Assembly for the Future of the Performing Arts, New Haven, September 1981).

16. Dorothy Jacobson and Michael J. Pittas, "Cultural Planning: A Common Ground for Development" *American Arts*, January 1982, pp. 22–24.

19

Leadership, Defined and Redefined

ON TRAINING THE PROFESSIONALS

Society has not supported the arts enough that there is enough staff to allow the leader to build the vision and see it implemented. We get spread too thin and keep taking on more.

Jonathan Katz

To assess the job of arts council leadership, one needs to look at what an arts council director does. The following is not atypical:

The Metropolitan Arts Council [of Greenville, South Carolina] is basically a service delivery system which identifies arts program needs and develops information and assistance for organizations which are geared to produce programs to meet these needs.

Services offered by the MAC include the following:

1. Maintaining a cultural calendar of events to avoid conflict in scheduling and provide information to the media and general public.
2. Providing free use of a copy machine.
3. Providing a computerized mailing list and use of a bulk-rate permit to members.
4. Providing secretarial services and volunteers.

5. Acting as ticket agency for member groups.
6. Providing a "volunteer lawyer" to members.
7. Housing the Office of the "South Carolina Lawyers for the Arts."
8. Providing technical assistance to members in the areas of grants writing, incorporation, publicity, public relations, fundraising, etc.
9. Acting as prime agent for grant applications.
10. Writing and mailing publicity releases for members.
11. Appearing on radio and television on behalf of member organizations and doing public service announcements for them.
12. Acting as promoter for the arts community.
13. Administering projects for other agencies (Greenville Arts Festival, Spoleto in the Piedmont).
14. Providing artists-in-residence to schools and community groups.
15. Maintaining registry of local talent available for programs.
16. Serving as a resource for information on developments in the field.
17. Brainstorming new ideas and seeking out groups to whom they may apply — e.g., audience development, new types of concerts for the symphony, etc.
18. Acting as coordinator of groups of the same discipline who want to work cooperatively.
19. Acting as consultant for groups outside the community wishing to form organizations of a similar nature.
20. Conducting surveys and doing research (1979 study of The Impact of the Arts on the Economy of Greenville County).
21. Acting as building manager for Falls Cottage.
22. Acting as manager for the Guild Gallery in the Cottage.
23. Conducting workshops, seminars, and conferences.
24. Publishing a biannual newsletter.
25. Acting as prime program sponsor where a need has been identified but no existing organization has expertise (e.g., Supergraphics on walls in downtown Greenville).

[Population: 57,752 city; 289,401 County. Budget: $33,000.][1]

The last decade has challenged the community arts agency field to create astute leadership. Respected administration of the most active councils has, in one sense, created the national leadership in the field.

Some of the present administrators have verbalized their concern over the developments of the coming decade. Some have held their first positions with great success and direction, and passing the helm to those who follow will be no easy task. They are concerned that leadership develop in a careful way, and also concerned because they personally have been identified almost too closely with their fledgling and maturing organizations. If their point is valid, the more mature organization — an institution — must stand free of individuals. As many directors put it, "When the clientele asks

for agency help, and not for me personally, we've made it institutionally." This problem of personal identification seems fairly pervasive where there have been tremendously active and successful councils.

There are other problems related to this. Only in the largest councils are there funds to pay a second-in-command enough to make the job attractive. Some rightfully become ready to assume a leadership role, and must move to other locations to do that. While this problem is not unusual in any field, it does mean that the training in the first institution does not bear its results in that community. There is great mobility among personnel, especially when there are not strong ties to a single community.

Several persons who have watched the formal training of community arts managers over the past years, and who themselves have had a part in defining the background that such a person needs, were asked to comment for the purposes of this book on where the field has been and where it is going.*

Hyman Faine helped found the Management in the Arts program at the University of California at Los Angeles in 1969, making it one of the oldest programs in the country. He describes it and its relationship to arts council opportunities as follows:

> It is a program sponsored jointly by the Graduate School of Management and the College of Fine Arts and is advised by a committee of interdepartmental faculty, practicing arts administrators and leaders of the arts community. The Master's degree received by the graduate is an MBA with a concentration in arts management.
>
> The UCLA program insists that students admitted to it be committed to one or more of the arts, so that the management training which they receive can build on that interest and prior involvement. However, the central point of the program is to turn out arts administrators who are generalists. . . . UCLA

*For a summary of the most current information about arts administration and management training programs, see the ACA publication, *A Survey of Arts Administration Training in the United States 1982–83*, which examines academic programs at the graduate level and includes a listing of short-term training programs, such as seminars, workshops, and institutes. Among arts management courses that have been offered are those by American Council for the Arts; American Law Institute–American Bar Association; Great Lakes Performing Artist Associates; Museums Collaborative, Inc.; Opportunity Resources for the Arts; Arts Management; Smithsonian Institution Workshops; Theatre Communication Group; WAAM The Art Museum Association, and several educational institutions. There are also organizations — for example, The Fund Raising School, Grants Management Advisory Service, The Grantsmanship Center, Public Management Institute, and Volunteer: the National Center for Citizen Involvement — offering courses that are not specifically designed for the arts, but that may be applicable to arts organization needs. See also Great Lakes Arts Alliance, *Resource Directory: Conferences, Seminars, and Workshops for Arts Managers, 1981–82* (Cleveland: Author, 1981).

believes in stressing the overall approach, the basic principles of management, and the general relationship of arts organizations to the community and the art form. . . .

Arts councils are one of the special areas into which the graduates can go into as administrators. If we look back historically, we can see that these councils, [which are as] yet very young really, must make their own special contribution. They are not unlike organizations which the ethnic communities who came as immigrants in the late 1890s formed for themselves through their own newspapers, theater groups, choral societies, etc.; they made themselves known not only to their own fellow newcomers, but helped the general community to know them better, and to integrate their culture into the general American scene. . . .

They [arts councils] must involve their own particular community in their activities and programs—because that is how their special character can best serve the whole community.[2]

John K. Urice of SUNY-Binghamton, who is Chairman of the Association of Arts Administration Educators as well as Director of the MBA/Arts Program and Center for the Arts at the Binghamton campus, has said:

For better or worse, the next generation of arts leaders is developing in an academic setting. Whether or not we like it, the arts, like so many other pursuits, are becoming structured, organized, and institutionalized. This is unavoidable and not necessarily "bad." While some people may rebel against trying to institutionalize the arts (which have traditionally opposed institutions), I do not see this trend as necessarily being destructive. As the arts have become increasingly complex and institutionalized, the need for management training has become more acute. . . . We . . . look for people who have had extensive experience either as a practicing artist or as an employee of an arts institution. Almost all have undergraduate backgrounds in the arts and therefore a strong affinity for the creative processes. . . .

I hold the opinion that managing an arts institution is not substantially different from managing other types of organizations. The basic and most fundamental qualities we look for are imagination and leadership. A good sense of humor is also essential.[3]

The Center for Arts Administration, headed by E. Arthur Prieve, Professor of Management and Director of the Center for Arts Administration, Graduate School of Business, University of Wisconsin–Madison, has not only a two-year course of study (which includes work experience and an internship), but also an applied research component, where students participate in research teams to examine aspects of arts administration and publish the results.

"It is important that the student get a sense of where he or she is in relationship to management. This ongoing relationship may help each one

see the real world of management and where they fit in," says Prieve. One of the aspects of the training program he runs is that there is ongoing involvement with an arts organization, in addition to the internship students assume while they do coursework. Although the training in most of the programs is for the wide range of management opportunities, he sees the leadership of arts councils as those who

> have political savvy in the sense of knowing how to guide the organization into the integration of the power structure. The councils are going to have to look at themselves in terms of their place within the total city, and it will be "inter," not just "intra," the arts. They will have to know what all of the other agencies within a city are doing so they can define their own role. The arts council staffs and their extensions, through task forces and committees, will help do this, but everyone will have to understand this mission.
>
> The manager will need a broad knowledge of the community, which, if he or she is not from the community, will need careful nurturing. If there is a solid organization, this will be easier to do, but arts councils may have some problems as a whole on this score. (How many have really seen the need to integrate into the total community?)
>
> This sense of community is not only the arts community — it is a thorough working relationship with everyone who counts and makes decisions and sits on boards, etc. It is the *total* demographics.[4]

Many arts council leaders have not really thought a lot about the problems of training and leadership. Too many council directors are wary of the training programs, the narrow definitions, and the unrealistic expectations of MBAs and other degreed graduates. "I want a creative person whom I can train," many say.

Jonathan Katz is Professor of Arts Administration and Director of the Community Arts Management Program at Sangamon State University (Illinois), a program that "emphasizes the skills and knowledge especially appropriate to the management of multiarts organizations such as community and state arts agencies and arts centers."[5] His concern is more about leadership and motivation than about the job of administering the arts. There are two kinds of jobs in arts administration. One is specialized within a large institution — such as box office management, research and development, fundraising, or public relations. Arts councils, on the other hand, usually have project manager types who do everything.

Arts council professionals generally believe that leadership cannot be generated; it can be stimulated through self-motivation and commitment. What are the components of leadership? "Leaders have ideas [and] 'people' skills and should have the tools for management," says Katz. "They must be able to motivate others to follow the visions, which are twofold; one is of the possible future, and the other is some idea of how to implement the vi-

sion." He notes further that "The process of arts administration has to do with the tools; setting up books, evaluation techniques, group planning processes, budgeting methods, and the like," and that "The art of administration is working with ideas and people."[6]

Jonathan Katz talks about the search for management training students:

> If . . . management student[s do not have] the sense of the importance of or commitment to the arts, they will not necessarily be arts managers because they could go into other fields. The program requirements at Sangamon include a philosophy of arts graduate course, which is important for developing the *context* for growth and change. Out in the field the staff must be highly motivated—I'd look for motivation in staff first off when recruiting. A good staff will have a common core of community values, and can then together accomplish what they *really* want to do. The value systems make the difference.[7]

In the last analysis people make the difference; they always have and always will; arts management is no different.

The prospectus of the Yale School of Organization and Management gives some possible points for reflection. Begun in the mid-1970s, the school has taken a different approach to the professional education of managers by seeking to integrate the study of public and private management throughout the curriculum — to educate future managers for business, government and human service and community organizations by combining the fundamental concerns of a school for business administration with those of a traditional school of public administration or public policy. This is in recognition that "accelerated blurring of the lines between public and private sector activity and responsibility has created a need for a form of graduate management education that reflects the interrelatedness and interdependence of public and private institutions."[8]

The average age of students is 26, and most students have worked full-time for at least one year after completing their BAs. The preference is for a student with work experience. That requirement seems a good potential requirement for arts administration programs as well. The Yale program is looking for candidates who can "think abstractly about institutions and their goals, coupled with the potential and motivation to effect constructive change."[9] Good candidates for community arts management have that potential, and it could be beneficial to be with both arts and nonarts managers.

Alvin H. Reiss, creator of the nation's oldest annual course in arts administration, the Performing Arts Management Institute (1957), and of the nation's first college course (1963) in arts management, has been directing the graduate certification program in management of the arts at Adelphi

University, which is for working arts administrators. The entire group of 15 to 20 students stays together for a year; all the courses are given only for the students in the program, which means they have a special slant toward the arts.

Reiss comments that directing an arts council is like being a labor organization leader — "you must know who you represent, the problems, how others feel about you." But it is equally important for an arts council to be vulnerable — to be challenged at all times about what it is doing and what it should be doing. The leader must make relationships, think laterally, and know their community thoroughly. They are, in essence, cultural salespeople — "the symbol of the arts in the community." It is critical to know that there are not instant answers; people do not look at enough alternatives and have too little sense of curiosity and probing. No one plan works for all. For example, there are now several configurations of business and arts councils — maybe eight or nine different models. Communities need to look at themselves, look at all of the models, and create "what makes sense for us." It should not be easy, Reiss concludes. To sum it up, leaders in the field need a sense of self-sacrifice, compassion, a sense of total community concern, a breadth of vision, an ability to think laterally, an ability to work with others, and the need to be continuously challenged. People do not know how complex the job really is.

Reiss himself has contributed substantially, many times working behind the scenes; he has provided the framework for the national (governors, mayors, etc.) legislators' group resolutions on the arts — their symbolic stands, which have been drawn from "A Bill of Rights for the Arts in America." His book *Culture and Company* envisioned the alliances that could be made between business and the arts — a visionary document in 1972. He is cofounder and editor of *Arts Management*, the first journal for arts administrators, and through that medium created the Arts Management Awards (1969) as a means of recognizing the contributions made to cultural development by the administrators of arts institutions and programs.

As an observer of the arts council movement, Alvin Reiss feels that arts councils are a recognized force in the arts. The best and strongest have sprung from community need. Arbitrary phenomena such as the Massachusetts Arts Lottery create real problems; it's hard to see how the syndrome of "let's have an arts council" will win in the long run.[10]

An observer and doer since the 1950s, when he headed the Winston-Salem Arts Council, Charles C. Mark, editor of *Arts Reporting Service* for over ten years and the first National Endowment for the Arts Director of State and Community Operations, has this to say about leadership and training: "The problem is that there is no agreed-upon core curriculum for arts organizations leadership training. For instance, the social history of the arts in America is a forgotten or neglected area. There ought to be social

service training for arts administrators because the arts are a social phenomenon."

In talking of leadership, Mark sees a good leader manipulating others to good ends through inspiration. Too many executives say "I will do it" instead of getting a committed community to do it. "The smaller the ego, the more you can get done." Leaders can animate a community; they ought to be able to organize a community to solve community problems and then teach others to do it.[11]

It would be negligent not to mention the specific problems of developing minority leadership in a field that says that it wants to reach broad segments of the community. It is a subject understood but little discussed. The will is expressed; the way is not yet found to create the ongoing assistance needed. It is, of course, a problem not unique to this field.

VOLUNTEERISM

The need for well-defined, reliable volunteer assistance extends far beyond traditional volunteer roles. This need is bound to increase in the 1980s.

Most arts councils, like other nonprofit groups, started with willing, tenacious, and enlightened groups of citizens, who believed that cooperation and service was the way to future success of the arts. Whether it was in Hays, Kansas, where "seventeen years ago a group of seven or eight 'art lovers' . . . met to discuss the possibility of forming a council to better recognize and study the visual arts in the growing city of 12,000,"[12] or the volunteer organization, Allied Arts, in Seattle, the original purpose and vision have been altered and expanded over the years as times have changed.

The mainstay of many arts councils is the quality of their lay leadership, for it is they who must motivate peers, articulate the message of function, and represent the arts council to the community. The board of trustees is the key to the strength of any council. Categorically, in their community commitment, they must place the council's interests first or the council doesn't work. There are many volunteer councils, but even in a community as small as Hays, Kansas, the founding group set a policy of having at least one paid person to whom volunteers could come with problems and suggestions. "This has meant having an important form of coordination from the very beginning."[13]

In a nearby community of about the same size, there is a sense that the same people have been involved forever, and a feeling that the increased number of working women has resulted in less volunteer time and less desire to contribute or go to another meeting. In a larger community, there is no volunteer effort save that of the board of trustees. Another council, with a staff that works particularly well with volunteers, estimates that more than 2,000 people-days are donated annually by more than 250 persons.

Volunteers are a central component of a united arts campaign. Although volunteers are not paid in money, they wish and expect to be paid in other ways. The payments they desire and the payments they receive are as varied as the reasons for volunteering. People volunteer so they can meet people, develop skills, interact with new groups or individuals, or generate a new source of stimulation or challenge. Much time can be spent productively trying to figure out what kinds of needs different volunteers have and trying to respond to those needs. It is important that we try to give something in return to those people on whom we so heavily depend. Just as we try to be sensitive to what volunteers can do for us, so should we be sensitive to how we can productively impact the lives of our volunteers.[14]

Use of volunteers can be a good way of evaluating your own program. . . . Because volunteers are not paid staff, they're not at your call 40 hours a week; you have to know exactly what your needs are in order to utilize them. You also have to have in mind what ways, either tangible or intangible, you expect a volunteer to feel "rewarded" or to "benefit" from his/her experience with your organization.

That goes for everyone, from the volunteer member of your Board of Directors, to the one-time person who helps type up a mailing list. Each of those people represents a potential valuable contribution to your organization — not just in terms of the skills or time they can contribute: When a volunteer has a good feeling about working with you, and feels "rewarded" and "useful," that is one of the best means of public relations you can ever find.

Many times small organizations, particularly in the arts, revolve around core groups of individuals who often feel they are under so much pressure that it is better or easier to do things themselves rather than delegate tasks to "outsiders." This attitude can be a real obstacle . . . volunteers can be a real resource to all of us. And — like any resource — they need nurturing. Thoughtfully solicited, well managed, and creatively employed, volunteers can and . . . do contribute much more than their time.[15]

The volunteer as friend and/or trustee has been very important to the arts. Across this land, wherever the arts have any history, there are tales of dedication unlike those in almost any other field. The men and women on traditional boards of trustees understood their major charge — to raise monies to keep the operation afloat. If they didn't give it themselves, women's committees and occasionally men's committees or friends organized the benefits and programs to raise the monies. Whether it is among our opera companies, theaters, dance companies, or other institutions, there is, for every successful one, an impressive story of ongoing dedication in terms of time and financial commitment. Traditionally, the boards and committees have been made up of the local leadership. Who and where are the new generations of these volunteers? Is this tradition as strong today as ever, or is arts volunteerism, like volunteerism in other fields, in trouble? The clues are that it might be.

The Director of the national Business Committee for the Arts has acknowledged that his group, a catalyst for corporate support of the arts, favors "getting an active involvement in the arts, not just a check," making well-defined volunteer roles even more critical. Although many councils have encouraged the development of corporate committees for the arts and financial support (including direct support, matching gifts, and the like), sustained partnerships between arts and business are rarer.

> The Arts Council of the Morris [N.J.] Area formed its unusual Business/Arts Committee in 1975 to encourage corporate awareness and support of the arts. . . .
> Everyone has benefited from the work of this unique committee, which functions as a working committee of the Council's board. In the last six years, Business/Arts has contributed its expertise and many dollars to help support major arts events, special arts-related services and activities for employees, and has been responsible for corporate involvement with arts at every level. . . .
> One of the most surprising discoveries was that businesses didn't want to give just money. They were eager to *participate* first and consider money later. The immediate goals were to obtain new business members and to develop services the Council could offer to member companies. . . . "We were developing consciousness about the need for art. . . . This got business on our side. If we had been pestering for money, the businesses would have been turned off and not cooperated the way they did." Business made it plain from the beginning that it was happy to offer in-kind help as well as advice to the Council and an inventory of possible business services was made. . . .
> Today business cares. The key to the success of the Business/Arts Committee is that everyone has benefited, business, employees, artists, the community, and the Council itself.[16]

The reasons people have chosen to become involved in board membership or in volunteerism usually have had something to do with the quid pro quos. The use of their time, energy, and money has translated to a public image and a pride in making possible productions, exhibits, and performances or other community arts events. Because they have represented significant financial support as individuals, it has been natural to want a hand in control of the product.

Times have changed, though, and the financial role of board members or individual donors is now only one of the many support systems needed by every arts organization. Public funding from local, state, and national sources, and foundation and corporate support, have become important partners in the funding picture. The inherent requirements of these other sources will change, in the long view, the raison d'être for board participation, including volunteering in general. This is starting to happen everywhere. Not only has the individual benefactor lost some of the quid pro quo, but some sponsors of benefits have found it harder and harder each

year to raise the monies they traditionally have raised. Even with government funding cutbacks on some levels, these trends are likely to remain with the growth of public interest in the arts.

There are reasons for the changes. One has already been mentioned. The new funding patterns not only will demand broader board roles, but will expand the roles volunteers might play in the success of an organization. A variety of skills, perhaps each quite different and specialized, is needed for success in reaching the various funding components. Some, such as applying for the federal, state, and local grants, require technical skills and professional paperwork. The development of strategies for reaching foundations and corporations requires other foci.

When staff and board members work in tandem, each group performing proper and mutually agreed-upon tasks, the council works best. The board's fundraising jobs need careful examination and precise description to produce results that are worth the time and energy. The volunteer, to do this job successfully, needs a good grasp of the total picture. Too often this is lacking.

The staff person needs to understand the potential volunteer roles in this and all other areas of the organization's work, as well as the value of time spent in defining them. Too often this, too, is lacking. The not atypical staff view of the volunteer does not necessarily enhance the situation. Often experienced volunteers can be threatening to paid jobs because they are efficient and productive. Professional staffs need to review their attitudes about the extended roles that can be filled by volunteers. All of the collective monies mentioned will not fill all of the organizational needs — ever.

The public framework opens other volunteer roles as an attempt is made to keep up with all arts legislation and, more than that, to lead well-informed discussions about the issues. Only in this way can an informed advocacy be developed. Ideally, each organization should have a well-developed information system where volunteer advocacy roles are defined and coordinated. There are, of course, other roles; these suggest only a few.

Organizations will need to recruit assistance in a contemporary style compatible with other areas of volunteer endeavor, where interviews, job descriptions, evaluations, and flexible but regular time commitments are part of the arrangement made with the organization. The arts, if they are not recruiting in this fashion, will find themselves behind other fields and will not be able to compete for uncommitted time down the line. Even though there is agreement that the traditional dependable volunteer ranks are thinner, the need for revamping recruiting methods has not yet been addressed. One little-recognized fact is that most people choose a volunteer role in the context most satisfying to them, and the arts are only among several possibilities. Often the arts volunteer is also a volunteer in other non-profit settings as part of his or her community involvement.

In the future, the extra time taken in the beginning will count. Persons today making volunteer commitments are seeking new quid pro quos that are individually satisfying and fulfilling. Examining the ways to meet individual needs compatible with organizational needs, and assessing functional skills that may be useful, are ultimately worth the time. To be fair to the mutual interests of both the organization and the volunteer, there should be a training program.

Other groups of arts volunteers that should have orientation to the field are those selected for public roles, such as lay members of local, state, or federal arts councils and public allocations panels; at times these appointments have too little relationship to the expertise needed for the complex subject at hand. Individuals may be involved in one aspect of the arts, but may have little understanding of the newer issues and problems. Publicly appointed volunteers, inundated with masses of proposals and policy materials for their evaluation, can hardly get through this reading, let alone more.

Individual organizations usually have important and increasingly complex agendas to wade through, and these leave little time to address other issues. What form should training take if time and reading matter are both problems? How are we to get to these discussions and understandings of issues that affect decision making by volunteers? Some assistance is now developing in the way of hard-core materials. It is proliferating at a rate that makes it difficult to keep up and siphon out the best.

Clues to what may be needed and wanted have come through short weekend-length courses for specific groups of trustees, such as the ones held at the Institute of Arts Administration at Harvard, and through some of the course material included in the various arts administration training sessions described earlier.

Clues as to what may be required come through the materials of such groups as the Volunteer Urban Consulting Group of New York. This particular group "serves as a liaison between nonprofit organizations which have specific business problems and business people interested in using their knowledge and skills in a volunteer basis to assist them."[17] They have worked with a variety of types of groups in health, social services, the arts, housing, and education in the Greater New York area. Their services have been offered in the areas of accounting, financial planning, personnel and organizational budgeting, planning, internal operations, and recruitment for boards of directors. The valuable point is not so much what they have done, although they helped nearly 100 cultural groups in one recent year, but the requirements for clarifying the job to be done asked of the groups they work with.

There are, as well, the training materials from Volunteer: The National Center for Citizen Involvement. In reviewing the present situation

of the public humanities in matters of volunteer policies and performances, Volunteer found them to be at much the same point that social service organizations were not too many years ago. The hazards blocking effective volunteer programming in many cultural institutions are already familiar. Volunteers are not involved to their fullest potential; the role of the volunteer coordinator is badly defined; paid staff members harbor suspicions about volunteers; there are insufficient training programs.[18]

> Humanities institutions have remained, for the most part, removed from the national and local volunteer support structures that have emerged over the last decade. Nor have cultural institutions developed a counterpart system. The result has been the continued lack of acceptance of volunteers, the inability to effectively build on each other's efforts, and the failure to realize the full potential volunteers bring to the institution.
>
> The majority of volunteer administrators in the public humanities have no formal training for their job. Very few surveyed by NCVA [National Center for Voluntary Action] could recall participating in workshops on volunteer administration. Most had learned their roles on the job and had not been exposed to the literature in the field of volunteer administration. They had had little chance to interact substantially with volunteer administrators in other fields. For the most part, they did not participate in workshops and conferences on volunteerism, with the result that many times difficulties with their programs seemed without precedent and insuperable.[19]

In Hartford, the Arts Council, sharing the wealth of talent and expertise in the business community, has set up the Arts Business Consultants, who assist arts organizations to help themselves in areas of management, marketing, and financial administration; this group has also sponsored a series on grantsmanship and accounting and bookkeeping. In cities such as New York, Houston, Los Angeles, Philadelphia, Seattle, and Huntington (New York), there are similar assistance programs.

> Pilot programs such as the Arts and Business Council's Skills/Services/Resources Bank, which trains business people in New York City to serve as volunteer consultants to arts groups, have grown considerably. Seattle's Bank, established with consultant help from [Arts Business Consultants], currently is helping develop similar programs in Houston, Los Angeles and Philadelphia. In New York 150 active . . . consultants currently are providing 100 arts groups with services valued at an estimated $500,000. . . . At the local level, several key volunteer programs and concepts, including but not limited to the arts, have national implications. Through the Huntington, N.Y., Arts Council's Liaison Network Project, every board member serves as a designated ombudsman to two or more of the council's 82 member groups. The Skillsbank, supported by a grant from the Charles Stewart Mott Foundation and located in ten national demonstration sites, including Philadelphia, matches volunteer

consultants with groups in need. New York's Public Interest Clearinghouse screens and evaluates volunteers and matches their abilities and interests with groups requesting assistance, while Tune in New York has a phone-in service for groups seeking volunteer help.[20]

For every volunteer, there should be a clear charge and clear delineation of duties and responsibilities, whether for a board member or a volunteer for specific projects or programs. This can vary with organizations, but a board member whose charge is to lend his or her name, give or raise money, and advise in certain ways should know those expectations in the process of recruitment. A leader of a fund drive or any project must know the extent of time and the extent of duties. Board members of an arts council must know what the council is, what their duties are, and where they will be expected to put their energies. They must know their responsibilities and liabilities. With all kinds of public programs, councils become responsible and liable in ways totally new to the arts.

Roles and expectations must be clarified. "The more cohesion, communication, and organization that exist within a volunteer team, the more productive the project."[21]

Work plans, timetables, and communication, starting with interviews with future volunteers to determine where they feel they can contribute best, are all part of a process that leads to sustained assistance and full benefit. There should be job descriptions, progress reports, and evaluations as these are determined to be appropriate.

In order that advocates, panel and board members, and other volunteers can do their work well, they must have information on such factors as the following: the makeup of the community they are serving; the sources and interrelationships of arts funds today; the nature of and changes in the volunteer sector; the "how-to's" involved in becoming a knowledgeable arts advocate; the place of the particular arts organization among others in the community; and the nature of peer organizations. All this information needs to be presented in an organized way. A series of discussions on these topics might end with a visit to an institutional base similar to the one being addressed. This would allow an exchange with a group coping with similar decisions because of similar basic goals. There are meetings and conventions for those involved in almost every art form, but these are usually attended by the professional managers, and they do not leave room for the detailed discussion available in the site visit. Such discussion would allow groups to make more confident, intelligent decisions and would enhance the board and staff work of the institution. Board membership, panel membership, and decision making, laden with the awesome and complex responsibilities facing those assuming these roles today, make such training mandatory.

Board members, as a specific group, need even more specific material

to bring them into current thinking on the roles, duties, powers, and liabil-
ities of boards, including clarification of board-staff relationships and other
important matters that will enhance effectiveness. Some corporations are
offering this material as it relates to potential nonprofit board participa-
tion. Sessions on such matters have been given in eclectic fashion, but ideal-
ly should be available to every board member today. These are sometimes
held at "retreats," where work sessions are held in a more informal atmos-
phere far away from the telephone.

One can, however, only offer the remedies. The symptoms are pres-
ent, and unless they are recognized, the solutions will sit on the shelf. Pres-
ent arts organizations must decide now to prepare for the future. For while
monies have been made available from new sources, federal and sometimes
state funding is being cut back, and inflation and energy costs have kept
budgets up. Volunteers are going to be as necessary and valued in the future
as they have been in the past.

This training will help arts organizations far beyond immediate de-
cision making. It will help them look at the reasons why their members par-
ticipate together for common causes. It may help them create the new quid
pro quos that will be satisfying to the new people whose participation they
would like to encourage. And it will give them new kinds of information
that should increase their own levels of self-esteem and confidence, whether
these are or are not acknowledged as presently low.

Perhaps the discussion sessions will go so well that other subjects and
issues, such as the place of public works of art or the support and diversity of
the American arts, may be included. Sessions on how to look and listen to
the work of our artists might even be helpful to decision makers and audi-
ences.

Decisions are being made daily that will affect the community, state,
or federal picture for years to come. In the arts, the task of decision making
should be undertaken with the best preparation possible. The procedures
discussed make sense, but more than that, they make the people working
for the organization able to do their best for the organization out in the
community.

In Charlotte, North Carolina, where the Arts and Sciences Council
reported to Volunteer the long-term impact on revenue,

> [The volunteers are] some of the best we have . . . in a company where office
> workers were loaned for the [United Arts Fund] drive, they enjoyed the exper-
> ience as a break from their normal office routine. They were enthusiastic about
> the Council when they returned to their company, and employee contribu-
> tions in that company increased dramatically that year.[22]

There are so many kinds of volunteers: board members and commit-
tees; businesspersons who "come to the rescue" of the small professional arts

group; volunteer problem solvers using their legal and accounting skills with artists and arts organizations. But volunteer efforts are often not as specific as matching law with a legal problem. The persons on these "busman's holidays" say they enjoy the experience because the contact with the arts may be a new and growing one for them personally. Many, many others are left wondering how they will use the skills they have. And they lose interest because their potential and valuable time has not been used.

ADVOCACY: AN EDUCATED CITIZENRY

> Grassroots efforts on behalf of . . . support of the arts are tremendously important. Regardless of whether those involved with the arts concern themselves with the matters at hand, arts legislation will be passed—but, perhaps not in ways that best serve the arts and artists [in California].
>
> Grassroots activity is not new to politics. However, it is relatively new to the arts community. Arts organizations can no longer exist only as cultural entities—they must also function within the political environment. . . .
>
> A democracy is founded on several important principles, one of which is that a group of well-informed and involved people can truly affect government. . . .
>
> The arts should be considered no less a priority in government attention than health and welfare services, commerce, recreation, or transportation.[23]

Advocate: supporter, ally, champion.

The education of the citizen to be a good arts partner with the professional artists and arts organizations in the community is an important mission today. The examples of advocacy efforts range from the model local Allied Arts of Seattle to state citizens' committees with volunteer or paid staff, from ad hoc committees to crisis-oriented scrambles for supporters for troubled local, state, and federal budgets.

There are clues in these efforts to new volunteer roles of great potential for the future of the arts. Such advocacy has accomplished a great deal in King County and Seattle: Much of the political groundwork that was laid by Allied Arts for the city's percent for the arts ordinance was helpful in getting the county ordinance passed in record time (two and a half weeks from drafting to finish).[24]

In 1974, the Mayor and the City Council responded to a proposal (made on behalf of large and small performing arts organizations by Allied Arts' ad hoc Committee on Arts Support) by approving $300,000 in city funds to sponsor drama, dance, and music performances in Seattle.[25]

> All of the money has not been automatically forked over by politicians mad for culture. . . . City and county council members have been lobbied annual-

ly (and successfully) for increased funding by Allied Arts of Seattle, a group of lawyers, architects, musicians, and artists who pitch the arts story to public and private funding sources. Allied Arts has also mobilized its expertise and clout on behalf of Seattle's recent neighborhood restorations, notably that of the food market overlooking Puget Sound.[26]

Allied Arts, now almost 30 years old, started the Washington State Arts Commission, the original Seattle Municipal Art Commission, and the present Seattle Arts Commission. Later, both the Arts Alliance of Washington State and the Washington State Ad Hoc Committee for the Arts grew from Allied Arts.

The organization reports an informal beginning in the early 1950s when some architects, "museum types," and artists discussed, as members of the "Beer and Culture Society," the state of the arts and what should be done. "They" became "we," as those who remember explained it, and after a while, through an outgrowth of a steering committee of the American Institute of Architects (AIA), an organization was formalized and known as Allied Arts.

> Its primary goals were defined at the time: to support the arts and artists of the Northwest and to help create the kind of city that attracts people who support the arts. . . . What was not spelled out — or anticipated was the method, which has been to use the legislative machinery to accomplish these goals. The establishment of the first Seattle Municipal Arts Commission in 1955 probably started the pattern.[27]

One of the outstanding characteristics has been the attraction that Allied Arts has had for lawyers, environmentalists, and other citizens committed to the arts and the city.

> Never involved in rating political candidates in any way, determined on a nonpartisan course, we attract citizens interested in the political process. By design, not a social group, we give great parties. An organization of just under 1,000 members with an office (in a wonderful renovated warehouse at Pioneer Square), and a regular schedule of numerous meetings, we're often described as a nonorganization for nonjoiners, or a front for individuals who care a lot about the arts and the city.[28]

All meetings are open, although they are not bound by the open meeting laws that govern municipal and state agencies. Newsletters cover all committee activities.

Allied Arts has evolved into a local advocacy group equal to none, from modest beginnings: "we wanted the city to develop beautifully — and become involved with not only 'arts' issues but environmental issues as

well." The plethora of items and new tasks has always been invigorating, and has kept bringing new people to their implementation. "It's an adult education process" and a cross-fertilization of those interested in the arts and those interested in related issues working in behalf of both. The eyes of the Mayor were really opened by the "people affair" during the effort to save the market.

Now housed in Pioneer Square in a renovated warehouse, Allied Arts operated for almost a decade from the house of its first director, Alice Rooney. She volunteered in the 1950s, worked part-time in the 1960s, and became the full-time director in the 1970s. In the fall of 1980, Alice Rooney left to assume new challenges.

But the institution was implanted.* As always, the association was intimately involved in the Seattle and King County budget allocation processes of 1981. The city has been able to rely on the presence of Allied Arts Committee members at the public budget hearings. They have been well-informed and well-educated spokespersons.

Over the years, people have joined Allied Arts to "save the market, plant street trees, abolish billboards." Sometimes efforts necessitated forming independent groups such as Friends of the Market and Washington Roadside Council. Among their causes, attention has been given to percent for art in public buildings legislation, removal of the admissions tax on performing arts events, and increased financial support for the arts in the state of Washington.

With a small budget and staff, Allied Arts has always worked with citizen committees that keep it replenished with new energy and causes. There were at one count ten committees among the membership, one only having to do with internal structure. The others include the Arts in Education Committee, Auction Procurement Committee, Performing Arts Committee, Artists' Spaces Committee, ACCESS: The Lively Arts Committee, and ACCESS/Distribution and Marketing Committee. To give a sample agenda, a concern of the Performing Arts Committee has been needed for increased availability of rehearsal and storage space for performing artists.

Through the years, Allied Arts has gained the respect of the private and public sector. It has developed clout and high regard from anyone who has looked at its record. The model is there for citizen advocacy — with an enviable, and perhaps unbeatable, record of service.

It is important to note that Allied Arts of Seattle was incorporated as a 501•C•4 organization from its inception. Reasoning that it was a broad ad-

*Starting in 1981, the economic problems of the state of Washington were starting to seriously affect arts allocations on all levels. By mid-1982, Boeing unemployment figures, for instance, were estimated to become higher than ever in its history. Allied Arts has stood firm over many years and under just such prior economic crises has done some of its most creative work.

vocacy group interested in the city as a whole, it remained so designated throughout the years, allowing it to lobby as well as to program. To ease the raising of monies, a separate 501·C·3 organization, the Allied Arts Foundation, was developed; this group has only a funding function. Through the years, the Foundation has tended to give attention and monies to organizations that are small, experimental, and of less interest to funding sources.

Every city needs a group like Allied Arts, for citizens can do and say things that staff people cannot. Groups patterned after Allied Arts have appeared in some other cities in Washington State, and recently in Washington, D.C. The secret is in their multiple interests in the good of the city, the arts being in the forefront. The secret is also in the quality of the job done, the ability to rely on action, and the ability to have an intelligence clued in to the ongoing needs, not operating by automatic command. The refreshing part is the initiative, the research, the action.

Although there is no group like Allied Arts in Houston, there has been a clear strategy since the late 1970s for building advocacy for the city's cultural development. According to this strategy, the Cultural Arts Council would funnel public money to the arts organizations, the Convention and Tourism Agency would promote them, and the Business and Arts Committee would generate private support for the city's arts institutions and organizations. That strategy and teamwork has had some remarkable results in getting the message across to many sectors over the first years of the Cultural Arts Council's existence.

Planned advocacy on the local level for all of the arts is a missing dimension in almost all communities. Those who head large and small arts organizations and councils, and a few individual artists, feel that they fight all of the battles. From time to time, the citizen leadership of major organizations will articulate a need if prodded and directed, but there are too few examples of studied, ongoing advocacy for *all* the arts. It would seem that this will be critically needed as we move into the modalities of the 1980s. Informally or formally, groups such as Allied Arts has been composed of people of all talents who cared. These people have seen to it that others are made aware of needs and issues so that the concerns can be studied and addressed constructively. And then they acted to make sure that what seemed right and best happened. They were not just responsive; they led the way. They remained vital and refreshed and constant. Every community needs such a group, whether there is a public or a private council, and whether there are many old arts institutions or many small ones that have cropped up recently. There can be only benefits to come from concerned, educated citizenry, respected as a community resource.

How are such groups organized? Differently in each locale. The causes will have common threads, but will be unique in their dimension and limitation.

Are there any clues in the success of statewide advocacy movements? Yes and no. Yes, because the mechanics of getting legislators to listen is the same, whether the legislature is in New York, California, Oregon, Minnesota, Ohio, Indiana, or wherever. No, if the focus of these movements is on the budget only. In most it is not; it includes providing services and information. In those states and others, statewide citizen advocacy groups have hammered away at the importance of the arts allocation at the state levels. And they've been successful. The state appropriations to state arts agencies has topped $123 million in 1982, up from $110 million in 1981. (Some states have since experienced budget problems, forcing the reduction of the initial figures, but this will always be a danger. The 1981 alterations were not only in the arts budgets, but affected the total picture, including education and human services of all kinds.)

What is also interesting is that in one year, when the National Endowment for the Arts represented .0273 percent of the U.S. budget provided for the arts, the states provide .0769 percent of their budgets to the arts through state arts agencies.[29] Citizens have worked hard to make this happen.

Of the over two dozen statewide advocacy groups that have formal headquarters, seven have responded for the purposes of this book to a series of questions on their activities. In New York, Ohio, Indiana, Oregon, Pennsylvania, New Hampshire, and North Carolina, the groups are primarily interested in the legislative allocation to the state arts councils, but some have goals that include getting involved in "grassroots advocacy," which translates as "local activity." Some are involved in support of percent for arts laws for public construction projects, as well as other arts-related legislation.

Why mention statewide advocacy in a discussion of community arts councils? In some states (not those with broadly based formal and active citizens groups), the coordinator of training for advocacy has been the state's assembly of community arts agencies, which trains for more effective citizen involvement in local affairs. In North Carolina, the large network of county and city community arts councils meant that the state budget request to the legislature could have statewide advocacy. The North Carolina Association of Arts Councils has held community workshops to teach citizens effective methods of reaching such constituencies as government and business, and has helped pull together all of the arts to present a united voice in support of the state budget. Other states (where there are fewer county arts councils) have also relied heavily on the arts councils to mobilize local energy in behalf of the state budget needs.

The better the articulation of a need, financial or other, the better articulation the legislators can give to their support of the arts. If the arts citizenry is of a single voice, having worked out philosophical differences among themselves, the efforts can be even more successful.

On the community level, the amount of local tax money from general

city funds allocated to the arts is suggested to be at least $300 million, well over the $85 million reported in Table 1. This, too, has generally been increasing. Business support of the arts reached the record level of $436 million in 1979,* up from only $22 million in 1967. The National Endowment for the Arts Challenge Grant program, requiring matching funds, had, during the first three years of its existence, awarded $84 million in grants and generated $500 million in new support for the arts from both private and local sources.[31]

cuts in federal spending, the clearest and most focused advocacy will be needed on all levels, *beginning* in the communities themselves. One role of the community arts council may be to take leadership and/or assist in a process that allows this advocacy to emerge in as intelligent and orderly a fashion as possible. The processes have been discussed in the context of cultural planning. The advocates cannot continue to be those employed only in the arts. It will be part of the civic responsibility of those who have said they favor more and better arts and cultural opportunities to see that these opportunities really come about, not just to respond to a poll.

The struggle for some kind of unified voice on the local level has not even begun in most communities, whether or not they have had arts councils. But the council is the potential neutral ground for its generation.

The time has come when the arts cannot afford to be haphazard about advocacy, although sometimes the adrenalin runs stronger and the articulation is sharper and more specific when the effort is not a daily affair. However, bills in Congress and in the state and local legislatures potentially affecting the arts need constant attention; the arts community has no choice but to keep abreast of them. The education of the local citizen/advocate should be a priority of the future.

For starters, this means that every arts organization needs a legislative watchdog who keeps up on current bills before the various governing bodies. If every arts group had had such a person, the impact of the Arts Lottery in Massachusetts would have been understood before so much energy and effort had been put into creating a new bureaucracy. If the same had been so, some CETA programs would have been taken on only if goals had been clarified and the full ramifications of the program understood. Finally, if the same had been true, there would be perhaps many more communities feeling that the arts should logically have a share of the local hotel/motel tax.

*This figure, from the Business Committee for the Arts, Inc., represents the estimated total of gifts from advertising space; travel expense for arts groups; sponsorship of radio and television programs (public and commercial broadcast); and loan of executives to arts groups, company equipment, space for performances, and administration, as well as cash contributed.[30]

Educating local advocates also means that training must be given so that advocacy opinions are formed on educated reason, not merely because the arts will get more money. Such training is perhaps as important as any that involves the future of the arts in this country. It is a tough assignment, but unless the arts become wise to this necessity, they will take the wrong opportunities for the wrong reasons, and decide by crisis only.

It will further be incumbent upon those who support these efforts to broaden their view of arts needs to include community needs. Parents who are arts patrons are also involved in their children's schooling. The arts-in-education issues should be important to them as they think about audience development, and the next generation of arts participants. Teachers and performers, boards of education and painters, actors and orchestra board members — all must be responsive to the problems far beyond their specific realm.

Perhaps Ben Shouse, a labor leader from the Cleveland Upholsterers' Union, has said it best in recent budget hearings in the state of Ohio discussing the needs of the arts there:

> I am a lifelong representative of working men and women. I also am an advocate for the arts that reach the working men and women of Ohio and the nation, because, for many of those union members, it is their only opportunity to be in touch with the arts.
>
> The arts are for everyone and in particular for working men and women because they need the rejuvenation and intellectual refreshment that only the arts bring. But we, you, legislators, labor, and the artists must provide the money, talent, and the lines of communication to destroy the Archie Bunker images.
>
> Why should an old "ausgespilt" [played out] labor leader be here before you today pleading for more support for the arts?
>
> I do it because I see that the arts are the future enrichment and joy for countless men and women in the factory, in the offices, in the senior citizens centers, in the neighborhoods. . . .
>
> If you have worked for eight hours on a hot assembly line, and don't let anybody kid you that factory workers don't work, then you know what free, public arts recreation means. . . .
>
> Every civilized society in the world that has a rich arts and culture life for all citizens supports the arts to one degree or another. Some totally support it. . . .
>
> We are here neither as the elitist nor the populist, not as the capitalist or the worker, not as the old or the young, not as the strong or the weak, not as the healthy or the sick or handicapped, not as the employer or the employee, not as the oppressor or the oppressed, not as the formally educated or the self-educated, not as the male or the female, not as the exploiter or the exploited, not as the inner city or suburbia, not as the black or the white, not as one area or another, not for one discipline or the other, but as your constituency, your taxpayers, your family — and as part of the family of man in its generic sense.[32]

Ben Shouse started out as a board member of the Cleveland Area Arts Council and was cochairman of the Cultural Arts Committee of the United Labor Agency for three years even before he retired to "devote his entire life to labor and the arts."

Advocates can act in many ways—at local arts budget hearings, at school board meetings as advocates for arts and education, and also as supporters for the issues of preservation, downtown beautification, and revitalization. It is usual that the advocacy for each is separated, and that the arts budget somehow sits as an isolated item. If the arts are truly integrated into the fabric of life, this ongoing effort must develop with a broad view in order to be successful in the long run.

If we took members and supporters of Artists' Equity, community theater associations, the Alliance for Arts Education (AAE), artists' associations, printmakers' associations, music and art teachers' associations, potters' guilds, bands and orchestras, the silversmiths' associations, and others, and developed a single voice, it would be a loud one. Add members, friends, and patrons of arts organizations—interested citizens—and it becomes a yell.

In Chapter 12, "Laws for Public Arts," the concentration is on the percent for arts in public works laws because these have affected or been affected by community councils and commissions the most. Consideration of advocacy efforts in the future could concentrate on the enactment of other kinds of laws that would affect the arts and artists. The state laws that also affect communities have been enumerated and discussed in *Arts and the States: National Conference of State Legislatures*, an arts task force report. They have ranged from laws concerning a percent for art in public places, to others concerning arts in education (arts in basic education, in-service teacher training, gifted and talented, schools for the arts); artists' rights (artist-dealer relations, artists' live-work space, art preservation, resale royalties); tax legislation (artists' income tax deductions, death taxes); consumer protection for purchasers of art (disclosure and warranties); and other issues (e.g., art banks, historic preservation, and local arts funding). These considerations broaden the choices for advocacy programs, and increase the need for citizens educated to the needs and the implications of action that might benefit the artists and arts organizations and/or the public most.

These citizens need to be there for all the issues—legislation, artists' rights, and preservation, as well as the arts allocation issues. They need to be informed and intelligent. This is a full-time citizen job. On the local level, the survival of arts service agencies and organizations may depend on it.

This is the only way that the momentum built up over the last 15 years

will continue to build and deepen. The issues are getting more and more complex; the need to clarify and educate on an ongoing basis is becoming paramount. On the local level, it may be the arts councils' role to try to do this with greater sophistication and style.

NOTES

1. Metropolitan Arts Council, Greenville, South Carolina, "Put Your Heart in the Arts" (brochure, 1980).

2. Interview with and letter from Hyman Faine, May 1, 1980.

3. Letter from John K. Urice to Nina Gibans (August 12, 1980).

4. Interview with E. Arthur Prieve, April 1980.

5. American Council for the Arts, *A Survey of Arts Administration Training in the United States and Canada 1979–80* (New York: Author, 1979), p. 16.

6. Interviews with Jonathan Katz, April and June 1980.

7. Ibid.

8. Yale School of Organization and Management, *Master's Program in Public and Private Management, 1979–80* (New Haven: Author, 1979), p. 2.

9. Ibid.

10. Interview with Alvin H. Reiss, May 1980.

11. Interview with Charles C. Mark, May 1980.

12. Association of Community Arts Councils of Kansas, *Ensemble*, February 1981, p. 1.

13. Interview with Carol Heil, Hays Arts Council, April 1980.

14. Paul Sittenfield, "Putting the Pieces Together," in *United Arts Fundraising Manual*, ed. Robert Porter (New York: American Council for the Arts, 1980).

15. John Engman (panelist), panel discussion by Arts Development Council in preparation for a conference (April 1980), "Volunteers in the Arts," sponsored by the Greater Milwaukee Voluntary Action Center; reprinted in *Milwaukee Arts Network*, April 1980, p. 6.

16. *NACAA Newsletter*, March 15, 1981, pp. 1–4.

17. Volunteer Urban Consulting Group, "A Guide to Operations," p. 3.

18. Isolde Chaplin and Richard Mock, *New Faces in Public Places: Volunteers in the Humanities* (Washington, D.C.: The National Center for Citizen Involvement, 1979), p. 2.

19. Ibid., pp. 5–6.

20. Alvin H. Reiss, "Major New Projects for Volunteers Aiding the Arts," *Arts Management*, January/February 1981, p. 3.

21. Volunteer Urban Consulting Group, "A Guide to Operations," Exhibit VII, p. 1.

22. Chaplin and Mock, *New Faces in Public Places*, 1979, p. 4.

23. California Confederation of the Arts, *Instructions on Advocacy* (Los Angeles: Author, 1980), pp. 1 and 6.

24. Robert Mayer, "The Local Arts Council Movement" (background paper for the National Endowment for the Arts, National Partnership Meeting, June 1980).

25. Seattle Arts Commission, *Annual Report* (Seattle: Author, 1980).

26. Daniel Henninger, "A City That Staged a Fair and Got Culture," *Wall Street Journal*, March 9, 1979.

27. Alice Rooney, *Western States Foundation Newsletter*, Edition 7, July 1975.

28. Ibid.

29. "States." *Re:*, December 1980, p. 6.

30. Charles C. Mark, *Arts Reporting Service*, no. 289 (April 5, 1982), p. 1.

31. Diane J. Gingold, *The Challenge Grant Experience* (Washington, D.C.: National Endowment for the Arts, 1980), pp. 1–4, 113.

32. Ben Shouse, testimony before the Finance, Education, and SubCommittee, Ohio State Legislature, March 11, 1981, pp. 1–3.

20

Artist Roles
and Value Systems*

ARTISTS IN THE COMMUNITY

Arts councils have made it more comfortable for artists to work outside New York City. Artists are more valued in their own hometowns; the concept of "feeding the artist in his own pen and home is taking hold."[1]

"Identify valid artistic purposes and combine them with valid public purposes." The arts council in too many cases has used the artist. The arts council leadership has a role in protecting the artist who is asked to serve a public purpose. The musician playing on the mall is playing because he or she loves music, and that is valid; an artist must not be asked to do inartistic things. Artists contribute by *being good artists* and making their art accessible. They need, too, to be in touch with their audience.[2]

We were not very concerned about artists in 1965; today we are concerned for their employment, as well as their integration with the look of the city (public work).

Sophie Consagra, Director of the American Academy in Rome and former Executive Director of the Delaware Arts Council and Visual Arts and Architecture Director for the New York State Council on the Arts, believes that if experimental artists are to be helped, then it will be by federal and state governments.

*Discussion in this chapter centers around the individual creative or performing artist, as opposed to those whose work cannot be accomplished without a group (i.e., theater, symphony, opera).

Foundations are too cautious, museums only buy what is approved, and patrons increasingly collect art as investment. No one is willing to take a chance on them. I don't see anyone really caring about them except us . . . the government. We *have* to care about the artists coming up, because we are all they have, and all they are going to have if things continue the way they are going.[3]

But the artist who chooses to commit his or her talent to serving other people seeks to make a more personal difference, by sharing his or her art with others as an instrument of human growth. And the experience . . . shows that whenever artists have reached out this way they have been met by outstretched hands.[4]

In the Southern Tier of New York State, at Binghamton, sits the Roberson Center for the Arts and Sciences. It is both an institution and the Arts Council for Broome County, although it is to assume a full united arts funding role in the future. Until now, it has had services very much like those of many other arts councils. However, the majority of the Center's efforts are directed at the primary functions of Roberson as a museum for research, exhibition, publication, and maintenance of collections. Its relationship with artists has been wide-ranging.

We are, of course, criticized roundly by local artists since we are very selective in the exhibitions that are shown in our major galleries. On the other hand, when we choose artists for an exhibition, it is extremely well researched, well presented, and includes quality publication. Those who are selected have, in fact, reached the pinnacle of local recognition and support. That has helped mitigate against the other criticism that is going to come no matter what we do. . . .

I believe because of the example that we set and the support that we are providing for the arts generally, people are coming to realize that the arts are not a frill but, indeed, are common to all of our experience.[5]

In other cities, the artists have been given the opportunities presented by the passage of percent for art in public places laws, individual counseling, an "Arts at the Airport" project and others like it, residencies of every kind in community institutions, and support for their careers through workshops on the business of being professional.

The councils have played several roles. Depending on their own priorities and focus on artists' needs, at times they have been the major instigators or, in a good many instances, have worked behind the scenes. The local artist has come to rely on the arts council for a shoulder to lean on, sympathy, and a place to "get one's act together" or do some ideological brainstorming. In the best situations, the local council seems to be filling a

need between formal training and involvement with the real world and a fully professional life. Many councils have expressed a need to do more that is substantial.

Though the National Endowment for the Arts, state arts councils, and private supporters have done more for individual artists ready for grants and fellowships, the local arts councils may have prepared them for, or made them aware of, those opportunities. Not only might they have been instrumental in creating the first opportunities, but some may have helped artists present themselves with confidence and the necessary backup.

In the best situations, an artist-in-residence in the schools or neighborhood finds a potential career direction that uses skills and talents fitting his or her individual temperament. He or she ultimately becomes hired by the institution itself.

Dozens of the best artists in cities, involving all art forms, talk about their relationships to the council. It takes three, five, or more years for some developmental processes to gel, for people to find themselves; but if they trace their experiences, many today would point to the arts councils' assistance along the way.

What is of particular interest is watching these talents develop. It has taken many artists the better part of a decade as they have moved through several phases, gaining maturity as persons and as professionals. They have, for the most part, also gained a knowledge of themselves, a sense of confidence, and a grasp of the wider issues in the world of the arts as they move to make their place in it. They are talented to begin with, but this process has been nurtured by their local support groups, cheering them through the student show, the regional exhibit, the first one-person show, and the first commission.

It is also interesting to watch their training patterns — do they move to New York and back, out West, or South to the newer opportunities? Do they go to special programs to work with identified mentors at the right time? Is this necessary to acquire new ideas and to gain new and multiple experiences? Do they perhaps find ultimately, and naturally, that returning to their original locale is good? The artist coming back is different from the artist who left, and is appreciated differently. Each part of this process has its effect upon the next. Individual development grows from the contacts made, the work accomplished, and the experiences absorbed.

If artists who have been this route and have "made it" are asked these questions, they will give some repetitive replies — personal goals set and well defined, and an organized professional approach. The combination of qualities is seen repeatedly: talent, commitment, focus, success — and luck. Most successful artists admit being at the right place at the right time — for exhibits, publishing, performing companies, readings, mentors, grants, fellowships, or whatever.

Among the oldest organizations that have assisted the creative artists are Poets and Writers, Inc. in New York, the Artists Foundation in Boston, and the New Organization for the Visual Arts in Cleveland, which was created with the assistance of the Cleveland Area Arts Council. These organizations have developed programs in direct response to the expressed needs of the professional creative artist, regardless of discipline. Their goals are to assist all artists who wish to become self-supporting and to increase public understanding and appreciation of contemporary artists' work and skills.

Becoming businesslike and professional in all respects is a major goal for all artists today. No longer is the artists' disdain for such aspects of professional life seen as appropriate; there's too much assistance around. The early work of these support groups in the 1970s has had an influence on the older training institutions serving the artists. Today most institutions include discussions of these topics.

Unemployment figures among artists are still devastating. Statistics point to improvement in the 1970s, but with general unemployment up, the 1980s could see a backsliding as priorities for unemployment are sorted out. For all of the better awareness of the roles and needs of artists today, most of the measures of support are one-time in nature. The one-time grant or fellowship, be it for a year of creative effort or a specific project, is important and not to be underestimated for its impact on opportunities provided. But the question still remains—what about ongoing sustenance?

"Arts weeks" and local festivals are celebrations—fun for artists and the public if well run; they are the best opportunities for craftspersons, mimes, some musicians, and those dancers who can perform. But they are seldom the *best* shows for painters, sculptors, choreographers, playwrights, or composers. Many times budgets are too limited for commissions and exhibitions; other times, the ambience may not be conducive to moving tons of sculpture material, or to trying to paint with the sun in one's eyes or with poor light inside. Furthermore, hanging and selling space is often poorly thought through for those who do display, and performance areas are not conducive to good performance. Finally, it's easy to think the job is done once the celebration is over; of course, it is not.*

A call from an artist recently inquired as to what kind of art was selling. She wasn't interested in any aspect of art except being successful in the marketplace—an "in today, out tomorrow" affair. She could create images on demand, as she said. There are few answers, because she'll make it, but

*Some artists today have created a new support system for themselves by focusing on the festival circuit and making a living by selling their works outside galleries. Also, the larger local or national festivals such as Houston or Spoleto budget and plan for commissioned work. There are also the specialized festivals such as jazz, film, or outdoor sculpture, which are among the most interesting.

her growth as an artist has long since ceased if that is *all* she is planning to do.

A playwright has made a suggestion. If every professional theater incorporated into its structure a playwright-in-residence who would be able to write as an established part of the contract, the ongoing basic need for more stability would be met. This idea could extend to the playwright's counterparts — the choreographer, visual artist, writer, and composer. A model for this can be found in the special residencies of Affiliate Artists, such as the Exxon Arts Endowment Conductors program, the Xerox Pianists program, and the San Francisco–Affiliate Artists Opera program, giving opportunities, extended training, and experience for employment, performance, and community informance* to gifted artists in these disciplines.

Ongoing sustenance needs the focus of private employers and the appropriate educational and performing arts institutions, where artists can be hired as artists — remembering, of course, that no professional in any field creates 100 percent of the time. There are related duties, paperwork, and business. Artist residencies have been tried at schools, colleges, and even factories. There have also been public roles well suited to artists. The success depends on how integral these jobs are seen to be — whether they are staff roles, not afterthoughts, for starters. There could be exchanges among institutions in various other cities, rotations, and other refreshing schemes to renew vigor and creative resources.

If the values represented in the contracts are straight "employer to artist," there could be some additional value for everyone who would consider these possibilities. Then fellowship and grant programs could take a proper place among incentives, instead of being dependency programs.

With the onslaught of government support, short-lived as it was, during the WPA of the 1930s, the artist as worker was compensated at what was thought to be a decent rate for a fair day's work. "Some had the chance to stay alive while learning [and] creating."[6] Today, after 15 years of concern and growing support from a network of the National Endowment for the Arts and state arts council agencies, the artist emerges as a professional to be considered in a different way. In the 1930s, the indigent artist, chosen for talent but also for ability to fit into a public work scheme, emerged as dedicated and serious. Many are well-recognized names. Their works, now emblazoned on the public memory for all time, are, in general, useful and technically adequate social commentaries. They are part of the fabric of our social history, a moment in our artistic history. We are to be reminded

*An "informance" is an informal presentation combining performance and conversation.

that the entire history of the arts projects from 1933 to 1943 was, from the inception, more or less tied to relief. However,

> in spite of differences in politics and esthetics, artists report having experienced a professional communality unique in American art history; in spite of pitifully meager wages, nagging frustration, and bureaucratic harassment, artists were regularly employed at professional tasks. . . . there was a new and positive sense of the artist's place in American society. . . . It still remains for many a "golden age."[7]

Federal support for artists in more recent times seems a catalyst for awareness on the part of other potential supporters of the positive power of creative energy and a blossoming of some of America's best artistic talent and recognition for such. Our arts history, until recent decades, is European-based. Today America's artists are American-trained and assume world leadership roles. Since World War II, many short-lived stylistic idioms have paraded before us; today, artists may work in a multitude of forms and styles, using a multitude of materials available in this contemporary period.

Artists as individuals are just discovering the potential of their roles, rights, and impact on the community — and even on the world. Their anti-institutional bias or individualistic bent on many matters may bring criticism of institutionalized planning and the decision-making process. Rightly or wrongly, the artist is just learning the responsibilities that surround the professional artist. Those responsibilities are juxtaposed with artists' demands for commission, recognition, and opportunities from all kinds of potential commissioners, including government bodies and corporations. The artist looks not only for financial and ongoing support, but also for living and working contexts that are compatible. These may turn out to be studios in steel mills with donations of materials, or outright commissions, protected by good contractural agreements and copyright. Volunteer lawyers' groups in many cities, including Chicago, New York City, Cleveland, and Indianapolis, have become intrigued with the ways in which they can be skillful in assisting the artist and have helped with specific contractual work and other legal matters.

This, for the individual artist, presents some natural dichotomies and dilemmas. The individual artist usually does not create to satisfy a public need. The very marrow of creative effort includes a need to be personal in style and free in expression. This is the kernel of artistic production that is worth anything, and invariably makes the difference between great and acceptable or passable art. Are the two ideas — the need for public response and satisfaction, and the needs of artistic creation — incompatible? This is the age-old problem highlighted in new contexts.

The setting for the artist needs to be supportive, not antithetical. Nothing is ever right about a poet reading in an open park bombarded by the harassment of automobile noise and other urban hostility. It is neither an artistic nor a poetic event. The modern artist rides it out, but the ancient Greek poet reciting in the amphitheater couldn't have imagined a successor fighting such elements. A forum for a poet does include public reading, but the contexts need to be carefully developed to make sense. Some of the most successful have been bookstores, coffeehouses, libraries, and larger well-planned staged events.

There is a common bond among such groups as HAI, Affiliate Artists, Young Audiences, state and community arts councils, neighborhood centers, museums, orchestras, governmental agencies, and corporations — it is that they all have the capability to support the individual artist. Affiliate Artists addresses the need to distribute the talent of performing artists on the way to major careers through residencies, and arts councils are a part of the distribution system (as are regional opera, theater, and dance companies, symphony orchestras, etc.). Since 1966, Affiliate Artists has placed 270 artists in more than 300 communities in 800 residencies. "As a broker, we have enabled the best to create their own new markets."

One assistance program to individual performing artists more recently, including visual artists and writers, has been the Great Lakes Artist Associates program based in Ann Arbor, Michigan. Focused on technical assistance to the artist, the hard questions are asked:

**What you've always wanted to know about advancing
your career, but had no one to ask!**
(Getting the right answers involves asking the right questions)

GOALS:	What do I want to accomplish?
IMAGE BUILDING:	Where am I in my development? How do I see myself? How do I want the public to see me?
AUDITIONS:	Where are the important auditions being held? What materials are the most appropriate for auditioning? What should I wear? What is the most important point to emphasize? Which people should I give as references? What additional visual or audio materials should I include?
PERSONAL REPRESENTATION:	How effectively can I represent myself? Can I project a professional image if I represent myself? What are viable alternatives to commercial management? . . .
CONTACTS:	What personal networks can I tap for valuable contacts? What professional contacts do I already

have? What political moves will enhance my career? What social events should I attend and create?

CORRESPONDENCE: To whom should I write, when, and where? When should I use a formal business letter? How is my personal writing style important?

PERSONAL STYLE: How does my manner of dress and my body language reflect my desired personal image?

RECORD KEEPING: Are all my professional expenses documented? Which expenses are tax-deductible? Can I afford professional help? What are the available alternative funding sources?

MARKETING: What is my product? How should I package my product? Who am I trying to reach? What is the most effective way to reach them? How much do promotional materials cost? Can I afford them?

ARTISTIC GROWTH: How recently has my repertoire expanded or changed? Should I be getting outside coaching? Who's available? How skillful is my programming? What audience am I trying to reach?[8]

Arts councils, by virtue of their diversification, have given less focused, individualized attention. Have they been "tough" enough to be helpful?

There aren't many ways these groups or organizations do work in common. Together they constitute the potential support system, the potential career direction, the potential forum for the contemporary or present artist in today's world. In the framework of these potential "systems" is the artist himself or herself, whose temperament, style and medium of working, personal needs for public display, outlets, work spaces, and supplies may dictate how these systems are seen and work in his or her behalf. No one can speak for every artist.

There is a tendency to expect that a single artist represents all artists in that particular aspect of art form. An artist represents exactly that: an artist — a single individual creatively involved. That individual sees the world from an individual perspective and cannot speak for all artists — not even for all who create in that art form, any more than a person could speak for artists in another art form. A sculptor may have very few problems in common with a performing artist, such as a theater person or even a poet. There are differing sets of needs, skills, supplies, and so on.

On one occasion, ten finalists in a sculpture competition found it difficult to agree on a scale of the model to be presented for final judgment. They chose collectively a scale that was absolutely unfair in terms of cost to one of them, whose piece happened to be aerial and was so foreign con-

ceptually that the others could not grasp her problems. It was a good example of the single artist's view, which is what we get when we ask for an opinion.

There are, of course, some common problems, but they are the largest of issues: the place of an artist in American contemporary society, the general malaise about businesslike and professional attitudes toward artistic business matters, the need for some institutional support, and others that emerge each time we think of the artist.

It may be true that there is no other group in society that is treated as unprofessionally as artists are. They are expected to "donate" to every known cause the very work that is their professional endeavor. What is misunderstood is that for an artist, this work *is* his or her livelihood. If grant systems and artists-in-residence systems (be they for communities in general or for specific institutions such as schools, prisons, hospitals, and cities) did not exist, the situation of artists would be even more difficult. The artist needs the multiple possibilities of support. The artist then also needs to understand that while creative efforts must be free from public intervention, the public has a right to opinions, since some public monies are being used for these systems of support.

Most artists have always combined careers in pursuing their own creative work with teaching or other jobs to help sustain themselves. More are fighting for the full life of an artist, free from other diversion and interruption. One artist, well-known but not sustaining herself solely from her art work, insisted that she was eligible for volunteer legal support because, indeed, the income she lived on did not come from the artwork she created; rather, it came from teaching. "Sources" of income are not divided when delineating eligibility for food stamps or scholarships for anyone else. Why should they be for the artist?

Artists are somewhat ambivalent about wanting exposure and wanting to be judged. For complex reasons, at times they tend to handle themselves badly when it comes to the business aspects of being professional. There may be many good reasons to "cop out" — to "reject" a bad contract, instead of working through it with legal assistance to a compatible conclusion. But how can the artist's potential interrelationship with business, government projects, neighborhoods, and other specific constituents be supported in a manner that is accurate and constructive? The frameworks for careers in teaching and working in the corporate framework as artists-at-large, artists-in-residence, and arts consultants can be developed and nurtured. The arts council could be one of the best agents for setting the groundwork.

One of the most solid ideas is one where the arts council becomes the broker for artist and institution. Prior to a commitment from the council to support the artist, artist and institution have to develop a mutual and workable idea to which the institution can make a commitment. The artist

and the institution then draw up a contract for work. The arts council sees that the artist is funded; the institution is responsible for the supervision, the commitment, and also some of the costs of supplies for the project (or at least the monies for obtaining the supplies). It seems as if the artist is here treated professionally and has the proper support mechanisms assured for successful creative venture. Responsibilities are spelled out clearly. It is when there is less clarity and the artist does not share equally in taking on the responsibility that there is less success all around.

Another interesting type of support program is that of the St. Louis Arts and Humanities Commission, which offers original prints by 16 area artists for sale as an opportunity "to expand your collection of original prints."

In the future, arts councils should encourage artists' inclusion in all phases of community life — from planning and designing with local government to working with transit systems, to getting involved in theater renovations and revitalization programs, and to creating an aesthetic unity with other aspects of a project. Care must be taken to assure that the artist is not "used" for political gain and that there is greater awareness about when this is so.

How is one to summarize the community arts council's role in all of this? Some local arts councils have done the following:

1. Nurtured local artists and probably helped those who were good become more professional, more directed, and more in touch with private and public sources of help.
2. Helped corporations, governments, libraries, and other nonarts institutions become more comfortable with the idea of commissioning and "living" with artwork, by offering guidance and assistance on commissioning processes — juries, contracts, implementation procedures.
3. Made exhibits and performances more widely known through calendars, directories, and phone lines.
4. Tried to understand the individual artist's needs and articulated them.

The state of the arts today shows this nurturing. It also seems apparent to some major critics that little "important" work is being done in almost any field. There seem to be as many artists and as few major and monumental statements as in any period of the history of the arts. The new great music, painting, opera, and plays are not being created and produced at this moment in history — or is it that it takes historical perspective to grasp their value?

What impact the support systems, beginning with those on the local level, have had on this would be impossible to say. But perhaps an artist

cannot create and serve on boards, fight for artists' rights, and think about overriding, earth-shaking community and national arts problems while being the best artist. And perhaps by insisting on their inclusion in such matters, we have done ourselves the greatest injustice of all — robbed them of some of their creative time and energy. It would seem that we are still searching for the best ways to involve them and can do no better than to provide the best opportunities to work.

VALUE SYSTEMS AND NEXT AUDIENCES

> If the arts are for everyone, let us build an educational and societal system in which everyone is for the arts.[9]

With the availability of CETA funds and the possibility of using them to support unemployed artists in their work for schools, it seems as if almost every arts council in the country must have descended upon the doors of its local school system. That, of course, is an exaggeration, but many point to this period, 1974–78, as the time when their artists-in-the-schools programs got their start. What is most disturbing is that too often this impetus has come from an employment incentive, and has nothing to do with the research, planning, training, and implementation of the arts concurrently taking place in education programs.

In the worst instances, the school systems acknowledge the arts councils' assistance, but the projects have little support from the school systems themselves beyond the classrooms they affect; or the projects represent a substitution for arts specialists whom the school systems haven't hired. These council programs are funded from the outside, and, serious as the intentions are, may even be setting back those systems that need to learn the difference between project and program, between arts as basic and arts as expendable "enrichment concepts." The rationales usually end with "not being able to afford it."

Leaders of school systems and councils are basically unaware of the work of the last decade reported here and its potential for application. They are not usually dedicated to research, planning, training, and advocacy in the arts education area. The programs are conducted on a year-to-year, hand-to-mouth basis. Any arts agencies whose efforts have these characteristics — be they arts councils, arts organizations (symphonies, museums, operas, etc.), Junior League chapters, recreation departments, or whatever — should not be involved in work with the schools (or any agencies) that is not well thought out and developed for the right reasons — to improve or support ongoing arts education programs.

The same problem can exist with the motivation of arts organizations involved in the schools:

> When the chief concern of an arts organization is simply to provide opportunities and security for artists to "do their own thing" rather than to translate an arts performance into a learning situation for schoolchildren, such performances are likely to have little lasting significance in the schools. Interest in children and in their capacity to learn [is] very important, as is the ability to relate to the particular age level of an audience. Engaging, outgoing, and enthusiastic visiting artists have made more inroads than have detached, removed performers. Artists who were open to questions and flexible enough to let children participate have had a greater impact.[10]

The schools, we say, are responsible for developing the value systems we want in place when the children are adults. Of course, in the best instances, the arts councils' work with the schools has added significant dimension. But this has come about only because dedicated citizens and professionals from both the schools and the arts have cared about putting it together.

An example of commitment and success has been the Community Resource Center for the Arts and Humanities in Tulsa, Oklahoma. It was founded as a joint project of the Tulsa Public Schools, the Junior League, and the Arts and Humanities Council of Tulsa, so that arts and humanities resources might be orchestrated with school curriculum. The council and the schools jointly fund and administer the project.

The arts council in Buffalo, Arts Development Services, Inc., was asked by the school system to develop a program, Presenting Arts in the Schools; the program was designed to coordinate community activities with ongoing curricula (Emergency School Aid Act funds), with parent groups and community organizations drawing upon the resources of five area professional organizations. Part of what emerged was the use by Arts Development Service of Buffalo Performing Arts vouchers, which are furnished to students and parent organizations to enhance cultural opportunities for students and their families. This allows families to attend a wide variety of dance, music, and drama performances, for the vouchers can be turned in for tickets at the box offices of 40 arts organizations in the area.

The idea of a voucher system is to create new audiences from the potential audiences by underwriting a portion of the cost of a ticket over a specific period of time. The theory is that every empty seat is a loss of revenue. The system has worked, and those on voucher move off into the regular art-going audience at regular prices with enough regularity that evaluation shows this to be an effective method in audience building, partially because it allows for frequency in attendance.

The Arts Development Services' Performing Arts voucher program is an audience development project that encourages attendance at theater, dance, and musical events through reduced price for those who would not ordinarily attend. Applications for the vouchers are available to students, senior citizens, handicapped persons, municipal employees, service workers, labor union members, and members of other groups in western New York. In addition, the program benefits participating performing arts or presenting organizations by subsidizing these performances at a modest level.

To circulate vouchers more fairly, households that have had vouchers for the previous two consecutive years are rotated off the program, except that senior citizens and handicapped persons on fixed limited incomes are exempt from the rotation. The performing or presenting organizations redeem the vouchers by returning them to the office. The redemption fund is made possible by grants from the National Endowment for the Arts, the New York State Council on the Arts, corporations, and foundations.

Voucher systems started in New York City with the Theater Development Fund, and they have been operating independently in some form in other cities, including Minneapolis and Houston. Lack of funding has affected ongoing programs in Boston, Chicago, and San Francisco. (The Theater Development Fund also started the first half-price ticket sale program, which has been a successful audience development system. It too has been adopted in other cities.)

The Arts Development Service voucher program was an important step for the fledgling Buffalo organization in 1973, for it meant that their board and corporate community had to commit themselves to raising proper funds to get it rolling, and that a visible program that would involve many arts organizations directly was being launched. The New York State Council on the Arts was responsible for urging Arts Development Service to undertake this activity — a fortuitous move for both. It is an example of important efforts that have emerged from persuasive state arts council leadership.

There is now enough experience with such systems to know that, for all of the talk about new audiences and the development of new habits and behavior patterns for portions of the community that would otherwise not be responding, some systems do seem to be working where there is adequate funding to keep them going. Does it work best in conjunction with other marketing programs designed to be directed to the potential known audiences? This is like comparing apples and oranges; the newer systems are designed to reach the untested groups. Both types of programs are valid and needed.

The term "audience development" evokes many definitions. It means looking at the potential of new attendance groups for performances and ex-

hibitions, and usually refers to the ways of encouraging that attendance. The main factors inhibiting attendance have been identified as economics, educational level, simple preference, priority, and awareness. However, it has long been felt that behavior patterns established early are the most reliable indicators of those that will be lifelong. Thus the relationship to arts and education is significant.

Arts councils might have another role, which is one aspect of the development of general arts advocacy on the community level — a role as arts-in-education advocates. But they must be clear about goals, purposes, roles, and processes, as in the other areas of arts concern. Otherwise, in the development of value systems, we give out mixed signals.

A review of the efforts to bring about change in the relationship between the arts and education in the country over the past 15 years will show that if any program is to serve the mutual interests of arts *and* education, it must contain several elements that are basic to ensuring that programs expected to extend beyond a trial period become absorbed by the school system. Too few have. The efforts to identify them and communicate about them have been made by people whose names are well known to anyone who has been involved in arts in education over that time. Two people who have documented and reported the progress have been Junius Eddy, an independent consultant for education and the arts (formerly the arts education specialist with the Arts and Humanities Program at the U.S. Office of Education and Education Advisor to the Ford and Rockefeller Foundations), and Charles B. Fowler, a journalist and consultant in the arts. One single document by The Arts, Education and Americans panel, *Coming to Our Senses*, pinpoints why "arts education is struggling for its life" in terms of broad national impact, and points to some of the arts education programs that would serve as models. There are three principles that underlie the panel's nearly 100 recommendations: (1) Only when the arts become central to an individual's learning experience in and out of school and at every stage of life can the goals of American education be realized; (2) the arts must be considered a basic component of curriculum at all levels; and (3) the schools should draw upon all available human and human-made resources in the community for their arts programming, which gives almost any part of the community of education and the arts the right to begin working on accomplishing these ends and the process of seeing that it is done.[11]

Everything we have found out supports and reiterates the need to supervise, plan, and train advocates in order for anything to happen that will have impact. This process must continue with the same vigor as any other aspect of the community's efforts does; or, as teachers move, children graduate, and parents become less involved, so the support groups will move on. The effort at strengthening the role of arts in education can be

synopsized by showing where its thrust began, and enumerating the contributions of several organizations who grew in response to the needs projected.

From the 1960s and first at the federal level,

> the pattern of support evolved in a random fashion rather than resulting from systematic analysis of all the components which together make up the extremely complicated arts education picture, . . . yet, whatever the gaps in this field . . . it seems likely that they will need to be informed by, and made operationally effective through, the ideas, methods, approaches, and strategies which have characterized the best arts education developments of the recent past.[12]

Critical to a sound beginning were the research and development activities of the Office of Education, carried on by many of the people who later had major developmental and administrative roles in the agencies and organizations doing major work in arts and education; these individuals included Stanley Madeja, Kathryn Bloom, Junius Eddy, Gene Wenner, Lonna Jones, and Martin Engel. Harold Arberg, still with the U.S. Department of Education in 1982, has been involved there since 1962.

Starting in the 1960s, when the groundwork was really built for the work that succeeded the wide range of arts education activities motivated and undertaken under the various titles of the Elementary and Secondary Education Act (1965), it seems that there has been a short-term program to match every style of school administrator, every community configuration, and everyone's taste.

They have been generated under various rubrics and auspices and with varying degrees of concentration and ongoing commitment. The 1960s programs are characterized by Junius Eddy in his report as the

> first arts education seeds of the modern era in the educational garden. The problem was, of course, that the garden was largely uncultivated and the seed were broadcast randomly; little attention was paid to preparing the ground adequately; seldom were all the other factors necessary for nourishment and ultimate flowering taken into account; and, as a result, many of the crops died when the first flurry of governmental support ended [ESEA (Elementary and Secondary School Act)-supported developments and early National Endowment for the Arts and National Endowment for the Humanities].[13]

The late 1960s and early 1970s brought the development of programs from the Office of Education. These programs are described as better planned, more systematically carried out, and more effectively evaluated than the preceding programs. In some of these systems, the plans, extended by other sources of funding and absorbed somewhat by the individual school systems, lasted a good part of the 1970s. Only a few programs of this era were

given continuing support by their states, but some states began to look at their educational priorities and to start to include the arts among them.

In the evaluation report of one of the Office of Education programs, IMPACT, involving models of interdisciplinary arts programs at the elementary level in five areas of the country — California, Georgia, Oregon, Pennsylvania, and Ohio — one observation substantiated the complexities of administering such a program. In this program, as in others, teams of specialists in the arts integrated their work with that of the classroom teachers.

> The congruence of administrative style with the IMPACT process is important to the overall success of the program. This is most true in terms of how the principal uses the resource team and how the principal integrates the team efforts with regular classroom activities. Improvement in this integration would probably be the single most effective strategy for overall program improvement.[14]

The evaluation acknowledged that IMPACT was a solid educational idea dependent, among other things, upon supportive and flexible school administrators and instructional leadership of the resource team. It was also seen as creating a positive school climate, and parents were very supportive of it.[15] This particular program ended in 1977 due to the financial state of the school system. It ended quietly with no protest, but its effects on the system can still be seen.

A program's moving from the status of a project to that of an integral part of the system is often misunderstood. Projects always do and should end. But their effect on the regular school program is often overlooked. This often leads to the belief that the project, because it died, was not valuable.

In "A Decade of Change," in *The Arts in Education: A New Movement,* Kathryn Bloom explains the developments that have "encouraged more positive attitudes towards the values of the arts in education." In addition to those already mentioned, there is the Artists-in-Schools program of the National Endowment for the Arts, officially launched in 1969 as a pilot program placing visual artists in school residencies in six states. Before this time, the Endowment had sponsored a poets-in-the-schools program that "was quite successful." Because of the success of these pilots, commitment was generated from all involved — artists, teachers, school officials, parents, and state agency staffs. The program expanded to include dancers, musicians, craftspeople, folk artists, filmmakers, video artists, architects, and environmentalists, as well as poets, writers, photographers, sculptors, painters, and graphic artists — working in all 50 states and five special jurisdictions.[16]

Today the Artists-in-Schools program has evolved into the Artists-in-

Education program after a full assessment of the impact and potential of the program. Of the year 1980, its director wrote the following in February 1981:

> The program exits the year broadened in vision, renewed in vitality, heightened in value, and enriched by a sense of mutual trust and commitment to cooperation on the part of agencies and individuals at every level. The planning process resulted in more than a new program. It established a climate for respect and advancement in the years ahead.[17]

Financial support for the Artists-in-Schools program has come from the Endowment and other sources, including the U.S. Office of Education, the Bureau of Indian Affairs, state and local arts agencies, and state and local education agencies. The Endowment's financial support had been viewed as "advocacy" or "seed" money for a concept whose nationwide acceptance would eventually generate the substantial funds necessary to place artists in a majority of the schools in this country.

The first steps were taken in 1967 to establish two programs that have the same goal in common — making aesthetics and the arts in education an essential part of the total educational programs of school systems and state education departments. They are the Aesthetic Education program of the Central Midwestern Regional Educational Laboratory (CEMREL) and the arts-in-education program of the JDR 3rd Fund.

> Both approaches may be viewed as major research and development programs. That is, each program was concerned with a particular concept and rationale, identified goals and objectives, worked closely and cooperatively with local and state education and arts agencies to develop successful practices, documented and evaluated steps taken to reach their goals, built upon knowledge as it accumulated, and disseminated information regarding outcomes to a wide audience.[18]

A comprehensive curriculum in aesthetic education for kindergarten through sixth grade has been designed by the Aesthetic Education program and works with school and community representatives in the implementation of aesthetic education programs that are appropriate for their particular communities.* In 11 sites, Aesthetic Education Learning Centers were established to provide services such as various types of technical assistance and training of teachers and administrators. These Learning Centers were linked together by a network called the Aesthetic Education Group. Two of the original 11 are now operated by CEMREL; several of the others are

*The many CEMREL publications on the Aesthetic Education program are valuable to those who wish to examine program content.

staffed and operated independently, as originally intended. The idea is that the arts should be an integral part of elementary and secondary school programs.

Wide national visibility has been given through the Arts Education program of the U.S. Office of Education, which is administered cooperatively with the John F. Kennedy Center for the Performing Arts through the Alliance for Arts Education (AAE). The AAE, with national offices at Kennedy Center, is a network of 55 communities, one in each state plus the Bureau of Indian Affairs, the District of Columbia, Puerto Rico, and Samoa and the Virgin Islands.

Each committee (as a rule, composed of representatives from organizations involved in arts education, such as the state department of education, the state arts agency, the state-level professional arts education groups, and others) sets its own goals, objectives, and activities. Most often these activities focus on forums, state-level advocacy work for arts education, development and implementation of state plans for comprehensive arts education, and provision of consultation services to individuals and organizations conducting arts education programs and projects.

The state committees are assigned to one of five regions (Northwest, Gulf-Atlantic, North Central, Western, and Pacific), each headed by a regional chairperson. These five individuals, who are present or former state AAE committee chairpersons, form the AAE Subcommittee, with the Kennedy Center Director of Education, the AAE Director, and a Department of Education representative serving in ex officio roles. The chairperson of this advisory committee serves on the National Education/AAE Committee. The national AAE office publishes and disseminates information pertinent to arts educators and others interested in providing quality arts education experiences.

In addition, four professional associations representing education in the visual arts, music, theater, and dance in the United States have given "support to the arts in education through activities initiated within the individual associations, as well as through programs carried on cooperatively with the U.S. Office of Education and the Alliance for Arts Education."[19] The Emergency School Aid Act, administered by the U.S. Office of Education, spent $1 million on grants to public agencies, such as state arts councils, for Emergency School Aid Act-Special Arts Projects designed to reduce minority group isolation in elementary and secondary schools through placing practicing artists of various racial and ethnic groups in day-to-day contact with school children.[20]

Under the Education Consolidation Act of 1981, which revamped or repealed many programs of the U.S. Department of Education through a "block grant" system, arts educators must take action at state and local levels if they want to be considered for funds. There are many questions as to how these funds will be useful to the arts and education.

During this time, several foundations broadened their interests in the arts and humanities. The JDR 3rd Fund addressed the question of whether the arts could be made a part of the education of all the children in our schools with a unique focus and commitment. John D. Rockefeller III (whose death in 1978 caused the program to be suspended a year later) believed that exposure and training in the arts had to be part of the educational program of all children. In 1967, Kathryn Bloom, director of the U.S. Office of Education's Arts and Humanities program, and formerly Virginia Lee Comer's successor as Consultant on the Arts for the Association of Junior Leagues, and Supervisor of Art Education at the Toledo Museum, was asked to head the program and did so for the 12 years of its existence. According to the JDR 3rd Fund's own report, the Fund's Arts-in-Education program had the following characteristics and impact:

1. It was exemplary in showing how to get the maximum amount of impact from small amounts of money. The total amount given to 30 different projects or programs over the 12 years was $3 million.

2. It articulated and gave credence to such ideas as the arts are an area of curriculum as important educationally as any of the others.

3. It expanded the former notion that "the arts" were basically art and music; the arts encompass dance and movement, theater and creative writing. Artists and community arts organizations and resources were involved as major resources for teaching and learning about the arts.

4. It demonstrated the importance of support from the state department of education and, of course, from the school districts themselves. This idea was supported by the creation of a network of states and cities that could share mutual concerns. Through the Ad Hoc Coalition of States for the Arts in Education (Arizona, California, Indiana, Massachusetts, Michigan, New York, Oklahoma, Pennsylvania, and Washington) and a League of Cities (six school districts — Hartford, Little Rock, Minneapolis, New York City, Seattle and Winston-Salem), key administrators and staff could meet, share information, and gain detailed insight about the other programs. They could help each other with the working definitions and make on-site observations that were important to support the philosophy and concept. These networks received money only to support their meetings. One of their mutual efforts has been "to develop authentic and tangible demonstrations of how the arts *can* serve the basic educational, social, and emotional needs of children and youth, given the current cry 'back to basics' with no clear understanding of what is basic."[21]

The Fund's report keeps circling around the major question: "What procedures could be identified or developed by which schools or school districts could plan and implement arts in education programs most effectively and efficiently so that they would be solidly institutionalized?"[22]

At the same time, it was addressing the issues concerning the arts in general education — emphasizing that the arts can be part of general education for all students as well as specialized education for a few students, and dealing with how to build these concepts around organizational structures in conceptual frameworks that had staying power beyond the initiators of projects.

The JDR 3rd Fund's efforts were focused on the school districts in University City, Missouri; New York City; Mineola, Long Island, New York; Jefferson County, Colorado; Ridgewood, New Jersey; and Oklahoma City, Oklahoma. As the work in these systems evolved and matured, the strengths and weaknesses of the various plans emerged until it was obvious that the information gathered was of potential value to those in other systems ready to absorb it.*

In 1975, a survey conducted by the Winston-Salem Arts Council indicated that

> The people of Winston-Salem are overwhelmingly in favor of arts courses being taught in the public schools, not just as a noncredit activity but as part of the core curriculum like English and mathematics. Furthermore, they believe the courses should be taught at all levels of the public school system and that the funds to pay for them should come from the regular school budget.[23]

At the initiation of the Winston-Salem Arts Council, concerned by the survey results, the JDR 3rd Fund personnel assisted the Winston-Salem/Forsyth County school system in developing a comprehensive arts-in-education program. There was a clear understanding of the difference between an arts enrichment program and a school development program focused on the arts. This concept is a basic one, and underlies everything that those involved in arts in education are trying to accomplish.

> The ABC program concentrates on having all children experience the arts as an integral part of their education. Emphasis is placed on the entire curriculum and on incorporating new dimensions of awareness through the arts. . . . The interdisciplinary approach to the arts in education prepares the individual

*Jane Remer's *Changing Schools through the Arts: The Power of an Idea* (New York: McGraw-Hill, 1982) chronicles the history and development of the League of Cities for the Arts in Education, a network sponsored and coordinated by the JDR 3rd Fund until August 1979. The book deals with the birth and development of the Arts in General Education program in New York City and the adaptation and refinement of the idea and process in Hartford, Little Rock, Minneapolis, Seattle, and Winston-Salem.

to utilize, throughout his [or her] life, the emotional, intellectual, and aesthetic fulfillment found in the arts.[24]

The Arts Council's role is to work "with" the school system through the Education Committee of the Council. Ultimately, the Council has co-ordinated community arts groups and artist activities with the schools and has matched funds provided by the school system for these services.

> The use of community resources has been interpreted broadly to mean more than the use of artists-in-residence. Arts groups work cooperatively with the schools; the schools make intelligent decisions and plan collaboratively with these groups. And just as important, the schools are not afraid to blow the whistle when things don't work out.[25]

The concept that the arts should be basic to, and integrated with, curriculum for all children has been an important idea that started to take hold in many ways during the 1970s. The JDR 3rd Fund's contribution was that of working with the processes in depth, so that clarifications of how to integrate the arts were developed. Their information base could be translated to those with serious intent in making significant progress in this area of education. No little credit belongs to the expertise of the Fund's staff members, who shared wherever possible. For instance, the Cleveland Area Arts Council's Education for Aesthetic Awareness Teacher Training program, which took four years to plan and three pilot years to implement, used the Fund staff's expertise (particularly that of Gene Wenner and Jack Morrison) all through the planning phase. Additional consultants for this and the other education programs included such others as Junius Eddy, Harry Broudy, Robert Stake, Allan Sapp, and Bernard Rosenblatt, who had been involved in the development of the arts-in-education concepts since the 1960s. Local leadership included Bennett Reimer, who has had a long involvement with the arts and education.

This program, geared to "teams" of teachers from individual schools, followed methodology suggested by national educators such as John Goodlad for creating change in the schools. Ideally, classroom teachers and arts specialists would be involved in learning about discrete arts, ways to relate them to each other and to subject matter, and ways to help all of their students to become aesthetically aware. Among its goals, the program sought to help the arts specialists become more effective in developing the aesthetic skills and understanding of all of their pupils; to promote close cooperation between arts specialists and classroom teachers; to investigate means by which the community's institutions and arts experiences could become more educationally effective; and to provide help for the teams in establishing their own models for change within the individual schools. The focus

was on the qualities that make a thing artistic, and included as many types and styles of art for study as possible. Given 16 Master's degree credits in the pilot stages at four area colleges and universities, the program was placed at one of them after that time. The faculty team of nine represented several art forms. This program was initiated, coordinated, and codirected by the Arts Council to address a perceived, well-discussed, and well-documented "gap" in teacher training. It was supported in the pilot phase by local school systems, in which "the concern for aesthetic education was at the highest administrative levels backed up by school principals, teachers, and parent-community support."[26] The clientele soon expanded beyond the pilot group by word of mouth and by formal communication about the program. In the first 5 years of the program, 914 teachers and administrators in the Greater Cleveland area participated in year-long credit work, single quarter work, or workshops.

Thus arts councils have played important roles in some arts-in-education programs. It must be added that they are not the only community organizations with this interest, and in some cities Junior Leagues have assumed unusual responsibilities because they believe in the value of the arts in education for every child. Programs in Birmingham and Pittsburgh are examples.

In Oklahoma City, the Junior League's role in the Opening Doors program was also substantial.

> Members of the Junior League were acquainted with the idea of a comprehensive approach to the arts in education through attendance at a national conference on this subject sponsored by the Associated Councils of the Arts and visits to CEMREL and the first pilot program established by the Fund. . . . the school system, which was under a desegregation order, perceived the cultural organizations as neutral sites where students from different ethnic backgrounds could be brought together in learning situations. . . . The Arts Council of Oklahoma City was in its earliest stages, but its representatives had a strong desire to play a catalytic role between the cultural organizations and the school district. . . . this is the first instance, to our knowledge, in which an arts council has developed a successful approach to the coordination of services of arts organizations for their most effective use by the school system.[27]

Young Audiences, Inc. was one of the first organized groups to place artists in the schools. Others include the Contemporary Music Project, involving composers, and other programs involving college and university personnel and individual artists. Young Audiences, Inc. started in the early 1950s with a philosophical conviction that music could somehow be conveyed better in small groups in intimate settings. The settings at first were in living rooms, as was the first national office in New York—that of

Rosalie Levintritt. There the finest of musicians would cross-fertilize ideas about music and children and settings. Young Audiences, Inc. today has more than 37 local chapters in 24 states, and its programming extends far beyond music into other art forms. The dimension of programming has expanded beyond a single event, and the style and methodology has changed with the times. The settings are no longer only schools. In the most effective local chapters, the one-shot performances have gradually been replaced with sequential performances and classroom visits, which provide a depth of experience and freer interaction between artist and audience.

The Young Audiences' auditioning process seeks "artists of professional performing ability as well as creative skills in presenting programs." In 1980 there were over 1,500 artists employed in a program reaching 2.5 million children in 5,200 schools. More than 12,000 performances and residency workshops are given each year.

The support systems of the state departments of education, the state education associations, and the Alliance of Arts Education have been critical to the success of many of the school programs reported here. One other important support organization has been the Musicians Performing Trust Fund, which has been the backbone of most local music programming. Arts councils on the state level have been significantly involved in the arts and education in multiple ways. Their relationship with Endowment programs relating to education is the most significant; a review of the programs emphasized their importance in working with community programs. But more than that, within the separate states some councils have had a strong relationship to the state departments of education, the state education associations, and the AAE. The nature and strength of this relationship varies widely, but where it is best, as in Oklahoma, North Carolina, and Michigan, it has spawned programming that is also strong.

Community arts councils, on the other hand, have not reported a significant relationship with the state education institutions by and large. Exceptions exist,* but arts councils have not been the catalysts for educational change that they conceivably could be. However, when the Office of Education's 1979 regulations included the possibility of funding to community groups in coordination with school systems, there seemed to be recognition on everyone's part — arts councils and state departments — of the potential role of councils in this network.

The issue of who is going to pay for an arts-in-education program is only resolved when a school system, acknowledging that the arts are indeed as integral as any other area of curriculum, considers them basic.

*The Westchester Council on the Arts (Westchester County, New York) is an example of a community organization that has been involved in comprehensive planning with the area school systems, and its program interfaces with the state education agency.

Two examples stand out among several of the few who have done this. The Montgomery County public schools in Rockville, Maryland, stimulated by curriculum revision, developed a whole portion "geared to fit an aesthetic mode." Aesthetic expression is, along with physical development, intellectual development, scientific understanding, and career development, spelled out as a goal of this school system. In the year examined, of the $300,000-plus budget for the program, only $10,000 came from the outside. The system has been dealing with minimum competence in the arts, such as it requires in English, math, and social studies.

In Seattle, before 1974, there was a very traditional art and music program. After much discussion and planning, and working with all the local, state, and national resources possible, Seattle emerged as a story of an 180-degree turnaround. Through the combined interests of the Junior League, the Seattle Arts Commission, the State Department of Public Instruction, and the Office of Education through the Kennedy Center Education Programs and the JDR 3rd Fund, the professional leadership in this system has been given the support needed to be able to propose that all children in all of the school system be "wholly educated." In looking at what children should know in the arts, and who should teach it, one present professional endeavor is to clarify for teachers and artists what teachers should be teaching and what artists should be contributing to education in a planning guide that teachers can work from.

> Student and teacher attendance have both increased since the beginning of Seattle's Arts in the Schools program. . . . Principals and teachers have said that when students are turned on to the arts, it changes their attitude about school as well as their ability to be successful achievers.[28]

> In Seattle as well as [elsewhere] . . . pilot projects have explored the role of the arts in education. Though the strategies and emphases of the various programs have differed because of local strengths and needs, the basic goal has been:
> "To improve the quality of education for all children, by making the arts an integral part of the basic curriculum through specialist, interdisciplinary, and community programs."
> The most successful of these projects have involved administration, teachers, and parents in planning arts programs related to ongoing educational priorities, and have developed new, mutually beneficial working relationships with professional artists and other community arts resources. Through in-service [sessions], artists-in-residence, all-school projects, arts resource centers, and model programs, an attempt has been made to define and practice learning *in* the arts (specialist programs), *through* the arts (interdisciplinary approaches), and *about* the arts (cultural and professional roles of artists and arts organizations). . . .
> [In order to accomplish these programs,] a clear statement of the objectives

for each arts discipline in terms of the knowledge and sequential skills to be learned, [has been needed] so that every teacher, including those not directly involved in teaching arts subjects, can know of and understand the overall objectives for students. . . .

The Instructional Framework [a project of Seattle] is an attempt to create [a] foundation block for arts in education, to provide a planning tool for teachers which can lead to a comprehensive program [with] . . . student objectives, level indicators, and measurable examples . . . for each of six arts disciplines (music, dance, drama, visual arts, literary arts, and media). . . . The arts process components of *perceiving, responding, understanding, developing skills, creating,* and *evaluating* are continually evolving in a circular effect as students are exposed to a wide variety of arts experiences.[29]

This work, initiated by the school system, is all too rare. Such professional work will provide guidelines that can be helpful to other systems.

It is not that in Seattle there haven't been hurdles all the way. CETA funds made it possible for the Arts Commission to provide community resources. Through planning and a demonstration project, Arts for Learning was the beginning of the exploration of the way in which the arts could become an integral part of the school program.

The intention was to develop a strong community/school arts partnership. . . . CETA artists (100) in the schools have had a great deal to do with the new relationship of arts and learning. . . . they have proved to be very independent, competent, reliable and exceptionally qualified people who have really worked out well. . . . Some schools have found funds on their own to rehire them when CETA contracts ran out. One was hired to be the arts resource coordinator, and as part of her charge has been writing a curriculum incorporating all of the activities of artists working with special education students.[30]

The state's Cultural Enrichment program, a 12-year-old, $1,501,000 program that has supported professional arts experiences for children in both urban and rural schools, has been in jeopardy in spite of the fact that it was a nationally recognized pioneering program of state support. As in many other states, there are financial difficulties in Washington, reflected in funding for the schools and also for the arts.[31]

Thus there remains the need for an advocacy that can be articulate about the need for the inclusion of the arts in basic education and for solid funding to implement it. Meanwhile, groups like the Alliance for Arts Education continue to bring together the "potent forces for the development and advancement of arts education nationwide" (as in the 1979 meeting of the leaders of the state Alliance for Arts Education committees and the chief state school officers) and to develop state and regional networks.

Arts, Education and Americans, an organization emerging out of the work on the report *Coming to Our Senses*, pledged to make itself "a vital instrument of change and model of collaboration in the field." It has developed approaches to advocacy for arts in education and has focused on educators, school board members, artists, arts administrators, parents, and legislators — those who together can establish the arts as essential to the education of every child. It is now disseminating information through a national information center at the Education Facilities Laboratory.

The programs mentioned here are only a few of those that have been involved in programming over the past years. The success stories exist in communities of all sizes and shapes, rural and urban, yet "the typical school district in this country spends less than 2 percent of its total annual budget on arts programs."[32]

In 1979, Vince Lindstrom, then Special Counsel for Arts and Education to the National Endowment for the Arts and the U.S. Office of Education, summarized his work when he said:

> I am really amazed how many people are committed to the importance of the arts in education. The problem is not building a case for the arts and their place in education, but rather to get all of the programs and people going in the same direction. That can only happen with good communication bridges. In that way the concept of the new position between the two agencies has proved successful.[33]

In some respects, he summarized the critical need for communication among all who have a role in the arts-in-education picture.

Education is an ongoing process. It is a proven reality that the quality of what we do when children are young affects adult behavior; arts in education in the schools are a necessity. It is a beginning, and if there is no beginning at those early ages, a lot of catching up must be done, and a very wide gap must be bridged. There are too many places where there is no beginning at school ages, where programs in the arts start in seventh grade and end in seventh grade except for the few students actively involved as performers or artists. And if the beginning is spotty or badly thought out, overcoming the effects may be even more problematic. One sentence in the report *The Humanities in American Life* sums it up: "Students are ill-served if their education excludes the arts and humanities, which contribute in important ways to skills, personal fulfillment, and participation in the life of the community."[34] If the value system and behavioral patterns are not in place by adult life, the chances are that the remodeling is a renovation project that must be done with some care.

Ruth Glick, founder and former Director of the Institute for Retirement Studies, Case Western Reserve University, discusses the relationship

of education to the behavior of older Americans in relationship to cultural opportunity:

> One unequivocal finding about education in later life was the existence of a direct relationship between the amount of previous education in earlier life and the extent to which it would be sought in later life. Not *valued*, but sought. It was valued very much . . . But . . . it was revealed that many older people with very skimpy educational backgrounds, [when] asked to indicate what kinds of things they wanted to learn, gave basic education their lowest priority. As for the arts, they were not even on the agenda.
>
> So it was the middle class, already at home in cultural settings (whether formally educated in college or not), who availed themselves of the opportunity to enter into the life of community arts very fully . . . the institutions became more hospitable as the decade advanced and funding for community arts was made available. The new participants and partakers, gray-haired and gray-bearded, were perceived usually correctly as the old participants grown older. . . . In short, older people are welcome if they can get to the programs on their own, if they can study or perform adequately by themselves or in a group, and if they can pay if necessary. As a matter of fact, "Discounts for Students and Seniors" is a commonplace sign outside many box offices and all seniors — poor, rich, and medium-poor — are eligible.
>
> Still totally absent from the arts scene was a large portion of the older population which was not educated, whose exposure to symphony concerts and museums, the theater and ballet, had been nil and to whose value system these were foreign. Many, but not all, were poor, but all were needy in other ways. It is these elderly people who constitute the clientele of the Senior Centers (in some places still called Golden Age Centers), the nutrition sites and the retirement homes. . . . It was not exclusively in behalf of this segment of the older population, but certainly with a keen awareness of their circumstances, that the earlier mentioned effort was undertaken in 1973 by the National Council on the Aging to invite and encourage decision makers in the aging agencies, and artists, arts educators, and arts administrators, to come together to work out a partnership.[35]

If adult life is a constant catching-up process, it takes special effort — probably related to leisure time — and requires looking at a great deal of art, listening to music, hearing and seeing opera and theater, reading literature, and the like. Some people have been involved in this kind of process in recent years, with some success. They are, by and large, the population that swells the audience figures and has caused "the renaissance of the arts." This catching up is done in many ways — travel and selective television among them. The bank of images, visual and aural, creates the ability to progress to new understandings. The acceptance of the color system of a Matisse, popularized in clothing and decor, has caused people to accept the popularization and the art itself, and to pass beyond it.

But there is another population for whom there is too little we can do — the culturally and financially impoverished; we have not started them off well from the beginning, nor nurtured their needs as adults. The one place there is a chance is in the public education programs. The outreach programs are eclectic and could do more if there were beginnings long before these experiences.

There is still another problem affecting most Americans without access to the arts on an ongoing basis: growth and development. Growth and development of taste — the world of enjoyment beyond the *Nutcracker* ballet. Testing new areas is problematic for those on tentative grounds. So modern dance for some, abstract art for others, and nudes as subject matter for still others remain barriers for too many, even though the first two have existed for almost 80 years, and the last has been with us since the inception of cultural history. Only if these areas are tackled early enough, and with sureness of process and the progressive development of skills pointed to lifetime perception goals, would we ever succeed. For these are the tools for the development of judgment, taste, and dimension, *and* the demand for quality.

It is curious when polls, such as the 1980 Harris *Americans and the Arts* series, tells us that Americans now "value" the arts in education. This "valuing" may be related to their "awakening to their values." It has not translated into action beyond participation in and attendance at arts events. It has not translated into a demand for arts education in the schools, for quality curriculum for everyone, or for vouchers to make it possible for all to attend events.

There has been no real translation of what this "valuing" calls for in the way of support. There should be a support link between those who support the arts institutions themselves and those who generate the next audiences for those institutions. The traditional arts supporters have been supporting arts institutions for all the reasons one supports a civic project — and not always for the art itself. How do we make arts education a part of the value system? Community and arts leaders who are also parents must see that link. The schools must do it as vigorously as they do other things.

Arts councils, concerned with the development of awareness and audiences, as well as new and future advocates, are in the position to do the following:

- Become the link between the arts supporter and the need for support for school arts budgets. They are as important as budgets for arts organizations.
- Become the link between the community and the institutions of learning. School administrators and teachers in elementary schools and in the nonarts secondary school disciplines need to feel comfortable with, to be educated about, and to value the arts as they do

the other basic subjects. This will include a better grasp of their role in relationship to the art teachers and visiting artists and the way in which they relate.

- Become a link between the community and the state department of education so that state laws affecting the arts can be reviewed and relevant ones considered and enacted.
- Become a link between the artist and the school system in more concentrated and substantial ways, so that there is an educational impact consistent with ongoing basic humanistic educational goals.
- Become the link between the work and the behavior — that is, to clarify the issues and processes for those who wish to advocate or participate in the arts but have no clear picture how to proceed. (Every child has a parent who is a potential advocate!)

These foci should be included in the arts council challenges of the 1980s.

NOTES

1. Interview with Charles C. Mark, 1980.
2. Interview with James Backus, May 1980.
3. James Backas, "The State Arts Council Movement" (background paper for the National Endowment for the Arts National Partnership Meeting, June 23-25, 1980), p. 19.
4. Ross Altman, "Creativity is Ageless" (brochure relating highlights of an arts program for older adults, San Fernando Valley Arts Council, 1980).
5. Letter from Duane Truex to Nina Gibans (July 14, 1980).
6. Milton Meltzer, *Violins and Shovels* (New York: Delacorte Press, 1976), p. 22.
7. Milton W. Brown, "New Deal Art Projects: Boondoggle or Bargain?" *Art News*, April 1982, p. 87.
8. Great Lakes Performing Artist Associates, Ann Arbor, Michigan, "What You've Always Wanted to Know about Advancing Your Career, but Had No One to Ask."
9. Harld Taylor, "The Transformation of the Schools," in *The Arts and the Gifted: Proceedings from the National Conference on Arts and Humanities/Gifted and Talented* (Reston, Va.: Council for Exceptional Children, 1975), p. 26.
10. Gene C. Wenner, "Arts-in-Education Program," in *Dance in the Schools: A New Movement in Eduation* (National Endowment for the Arts and the U.S. Office of Education, 1973) p. 3. (Description of use of dance in schools as developed through the Dance Component of the Artist in Schools program of the Endowment and the Office of Education.)
11. Junius Eddy, "Toward Coordinated Federal Policies for Support of Arts Education" (position paper of the Alliance for Arts Education, with the assistance of the National Arts Education Adivsory Panel, 1977), pp. 3-4.
12. Ibid., pp. 12-16.
13. Ibid., p. 17.
14. Columbus City School District, Department of Evaluation, Research and Planning, *Arts Impact* (Columbus, Ohio: Author, 1974), p. 5.
15. Ibid., p. 7.

16. Kathryn Bloom, "A Decade of Change," in *Arts in Education: A New Movement* (New York: Georgian Press, 1977), pp. 12–13.

17. *NACAA Newsletter*, February 15, 1981, p. 2.

18. Bloom, "A Decade of Change," pp. 13–14.

19. Ibid.

20. Ibid.

21. Charles B. Fowler, ed., *An Arts-in-Education Source Book: A View from the JDR 3rd Fund* (New York: JDR 3rd Fund, 1980), pp. 16–20.

22. Ibid., p. 18.

23. Ibid., p. 121.

24. Ibid., p. 124.

25. Ibid., p. 126.

26. Bennett Reimer, "Education for Aesthetic Awareness: The Cleveland Area Project," *Music Educator's Journal*, February 1978, p. 67.

27. Bloom, "A Decade of Change," p. 45.

28. Margaret B. Howard, "The Arts Are Basic: Have We Come to our Senses?" (keynote speech at the National Guild of Community Schools of the Arts, St. Louis, Mo., October 29, 1979), pp. 22–23.

29. Carolyn Anderson, *An Instructional Framework for the Arts in Education*, (draft — "Strengths Assessment Component," Title IV-9, Seattle School District, 1980). This basic philosophy comes from the arts education work of Charles B. Fowler.

30. Seattle Arts Commission, "Artists in Education," *Seattle Arts*, April 1978, p. 1.

31. Walter C. Wilson, "CEP May be Wiped Out," *Northwest Arts*, February 6, 1981, p. 8; also, 1981 and 1982 issues of *The Arts*, newsletter of the King County Arts Commission, Seattle, Washington.

32. Arts Education and Americans, Inc., "Something's Missing" (brochure, 1979).

33. Vince Lindstrom, "Priorities for the Year Ahead," in *Summit Conference on the Arts and Education: A Report* (Washington, D.C.: Alliance for Arts Education, 1980), p. 17.

34. Commission on the Humanities, *The Humanities in American Life* (Berkeley: University of California Press, 1980), p. 37.

35. Ruth Glick, "The Arts and Older Americans: A Progress Report" (paper prepared for the Symposium on the Arts, the Humanities, and Older Americans, Philadelphia, February 1–3, 1981), pp. 6–7.

21

On Images

EVALUATION AND THE PLACE
OF THE ARTS COUNCIL

"Turf" has many characteristics. Age is one; size is another; money is still another. Power is the intangible mixture of the three. Sharing is not a natural characteristic of those who have nurtured and developed a piece of the arts world with individual wealth and energy. The last 15 years, as everyone knows, have been marked by a phenomenal growth and development of arts organizations, artists, and audiences. "The number of opera companies has doubled; orchestras have tripled; dance and theater fields report tenfold increases; the artist workforce has doubled; and audiences [have] tripled."[1] With this kind of proliferation, representing intense and widespread interest and energy, the territorial rights of those who came first may no longer hold. The varieties of funding needed to keep any operation afloat means that everyone needs everyone else's support to survive.

Turf is a psychological and philosophical concept. If one is territorial, then one owns something. There is a sense of security if one doesn't know or have to be concerned about the wider community. It is comfortable to be in command, to make decisions, to "know" values. Opinions are not as worthwhile as decisions. "I know because I know."

The Rockefeller Panel report of the 1960s described arts councils as emulating the cooperative movements in health and welfare—

stimulating practical cooperation among the arts organizations and focusing community attention on their activities, while at the same time preserving the artistic independence of each institution. . . . There are hazards in the operation of an arts council, largely those of bureaucracy, but these can be avoided if the leadership has sufficient experience and high quality. Councils provide important services that are often missing or when available are needlessly duplicated by individual organizations: central clerical and promotional services for members, professional leadership for fundraising, publication . . . advice . . . and provision of management counseling services.[2]

The range of basic services described then still holds today; what wasn't envisioned was the extent of the burgeoning of new arts organizations. In another section, the report notes,

As the rise of new facilities encourages hope, so does the rise of other forms of cooperation between arts organizations. If arts councils in cities and states can focus attention on common problems and bring the representation of various art forms together to help solve them, then it is possible to hope that these efforts can be expanded to embrace regional and national cooperative efforts.[3]

The philosophical agenda likewise holds today. What wasn't envisioned was that with the burgeoning of arts organizations, the group with common problems was to be enlarged very quickly. The arts community has grown; it is not the community of the report.*

With only about 100 arts councils in existence at that time, it meant that the coordinators were going to develop as organizations at the same time as the many groups they were to coordinate. It also meant that one of the first priorities of these councils was going to be that of being sensitive to the tradition, roles, and pride of individual leaders and patrons and the established organizations. The concept of sharing was new in the arts, and the organization developing to make it work was new as well. Trust and respect, basic to acceptance, take time to become established. There were and always will be subtle and outright fears undulating through assurances that the "turf" is to be protected, but the common interests have to be recognized. This is an ongoing concern needing continuing attention.

John D. Rockefeller III said in the same report, "Only have we begun to recognize the arts as a community concern to be placed alongside our long-accepted responsibilities for libraries, museums, hospitals and schools."[4] And the report added,

*The report's purpose was to "present a thoughtful assessment of the place of the performing arts in our national life," which it did. There had already been increased arts activity in the 1950s and 1960s, as has been noted in the early chapters of this book.

The panel is motivated by the conviction that the arts are not for a privileged few but for the many, that their place is not on the periphery of society but at its center, that they are not just a form of recreation but are of central importance to our well-being and happiness. In the panel's view, this status will not be widely achieved unless artistic excellence is the constant goal of every artist and every arts organization, and mediocrity is recognized as the ever-present enemy of true progress in the development of the arts.[5]

The arts community has several types of institutions, although some may have attributes of more than one type.

1. Professional arts organizations of all sizes whose purposes may include maintaining a facility for the exhibit of art or performances by a company based there. These institutions are primarily interested in the highest professional quality. Age is irrelevant, except that it does take several years to mold an ensemble and/or to establish a stable and substantial support system (necessary to attain the highest professional aspirations).

2. Organizations in all art forms *whose main purposes* are to allow people to participate in the arts. They are professionally administered; the process *and* the product are equally important. Those participating have *chosen* to pursue the arts as avocation. Others may participate for reasons having to do with therapy, self-development, and enjoyment.

3. The artist. The artist is the most important component of the arts community. While the community's professional artists are grouped for dance, music, and theater, and composers, playwrights, and choreographers need the ensemble performance to complete the intent of the work, there are others in visual arts and literature whose efforts are individual — from creation to exhibition or performance.

4. Arts service organizations. They may serve the entire community (arts councils); the arts community or a segment of it (most united arts funds or alliances); or a specific segment (poets' and writers' groups, visual arts organizations, United Labor Agency arts committees). In addition, in some communities separate nonprofit groups may deliver services, such as a ticket voucher system or volunteer law, accounting, and business advice for the arts. (In some cities, the arts council might deliver these services.)

5. Colleges and universities, historical societies, libraries, and the like that carry arts and cultural programming as part of their activities (using professional artists).

6. Nonarts or cultural institutions with arts programs, which are dependent on professional artists and work with specific age groups

or with a special constituency in mental and physical health. In the smallest towns, it has often been the arts council's role to import what isn't indigenous, whether it is a professional performing arts group or an individual artist-in-residence.

Transcending any single community are those exhibiting and performing arts organizations with national scope, such as Young Audiences, Inc., Affiliate Artists, Inc., and HAI, as well as museums, orchestras, and dance and opera companies with national or international reputations. Still other unique organizations of any size may bring special prominence to the community in which they are located.

If the leaders of all of these components have not gotten to know each other well enough, how can the arts organizations themselves understand the breadth of what is now part of their own community? If the arts council has not taken on the tasks of coordinator and catalyst (which are far more complex today than they were when the Rockefeller report was written) with strong and professional community leadership, then it has failed to live up to its potential.

The arts council can be the neutral ground, the ombudsman, the advocate, the forum, and the professional community planner and organizer in the arts. This does not happen alone, but by a process that is understood as "community process" in other professions.

The arts council, if it is working well, will act behind the scenes on everyone's behalf, and there will be no such thing as arts council "turf"; but if those for whom it has raised awareness, coordinated efforts, and acted as a link between such segments as labor, business, and government, do not understand the value of this service, there are problems. Few arts council leaders from the community have been articulate enough about this. It is perhaps more difficult to communicate this than to emphasize the value of museums or individual performing companies and ensembles, but it needs a voice in the individual communities and at the state and national levels.

There is a professional attitude about service, support, presenting, or whatever roles the council is playing, that can be communicated. But it must be valued, and that can only happen if those who esteem the highest products of the professional organizations also understand the values of community arts and artists. There is the business of outreach and community process, and it is a business different from curating or managing orchestras and galleries. There is no such thing as "the arts as a community concern" without it.

Community process does not stop with the process of collecting ideas. Someone with leadership and background must gather the information and give it design and professional management. Just as an artistic director molds a company or plans the way an orchestra piece will sound, so the arts

council professional must assure high goals for community programs and methods for reaching them.

Arts councils attempt to do some of these things, but arts council leaders, new to their jobs and trying to keep up with the pace of the field, have had a difficult time setting professional standards. Council boards are unsure — following instead of leading. So the professionals, new as they are, have been the spokespersons for the field.

Is it of greater importance to make it possible to bring the Joffrey and Martha Graham companies to rural Kansas, or to develop top ballet in Philadelphia? Is it of greater importance to write a fine percent for art in public works law, or to listen to the finest symphony concert? Is it of greater importance to come to some realistic long-range organizational plans, or to see a fine regional professional theater production? Is it of greater importance to come to some allocations decisions based on high standards of administrative responsibility and accessibility, or to be able to see the finest paintings in our cultural heritage? The answer is, of course, that all are important. However, the importance of the service work related to processes is less easy to see and less concrete. The goals are not of lesser importance to the community's future.

The arts council is the only organization whose *priority* it can be to look at these issues with the community. It must be done without stepping on toes or duplicating the work of any of the arts groups; it can become *the* area of greatest council expertise.

If the process is professionally and totally executed, the turf and dollar issues are diminished; polarized attitudes have no relevance, because all philosophies are essential elements in the development of the community's cultural policy. The major institutions would receive the largest allocations; judicious smaller grants would complement, rather than compete with, these institutions. Community priorities would be clear.[6]

The inherent mythologies about quality infiltrate the area of turf and dollars. In the past, arts organizations were entirely controlled by the private sector. That group, which represented corporate and individual civic and cultural leadership, gave hard, worked hard, and by and large controlled the destiny of the organization. Today, that leadership is very important, although it is only part of the picture. But it remains the core needed for the survival of any private nonprofit group, including many arts councils.

However, there are the public aspects of arts life today. These have to do with democratic process, outreach, and access. They have to do with considering many varieties of art forms. It is disquieting to those who wish to be left alone with the masterpieces of the past and the value systems related only to the bigger and/or older institutions. This dilemma lies at the crux of support for the arts.

There is not much question of the value of most of the major institutions that comprise our historic cultural heritage. The artistic vision is disseminated through their work in a unique way and is the major way in which the history of our culture survives. If they are large and important enough, their staffs are large and generally efficient. They all need money. The arts council can assist in the search for the new dollars and new opportunities for the arts as a priority.

Arts councils can become more useful even to the largest organizations in the area of public support by helping to create a unified advocacy. They are useful in developing an information base on such things as the community economy and its relationship to the arts. They can coordinate the flow of information, and in the future accomplish this in new and sophisticated ways using computer technology. They can bring lower-echelon staff members of the major organizations together to share expertise and information.

The arts council has, through processes for the distribution of dollars — whether public (as in CityArts or grassroots programs) or private (as in united arts funds) — caused criteria to be developed for allocations purposes, usually through committees or panels. "Criteria" means coordination and standards. In addition, their attempt has been to develop the best processes possible and to coordinate them professionally. Such methodologies have been new to the arts world; the models exist primarily in the United Ways.

The problem has been in supporting these council services. They are taken for granted. One successful arts council, which over the past few years has mounted a successful bond issue for a downtown center restoration and has mounted an increasingly successful united fund campaign for the arts, bemoans the fact that the arts council group is still understaffed and remains at the same budget level. Services do cost money and must be paid for somehow.

Though the visibility for the agency may not be extremely high, the arts council is becoming a community resource and is called upon to advise and assist in activities related to the arts, whether it is a private or public agency and whether the town is rural and small or large and urban.

Coordinating efforts and sharing human, cultural, and financial resources are important everywhere, but may be especially important for rural areas. Greater organization and cooperation may be the stimulus for greater dollars and for such inevitable results as a greater volunteer force, better private and public support, and ultimately greater visibility.[7] The Chautauqua County Association for the Arts is a good example of these philosophies at work, as it spans the multiple and wide-ranging interests and geography of one county in New York State.

The potential for greater community awareness of the arts awaits the

full development of cable TV in both rural and urban settings. Arts councils in some communities see this as an important part of their future agendas. The development of high-quality local programming is important, but is something not yet really envisioned by many communities. Well done, it will require the same community organizational skills as most other arts council endeavors do. The arts council will perhaps see a role in enhancing the cooperative and coordinating efforts through this medium in the future; they may sponsor and produce community planning sessions, as well as promotional, interpretive, and educational programs. There is also the need to investigate the costs of cooperative and shared ventures among arts organizations and the ways to make use of the potential and special nature of this medium.

In the franchise negotiation stages, the arts council's interests might be in areas of shared arts organization needs, such as those identified in the position statement for "Arts Channel, Arts Programming, and Institutional Network Use" by the Fairfax County (Virginia) Council of the Arts, Inc., requesting a specific channel reserved for cultural programming of local and national origin.

The cooperative efforts envisioned by the Rockefeller Panel report are still cogent and could embrace new problems common to arts organizations. This would probably not be possible unless councils have assisted in solving some basic economic problems for the arts first and have healthy and respected places in their communities as a valued resource.

THE ARTS AND THE TOTAL COMMUNITY

The country is littered with community arts councils (somewhere between 1,000 and 2,500 at last count). But probably if a thousand of those were swept away tomorrow, the truth is nobody would notice because many of them don't live up to their potential. The reason they don't live up to their potential is because they are weak organizations.[8]

A synthesis of the opinions of many observers indicates that arts councils of the future must understand their own functions and strengths, must understand what the arts mean in the total community, and must be strong enough to bring the total community together.

What is a total community project? Perhaps a festival that unifies "families, businessmen and women, teen centers, housing projects, the elderly, universities, and ethnic and neighborhood groups in a series of celebrations which culminates in a grand finale and the ringing of church bells calling everyone together."[9] In other words, such a project brings the various segments of the community together — the old families, the new corporate leadership, and government officials.

What does it take? It takes the right people at the right time — individuals and teams who can represent a responsible and imaginative leadership, who have gained the confidence of the mayor, city manager, or council (public officials) and the private and corporate leadership. The festival may be the catalyst for unity; or it may be a united arts appeal, a fundraiser for a new center, or an effort toward the recycling of historic buildings and downtown revitalizations through the arts. It may be a place for making more subtle statements about artists and the place of the arts in our lives through such projects as Arts on the Line (Cambridge, Massachusetts) and Earthworks (King County, Washington), or about the concern for pragmatic and aesthetic human services to neighborhoods and all of the minorities, wherever they live and whatever their needs. The objective may be the distribution of public funds, or the establishment of a voucher program — a dynamic service to arts organizations and people.

Whether it's the Cambridge Arts Council's programs or the Galveston County Cultural Arts Council's success in the development of an art center as a much-needed professional resource (and a productive reuse for the historic First National Bank building and the revitalization of the Strand District), the story behind the story is the same — leadership, and the arts in and for the total community.

The fabric of the communities will differ, but whether they have 1,500, 20,000 or 800,000 people, the issues concerning human and physical resources, turf and dollars, economics and value systems usually exist. Understanding the limitations and potential is the job of the local community council. Failing to make an accurate assessment and to act accordingly probably is the principal reason for the failure of many councils.

Some specific questions that councils should ask themselves are:

- Human resources: What is the caliber of individual and group community leadership and artistic talent (indigenous)? What levels of participation are possible from the nonarts parts of the community?
- Physical resources: Where are the facilities? What is the competition for their use? How limiting are they? Who owns them? There is a symbiotic relationship; the answers will vary according to the community.

What are community values? Arts councils can be one agent of change. For in this process of thinking and assessing and involving, new ideas and approaches may surface that address much more than the arts.

The festival in Cambridge is not a one-shot program; its permanent imprint can be felt in the community far beyond the annual week of events. The cultural centers in many cities have spurred building in the arts community far beyond the physical plants. The cultural organizations them-

selves, if they are building a supportive and nurturing context, will flourish together.

> With collaborative action and mutual self-interest, cultural organizations can make order out of chaos, communicate their importance to the broader community, and be activists on their own behalf. Taken as a "community," cultural organizations are very powerful indeed.[10]

And now that legislators have decided that it is all right to support the arts, arts councils can assist in getting beyond the words to the definitions of goals and can focus on the ways to achieve them. There will be no excuse for not recognizing that such programs as artist unemployment programs cannot be couched as something else. Buildings are just that if there is no money to keep them open.

Historically, some National Endowment for the Arts federal programs have given us some of the incentives and tools to look at the total community. National Endowment for the Art's City Spirit program urged communities to plan together — to know who they are, what they are, and what they want to be. Not only have the Expansion Arts programs caused us to expand our definitions of the arts to include the smaller organizations, minority groups, and such arts forms as jazz, crafts, and folk; but the City-Arts program, which gave incentive for local public monies to support them, made us evaluate the contributions and quality of our own local groups and helped us define a process for assisting them.[11]

Arts councils have not done their share in conveying the message well. Articulation needs to be given to the values of "lifelong" learning in the arts, of the "social services" and to the newer artist-in-residence programs. The council view has not been represented well on local boards of trustees nor on such groups as the National Council on the Arts. There is no leadership, only a few leaders.

Yet, of all the existing cultural organizations, the community arts council has tried more than any other group to consider the interests of the total community in its efforts. But such consideration requires even better planning. Until there is support for highly complex decision making and prioritizing of problems, no council can decide what to do about issues like these:

- Whether it is in the community's best interest to apply for funds from HUD, HEW, or the Endowment; to float bond issues; to levy taxes; or to get behind the generation of revenues from hotel/motel taxes or oil rig revenues.
- Whether to be a direct-service council for presenting, managing, and programming, or an alliance that serves the arts organizations only.

- Whether it is in the community's best interest to be a catalyst for an examination of urban design issues (adaptive reuse of buildings, uses of waterfronts, new land use, neighborhood conservation, or downtown revitalization).
- Whether to be of assistance in relating the arts to tourism and the image of the city.
- Whether to improve community opportunities to those who are underserved.

The fact is that arts councils in many places are being bypassed in such considerations because of their weak leadership; others far less interested in the arts and the community are involved in "using the arts" for other ends.

One characteristic of today's councils may be that they are moving from the priorities described in this book, for many are reassessing and evaluating where they have been and where they are going. This should be continuous and part of their own operational process; we may hope that it is not just being done in crisis situations.

Just as performing groups look at quality of performances or number and makeup of audiences (same, new, old, asleep), arts councils must address criteria for self-evaluation. The facts and figures must be clear; the checks and balances must be understood; the strengths and weaknesses must be discussed. There is not an organization in existence that has no weaknesses, and identifying them is only the first step to progress.

Evaluation needs to come from several sources in order to be complete; otherwise, it is always opinion and conjecture. The organization itself should conduct its own evaluation, involving those from the inside, those from the outside who affect and are affected by the organization, and an objective source who can gather information without a bias.

Some believe that the results of such activity may be even more precisely on target and appropriate to the 1980s as others might have been to the needs of the 1970s.

THE IMAGE OF THE ARTS

In 1980, it had been more than five years since the last ACA survey of the American public's attitudes toward the arts.[12] The 1980 survey, conducted by the Louis Harris group, shows a sharp rise in arts attendance and greater support for the importance of the arts in education and in a full community life. The last part of the 1970s would also be the time when the greatest impact of the arts council movement would have been felt around the country.

While the Harris studies have probably been among the most often quoted documents to create a succinct and clear backup for the articulation

everyone has tried to give the importance of the arts in their communities, the arts councils may have been among those to quote them most. The role of community arts councils during this time in creating the differences in the statistics must be discussed. They have worked behind the scenes to support the arts through providing directories of the organizations and direct telephone lines that inform the public about the arts events schedules; through highlighting the work of the arts organizations on radio and television; through coordinating calendars; and also through being major voices in behalf of individual artists. They have created, in multiple ways, the image that the arts are important in *this* community (whichever one it may be). The increase in audiences per se in individual instances (dance, theater, opera, etc.) is not connected with the subliminal effects of these efforts in a one-to-one relationship, but the efforts have created the image that the arts are important community opportunities and experiences. In tandem with the power of media — TV in particular — and the updated marketing efforts of the individual arts organizations, the message is powerful.

Other activities of arts councils, such as coalescing ideas and people around the needs in the arts, come into some focus and importance. By developing a context for business leadership, either in terms of formal fundraising or less formal business committees for the arts, the arts councils in many communities have opened the eyes of their corporate leadership to the breadth of the local arts scene, and also to its problems and needs. They have added a broader civic involvement to the civic roles these leaders have often played on boards of health and welfare agencies and single-discipline groups such as symphony orchestras. Many councils have sponsored business and art symposiums to create a "more positive climate for broadening support of the arts; to create a greater sense of mutual responsibility among business, government and the arts; and to ultimately improve the quality of cultural life in our community."[13] While many such events have been sponsored in part by the national Business Committee for the Arts, which may have been a stimulus for such local activity, many have been sponsored by the local councils themselves. Efforts to create local business committees have been a desire and priority of many community councils.

The United Labor Agency Cultural Arts Committee in Cleveland has an ongoing program for its own clientele that is multiple and complex. Leaders in this program gained their initial confidence and contacts in the arts as board members of the Cleveland Area Arts Council. The same can be said for the lawyers involved in Volunteer Lawyers for the Arts, or accountants in the Accountants for the Arts, or the statewide citizens' committee that created the new advocacy and assistance roles for citizens interested in participating.

Paul H. Elicker, President of SCM Corporation, has said,

> It's important . . . that we become known by more and more people. . . .
> By associating ourselves with great works of art to the public . . . [we hope]
> that a little of that prestige and favorable association may rub off on our com-
> pany.[14]

Elicker was brought in to speak to the corporate community by the arts
council.

The work of the united fund alliance groups or councils in promoting
partnership programs between corporations and the arts and benefits such
as matching employee-employer memberships, backstage tours for em-
ployees, company nights at the theater, art exhibits at company offices,
and lunches at the arts center for business employees (tabs picked up by
their chief executive officer) has been successful. In Syracuse, a whole new
participant group takes part in "On My Own Time," in which 16 compa-
nies' employees who also participate in the arts as artists enter a juried ex-
hibit at the Everson Museum of Arts. The reception honoring artists, fami-
lies, and company officials is only the final point. It starts with in-house
exhibits and incentives along the way. Under the Syracuse Cultural Re-
sources Council's guidance, programs like this have been continued or
initiated in at least seven other New York communities, and as far away as
Decatur, Illinois; Des Moines, Iowa; and Tucson, Arizona.

Arts councils have altered the consciousness of the community in re-
gard to the arts in other ways, with the guiding idea being that "the more
people we help, the more advocates we'll have." If arts councils did not ful-
fill that role, many communities would not have newly informed, newly
participating citizens. Indeed, in some small communities, there are no
other arts organizations, and nothing would happen if the councils weren't
around to coordinate events and bring artists and performances into town.

The much-debated CETA programs have meant, in the last few years,
that artists were employed for new services — with the schools, with the el-
derly, and with other special constituents to help them find new dimension
in the programs that often showed no priority for the arts, except with the
most enlightened agencies run by the most tenacious administrators. (En-
dowment research has shown an increase in artist employment in the 1970s
of 46 percent.)[15] Many government officials first saw the arts through these
programs. The arts commissions and councils have been among the greatest
proponents of widening the view of the arts through involving new kinds of
people. Properly, there could be criticism leveled at some of the programs
and some of the ways in which that has been accomplished. But the best of
these efforts have given new dignity and confidence to people who could re-
spond to the new opportunities, and to whom the arts were formerly some-
thing for someone else.

The arts councils have, in many ways, meant survival for the smaller arts agencies. They have "acted as a catalyst for making latent ideas come to fruition and given empathy and direction to individuals and organizations who had given up as to their worth. It's been a real shot in the arm in very concrete ways." They have given them "a chance for life" through a "supermarket of services." As one arts council director has put it, "when you've had an impact, the community starts to look to you for all sorts of things."[16]

There are, as well, few citizen advocacy groups on a local level, and changes cannot occur without them. The arts councils have tried to breach some of the gaps left as citizens, government officials, institutions, artists, and business leaders struggle to understand the total responsibility underlying the wishes outlined in the Harris survey.

Images are very often intangible items. However, when people see the arts in every nook and cranny, the idea gets through. Arts councils have been part of that image building.

The image may be problematic, but only by hearing and seeing many art forms and many levels within art forms can one begin to make one's own value judgments. As has been said, it is the lack of starting early enough with enough exemplars and perceptual training that denies people that ability. People have not really identified what they want exactly; only that they want more—almost as if they have been starved in search for sustenance for the inner self. Many have not yet gained the self-confidence to identify what is *worth* looking at or hearing and for what reasons, or to know how to support such identifications. When potentially inherently good experiences such as superstar concerts or blockbuster exhibits "catch" on, the "star" image draws people, and, if truth be told, some of these events turn out to be less than artistic experiences. This presents a dilemma. On the other hand, some independent-minded persons resist some of the traditional definitions of art; satisfaction does not result from others' telling them that something is worthwhile.

If arts councils can be said to have been one of the most important links with local government that arts organizations have had, then by and large this link with the public sector has been a critical factor in bringing the attention of all citizens to the arts. This includes festivals—the big gathering places for the arts—as well as the city parks, public buildings, neighborhood centers, and civic centers. The arts organizations have not always liked the public service requirements tied to the tax monies received, but their performances in fulfillment of these requirements are part of the positive image for the arts. This is part of the quid pro quo for the orchestras and operas and dance companies who would prefer straight operational support to be sure that every performance is open to all who pay that tax.

The private and public sectors alike are focused on those revitaliza-

tion projects that cause people to find reasons for new gatherings in older downtown buildings. The arts and entertainment will cause them to bring life to the city again. But there is the problem of the health and needs of the individual arts organizations per se (quite apart from the complexes). Arts interests and civic interests have an area of intersection, but clarification is needed.

In the years of research and writing for this book, new trends have been seen that will affect the arts world. Some are brought out by the Harris study. Many indicate the need for volunteer forces and advocacy as never before, and show the trend toward small-town living, which is causing the arts to become an important potential factor there as well. Older Americans are seeking quieter and more satisfying environments for retirement. "Satisfying" includes the availability of cultural opportunities, which previously have been thought of as major city opportunities.

Observations from the Harris study confirm these changes:

1. These first approximations of activity by the American people are harbingers of much more definitive evidence in this study that as the country enters the decade of the 1980s, in a time of economic crunch, when leisure time has been declining, when competition for attracting audiences and participants has rarely been tougher, the arts are the only areas tested where people report an increase rather than a decrease in involvement. This can only mean that the arts are becoming a more vital and integral part of the mainstream of life of the American people. . . .
2. The roster of deterrents to higher attendance at performing arts events reflects the growing pains of a vastly expanded potential audience. It also is indicative of the inability of supply to keep up with the burgeoning demand. . . . But there is no doubt that the arts are confronted by a major challenge of how to meet the substantial growth in demand, while not discouraging potential attenders by less than satisfactory performances, inadequate support facilities, and prices that can cut off major segments of the market.[17]

In doing their part to make the arts more visible, arts councils have had a role in generating new audiences for all arts activities based in institutions of all sizes.

The traditionalists and populists alike have said that they feel the arts are important and a basic ingredient for a life with quality. Each group may have different definitions of these terms. Many, according to the Harris survey, wish to be more than members of a passive audience. They wish to be involved and to be able to point with pride to that involvement; it may be hoped that some will choose to be advocates. May the arts councils of the future help them do that with insight, vision, and confidence in their judgment.

NOTES

1. Ohio Arts Council, *Artspace*, January/February/March 1981, p. 1.

2. Rockefeller Panel, *The Performing Arts: Problems and Prospects* (New York: McGraw-Hill, 1965), pp. 166–67.

3. Ibid., p. 49.

4. Ibid., "Foreword by the Chairman."

5. Ibid., pp. 11–12.

6. Conversation with Ralph Burgard, February 26, 1982.

7. Syd Blackmarr, "Rural Connection," *NACAA Connections*, August 15, 1981.

8. Michael Newton, "The Pros and Cons of United Fundraising for the Arts," in *United Arts Fundraising Manual*, ed. Robert Porter (New York: American Council for the Arts, 1980), p. 6.

9. Pamela Worden, "The Arts: A New Urban Experience," *Challenge*, February 1980, p. 17.

10. *Option for Action* (conference, Metropolitan Cultural Alliance, Boston, December 1978), p. 6.

11. National Endowment for the Arts, *Guide to Programs — 1981* (Washington, D.C.: Author, 1980), p. 25.

12. American Council for the Arts, *Americans and the Arts: I, II, III* (New York: Author, 1975, 1976, 1981). The surveys were conducted by the National Research Center of the Arts, an affiliate of Louis Harris and Associates for Philip Morris, Inc., and the American Council for the Arts under a grant from the National Endowment for the Arts in 1973, 1975, 1980.

13. Greater Columbus Arts Council, "Business and Arts Symposium" (1978).

14. Marcelline Yellin, "Business and the Arts," in *A New Kind of Currency: A National Conference on the Role of the Arts in Urban Economic Development* (Minneapolis: Minneapolis Arts Commission, 1978).

15. National Endowment for the Arts, "More Artists, More Jobs," *Cultural Post*, May/June 1982, p. 19.

16. All the quotes in this paragraph come from interviews with the following arts councils (in this order): Syracuse, New York; Westchester County, New York; Hays, Kansas; Chatauqua, New York; Buffalo, New York; and Lorain County, Ohio.

17. ACA, *Americans and the Arts*, pp. 6 and 15.

Epilogue: The Future

There are two laws discreet, not reconciled;
Law for man and law for thing —
The last builds town and fleet, but it runs wild,
And doth the man unking.

> From Ralph Waldo Emerson, "Ode Inscribed
> to W. H. Channing" (quoted by James Backas
> during interview)

Cognizant of the fact that the American people have asked for some solutions to the nation's economic problems, the tendency is to be supportive in the search for answers. But the cuts to the arts and humanities and other cultural programs, both alone and in the context of other programs concerned with the quality of our community life, promise to be greater than their "fair share."* "The President's recommendations (for the 1983 budgets at $100 million from $143 million) have not only threatened Endowment support, but have begun to erode a decade of modest but important growth in local government's commitment to the arts."[1]

*In early 1982, the Reagan administration was proposing cuts of almost 30 percent from the 1982 actual appropriation level of $143.04 million. The House and Senate were recommending that the level remain at least at the 1982 level, a figure which was shepherded through the legislative process *before* the House had adopted the 1981 Reconciliation Act, which effected a ceil-

Although the most recent estimates show an increase in the amount that the largest cities expended on the arts, inflation and the labor-intensive nature of the arts have caused the arts organizations to retrench in spite of the greater increases. The arts, of course, are not alone, but as someone has said, "if we don't become clamorous enough for that portion which affects one of *our* priorities, no one will."

There is growing evidence that the arts (and other amenities, ranging from clean air and efficient transit systems to community and economic development spurring preservation and conservation) are essential to economic development and social stability, and demand considered long-range solutions. Others ask for the "good fight in behalf of arts professionals," "arts as distinct from arts-as-recreation," "arts as learning experience," or "arts for social change." Many issues, many views.

The response in our communities, where an average of 3 percent of the arts budgets came from the Endowment, 9 percent from other federal sources, and 17 percent from state funds,[2] must be to look within the communities themselves. A considered, intelligent, and contemporary response there will take clear and enlightened leadership. Some leadership could come from the community arts councils.

Arts councils are past the definition stages. They must be a mature resource for information on local, state, and federal issues as well as a resource for what's happening in town. They must extend this to a responsibility for developing a serious and educated advocacy for the arts of the total community, and must find ways of translating what that means. They are the best vehicles for cultural planning and for linking private and public sectors, for assisting small and medium-sized groups, and for creating programs that fill the gaps. The last may differ very widely, because what is desperately needed in one community may be irrelevant in another. Councils have been coordinating efforts of one kind or another in the arts longest on the local level, and have shown many arts organizations and institutions the potential for cooperative ventures. Whether the fact is acknowledged or

ing of $119.3 million. No one had raised a point of order, but technically the Act would be binding, and new authorization action would be required to lift the ceiling in the 1982 round of negotiation. It was noted that if the White House had its way (it looked like it would by June), one-third fewer dollars would be appropriated to the arts than had been appropriated two years before. At the same time, the proposed level of monies to the Department of Defense would indicate an expenditure there of nine National Endowment for the Arts a day. (See "Can the Government Promote Creativity — Or Only Artists?" New York *Times*, April 25, 1982).

By mid-June, the House and Senate votes on the budget for the National Endowment for the Arts for fiscal year 1983 ($100.875 million and $143.04 million, respectively) differed, and a "conference committee" was working on a compromise, which, when agreed upon, had to be voted on and passed by both bodies. (See American Council for the Arts, "Washington Update," *ACA Update*, June 18, 1982, pp. 1–3.)

not, many major institutions possibly never saw the wisdom of combined ef-
forts much before united funding, public incentives, and economic squeezes
made them viable. If mailing lists can be shared, why not a host of other
things? There is a need to keep all groups cognizant of their value to one
another.

In a recent decision, the board of trustees of a young but highly suc-
cessful performing arts organization decided to suspend operations until it
could accomplish the long-range planning process that was needed to as-
sure a solid future. Suspending operations is a difficult decision for an arts
organization in motion, yet sometimes it is very necessary if structural
change, fundraising, and artistic goals are to be achieved.

In one Western city, rapid arts development of the 1970s saw the
number of full-seasoned theater groups (not including community theater)
increase fivefold, but educated guesses indicate that attrition in the 1980s
will leave only three out of five alive at the end of the decade.

Every city has felt the impact of arts growth, most in equally dramatic
ways. The causes and results are multiple and complex, but it is clear and
predictable that there will be leveling as the impact of the federal decisions
takes its toll. This does not mean that the mix of fundraising techniques has
been exhausted, nor that the limits of potential in the private and public
sectors have been reached. It does mean that each community will have to
look at the total complex picture realistically.

There is a mythology about how arts organizations get started and
take hold in a community. Those who have started them or have the re-
sponsibility for keeping them alive know the realities, or learn them very
quickly. To the public out there, decisions seem to be made in mysterious
board rooms by an "in group," but truthfully, they are made through hard
and deliberate long-term commitment — usually several years at least. The
day has passed when a few dedicated people can start a ballet company, a
museum, or even an arts council without the help of an expert group of
trustees, advisors, and professionals for whom this project has priority.
Gone are the immediate endowments and the privacy; the complexities are
enormous.

That means that many people have cared enough over enough time
recently to launch opera groups, performing arts series, artists' service or-
ganizations, film festivals, and many other community and regional organ-
izations. Most of these people were seeing new avenues for community ef-
fort, new needs that had gone unmet. In most cases where there is an arts
council, somewhere in the earliest ferment of planning there were tele-
phone calls and/or meetings — more than likely, many of them, to help and
assist the new groups.

Each organization, large or small, must spark the enthusiasm and in-
terest of some part of the community. There will be many to be listened to

and many to be persuaded. The route to success contains a mixture of idealism and practicality, planning and flexibility, dreaming and professionalism. Timing will be ever important. There are many reasons why an idea cannot happen. But most things come about when a group has clarified why they *should*. If the timing is off, statements and events will fall on deaf ears. The arts council must try to help others understand the patterns described. It is a struggle. Intense people are not always ready to listen.

There is a critical need for planning and evaluation among arts organizations, big and small — for realizing the symbiotic relationships among them in a given community. Not only that, the ramifications in any given art form of occurrences such as orchestra strikes or an organization's demise are no longer really contained in one city, but affect sibling groups in other locations. It is impossible for an arts organization to live in isolation.

Some creative solutions to these problems will be found — for example, the development of new sources of arts dollars, such as the hotel/motel tax portion allocated to the arts in some cities. Others will be tried — bingo games in California, the Arts Lottery in Massachusetts, coal taxes in Montana, and a special arts fund in Oregon. Some answers will fit properly; others will fall by the wayside because they are poorly conceived for the purpose.

Other solutions will be reflected in new types of board commitments, new volunteer roles, and coordinated efforts that make sense because they economize on administrative and organizational costs. Necessity could breed all kinds of sensible planning.

In order for planning and problem solving to take place, there needs to be an incentive. One kind is the planning grant, such as the one by the California Arts Council for developing county and/or city plans for arts programming. This state and local partnership program, to encourage local cultural planning and decision making, hopes eventually to reach objectives such as preventing duplication and overlap among federal, state, and local program funds; expanding local private sector support for the arts; and working with local government agencies. This local planning process is being reinforced by the state with planning workbooks, resource guides, and educational seminars. Local cultural leadership, government officials, and interested individuals have been involved.

If this is a clue as to how planning may occur in the future, it certainly will be incumbent upon individual organizations to know their own priorities and goals, so that there will be some relationship between them and the total community plan of which they will be a part.

The organization that suspends operations to get a handle on a plan that meets future needs takes a brave step, but that, too, may be a model. Too often all kinds of proprietary and self-serving reasons keep organizations going far beyond usefulness, necessity, or need — and change seems

extraordinarily difficult. The handwriting is on the wall; planning is a necessity.

At this writing, there is research being done on the relationship of government funding to arts organizations, including arts councils. Data is being sought from the recipients of the funds. Will there be vast differences from the results of past work — that government funding (at all levels) can be responsible for many times its dollar amount, and substantially more in terms of local, psychological, sociological, and artistic impact?

Faced with the seesaw of arts funding from other government levels, attention for planning and resourcefulness focuses on the communities. Through the "Sputnik" years of the 1970s (although the analogy falls short, for the amounts for the sciences were of greater dimension), there were some new concepts adopted — ones that drew us out of the "unemployment" framework of WPA and into the other dimensions and directions. Corporations, those Medicis of the twentieth century, are, in the best instances, finding the ways to support all kinds of arts endeavors and the work of creative artists. But the support is as uneven as the agendas of those who are in business. Business response in the past has come from relatively few corporations that have made cultural affairs an important portion of their largesse and community commitment. That small base needs broadening; arts councils have a future role in helping to motivate other corporations to examine the many possibilities for support, from individual payroll deduction plans to corporate contributions for sustaining artists and arts organizations. There are now many kinds of programs implemented somewhere that can bolster the confidence of those needing models. The innovative councils will seek still new ways for business and the arts to work together; but in a time of retrenchment, this effort will take commitment and persistence.

In San Francisco in 1981, the American Express Company assisted the San Francisco Art Commission in its effort to save the 35-year-old traditional annual Arts Festival in the face of greatly diminished funding. Not only did the corporation establish an expansive advertising campaign, but the Arts Commission gained five cents every time an American Express card was used, and two dollars every time a new card was issued in the local market area. The company also became involved, through provision of funds, publicity, and printing, in the Neighborhood Arts programming of the Commission. The impact of this activity by a major corporation is still being felt; other businesses and the new state Fair and Exposition Agency have joined a restructured festival program that will give this activity greater ongoing stability. Everyone has gained through this symbiotic activity involving public and private sectors working together.

The Greater Washington (D.C.) Cultural Alliance became a limited partner in the Portal Associates, with the Investment Group Development

Corporation and Tyroc Construction Corporation, in the proposal for the development of Washington's Portal Site. It provided an arrangement whereby the Alliance was to participate in gross revenues, amounting to a 1.5 percent share of office space and parking revenues and a 1 percent share of hotel revenues from the development package. The corporation would build a theater and art gallery, furnish the facilities for free, and absorb all associated operating expenses. In addition, 2,000 feet of office space would be provided to the Alliance, free of charge. Although the Portal Associates were not designated as the developers of Portal Site, the plan has become a model for potential partnership between the arts and business.

These two instances may become common stories in the future.

The foundations have been reevaluating the extent of their support, after, in some cases, substantial participation in arts education and arts organizations.

There are only a few certainties:

1. There is increased interest from the public that needs to be channeled and made productive.
2. Newer organizations without their own endowments will have even a rougher time coping without the multiplicity of funding sources — one stimulating the other.
3. Smaller organizations will need ever more help in forming supportive coalitions, or even in formulating ideas and well-organized proposals for private funding sources — a problem stemming from the small size of their staffs, as well as from less sophistication among board and/or volunteer groups.
4. Business, while it has been increasingly supportive of the arts, will not be able to take up the slack left by the loss of federal and state funds altogether. The smaller organizations, without the bark and bite of large ones, will lose out with the increased pressure from high-powered groups.
5. The multiplicity of public sources starts to erode without the stimulation of federal-state funding, which was just getting to the point of including community councils in the partnerships with the public sector. It will be tricky to keep regional activities and statewide service activities afloat. Community arts groups have derived less than 10 percent of their budgets from federal sources in the past, but it is the synergistic effect of the federal cuts that has a real impact on cities.
6. The potential for the arts as "peacemaker" in our cities, as frustrations build and tensions mount, may be a rallying cause.
7. The service organization is more needed than ever, but, without distinct and compelled advocates, it could be in great trouble and

also in great demand. The situation will depend on the creativity and vision of the local leadership.

8. The arts council may be the only kind of organization that can clarify issues on a neutral ground. Community understanding of many issues — for example, differentiating the need for support for such things as revitalization and arts centers and that for arts organizations per se — is critical to the ongoing support for both. This will be an important responsibility.

The value of the arts council will be the quality and depth of services, including the ability to lead in the development of educated advocacy. This will be especially important in the area of translating the issues clearly and the needs of the artists and arts organizations accurately. It will be important whether the advocacy is for laws and governmental support on the various levels and for arts education or whether it is for opportunities for artistic innovation and experimentation.

It may mean one-on-one problem solving and planning sessions with the smaller organizations in greater depth and a look at budgets, dreams, and priorities. Funding organizations will need to address the multiple ways that private funding can be developed, especially in the corporate sector, giving a broader group of businesses the confidence to design allocations policies, employee plans, and the quid pro quos that satisfy the needs both of the corporate entity and of the cultural community.

The municipal agency really wants and needs the advocacy and support of private sector; the private agency needs and wants the support of the community's public forces. Multiple funding patterns, given all the variations of levels and relationships, are probably here to stay, which means that there are multiple roles for leaders and advocates.

Some arts councils have performed with maturity and quality, and have created the models for others who are far from reaching their potential within the community they are serving. The future goal would be to strive for that increased depth of service and vision. For that is leadership, and the arts council has the possibility of a leadership role in the community.

Over a very short period, it is said, the 50-year-old Chautauqua movement disappeared; some of the factors affecting this were the external ones, such as improved transportation and communication by radio. WPA came and went in a few short years. As has been said, strong councils have come and gone for many reasons. Will the newer municipal agencies create the role models of the 1980s, and will the strong private councils continue to find new ways to work successfully? Will the small and large older councils with changing leadership maintain their strengths? Will the new strength in the movement in the South be sustained? Will there emerge new strength in the West or in other yet-to-be determined areas? Will we see

more alliances among arts organizations such as orchestras and dance groups for coordinated efforts, as well as for other more fragmented coordinated efforts?

The idea of the community arts council is so adaptable as to be potentially applicable to settings as divergent as universities, regions, cities, and towns. It will take people with vision, a sense of community, and proper timing of appropriate actions to let the spirit continue.

Geoffrey Platt, Jr., Executive Director of NASAA, has stated:

> As arts policy makers, we are often so concerned with numbers, ratios, charts, and other baggage of government work we lose sight that the end result for which we toil is essentially nonquantifiable: the effect on the human spirit. To be sure, we can produce figures to justify the means we take, their efficiency, equity, and rationale, but in the end the real effect is made, I believe, by those that present the case with passion and conviction.[3]

Since the greatest growth of arts councils has occurred in the last decade, those few years are no time and a lot of time — both. Obviously, there has not been enough time for enough communities to mature in their own activities to act together as a team. But there has been enough time for there to be many clues to the ways in which communities might act in the future. There have been creative solutions to many problems worked through a community context. Whether they are meaningful from community to community is a question, as the tendency is to look at the dissimilarities before acknowledging the ways in which problems are similar and might be similarly solved. There are no perfect solutions, but there is a wide variety of possible approaches to support systems, services and needs assessment, and fulfillment. The potential is often very complex and subtle, yet must be articulated and marketed well. This is the challenge to the community arts council.

Instead of being disheartened, the time has come to pull together community forces as never before. It will call for the best creative energies. When and if there is a time for the federal government to be more involved, the communities will be in a better position than ever to lead the way, because their collective thinking will have developed points of consensus. Then the local, state, and federal partnership will include leadership from and take its cues from communities. This is the next phase in the evolution of support for the arts in America.

Because of the nature of the community council movement, it has few definitive leaders at this moment. It represents many varying constituencies and varying foci. Therefore its structure, support groups, and the leadership within groups changes with the issues; the group makeup, priorities, and strategies keep changing and need reassessment. Confidence must be built up on the basis of experiences. Styles of leadership vary greatly, and

councils can easily become involved in the styles rather than the issues. Garnering leadership in such a setting challenges the problems inherent in democratic process.

The profile of communities will change; the cities growing in the 1970s may be "no-growth" communities in the 1980s. Small towns may become larger communities. Evaluation of the context and need must be continuous.

So, for the arts, a community base in the partnership sense is new. It is unnerving, tenuous, and disorienting. Former, present, and potential future leaders search for the priorities, but only through taking hold and defining them can progress be made.

The arts councils fear that they cannot keep up the pace of the last few years—most are overworked, understaffed, underbudgeted, and spread very thin. The major frustration, however, is with the level of citizen advocacy in their own communities. Citizens throughout our communities must come together, not only to look at the things that ought to be accomplished in their own communities (as in the discussions in the living-room settings of the Beer and Culture Society of Seattle in the 1950s), but to align themselves to those causes for a better cultural environment, as they have grown to do. A comment about WPA seems to apply: "The importance was, in the long run, what the people saw as valuable about the projects and whether they would fight for [their] political survival."[4]

With a policy now formally framed at the federal level, the federal-state-local partnership could become a logically developed system. It has a beginning point; the quality of the community portion and the advocacy behind it will be the important development of the 1980s. The groundwork has been done.

And what about the arts in all of this? The arts should thrive because they have advocates who are educated and demanding, questioning and responsive, and ultimately supportive. The arts councils must know how to address the issues and how to help the community attitudes develop. That will only come with maintaining their own high standards with solidly based backgrounds and solid leadership. As the director of one arts council and president of a state alliance has said, "We are full-fledged partners in the utility of our communities."[5]

NOTES

1. *NACAA Connections*, Spring 1982, p. 8.

2. National Assembly of Community Arts Agencies, *Report to the National Council on the Arts* (Washington, D.C.: Author, 1979), p. 6.

3. Geoffrey Platt, Jr., "Capital Comments," NASAA newsletter, February 15, 1981.

4. Milton Meltzer, *Violins and Shovels* (New York: Delacorte Press, 1976), p. 22.

5. Philip Morris, "Development—Just Another Buzzword?" *The Alliance Connection* (Huntington, New York), Summer 1982, p. 3.

Appendix:
Interviewees
and Resources

The resource persons represented their opinions from positions as listed, although some are presently employed or have been affiliated with different organizations. Some discussions were extensive; others could not really be considered interviews, amounting to little more than a response to a request for material that covered the subject. I plead for understanding if there should be inadvertent omissions or technical errors unavoidable in a research project of this dimension. Available resource material written by these persons was also considered.

COMMUNITY ARTS COUNCILS
(INCLUDING ALLIANCES, UNITED FUNDS, ETC.)

Name of Organization*	Name(s) of Major Contact(s)
Atlanta Arts Alliance, Atlanta, Georgia	Beauchamp C. Carr
City of Atlanta, Department of Cultural Affairs, Atlanta, Georgia	Tom Cullen and the office of Maynard Jackson
Roberson Center for the Arts and Sciences, Binghamton, New York	Duane Truex
Arts Development Services, Buffalo, New York	Maxine Brandenburg

*Organizations are listed according to alphabetical order of city, county, or state to which each belongs.

Name of Organization	*Name(s) of Major Contact(s)*
Cambridge Arts Council, Cambridge, Massachusetts	Pamela Worden
Arts and Sciences Council, Charlotte, North Carolina	Charles Hesse
Chautauqua County Association for the Arts, Dunkirk, New York	Philip Morris
Chicago Council of Fine Arts, Chicago, Illinois	Marie Cummings
Greater Columbus Arts Council, Columbus, Ohio	Frederic Wanetik, Tim Sublette
Council on the Arts for Cortland, New York, Inc.	Janet Steck
City of Dallas, City Arts Program Division, Park and Recreation Department, Dallas, Texas	Richard Huff
Dodge City Arts Council, Dodge City, Kansas	Sally Luallen
Durham Arts Council, Durham, North Carolina	James McIntyre
Fredonia Arts Council, Inc., Fredonia, Kansas	Joan Bayles
United Arts Council, Greensboro, North Carolina	Helen Snow
Greater Hartford Arts Council, Hartford, Connecticut	Ilene Chalmers
The Hartford Office of Cultural Affairs, Hartford, Connecticut	Paul Germaine-Brown
Hays Arts Council, Hays, Kansas	Carol Heil
Cultural Arts Council of Houston, Houston, Texas	John Blaine, Mary Anne Piacentini
Huntington Arts Council, Huntington, New York	Cindy Kiebitz
Grand Monadnock Arts Council, Keene, New Hampshire	Sara W. Germain
King County Arts Commission, Seattle, Washington	Yankee Johnson
Lima Area Arts Council, Lima, Ohio	Dean Gladden
Lorain County Arts Council, Inc., Elyria, Ohio	Constance Mateer
Macon County Arts Council, Franklin, North Carolina	Bobbi Contino
Manhattan Arts Council, Manhattan, Kansas	Rosanne Uhlarik

Name of Organization	*Name(s) of Major Contact(s)*
Minneapolis Arts Commission, Minneapolis, Minnesota	Melisande Charles
Arts Council of Greater New Orleans, New Orleans, Louisiana	Geoffrey Platt
Greater Philadelphia Cultural Alliance, Philadelphia, Pennsylvania	Carol Veit
Federated Council of Richmond, Richmond, Virginia	Kathy Dwyer
East End Arts and Humanities Council, Riverhead, New York	Mardythe Di Pirro
Sacramento Metropolitan Arts Commission, Sacramento, California	William Moskin
Arts and Humanities Commission of St. Louis, St. Louis, Missouri	Nicholaas Van Hevelingen
Arts and Education Council of St. Louis, St. Louis, Missouri	Richard Tombaugh
COMPAS, St. Paul, Minnesota	Molly LaBerge
St. Paul-Ramsey Arts and Sciences Council, St. Paul, Minnesota	Linda Hall
The Arts Council of San Antonio, San Antonio, Texas	Robert Canon
Community Arts of San Diego, San Diego, California	June Gutfleisch
San Francisco Art Commission, San Francisco, California	Joan Ellison
Seattle Arts Commission, Seattle, Washington	Daphne Enslow Bell
Corporate Council for the Arts, Seattle, Washington	John Renforth
Springfield Arts Council, Springfield, Ohio	J. Chris Moore
Toe River Arts Council, Spruce Pine, North Carolina	Susan Larson
The Cultural Resources Council of Syracuse and Onondaga County, Inc., Syracuse, New York	Joseph Golden
Texarkana Regional Arts and Humanities Council, Texarkana, Texas	Jerry Hill
Cultural Alliance of Greater Washington, Washington, D.C.	Peter Jablow

Name of Organization	*Name(s) Major Contact(s)*
Council for the Arts for Westchester County, White Plains, New York	Steven Goldshore
The Arts Council, Inc., Winston-Salem, North Carolina	Milton Rhodes

SPECIAL RESOURCE PERSONS*

James Backas (Consultant)

John Blaine (Director, Alaska State Council on the Arts; former Chairman, NACAA; former Director of the local council/commission, Seattle, Washington and Houston, Texas)

Ralph Burgard (Consultant)

Virginia Lee Comer (former Senior Consultant on Community Arts, Association of Junior Leagues of America, Inc.)

Hyman Faine (Founder, UCLA Management in the Arts Program)

R. Philip Hanes (Founder, ACA; President 1964–66; Chairman and Founder, North Carolina Arts Council)

Nancy Hanks (Chairman, National Endowment for the Arts 1969–77)

George Irwin (Founder, Quincy Society of Fine Arts, Quincy, Illinois)

Jonathan Katz (Director, Community Arts Management Program, Sangamon State University, Springfield, Illinois)

Frank Logue, Jr. (Chairman, National League of Cities Task Force on the Arts 1976–79)

Michael Lomax (Commissioner, Fulton County, Georgia)

Charles Christopher Mark (Editor/Publisher, *Arts Reporting Service*)

Michael Newton (President, ACA 1972–78)

Arthur Prieve (Director, Center for Arts Administration, University of Wisconsin-Madison)

Alvin H. (Skip) Reiss (Editor, *Arts Management*)

Wesley Uhlman (former Mayor, Seattle 1969–77)

John Urice (Director, MBA/Arts Program and Center for the Arts, SUNY-Binghamton, New York)

OTHER INTERVIEWEES AND RESOURCE PERSONS

Daniel Abrahms (Intern, Maryland National Captial Park Planning Commission)

Thomas A. Albert (City Spirits facilitator, National Endowment for the Arts)

Julie Anderson (former Chairman, Seattle Arts Commission)

Denise Bailey (Residency Administrator, Affiliate Artists, Inc.)

*Other biographical material is included in text.

Barbara Beach (Fairfax County Council of the Arts, Inc., Alexandria, Virginia)

Livingston Biddle (former Chairman, National Endowment for the Arts)

Robert Brickel (first Director, North Carolina Arts Council)

W. Grant Brownrigg (Director, ACA)

Sue Buske (National Federation of Local Cable Programmers)

Marlo Bussman (Director, Alabama Assembly of Community Arts Councils)

Gail Centini (Atlanta Department of Cultural Affairs)

Judy Chalker (Community Arts Coordinator, Ohio Arts Council)

William Cook (Executive Director, California Arts Council)

Alan Cowan (Director, Greater Louisville Fund for the Arts)

Charles Dambach (former Director, NACAA)

William Dawson (Executive Director, ACUCAA)

Paul DiMaggio (Yale School of Organization and Management)

Lani Lattin Duke (Executive Director, California Confederation of the Arts)

John Edwards (Manager, Chicago Symphony; former President, ASOL)

Karen Gates (Director, Seattle Arts Commission)

Henry Geldzahler (Commissioner, Department of Cultural Affairs, New York City)

Gracia N. Ginther (Director, Arts Development Services, Buffalo)

Maxine Cushing Gray (Editor and Publisher, *Northwest Arts*, Seattle)

Paul Gunther (Assistant, Department of Cultural Affairs, New York City)

James Hazeltine (Executive Director, Washington State Arts Commission)

Gail Heilbron (dancer, Seattle)

Harold Horowitz (Research Division, National Endowment for the Arts)

Elizabeth (Lee) Howard (Executive Director, Alliance of New York State Arts Councils; President, NACAA)

C. David Hughbanks (PONCHO, Seattle)

Paul Hummer (Chicago Council of Fine Arts)

Joan Jeffri (Associate in the Arts, Columbia University; author of *The Emerging Arts*)

Max Kaplan (private consultant)

Elizabeth Kennedy (Kansas City Arts Council)

Wayne Lawson (Executive Director, Ohio Arts Council)

Edgar Marston (Director, Division of the Arts, North Carolina State Department of Cultural Resources)

David B. H. Martin (Center for Responsible Government)

Robert A. Mayer (Executive Director, New York State Council on the Arts)

Robert McNulty (Partners for Livable Places; former Assistant Director, Architecture and Environment program, National Endowment for the Arts)

Clark Mitze (Director, Illinois Arts Council)

Susan Neumann (Deputy Director, Ohio Arts Council)

Halsey North (third Director, North Carolina Arts Council; former Director, Charlotte Arts and Sciences Council)

Mary Owen (Director, Allied Arts, Inc., Seattle)

Joanne Pearlstein (National Endowment for the Arts)*

*Deceased. This project would not have been as complete without the special attention and insight of Joanne Pearlstein, who had been at the National Endowment for the Arts since its inception.

Robert Porter (ACA)

William Potter (Researcher, National Endowment for the Arts)

Mary Regan (Executive Director, North Carolina Arts Council)

Alice Rooney (former Director, Allied Arts, Inc., Seattle)

Ken Saunderson (Downtown Seattle Corporation)

Steven Schmidt (Association of Community Arts Councils of Kansas)

Fred Schultz (North Carolina Arts Council)

E. Ray Scott (Director, Michigan Arts Council)

Mary Silerud (Minnesota State Arts Board)

Paul Sittenfeld (President, Cincinnati Institute of Fine Arts)

Peter Spackman (Executive Director, Council for the Arts at Massachusetts Institute of Technology)

A. B. Spellman (Expansion Arts program, National Endowment for the Arts)

Alfred Stites (Director, CART)

Romalyn Tilgman (Director, Association of Community Arts Councils of Kansas)

Tom Turk (President, Michigan Association of Community Arts Agencies)

Denise Vallon (National Cable Arts Council, New Orleans)

John Wessell (Regional Coordinator for New York–Caribbean, National Endowment for the Arts)

Gretchen Wiest (Executive Director, NACAA)

Jessie A. Woods (member, National Council on the Arts; arts administrator, Chicago, Illinois)

Burton Woolf (former City Spirit Program Chairman, National Endowment for the Arts; Executive Director, Metropolitan Cultural Alliance [Massachusetts Cultural Alliance], Boston)

George Worthingham (Austin Community TV, Austin, Texas)

RESOURCE PERSONS: ARTS IN EDUCATION

James Allison (Arts Coordinator, Jefferson County Public Schools)

Carolyn Anderson (Project Director, Seattle Public Schools)

Kathryn Bloom (former Director, JDR 3rd Fund, Arts in Education)

B. J. Bucker (Executive Director, Young Audiences, Inc., Kansas City, Kansas)

C. Douglas Carter (Assistant Superintendent, Winston-Salem/Forsyth County Schools)

Paul Dilworth (Coordinator, Department of the Arts, Hartford Public Schools)

Junius Eddy (private consultant in education and the arts)

Alfred Fischer (Consultant, Music and Arts, Minneapolis Public Schools)

Charles Fowler (private consultant in arts and education)

Charlotte Harrison (Oklahoma City Schools)

Harlan Hoffa (University of Pennsylvania)

Margaret Howard (Executive Director, The Arts, Education and Americans, Inc.)

Ruth Kaplan (Arts Coordinator, Arts in Education Program, Little Rock Public Schools)

Jack Kukuk (Director of Education, John F. Kennedy Center, Washington, D.C.)

Vince Lindstrom (Special Counsel for the Arts and Education, U.S. Office of Education and the National Endowment for the Arts)

Stanley Madeja (Vice President, CEMREL, Inc.)
Judith Meltzer (Seattle Public Schools)
Jack Morrison (Director, American Theater Association)
Mary Surat Pfeifer (Urban Arts/Arts in General Education, Minneapolis Public Schools)
Richard T. Pioli (Director, Aesthetic Education Division, Montgomery County Public Schools, Maryland)
Joe Prince (Artists in Education program, National Endowment for the Arts)
Jane Remer (private consultant, New York City)
Bernard Rosenblatt (CEMREL, Inc., Director, Arts and Humanities Group)
Martin Russell (Director, Fine and Performing Arts and Project Director for IMPACT, Columbus, Ohio)
Bennett Tarleton (Director, Alliance for Arts Education)
Ray Thompson (Arts Specialist, Seattle Public Schools)
Warren Yost (Director, Young Audiences, Inc.)

CONCLUDING NOTES AND ACKNOWLEDGMENTS

Special and separate questionnaires were prepared and sent to all interviewees, and to all statewide advocacy groups and cities and states with percent-for-public-art laws. Those groups are not listed separately here unless they returned more material than the questionnaire itself:

- California Confederation of the Arts
- Indiana Advocates for the Arts
- Minnesota Citizens for the Arts, Inc., and Citizens for the Arts, Inc.
- Concerned Citizens for the Arts of New York State
- Ohio Citizens Committee for the Arts

Special thanks to the librarians and staff at ACA and the National Endowment for the Arts for their assistance, especially William Linden, Chris Morrison, and Sharon Pope.

Also, to the executive assistants and secretaries at the various agencies. And to Beth Fisher, Public Information Office, Ohio Arts Council.

Bibliography*

GENERAL

Adler, Charles. "F-Stops with Artists." *Seattle Arts*, September 1980, p. 1.
Albert, Thomas A. City Spirit facilitation material for visit to Rochester, New York, 1978.
All in Order: Information Systems for the Arts. Report of the National Information Systems Project. Washington, D.C.: National Assembly of State Art Agencies, 1981.
Altman, Ross. "Creativity is Ageless." Brochure relating highlights of an arts program for older adults, San Fernando Valley Arts Council, 1980.
American Association of State Colleges and Universities. *Focus on the Arts: Discus-*

*The bibliography is arranged as follows:
 Community arts councils, commissions, federations, alliances, and other local groups: If items referred to are brochures, by-laws, calendars, constitutions, correspondence, directories, newsletters, pamphlets, or reports, the groups are listed alphabetically. Special contracts, publications, statutes, or studies are listed separately as well.
 Alliances, associations, state arts councils, regional groups, and all other groups, including national service groups: If items referred to are brochures, correspondence, newsletters, or guidelines, the organizations are listed alphabetically. Special publications, studies, and so on are listed individually as well.
 In general, all arts council material through March 1981 is included. General newsletters have been followed through June 1982. Material written *about* arts councils is included as individual entries.

sions from the Fifteenth Annual Meeting of the American Association of State Colleges and Universities. Washington, D.C.: AASCU Publications, 1976.

American Conservatory Theatre, November 1977.

American Council for the Arts. American Arts, October 1979–March 1982.

American Council for the Arts. Americans and the Arts: III. New York: National Research Center for the Arts, Inc., an affiliate of Louis Harris & Associates, author, 1981.

American Council for the Arts. The Arts and Tourism: A Profitable Partnership. New York: Author, 1981.

American Council for the Arts. Cable Television and the Performing Arts: Based on Proceedings of the National Conference Sponsored by New York University. New York: Author, 1982.

American Council for the Arts. A Survey of Arts Administration Training in the United States 1982–1983. New York: Author, 1982.

American Council for the Arts. A Survey of Arts Administration Training in the United States and Canada 1979–1980. New York: Author, 1979.

American Society of Association Executives. Achieving Goals: Making Your Mark as a Board Member. Washington, D.C.: Author, 1980.

American Society of Association Executives. Getting Involved: The Challenge of Committee Participation. Washington, D.C.: Author, 1980.

American Society of Association Executives. Moving Forward: Providing Leadership as the Chief Elected Officer. Washington, D.C.: Author, 1980.

Anderson, Carolyn. An Instructional Framework for the Arts in Education. (Draft) Strengths Assessment Component Title IV-C, Seattle School District, 1980.

Anderson, Donald. "Hey Cabbie, Take Me to Your Picasso." Mainliner, June 1975.

Anderson, Parks. "The Question of an Ideology of Public Art." In Art in Public Places Issue, Seattle Arts Commission material, 1980.

Anderson, Walt. Therapy and the Arts. New York: Harper & Row, 1977.

Aranson, H. H. History of Modern Art. New York: Abrams, 1977.

Arts Alliance of Washington State (Spokane). Artsplan 1. Washington, D.C.: U.S. Department of Commerce, 1979.

Arts Commission of Greater Toledo. "Economic Impact of the Arts in Toledo." Booklet, 1980.

Arts in Common. January/February 1976, May 1973, February 1973.

"The Arts Council: A Lesson in the Arts." The San Antonio Herald, November 4, 1976.

Arts Council of San Antonio. "Contract between the Arts Council of San Antonio and the City of San Antonio."

Arts Council of San Antonio. Summary Report: City Spirit, San Antonio 1976. San Antonio: Author, 1976.

Arts Councils of America. The Arts: A Central Element of a Good Society. New York: McGraw-Hill, 1965.

The Arts, Education and Americans Panel. Coming to Our Senses. New York: McGraw-Hill, 1977.

The Arts, Education and Americans, Inc. People and Places: Reaching Beyond the Schools. Report no. 1. New York: Author, 1980.

The Arts, Education and Americans, Inc. Ideas and Money for Expanding School Arts Programs. Report no. 4. New York: Author, 1980.

The Arts, Education and Americans, Inc. *Your School District and the Arts: A Self-Assessment*. Report no. 2. New York: Author, 1980.

Arts in Society. Spring/Summer 1971, Fall/Winter 1972, Spring/Summer 1973, Fall/Winter 1973, Spring/Summer 1975, Summer/Fall 1975.

Artworks '78: Documentary Journal of the CETA and the Arts '78 Program. Cleveland: Cleveland Area Arts Council, 1979.

Associated Councils of the Arts. *Americans and the Arts: I and II*. New York: National Research Center for the Arts, Inc., an affiliate of Louis Harris & Associates, author, 1975, 1976.

Associated Councils of the Arts. *The Arts: Planning for Change*. New York: Author, 1966.

Associated Councils of the Arts. *Community Arts Agencies/State Arts Agencies Relationships: CAA Perceptions* (a study for NACAA). New York: Author, 1976.

Associated Councils of the Arts. *Directory of Community Art Councils*. New York: Author, 1972.

Associated Councils of the Arts. *Guide to Community Arts Agencies*. New York: Author, 1974.

Backas, James. *A National Program for the Development of the Arts at the Community Level*. Washington, D.C.: National Endowment for the Arts, 1977.

Backas, James. *Public Arts Agencies: Toward National Public Policy*. National Policy Development Series. Washington, D.C.: National Assembly of State Arts Agencies, 1981.

Backas, James. "The Regional Arts Organization Movement." Background paper for the National Endowment for the Arts National Partnership Meeting, June 23–25, 1980.

Backas, James. "The State Arts Council Movement." Background paper for the National Endowment for the Arts National Partnership Meeting, June 23–25, 1980.

Baldwin, Pamela. *How Small Grants Make a Difference*. Washington, D.C.: Partners for Livable Places, 1980.

Barron, Fraser. *Government and the Arts*. Monthly analysis of developments in federal support for the arts and humanities. December 1979–December 1980.

Barzun, Jacques. *The Use and Abuse of Art*. Bollingen Series, vol. 35, no. 22. Princeton, N.J.: Princeton University Press, 1975.

Barzun, Jacques, and Saunders, Robert J. *Art in Basic Education*. Washington, D.C.: Council for Basic Education, 1979.

Baumol, William. *The Effect of Theater on the Economy of New York City*. Princeton, N.J.: Mathmatica, 1975.

Baumol, William J., and Bowen, William. *Performing Arts: The Economic Dilemma*. Cambridge, Mass.: MIT Press, 1977.

Beach, Barbara, and Eddy, Junius. *Bridges for Arts in Education: Three Speeches*. From the Conference on Arts and Education Evaluation, Cleveland, Ohio, September 19, 1975.

Beardsley, John. *Art in Public Places: A Survey of Community-Sponsored Projects Supported by the National Endowment*. Washington, D.C.: Partners for Livable Places, 1982.

Bentley, Eric. *What Is Theater?* New York: Horizon, 1956.

Blaine, John. Statement concerning language contained in the Senate Committee report on H.R. 12932, Department of the Interior and Related Agencies Appropriations Bill of 1979.

Bloom, Kathryn. "A Decade of Change." In *Arts and Education: A New Movement.* New York: Georgian Press, 1977.

Bradshaw, Bill. "Irwin Retires as Arts Society President." *Quincy Herald-Whig,* July 18, 1978.

Brambilla, Roberto, and Longo, Gianni. *Learning from Seattle.* New York: Institute for Environmental Action, 1979.

Broman, John. "Grantsmanship Resources for the Arts and Humanities." *Grantsmanship Center News,* March/April 1980.

Brown, Kenneth A. *Arts Councils: What and Where They Are.* Charleston, W. Va.: American Symphony Orchestra League, 1958.

Brown, Milton W. "New Deal Art Projects: Boondoggle or Bargain?" *Art News,* April 1982, pp. 82–87.

Brownrigg, W. Grant. *Corporate Fund Raising: A Practical Plan of Action.* New York: Associated Councils of the Arts, 1978.

Brush, Victoria, and O'Karma, Alexandra (researchers). *Sponsors List: 606 National Organizations That Sponsor Programs Involving Fiction Writers and Poets.* New York: Poets and Writers, Inc., 1979.

Burgard, Ralph. *Arts in the City: Organizing and Programming Community Arts Councils.* New York: Associated Councils of the Arts, 1968.

Burgard, Ralph. "The Arts World: A Brief Glance." Chart, 1979.

Burgard, Ralph. *Completing the Circle: State/Local Cultural Partnerships.* Draft. Washington, D.C.: National Assembly of State Arts Agencies, 1982.

Burgard, Ralph, "Creative Activities: Essential for Psychological Survival." Unpublished, 1979.

Burgard, Ralph. "The Creative Community." Unpublished case study on arts and sciences programs for new and renewing communities, 1973.

Burgard, Ralph. "Cultural Decentralization." Unpublished paper, 1972.

Burgard, Ralph. *Cultural Facilities.* Santa Cruz, Calif.: Cultural Action Plan, 1980.

Burgard, Ralph. *Cultural Programs.* Santa Cruz, Calif.: Cultural Action Plan, 1979.

Burgard, Ralph. Notes from his twenty-fifth anniversary celebration, National Assembly of Community Arts Agencies, 1980.

Burgard, Ralph. "Towards an American Cultural Policy." Paper written during the Northeast Assembly for the Future of the Performing Arts, New Haven, September 1981.

Burt, Nathaniel. *Palaces for the People: A Social History of the American Museum.* Boston: Little, Brown, 1977.

Bushnell, Don D., and Bushnell, Kathi Corbera. *The Arts, Education, and the Urban Sub-Culture.* Washington, D.C.: U.S. Office of Education, 1969.

Bussman, Marlo. Position paper, Alabama Assembly of Community Arts Agencies, 1980.

Cablevision. Various issues.

"California Arts Councils State-Local Partnership Program: 1980–81 Guidelines."

Cambridge (Massachusetts) Arts Council. "Arts on the Line/Art for Public Transit Spaces." Brochure, 1980.

Cambridge (Massachusetts) Arts Council. *From Hearing My Mother Talk: Stories by Cambridge Women.* Cambridge, Mass.: Pomegranate Press, 1979.

Cambridge (Massachusetts) Arts Council. Speech given by Joan Mondale on the occasion of the opening of the exhibition "Arts on the Line," February 8, 1980.

"Can the Government Promote Creativity—Or Only Artists?" New York *Times,* April 25, 1982.

Canon, Robert M. "The Rise of the Private (Independent) Community Arts Agency in City Government." In *Local Government and the Arts,* edited by Luisa Kreisberg, pp. 147–149. New York: American Council for the Arts, 1979. Updated here, 1982.

Carolan, Jane. *Awards List: 100 Grants, Fellowships, and Prizes Offered in the United States to Poets and Fiction Writers.* New York: Poets and Writers, Inc., 1978.

Carter, C. Douglas, and Adams, James A. "ABC Program." *Music Educator's Journal,* January 1978.

Case, Victoria, and Case, Robert Ormond. *We Called It Culture: The Story of Chautauqua.* Freeport, N.Y.: Books for Libraries Press, 1948.

Central City Businesses Plans and Problems. A study prepared for the use of the Subcommittee on Fiscal and Intergovernmental Policy of the Joint Economic Committee, Congress of the United States, January 1979.

Chapin, Isolde, and Mock, Richard. *New Faces in Public Places: Volunteers in the Humanities.* Washington, D.C.: The National Center for Citizen Involvement, 1979.

Chicago Council on Fine Arts. "Chicago Museums." Brochure, n.d.

Chicago Council on Fine Arts. *Corporate Support of the Arts.* Chicago: Author, 1977.

Chicago Council on Fine Arts. *Guide to Careers in the Arts 1978–79.* Chicago: Author, 1978.

Chicago Council on Fine Arts. *Guide to Chicago Murals: Yesterday and Today,* edited by W. A. Sorell. Chicago: Author, 1979.

Chicago Council on Fine Arts. "Your Guide to Loop Sculpture." Brochure, n.d.

City Spirit (National Endowment for the Arts). Staff program proposal for the second year (November 1975); assorted papers, guidelines, programs, 1976 ff.

Cleveland Area Arts Council. "The Arts Connection—Placing Artists in the Schools." Pamphlet, 1977.

Cleveland Area Arts Council. "Community Arts Resources for Schools." Paper, 1977.

Cleveland Area Arts Council. "Proposal to the Cuyahoga County Commissioners for Direct Support of the County's Cultural Resources." 1979.

Coe, Linda, and Benedict, Stephen, eds. *Arts Management: An Annotated Bibliography.* Washington, D.C.: National Endowment for the Arts, 1978.

Coe, Linda C., Denney, Rebecca, and Rogers, Anne. *Cultural Directory II: Federal Funds and Services for the Arts and Humanities.* Washington, D.C.: Smithsonian Institution Press, 1980.

Coleman, William T., Jr. "Design, Art and Architecture in Transportation." Report. Washington, D.C., 1977.

"Columbus Artists: From Every Corner of the City." Brochure for a cultural exchange exhibition between Honolulu and Columbus, Ohio, 1980.

Comer, Virginia Lee. The *Arts and Our Town: A Plan for a Community Cultural Study*. New York: Association of Junior Leagues of America, Inc., 1944.

Comer, Virginia Lee. "The Arts and Your Town: The Junior League Explores a New Field for Community Planning." *Community: Bulletin of Community Chests and Councils, Inc.*, November 1946, pp.44–46.

Commission on the Humanities. *The Humanities in American Life*. Berkeley: University of California Press, 1980.

"Community Arts Agencies Discussion Paper." Draft from the Planning Office of the National Endowment for the Arts, 1976.

Congressional Arts Caucus Education Programs. Letter from Fred Richmond, Chairman. Washington, D.C., September 11, 1981.

Cooney, Patricia. "Mural Project Gets People Involved." Des Moines *Sunday Register*, December 28, 1980.

Crist, Christine Myers. *An Unprecedented Conference: Arts and Education at Little Rock*. New York: American Council for the Arts, 1979.

Cultural Affairs. Assorted issues. Published by the Associated Councils of the Arts.

Cultural Alliance of Greater Washington. "NEA Community Program Policy Not Yet Dead." *Alliance News*, December/January 1979/80.

Cwi, David. *The Economic Impact of Six Cultural Institutions on the Economy of the Columbus SMSA*. Baltimore: Johns Hopkins University Center for Metropolitan Planning and Research, 1981.

Dallas Park and Recreation Department, City Arts Program Division. "Cultural Policy and Program for the City of Dallas." First draft, January 1980.

Daniels, Ellen Stodolsky, ed. *How to Raise Money: Special Events for Arts Organizations*. New York: Associated Councils of the Arts, 1977.

Data Use and Access Laboratories. *Where Artists Live: 1970 Research Division Reports No. 5*. New York: Center for Cultural Resources, 1977.

Day, Ann. "Community Arts Agencies Project: Overview and Points for Discussion." Position paper examining the relationship of the National Endowment for the Arts and community arts agencies, June 1976.

DiMaggio, Paul. "The Impact of Public Funding on Organizations in the Arts." Program on Non-Profit Organizations Working Paper no. 31. New Haven: Yale University, Institute for Social and Policy Studies, July 1981.

Dobbs, Stephen M., ed. *Arts Education and Back to Basics*. Reston, Va.: National Art Education Association, 1979.

Doezema, Marianne, and Hargrove, June. *The Public Monument and Its Audience*. Kent, Ohio: Kent State University Press, 1977.

Dowley, Jennifer, ed. *Money Business: Grants and Awards for Creative Artists*. Boston: The Artists Foundation, Inc., 1978.

"The Economics of Amenity," *Economics of Amenity News*, December 1, 1980.

Eddy, Junius. *Arts Education 1977—In Prose and Print*. Report prepared for the Subcommittee on Education in the Arts and the Humanities of the Federal Interagency Committee on Education, 1977.

Eddy, Junius. *A Report on the Seattle School System's Arts for Learning Projects*. Seattle: Seattle Public Schools, 1978.

Eddy, Junius. "Toward Coordinated Federal Policies for Support of Arts Educa-

tion." Position paper of the Alliance for Arts Education, with the assistance of the National Arts Education Advisory Panel, 1977.

Eddy, Junius. *The Upsidedown Curriculum*. A Ford Foundation reprint from *Cultural Affairs*, Summer 1970.

Educational Facilities Laboratories. *The Place of the Arts in New Towns*. Report, 1973.

Educational Testing Service. "National Merit Awards Programs in the Arts: Primed Objectives and Characteristics." Report, September 26, 1976.

Educational Testing Service. "National Merit Awards Program in the Arts: What Might Cosponsorship Entail?" Report, September 1978.

Edwards, Lavillyn. "Young Chamber Group Has Wealth of Experience." Columbus *Dispatch*, November 1, 1980.

Engman, John (panelist). Panel discussion by Arts Development Council in preparation for a conference (April 1980), "Volunteers in the Arts," sponsored by the Greater Milwaukee Voluntary Action Center; reprinted in *Milwaukee Arts Network*, April 1980, p. 6.

Ewell, Maryo, and Ewell, Peter. "Planning for Grassroots Arts Development: A Research Study of Nine Communities in Transition." *Arts in Society* 12(1975): 92–94.

"An Exhibition: Selections from the collection of George M. Irwin." Brochure, Krannert Art Museum, University of Illinois, Urbana-Champaign.

Faul, Roberta, ed. *Places for the Arts*. Washington, D.C.: National Endowment for the Arts, n.d.

Fayetteville/Cumberland County (North Carolina) Arts Council, "Facts of the Matter—Design in '80." Brochure, 1980.

Federal Grants A-02042-1, A-68-0-57, and A-69-0-53, July 1966–June 1969. Grants given by the National Endowment for the Arts to the Office of Community Arts Development, University of Wisconsin Department of Extension Arts.

Field, Lyman. "The States: Partnership in the Public Interest." *Cultural Affairs*, Spring 1970, p. 18.

Folio: Collection of Artistic Pieces. Buffalo: Arts Development Services, Inc., 1978.

Ford Foundation. *Sharps and Flats: A Report on Ford Foundation Assistance to American Music*. New York: Author, 1980.

The Foundation Center. *Conducting Evaluations: Three Perspectives*. New York: Author, 1980.

Fowler, Charles B., ed. *An Arts-in-Education Source Book: A View from the JDR 3rd Fund*. New York: JDR 3rd Fund, 1980.

Fowler, Charles B. *The Arts Process in Basic Education*. Arts in Basic Education Project, Pennsylvania Department of Education, 1974.

Fowler, Charles B. "On Education." *The Community School Movement: High Fidelity/Musical America*, July 1977.

Fowler, Charles B., ed. *Summit Conference on the Arts and Education: A Report*. Washington, D.C.: Alliance for Arts Education, 1980.

Fowler, Charles B. "In Tribute: The JDR 3rd Fund." *Musical America*, April 1980, pp. 12–15.

Friedli, Max. "The Arts Lottery: A Piece of the Public Action." *American Arts*, January 1981, pp. 10–13.

Fuld, Alice, "Arts for Special Audiences." In *Community Focus*. Alexandria, Va.: United Way of America, February 1980, pp. 14–15.

Fuller, Lucille. *Arts Commissions in Washington State*. Seattle: University of Washington (Institute of Governmental Research), 1979.

Gard, Robert. "The Arts in the Small Community." *Arts in Society* 12(1975):82–91.

Gates, Karen. "1981 SAC Budget Recommendations Reviewed." *Seattle Arts*, May 1980, p. 1.

Gelles, George. "Public Arts Support and the Federal Presence." Background paper for the National Endowment for the Arts National Partnership Meeting, June 23–25, 1980.

Gelles, George. *Report of Proceedings of the National Partnership Meeting (June 1980)*. Washington, D.C.: National Endowment for the Arts, 1980.

Gibans, Nina F. "Education for Aesthetic Awareness." Paper presented to the Rockefeller Panel and Report Conference, September 29, 1977.

Gibans, Nina F. "On New Public Art in Cleveland, Ohio." Speech given at conference on Monumental Art in Our Society: Public Art and Public Policies, Cincinnati, July 1980.

Gibans, Nina F., and Rago, James. "Arts Management Institute." Schedule of a three-day symposium, January 1975.

Gingold, Diane J. *The Challenge Grant Experience*. Washington, D.C.: National Endowment for the Arts, 1980.

Glackin, William C. "The Fine Art of Artistic Survival." Sacramento *Bee*, September 30, 1979.

Glick, Ruth. "The Arts and Older Americans: A Progress Report." Paper prepared for the Symposium on the Arts, the Humanities, and Older Americans, National Council on the Aging, Inc., Philadelphia, February 1–3, 1981.

Golden, Joseph. *Olympus on Main Street*. Syracuse: Syracuse University Press, 1980.

Graham, John E. "Understanding the 'Majors.'" *Northwest Arts*, December 19, 1980, pp. 1.

"Greater Columbus Arts Council Long-Range Plan: June 1979–June 1982." Report, April 11, 1979.

Great Lakes Arts Alliance. *Resource Directory: Conferences, Seminars*, and *Workshops for Arts Managers, 1981–82*. Cleveland: Author, 1981.

Great Lakes Performing Artist Associates. "What You've Always Wanted to Know About Advancing Your Career but Had No One to Ask." Information Sheet. Ann Arbor, Mich.: Author, 1981.

Green, Dennis. *Percent for Art: New Legislation Can Integrate Art and Architecture*. Denver: Western States Arts Foundation, Inc., 1976.

Green, Lynn. "Eyes on the Arts." *The Long Islander*, January 14, 1980.

Grove, Richard. "The Arts and the Gifted." In *Proceedings from the National Conference on Arts and Humanities/Gifted and Talented*. Reston, Va.: Council for Exceptional Children, 1975.

Guide to Developing a Two-Year Operational Plan. St. Paul, Minn.: Ramsey Arts and Sciences Council, 1980.

Gustavson, Robert. "Corporate Council on the Arts." *Northwest Arts*, October 30, 1981, p. 7.

Halpin, Lawrence, Ikeda, Sue Yung Li, and Burns, Jim. *Roundhouse: A Handbook*

for City Spirit Facilitators. Washington, D.C.: National Endowment for the Arts, 1976.

Handy, Edward William J., and Westbrook, Max, eds. *Twentieth-Century Criticism: The Major Statements*. New York: Free Press, 1974.

Hanes, R. Philip, Jr. "Arts Councils of America: Progress in Review." In *The Arts: A Central Element of a Good Society*. New York: Arts Councils of America, 1965.

Harney, Audy Leon, ed. *The City and the Arts*. Washington, D.C.: Partners for Livable Places, 1980.

Harney, Audy Leon. *Reviving the Urban Waterfront*. Washington, D.C.: Partners for Livable Places, National Endowment for the Arts, and the Office of Coastal Zone Management, n.d.

Harris, Louis. "What Arts People Think." *Cultural Affairs*, August 1971, pp. 1–6.

Hart, Raymond. "Cable TV: Its Time Has Come." Cleveland *Plain Dealer*, February 24, 1980.

Hatfield, Thomas A., ed. *Arts and Schooling: A Record of the Proceedings of the Arts and Schooling Conference held in Columbia, South Carolina, April 1979*. Columbia, S.C.: South Carolina Department of Education, 1979.

Haworth, John. "Structuring Community Arts Services in Urban Areas." *ACA Reports* 9(1978):7–8.

Hayes, Cecil B. *The American Lyceum: Its History and Contribution to Education*. Washington, D.C.: U.S. Department of the Interior, 1932.

Hays, William, ed. *Twentieth-Century Views of Music History*. New York: Scribners, 1972.

Heimann, Fritz, ed. *The Future of Foundations*. Englewood Cliffs, N.J.: Prentice-Hall, 1973.

Hellman, Mary. "Community Arts: A Family Looking for a House." San Diego *Union*, August 12, 1979.

Henninger, Daniel. "A City That Staged a Fair and Got Culture." *Wall Street Journal*, March 9, 1979.

Herron, Caroline Rand. *A Writer's Guide to Copyright*. New York: Poets and Writers, Inc., 1979.

Hodsoll, Frank. Address given at CityArts Conference, Wingspread, Racine, Wisconsin, March 9, 1982.

Hoffa, Harlan. *An Analysis of Recent Research Conferences in Art Education*. Washington, D.C.: U.S. Department of Health, Education and Welfare, 1970.

Hoffa, Harlan. "The History of the Idea." Prepared for discussion at "Arts and Aesthetics: An Agenda for the Future," a conference co-sponsored by CEMREL. Inc. and the Education Program of the Aspen Institute for Humanistic Studies. Unpublished manuscript, 1976.

Hospital Audiences, Inc. *HAI News*, Fall 1979.

Howard, Margaret B. "The Arts Are Basic: Have We Come to Our Senses?" Keynote Speech at the National Guild of Community Schools, St. Louis, Missouri, October 29, 1979.

Hufstedler, Shirley Mount. *Statement on the 1981 Budget and Revisions to the 1980 Budget for the Department of Education*. Washington, D.C.: U.S. Department of Education, 1980.

Institute on the Humanities, Arts, and Aging. *Human Values and Aging* 3(1981).

Jacobson, Dorothy, and Pittas, Michael J. "Cultural Planning: A Common Ground for Development." *American Arts*, January 1982.

Jaymont, Barbara, ed. *Planning Arts in Education*. Washington, D.C.: National Endowment for the Arts, 1976.

JDR 3rd Fund. *Ad Hoc Coalition of States for the Arts in Education: Comprehensive Arts Planning*. New York: Author, 1975 and 1977.

JDR 3rd Fund. *Considerations for School Systems Contemplating a Comprehensive Arts in General Education Program*. New York: Author, 1977.

Jeffri, Joan. *The Emerging Art: Management, Survival and Growth*. New York: Praeger, 1980.

Johnson, Alton C., and Prieve, E. Arthur. *Older Americans: The Unrealized Audience for the Arts*. Madison: University of Wisconsin Press, n.d.

Johnson, Elmer D., and Harris, Michael H. *History of Libraries in the Western World*. Metuchen, N.J.: Scarecrow Press, 1976.

Jones, Welton. "The Lively Arts." San Diego *Union*, October 16, 1977.

Jones, Welton. "Rancho's Gain, Downtown's Loss." San Diego *Union*, March 30, 1980.

Journal of Architectural Education. November 1976.

Junior League of Little Rock Magazine. September 1977 and March 1979.

Kamarch, Edward. "The Surge of Community Arts." *Arts in Society* 12(1975):6–9.

Kaplan, Max. *Art in a Changing America*. Urbana: University of Illinois Press, 1956.

Kaplan, Max. *Foundations and Frontiers of Music Education*. New York: Holt, Rinehart & Winston, 1966.

Kaplan, Max. *Leisure in America*. New York: Wiley, 1960.

Keller, Anthony S. "Contemporary European Arts Support Systems." Background paper for the National Endowment for the Arts National Partnership Meeting, June 23–25, 1980.

Kennedy, Wallace. "Where the Arts are Created, Housed, and Performed." *Urban Arts 10th Anniversary Photo-Journal*, 1980.

Kilpatrick, Charles O. "Arts Council Serves City." San Antonio News, July 13, 1977, p. 14a.

Kilpatrick, Charles O. "Culture Quotient Tests a Town." San Antonio *Sunday Express-News*, April 15, 1979, p. 2H.

Kreisberg, Luisa, ed. *Local Government and the Arts*. New York: American Council for the Arts, 1979.

Kurzig, Carol. *Foundation Fundamentals: A Guide for Grants Seekers*. New York: The Foundation Center, 1980.

Landheer, Bartholomeus. *The Social Function of Libraries*. Metuchen, N.J.: Scarecrow Press, 1957.

Larsen, Peter. "Neighborhood Arts." Seattle Arts Commission materials, 1977.

Lee, Sherman, ed. *On Understanding Art Museums*. Englewood Cliffs, N.J.: Prentice-Hall, 1975.

Levinson, Nan. *Local Arts Agencies*. Washington, D.C.: National Endowment for the Arts, July 1981.

Lindstrom, Vince. "Priorities for the Year Ahead." In *Summit Conference on the Arts and Education: A Report*. Washington, D.C.: Alliance for Arts Education, 1980.

Lloyd, Virginia M. *Minimum Standards for Ohio Elementary Schools*. Columbus: Ohio Department of Education, 1970.

Lomax, Michael. "Opening Remarks." In *Report for conference on Options for Action: Building our Cultural Community.* Boston, December 1978, pp. 9–14.

Lopez, Bernard B. *State Arts Agencies' Perceptions of Community Arts Agencies, A Report.* Washington, D.C.: NASAA, 1976.

Lowry, W. McNeil, ed. *The Performing Arts and American Society.* Englewood Cliffs, N.J.: Prentice-Hall, 1978.

Lowry, W. McNeil. "The State of the Arts Today." Speech presented at The Great Lakes Assembly, Cleveland, Ohio, 1980.

Lowry, W. McNeil. "The University and the Creative Arts." A Ford Foundation reprint from *Educational Theater Journal* 14(1962).

Mahony, Sheila, DeMartino, Nick, and Stengel, Robert. *Keeping Pace with the New Television.* New York: Carnegie Corporation of New York, 1980.

Mangione, Jerry. *The Dream and the Deal.* Boston: Little, Brown, 1972.

Mark, Charles Christopher. *Smiles on Faces All Over the Country: A Study and Evaluation of Affiliate Artists' CART Program, 1978–80.* New York: Affiliate Artists, Inc., 1980.

Martin, David B. H. Materials prepared for the Office of Partnership, National Endowment for the Arts, 1980.

Martin, David R. "Management for Arts' Sake." *Corporate Report,* May 1979.

Matson, Katinka. *The Working Actor: A Guide to the Profession.* New York: Penguin, 1976.

Mayer, Martin, ed. *Bricks, Mortar, and the Performing Arts.* Millwood, N.Y.: Kraus Reprints, 1970.

Mayer, Robert A. "The Local Arts Council Movement." Background paper for the National Endowment for the Arts National Partnership Meeting, June 23–25, 1980.

McDonald, William. *Federal Relief Administration and the Arts.* Columbus: Ohio State University Press, 1969.

McLaughlin, Jeff. "A Sound Kaleidoscope." Boston *Globe,* June 2, 1980.

McNulty, Robert P. *The White Paper: Architecture and Environmental Arts Program.* Washington, D.C.: National Endowment for the Arts, 1973.

Meltzer, Milton. *Violins and Shovels.* New York: Delacorte Press, 1976.

Meyer, Leonard. *Music, the Arts and Ideas.* Chicago: University of Chicago Press, 1967.

Miaoulis, George, with Lloyd, David W. *Marketing the Arts in a Rural Environment: The Monadnock Arts Study.* Monograph Series no. 4. Dayton, Ohio: Wright State University Press, 1979.

Miller, Margo. "United States Arts Panel Comes to Town." Boston *Globe,* March 19, 1979.

Mills, C. Wright. *The Sociological Imagination.* London: Oxford University Press, 1980. (Originally published, 1959.)

Moon, Robert. "Program Management: A New Way to Structure Project Development in an Arts Council." *Performing Arts Review* 3(1972).

"More Artists Join Work Force." Cleveland *Press,* April 18, 1982.

Morris, Jerry W., and Stuckhardt, Michael H. *Summary and Evaluation: The Alliance for Art Education Region II Conference.* Columbus: Alliance for Art Education, Inc., 1978.

Morrison, Theodore. *Chautauqua: A Center for Education, Religion, and the Arts*

in America. Chicago: University of Chicago Press, 1974.

Moskow, Michael H. *Labor Relations in the Performing Arts: An Introductory Survey*. New York: Associated Councils of the Arts, 1969.

Moynihan, Daniel P. "On Pluralism and the Independent Sector." Speech reprinted in *NACAA Newsletter*, May 15, 1980, pp. 1–4.

Murphy, Judy, and Gross, Ronald. *The Arts and the Poor: New Challenge for Educators*. Washington, D.C.: U.S. Government Printing Office, 1968.

Murphy, Judy, and Jones, Lonna. *Research in Arts Education*. Washington, D.C.: U.S. Department of Health, Education and Welfare, 1976.

Murphy, Mary Jane. "Unified Arts for the Junior High School." *Art Teacher*, Fall 1976.

National Assembly of Community Arts Agencies. *The Arts Talk Economics*. Washington, D.C.: Author, 1980.

National Assembly of Community Arts Agencies. Assorted minutes, memos, papers, 1972–82. (Available from the author.)

National Assembly of Community Arts Agencies. *Report to the National Council on the Arts*. Washington, D.C.: Author, 1979.

National Assembly of State Arts Agencies. *Arts Organizations, Lobbying, and the Law*. Washington, D.C.: Author, 1980.

National Assembly of State Arts Agencies. Position paper on the Community Arts program of the National Endowment for the Arts, September 27, 1980.

National Association of State Universities and Land-Grant Colleges. *The State of the Arts at State Universities and Land-Grant Colleges*. Washington, D.C.: Office of Communications Services, 1979.

National Committee for Cultural Resources. *National Report on the Arts*. New York: Author, 1975.

National Conference of State Legislatures Arts Task Force. *Arts and the States: A Report*, compiled by Larry Briskin. Denver: Author, 1981.

National Conference on the Role of Arts in Urban Economic Development, October 1978, at Minneapolis. "Summation."

National Council on the Aging, Inc. *Arts and the Aging: An Agenda for Action*. Washington, D.C.: Author, 1977.

National Council on the Aging, Inc. *The Arts, the Humanities, and Older Americans*. Washington, D.C.: Author, 1981.

National Council on the Arts. *Advancing the Arts in America: Report to the Presidential Task Force*. Washington, D.C.: Author, 1981.

National Council on the Arts. *Report of the Task Force on the Education, Training, and Development of Professional Artists and Arts Educators*. Washington, D.C.: Author, 1978.

National Elementary Principal. January/February 1976.

National Endowment for the Arts. *Adaptive Use: Alleys to Zoos*. Washington, D.C.: Author, n.d.

National Endowment for the Arts. *Advisory for Community Arts Agencies: Funding Possibilities from the NEA and Other Federal Sources*. Washington, D.C.: Author, 1976.

National Endowment for the Arts. *Artists-in-Schools Program*. Washington, D.C.: Author, 1980.

National Endowment for the Arts. *Bulletin on Federal Economic Programs and the Arts*. Washington, D.C.: Author, 1979.

National Endowment for the Arts. *Challenge Grants: Application Guidelines, Fiscal Year 1981.* Washington, D.C.: Author, 1979.

National Endowment for the Arts. *Composers: Centers for New Music Resources — Application Guidelines, Fiscal Year 1982.* Washington, D.C.: Author, 1980.

National Endowment for the Arts. *Dance, Mime: Application Guidelines, Fiscal Year 1982.* Washington, D.C.: Author, 1980.

National Endowment for the Arts. *Dance Touring Program: Application Guidelines, 1980–81 Touring Season.* Washington, D.C.: Author, 1979.

National Endowment for the Arts. *Dance Touring Program: Application Guidelines, 1981–82 Touring Season.* Washington, D.C.: Author, 1980.

National Endowment for the Arts. *Downtowns: Reinvestment by Design.* Washington, D.C.: Author, 1977.

National Endowment for the Arts. Draft discussion paper on Local/Community Policy, 1980.

National Endowment for the Arts. *Employment and Unemployment of Artists: 1970–75.* Washington, D.C.: Author, 1976.

National Endowment for the Arts. *Expansion Arts: Application Guidelines, Fiscal Year 1982.* Washington, D.C.: Author, 1980; also materials, notes, evaluation on CityArts program.

National Endowment for the Arts. *Federal-State Partnership: Program and Funding Information.* Washington, D.C.: Author, 1973–78; also assorted memos, papers, drafts, studies, notes.

National Endowment for the Arts. *Folk Arts: Application Guidelines, Fiscal Years 1981–82.* Washington, D.C.: Author, 1980.

National Endowment for the Arts. *Goals and Grants.* Washington, D.C.: Author, 1976.

National Endowment for the Arts. *Guide to Programs 1981.* Washington, D.C.: Author, 1980.

National Endowment for the Arts. *Inter-Arts Program (Formerly Special Projects Program): Application Guidelines, Fiscal Year 1981.* Washington, D.C.: Author, 1980.

National Endowment for the Arts. *Jazz: Application Guidelines, Fiscal Year 1981.* Washington, D.C.: Author, 1980.

National Endowment for the Arts. *Literature: Application Guidelines, Fiscal Year 1981.* Washington, D.C.: Author, 1980.

National Endowment for the Arts. *Media Arts (Film/Radio/Television): Application Guidelines, Fiscal Year 1981.* Washington, D.C.: Author, 1980.

National Endowment for the Arts. Memo from Eva Jacob concerning "Policy Statement of the National Council on the Arts on Service Organization Support/ Service Organization Study Report," August 12, 1980.

National Endowment for the Arts. Memo from Robert Peck concerning National Endowment for the Arts contribution to the formation of Carter administration's urban policy, September 26, 1977.

National Endowment for the Arts. Memo from Robert Peck concerning draft report on Urban Policy and the Arts, October 11, 1977.

National Endowment for the Arts. *Minorities and Women in the Arts: 1970.* Washington, D.C.: Author, 1978.

National Endowment for the Arts. *Museums: Application Guidelines, Fiscal Year 1982.* Washington, D.C.: Author, 1980.

National Endowment for the Arts. *The National Council on the Arts and the National Endowment.* Washington, D.C.: Author, 1976.

National Endowment for the Arts. *National Endowment Fellowship Program (Formerly Work Experience Internship Program): Application Guidelines, Fiscal Year 1981.* Washington, D.C.: Author, 1980.

National Endowment for the Arts. *Neighborhoods: Revitalization by Design.* Washington, D.C.: Author, 1977.

National Endowment for the Arts. *New Music Performance and Chamber Music.* Washington, D.C.: Author, 1979.

National Endowment for the Arts. *Opera, Musical Theater: Application Guidelines, Fiscal Year 1981.* Washington, D.C.: Author, 1980.

National Endowment for the Arts. *Policy Report for the National Council on the Arts on the Federal-State Partnership Reassessment.* Washington, D.C.: Author, August 1977.

National Endowment for the Arts. *Presenting Organizations, 1981 (Special Projects Program).* Washington, D.C.: Author, 1980.

National Endowment for the Arts, Research Division. *Reports,* nos. 1–15. Washington, D.C.: The Publishing Center for Cultural Resources, 1976–82.

National Endowment for the Arts. *Support the Arts* 1(1977).

National Endowment for the Arts. Task Force on Community Program Policy. "Report for Discussion no. 104." August 1979.

National Endowment for the Arts. *Theater: Application Guidelines, Fiscal Year 1980 (Performance Season 1980–81).* Washington, D.C.: Author, 1979.

National Endowment for the Arts. *Theater: Application Guidelines, Fiscal Year 1981 (Performance Season 1981–82).* Washington, D.C.: Author, 1980.

National Endowment for the Arts. *Visual Arts: Application Guidelines, Fiscal Year 1981.* Washington, D.C.: Author, 1980.

National Endowment for the Arts. *Where Artists Live: 1970.* Washington, D.C.: Author, 1977.

National Endowment for the Humanities. *Division of Research Programs: Guidelines.* Washington, D.C.: Author, 1980.

National Endowment for the Humanities. *Humanities Institutes Program Guidelines for Institutes for Teaching in the Humanities.* Washington, D.C.: Author, 1976.

National Endowment for the Humanities. *Program Announcement 1981–82.* Washington, D.C.: Author, 1981.

National Endowment for the Humanities. *Residential Fellowships for College Teachers: Seminar Descriptions 1981–82.* Washington, D.C.: Author, 1981.

National Foundation on the Arts and Humanities Act of 1965, Section 2. Public Law 209, 89th Congress, as amended through October 8, 1976.

National League of Cities Task Force on the Arts. City and the Arts Questionnaire sent to 450 cities, 1977.

National Information Systems Project. "Report of the National Information Systems Project." Paper, 1980.

National Urban Coalition. *Understanding CETA.* Washington, D.C.: Author, n.d.

Nation's Cities Weekly. Newspaper, National League of Cities, December 31, 1979.

Nelson, Charles A., and Turk, Frederick, J. *Financial Management for the Arts.* New York: Associated Councils of the Arts, 1975.

Netzer, Dick. *The Subsidized Muse: Public Support for the Arts in the United States.* Cambridge, England: Cambridge University Press, 1978.

"New Arts Council Plans to Aid Individuals and Bold Experiments as National Movement Grows." *Arts Management,* February 1962.

New England Foundation for the Arts. "The Arts and the New England Economy." Study, n.d.

Newman, Danny. *Subscribe Now.* New York: Theater Communications Group, 1978.

Newman, Joyce. "One Percent for Art." *American Artist Magazine,* January 1975.

"New Orleans: Forgetting to Care about Art." *Art News,* December 1979.

Newton, Michael. "City Government and the Arts." Speech given in St. Louis, 1978.

Newton, Michael. "A Community of Interest." Speech at the annual meeting of the Associated Councils of the Arts, June 18, 1978.

Newton, Michael. "Pros and Cons of United Fundraising for the Arts." In *United Arts Fundraising Manual,* p. 6, edited by Robert Porter. New York: American Council for the Arts, 1980.

Newton, Michael. Remarks at Arts and City Planning Conference, San Antonio, December 1979.

Newton, Michael. Speech at CARE for St. Louis Conference, March 4, 1977.

Newton, Michael. Speech in St. Louis at the General Assembly of the Arts and Education Council of Greater St. Louis, May 13, 1975.

Newton, Michael, and Hatley, Scott. *Persuade and Provide.* New York: Associated Councils of the Arts, 1970.

Noffsinger, John S. *Correspondence Schools, Lyceums, Chautauquas.* New York: Macmillan, 1926.

North Carolina Arts Council. *The Arts in North Carolina 1967.* Raleigh: North Carolina Arts Council, 1967.

Nye, Russell B. *The Unembarrassed Muse.* New York: Dial Press, 1970.

O'Connor, Francis V. *The New Deal Art Projects: An Anthology of Memoirs.* Washington, D.C.: Smithsonian Institution Press, 1972.

Ohio Arts Council. *Environmental Arts Grant Awards Program: Design Forum.* Columbus: Author, 1979.

Ohio Arts Council. *Guidelines: 1980–81 Addendum.* Columbus: Author, 1980.

Ohio Arts Council. *Policy-Making Meetings: Agendas, Appropriate Paperwork, Etc.* Columbus: Author, 1980.

Ohio Department of Education. *Standards for Colleges or Universities Preparing Teachers.* Columbus: Author, 1975.

Ohio Department of Education. *Task Force on Minimum Competency Expectations.* Columbus: Author, 1977.

Ohio State University. "Studies in Art Administration." Courses offered, 1980–81, College of Arts.

Option for Action. Conference, Metropolitan Cultural Alliance, Boston, December 1978.

Parker, Will. "MRCA Survey Shows Strong Arts Support." Peterborough (New Hampshire) *Ledger,* June 1, 1977, p. 5.

Partners for Livable Places. "Economics of Amenity News," edited by Dorothy Webb, September 1981–April 1982.

Partners for Livable Places. *Partners for Livable Places News,* October 10, 1980.

PEN American Center. *Grants and Awards Available to American Writers*, 11th ed. New York: Author, 1980.

Perlman, Bernard B. *One Percent in Civic Architecture*. Baltimore: RTKL Associates, 1973.

Pfeifer, Mary S. *A Consumer Survey of the Urban Arts Program*. Minneapolis: The Urban Arts Program, 1978.

The Philanthropy Monthly, April 1978.

Pierce, Neal R. "North Carolina's Arts Strategy is Returning Double Dividends." Albuquerque *Journal*, June 8, 1980.

Porter, Robert, ed. *The Arts and City Planning*. New York: American Council on the Arts, 1980.

Porter, Robert. "State Appropriations: Will They Be Enough?" *ACA Update*, January 1982, pp. 10–13.

Porter, Robert. *United Arts Fundraising*. New York: American Council on the Arts, 1979, 1980, 1981.

Poulin, A., Jr., ed. *Contemporary American Poetry*. Boston: Houghton-Mifflin, 1975.

Presidential Task Force on the Arts and Humanities. *Report to the President*. Washington, D.C.: 1981.

Public Administration Review. July/August 1970, pp. 376–408.

"Public and Private Support for the Arts in New York City." Cultural Assistance Center, Inc., January 1980.

Putsch, Henry E. "Issues and Opportunities Facing the Public Sector Arts Support Network." Background paper for the National Endowment for the Arts National Partnership Meeting, June 23–25, 1980.

Putsch, Henry E. *Local/Community Arts Agency Policy Development*. Washington, D.C.: National Endowment for the Arts, 1981.

Putsch, Henry E. *Towards a Federal-State-Local Partnership: Policy and Program Recommendations for Strengthening Support for the Arts by Local Arts Agencies*. Washington, D.C.: National Council on the Arts, 1981.

Re:. East Lansing, Mich.: Michigan Association of Community Arts Agencies, December 1980.

Reade, Cynthia, and Van Cott, Bruce. "The CAA/SAA Relationship: CAA Perceptions." Report to the Associated Councils of the Arts, June 26, 1976.

Regan, Mary. *Community Development Through the Endowment*. Washington, D.C.: National Endowment for the Arts, 1976.

Regan, Mary Jane. *Echoes from the Past: Reminiscences of the Boston Athenaeum*. Boston: Boston Athenaeum, 1927.

Regelski, Thomas A. *Arts Education and Brain Research*. Reston, Va.: Musical Educators National Conference, 1978.

Reger, Larry. "Recommendations on How to Proceed on the Questions of Small Groups and Struggling Artists." Paper presented to the Executive Committee, National Assembly of Community Arts Agencies, July 1977.

Reich, Ann. *The Arts: A Dimension in Education*. Seattle: Arts Office of the Seattle Public Schools, 1978.

Reimer, Bennett. "Education for Aesthetic Awareness: The Cleveland Area Project."

Music Educator's Journal, February 1978, pp. 7, 66–69.

Reiss, Alvin H. *The Arts Management Reader.* New York: Audience Arts, 1979.

Reiss, Alvin H. *Culture and Company: A Critical Study of an Improbable Alliance.* New York: Twayne, 1972.

Remer, Jane. *Changing Schools through the Arts: The Power of an Idea.* New York: McGraw-Hill, 1982.

Rhodes, Milton. "Fastest-Growing Arts Institution in America — Community Arts Agencies." Task Force Study for the Federal-State Partnership Reassessment, July 1977.

Roberson Center for the Arts and Sciences. "Treasure House," a brochure on the museums of New York State, 1979.

Roberson Center for the Arts and Sciences. "Charles Eldred: Sculpture and Drawing," exhibit brochure, March–June 1980.

Roberson Center for the Arts and Sciences. "Emil Holzhauer: 75 Years of an Artist's Life," exhibit brochure, April–June 1980.

Robiner, Linda G. "Aesthetic Awareness: Teaching the Teachers About the Arts." *American Arts*, December 1979, pp. 16–18.

Robiner, Linda. "A Quiet Revolution: Education for Aesthetic Awareness." *School Arts*, May 1980, pp. 32–35.

Rockefeller Foundation. *Working Papers: The Healing Role of the Arts.* New York: Rockefeller Publications Office, 1978.

Rockefeller Panel. *The Performing Arts: Problems and Prospects.* New York: McGraw-Hill, 1965.

Rodosky, Robert. *Final Evaluation Report of Arts IMPACT.* Columbus, Ohio: Columbus City School District, 1974.

Rooney, Alice. *Western States Foundation Newsletter*, July 1975, Edition 7.

Rosenblatt, Bernard S. *Handbook: Teacher Education for Aesthetic Education.* St. Louis: Central Midwestern Regional Educational Laboratory, 1977.

Rosenblatt, Bernard S., and Mikel, Edward. Final Draft of *Practitioners' Guide — CEMREL'S Aesthetic Education Program.* St. Louis: Central Midwestern Regional Educational Laboratory, 1977.

Rotzoll, Brenda W. "State Commitment to Art Is Urged at House Hearing." Keene (New Hampshire) *Sentinel*, April 20, 1979.

Ruttenberg, Friedman, Kilgallon, Butchess & Associates, Inc. *Survey of Employment, Underemployment, and Unemployment in the Performing Arts.* Washington, D.C.: Human Resources Development Institute, 1977.

St. Louis Arts and Humanities Commission. St. Louis *Editions*, 1982.

Sacramento City Code. Ordinance no. 4274, October 16, 1979.

San Francisco Neighborhood Arts Program. "An Interview with Stephen Goldstine." July 14, 1974.

Sansweet, Stephen J. "Proposition 13's Impact on the Arts." *Wall Street Journal*, July 14, 1978, p. 11.

Sawyer, Ellen. "Arts Council Works Hard for San Antonio." San Antonio *Express-News*, July 10, 1977, p. 124.

Scheyer, Patricia T. *The Arts Connection: CAAC Self-Evaluation of Arts-in-Education Programs.* Cleveland: Cleveland Area Arts Council, 1975–76.

Schiff, Bennett. "Arts in Park and Recreation Settings" (Arts, Parks, and Leisure Project). Washington, D.C.: National Park Service, The National Recreation and Park Association, and the National Endowment for the Arts, 1974.

Schilit, Henrietta, ed. *All the Arts for All the Children*. New York: Arts in General Education Program, 1974–77.

Seattle Public Schools. *Long-Range Educational Plan: Report of the Program Study Committee for the Arts*. Seattle: Author, 1980.

Seattle Public Schools. *Futures Paper*. Rev. ed. Seattle: Author, 1980.

Sheehan, Kathy, and McLaughlin, Jeff. "River Festival Shows a City How to Get Along." Boston *Sunday Globe*, May 22, 1977.

Shoup, E. Richard, and Tollifson, Jerry. "A New Direction for the Arts in Education in Ohio." *Ohio Elementary Principal*, March 1978, pp. 25–26.

Shouse, Ben. Testimony before the Finance, Education and Subcommittee, Ohio State Legislature, March 11, 1981, pp. 1–3.

Shuker, Nancy, ed. *Arts-in-Education Partners: Schools and Their Communities*. New York: Georgian Press, 1977.

Sittenfield, Paul. "Putting the Pieces Together." In *United Arts Fundraising Manual*, edited by Robert Porter. New York: American Council for the Arts, 1980.

Skuce, John E., and Lockhart-Moss, Eunice. "CityArts: An Evaluation." Draft, 1980.

Sorell, Walter. *The Dance through the Ages*. New York: Grosset & Dunlap, 1967.

Spencer, Sharon. *Space, Time, and Structure in the Modern Novel*. New York: New York University Press, 1971.

Spicker, Stuart F., Woodward, Kathleen M. and Van Tassel, David D., eds. *Aging and the Elderly*. Atlantic Highlands, N.J.: Humanities Press, 1978.

Stake, Robert E. "To Evaluate an Arts Program." *Journal of Aesthetic Education*, Fall 1973.

Stoughton, R. "Observable Aesthetic Behaviors among Participants in Education for Aesthetic Awareness." Unpublished manuscript, Cleveland, Ohio, Sessions 2, 3, and 4, September 1977–May 1978.

Straight, Michael. *Twigs for an Eagle's Nest*. New York: Devon Press, 1979.

Sublette, Tim. "Disabled Have Right to Arts Activities." Columbus *Dispatch*, December 24, 1979, p. B-3.

"Superfluous 'S' Merits a Guess." (Buffalo, N.Y.) *City Editor*, October 23, 1979.

A Survey of Arts and Cultural Activities in Chicago. Chicago: Chicago Council on Fine Arts, 1977.

Takacs, Carol. "Measuring the Impact of an In-Service Workshop on Elementary Teachers' Self-Perceptions as Aesthetic Educators." *Contributions to Music Education*, no. 6.

Taper, Bernard. *The Arts in Boston*. Cambridge, Mass.: Harvard University Press, 1970.

Taylor, Harold. "The Transformation of the Schools." In *Proceedings from the National Conference on Arts and Humanities/Gifted and Talented*. Reston, Va.: Council for Exceptional Children, 1975.

Taylor, Joshua. "America as Art." In *The New Deal Art Projects: An Anthology of Memoirs*, edited by Francis V. O'Conner. Washington, D.C.: Smithsonian Institution, 1972.

Temkin, Sanford, and Brown, Mary V., eds. *What Do Research Findings Say about Getting Innovations into Schools?: A Symposium.* Philadelphia: Research for Better Schools, 1974.

Texas Tourist Development Agency. "1979 Texas City Room Occupancy Tax Survey." Report. Austin, Tex.: Author.

Theater Communications Group. *Theater Profiles: Resource Book on Non-Profit Professional Theater of the United States.* New York: Author, 1979.

Thompson, Helen M. *History and Purpose of the Arts Council Survey.* Charleston, W. Va.: American Symphony Orchestra League, 1958.

Turner, Alberta, ed. *Collection of Fifty Contemporary Poets: The Creative Process.* New York: David McKay, 1977.

Turner, W. Homer. "Opportunities for Action in Support of Cultural Needs." Address given in Philadelphia, 1962.

Turney, Anthony B. "Summary of Responses to Community Arts Agency Survey." Memo, National Endowment for the Arts, July 1980.

Uhlman, Wes. "The Mayor and the Arts: Big Business, Good Politics, and Urban Renaissance." Speech given at a seminar for newly elected mayors, November 1975, Harvard University.

Ulman, Elinor, Kramer, Edith, and Kwiatkowska, Hanna Yaxa. *Art Therapy in the United States.* Craftsbury Common, Vt.: Art Therapy Publications, 1977.

"U.S. Arts Grant Aids Desegregation." Buffalo *Evening News*, February 24, 1980.

U.S. Conference of Mayors. "Quality of Life in Our Cities." Resolution, 1974.

U.S. Conference of Mayors and the National Assembly of Community Arts Agencies. *Analysis of State and Local Government-Supported Cultural Facilities and Resources.* Washington, D.C.: Authors, 1978.

U.S. Conference of Mayors' Committee on the Arts. "The Taxpayers' Revolt and the Arts." Position paper, 1978.

U.S. Congress. House. Subcommittee of the *Supplemental Appropriations Bill: Hearings.* 89th Congress, 1st session. Washington, D.C.: U.S. Government Printing Office, 1966, pp. 25–26.

U.S. Congress, Senate. Bill to amend the National Foundation on the Arts and Humanities Act of 1965. June 25, 1979.

U.S. Congress, Senate. *Report on the Arts and Humanities Act of 1980.* January 29, 1980.

U.S. Department of Health, Education and Welfare. *Application for Grants under the Arts Education Program.* Washington, D.C.: U.S. Government Printing Office, 1979.

U.S. Department of Health, Education and Welfare. *Arts Education Program.* Washington, D.C.: U.S. Government Printing Office, 1980.

U.S. Department of Health, Education and Welfare. *The Education of Adolescents.* Washington, D.C.: U.S. Government Printing Office, 1976.

U.S. Department of Health, Education and Welfare. *Try a New Face: A Report on HEW-Supported Arts Projects in American Schools.* Washington, D.C.: U.S. Government Printing Office, 1979.

U.S. Department of Health, Education and Welfare, Institute of Museum Services. "Museum Services Program." *Federal Register*, Part IV, September 29, 1978.

U.S. Department of Health, Education and Welfare, Office of Education. *Arts and Humanities Program*. Various materials through the office of Harold Arberg, Director.

U.S. Department of Labor, Employment and Training Administration. *The Partnership of CETA and the Arts*. Reprints from *Worklife*. Washington, D.C.: U.S. Department of Labor, 1978.

U.S. General Services Administration. "On the 'Art-in-Architecture' program: Artworks in Federal Buildings." Washington, D.C.: Author, 1979.

The United Way of America. "Community Focus." Brochure, February 1980.

Urban Innovations Group. *The Arts in the Economic Life of the City*. New York: American Council for the Arts, 1980.

Vaughan, Mary Ann, and Jensen, Olive J. "Music and Art: Field-based Experience for Education Students." *Art Teacher*, Fall 1976.

Vinson, Elizabeth. *For the Soul and Pocketbook: Resource Guide for the Arts in Rural and Small Communities*. Washington, D.C.: National Rural Center, 1981.

Volunteer Lawyers for the Arts. *A Guide for Arts Groups*. New York: New York State Council on the Arts, 1975.

Volunteer Lawyers for the Arts. *Housing for Artists: The New York Experience*. New York: New York State Council on the Arts, 1976.

Volunteer Urban Consulting Group. *A Guide to Operations*. New York: Author, n.d.

Ward, Charles. "A Positive Outlook for Cultural Arts Councils." Houston *Chronicle*, April 15, 1980.

Warfield, John N. *Totos: Improving Group Problem-Solving*. Columbus, Ohio: Academy for Contemporary Problems, 1975.

Warfield, John N., Geschka, Horst, and Hamilton, Ronald. *Methods of Idea Management*. Columbus, Ohio: Academy for Contemporary Problems, 1975.

Warlum, Michael, ed., with Kohlhoff, Ralph, and Even, Mary Jane. *The Arts and the Small Community*, vols. 1 and 2. Madison, Wisconsin, 1967.

Washington Comprehensive Arts Education Program. *Arts in Education*. Seattle: Washington State Alliance for Arts Education, 1980.

Weaver, Sayre, ed. *Access: The Lively Arts*. A directory of arts organizations and their activities in the Puget Sound area. Seattle: Allied Arts of Seattle, 1976.

Weiner, Steve. "Bassett, Nebraska, leads the U.S. in Spending per Resident on Arts." *Wall Street Journal*, April 7, 1981, p. 1.

Wenner, Gene C. "Arts-in-Education Program." In *Dance in the Schools: A New Movement in Education*. Washington, D.C.: National Endowment for the Arts and the U.S. Office of Education, 1973.

Wertheimer, Barbara M. *Exploring the Arts: A Handbook for Trade Union Program Planners*. New York: New York State Council on the Arts, 1968.

West, Valerie. "Art Extension Service." Background material for "A New Kind of Currency" A National Conference on The Role of the Arts in Urban Economic Development, Minneapolis, October 1978.

White, Leslie C., and Thompson, Helen M., eds. *Survey of Arts Councils*. Charleston, W. Va.: American Symphony Orchestra League, 1958.

White, Richard A., ed. *Of Erie County*. Buffalo: Arts Development Services, 1978.

Whitfield, Van Tile. *Policy Paper on Expansion Arts*. Washington, D.C.: National Endowment for the Arts, 1978.

Whitney Museum. *Two Hundred Years of American Sculpture*. Boston: Godine, 1976.

Wiener, Louise. "The Cultural Industry Profile." Unpublished memo, January 1979.

Wiener, Louise. *Perspectives on the Economic Development Potential of Cultural Resources*. Washington, D.C.: U.S. Department of Commerce, 1978.

Wilson, Edwin. "The Arts Provide an Old City's Foundation." *Wall Street Journal*, August 31, 1979.

Wilson, Marlene. *Effective Management of Volunteer Programs*. Boulder, Colo.: Volunteer Publishing, 1976.

Wilson, Walter C. "CEP May Be Wiped Out." *Northwest Arts*, February 6, 1981, p. 8.

Wittlin, Alma. *Museums in Search of a Usable Future*. Cambridge, Mass.: MIT Press, 1970.

Woolf, Burton. "Figures on Municipal Support for the Arts, March 1, 1977." Memo, 1977.

Worden, Pamela. "The Arts: A New Urban Experience." *Challenge*, February 1980, pp. 17–21.

Worden, Pamela, and Fleming, Ronald Lee. "Neighborhood Values: Reinvestment by Design." *Public Management*, August 1977, pp. 14–17.

Worthy, Edmund H., Jr. *A Kaleidoscope of Facts, Statistics Trends, and Policies Pertaining to Older Americans, the Arts, and the Humanities*. Washington, D.C.: National Council on the Aging, 1980.

Yale School of Organization and Management. *Master's Program in Public and Private Management*. New Haven: Author, 1979.

Yegge, Robert B. "State Arts Agency Enabling Legislation: A Model, Annotated." Study, September 1981.

Yellin, Marcelline. "Business and the Arts." Background material for "A New Kind of Currency." A National Conference on The Role of the Arts in Urban Economic Development, Minneapolis, October 1978.

Zimmer, Anne, ed. *The Arts, Education, and Ohio*. Columbus: Ohio State University Press, 1977.

REGULAR PUBLICATIONS

American Council for the Arts (formerly Arts Councils of America and Associated Councils of the Arts). *American Arts* (replaced *ACA Reports* – October 1968– September 1979), William Keens, ed.; *ACA Update* (replaced *Word from Washington* – January 1970–September 1979), William Keens, ed.; other former ACA periodicals include *Cultural Affairs* (January 1967–May 1971) and *Arts in Common* (January 1967–April 1974); 570 Seventh Avenue, New York, New York 10018.

The Arts Chronicle, Dori Berger, ed., P.O. Box 5350, FDR Station, New York, New York 10150.

Arts Management, Alvin H. Reiss, ed., 408 West 57th Street, New York, New York 10019.

Arts Reporting Service, Charles Christopher Mark, ed., P.O. Box 40937, Washington, D.C. 20016.

Business Committee for the Arts, *Arts Business*, 1501 Broadway, New York, New York 10036.

Government and the Arts, Fraser Barron, ed., 1054 Potomac Street N.W., Washington, D.C. 20007.

Grassroots and Pavements, Art Media Service, Vantile E. Whitfield, publisher, 1940 15th Street N.W., Washington, D.C. 20009.

National Assembly of Local Arts Agencies, *Connections*, 1625 I Street N.W., Suite 725A, Washington, D.C. 20006.

National Endowment for the Arts, *Cultural Post*, Mail Stop 550, Washington, D.C. 20506.

National Endowment for the Humanities, *Humanities*, Mail Stop 204, Washington, D.C. 20506.

Neighborhood Arts Programs National Organizing Committee (NAPNOC), *Cultural Democracy*, P.O. Box 11440, Baltimore, Maryland 21239.

Northwest Arts, Maxine Cushing Gray, ed., Box 97, Seattle, Washington 98125.

Partners for Livable Places, *PLACE, the Magazine for Livability*, and *Livability Digest*, 1429 21st Street N.W., Washington, D.C. 20036.

Washington International Arts Letter, T. N. Snyder, ed., Box 9005, Washington, D.C. 20003.

SOURCES FOR ORGANIZATION, FEDERATION, ALLIANCE, COUNCIL, AND COMMISSION MATERIAL*

Alabama Assembly of Community Arts Councils
Alaska State Council on the Arts
Ashtabula (Ohio) Arts Center
Atlanta Department of Cultural Affairs
Atlanta Memorial Arts Center/Atlanta Arts Alliance
Arts and Humanities Council of Greater Baton Rouge (Louisiana)
Metropolitan Cultural Alliance, Inc. (Massachusetts Cultural Alliance) (Boston)
Arts Development Services (Buffalo and Erie County, New York)
California Confederation of the Arts
Cambridge (Massachusetts) Arts Council
Arts and Sciences Council (Charlotte, North Carolina)
Chautauqua County (New York) Association for the Arts
Chicago Council on Fine Arts
Cincinnati Commission on the Arts
Cleveland Area Arts Council
Colorado Council on the Arts and Humanities
Columbus (Ohio) Association for the Performing Arts
Greater Columbus Arts Council
Connecticut Commission on the Arts
Council on the Arts for Cortland, New York

*Sources are arranged according to alphabetical order of city, county, or state to which each belongs.

Dallas Park and Recreation Department, City Arts Program Division
Arts and Humanities Council of the Lake Region (Devil's Lake, North Dakota)
Durham (North Carolina) Arts Council
Arts Council of Fayetteville/Cumberland County (North Carolina)
Concerned Citizens of Fort Wayne, Indiana
Fredonia (New York) Arts Council
Metropolitan Arts Council (Greenville, South Carolina)
United Arts Council of Greensboro (North Carolina)
Town of Greenburgh (New York)
City of Hartford Commission on Cultural Affairs/Office of Cultural Affairs
Greater Hartford Arts Council
Hays (Kansas) Arts Council
Cultural Arts Council of Houston
Illinois Arts Council
Indiana Advocates for the Arts
Indiana Arts Commission
Metropolitan Arts Council of Indianapolis
Iowa Arts Council
Arts Assembly of Jacksonville (Florida)
Association of Community Arts Councils of Kansas
Kansas Art Commission
Grand Monadnock Arts Council (Keene, New Hampshire)
King County (Washington) Arts Commission
Community Council for the Arts (Kinston, North Carolina)
Greater Knox Council for the Arts (Knoxville, Tennessee)
Acadiana Arts Council (Lafayette, Louisiana)
Lake County (Ohio) Council of the Arts
Lansing (Michigan) Federated Cultural Appeal
Council for the Arts of Greater Lima (Ohio)
Lima Area Arts Council
Junior League of Little Rock (Arkansas)
Lorain County (Ohio) Arts Council
Performing Arts Council of the Music Center (Los Angeles)
Macon County (North Carolina) Cultural Art Council
Manhattan (Kansas) Arts Council
Commonwealth of Massachusetts Council on the Arts and Humanities
Council for the Arts at MIT (Massachusetts Institute of Technology)
University of Massachusetts at Amherst, Cooperative Extension Service
Michigan Association of Community Arts Agencies
Midland Center for the Arts
Milwaukee Art Commission
Milwaukee Arts Network
Minneapolis Arts Commission
Twin Cities Metropolitan Arts Alliance (Minneapolis–St. Paul)
Citizens for the Arts, Inc./Minnesota Citizens for the Arts
Minnesota State Arts Board
Burke Arts Council (Morgantown, North Carolina)
Nebraska Arts Council

Arts Council of (Greater) New Orleans
New York City Department of Cultural Affairs
Alliance of New York State Arts Councils, Inc.
New York State Council on the Arts
North Carolina Arts Council
Northwood (Michigan) Institute
Alliance of Ohio Community Arts Agencies
Association of Ohio Dance Companies
Ohio Arts Council
Oregon Citizens for the Arts
Oswego County (New York) Council on the Arts
Greater Philadelphia Cultural Alliance
Metropolitan Arts Commission (Portland, Oregon)
Quincy (Illinois) Society of Fine Arts
East End Arts and Humanities Council (Riverhead, New York)
Performing Arts Center (Riverhead, New York)
Sacramento Metropolitan Arts Commission
Arts and Eduation Council of Greater St. Louis
Ramsey Arts and Science Council (St. Paul, Minnesota)
Arts Council of San Antonio
Combined Arts and Education Council of San Diego
Community Arts (San Diego)
San Francisco Arts Commission
Corporate Council for the Arts (Seattle)
Seattle Arts Commission
Shreveport (Louisiana) Regional Arts Council
Springfield (Ohio) Arts Council
Toe River Arts Council (Spruce Pine, North Carolina)
Cultural Resources Council of Syracuse and Onondaga County (New York)
Tacoma–Pierce County (Washington) Civic Arts Commission
North Tahoe Fine Arts Council
Arts Commission of Greater Toledo (Ohio)
Tucson Commission of the Arts and Culture
Arts and Humanities Council of Tulsa (Oklahoma)
Community Arts Council of Vancouver
City of Walnut Creek (California) Civic Arts Department
Cultural Alliance of Greater Washington (D.C.)
Arts Alliance of Washington State
Council for the Arts in Westchester County (New York)
The Arts Council, Inc. (Winston-Salem, North Carolina)

SOURCES FOR ARTS-IN-EDUCATION MATERIAL (IN ADDITION TO THOSE LISTED ELSEWHERE)*

Alliance for Arts Education
Arts, Education and Americans, Inc.
Cultural Education Collaborative (Boston)
Brecksville-Broadview Heights (Ohio) City Schools
Central Midwestern Regional Educational Laboratory (CEMREL)
Columbus (Ohio) City Schools
Jeffco Arts in Education Program (Jefferson County, Colorado)
John F. Kennedy Center for the Performing Arts
Lakewood (Ohio) Public Schools
Arts in Education (Little Rock Public Schools)
Little Rock School District
Minnesota State Arts Board
National Art Education Association
Ohio Department of Education
Ohio, State Superintendent of Public Instruction, Advisory Committee for the Arts
 in Education
Seattle Public Schools

SOURCES FOR ADDITIONAL MATERIAL*

Affiliate Artists, Inc.
State of Arkansas, Department of Arkansas Natural and Cultural Heritage
Association of College, University, and Community Arts Administrators, Inc.
 (ACUCAA)
Birmingham Children's Theatre
Ballet Theatre Foundation
Village Bach Festival (Cass City, Michigan)
Spirit Square Arts Center (Charlotte, North Carolina)
Playhouse Square Foundation (Cleveland)
United Labor Agency (Cleveland)
Community Artists Residency Training program (CART)
Cornish Institute of Allied Arts
Lake Region Chautauqua Corporation (Devil's Lake, North Dakota)
Hospital Audiences, Inc. (HAI)
Jersey City (New Jersey), Governor's Ethnic Advisory Council
Kansas City Chapter of Young Audiences, Inc.
Montgomery County (Maryland) Recreation Department

*City, county, and state organizations are arranged according to alphabetical order of locality to which each belongs; national organizations are arranged according to alphabetical order of title.

National Assembly of Community Arts Agencies (NACAA)
National Assembly of State Arts Agencies (NASAA)
National Guild of Community Schools of the Arts, Inc.
Neighborhood Art Programs National Organizing Committee (NAPNOC)
Association of Ohio Dance Companies
Organization of Ohio Orchestras
Downtown Seattle Development Association
Crosby Gardens (Toledo Artists' Club)
Yale School of Organization and Management

Index

About the Author

NINA FREEDLANDER GIBANS has a background as an arts consultant, manager, teacher, writer, and civic leader. She has received individual grants to discuss contemporary arts issues over radio and to research the material for this book. An advisor to businesses, civic groups, arts groups, and educational institutions on planning, programming, and financial development, she has counseled individual artists and arts managers. She has written and taught on the arts, arts management, and arts issues. Gibans was Executive Director of the Cleveland Area Arts Council and an instructor at the Cleveland Museum of Art; she started the Cleveland chapter of Young Audiences, Inc., and has served on the boards of about two dozen civic and arts organizations. She has served on the national boards of NACAA and ACUCAA. She received the Arts Management of the Year Award from Arts Management and the Arts and Business Council, Inc., in 1974. She was educated at Wellesley and Sarah Lawrence Colleges and earned her Master's degree in aesthetics and art history at Case Western Reserve University. She has lived in Cleveland, Ohio; Kansas; and California.